Enteignet, entzogen, verkauft

BAND 3

Provenire

Schriftenreihe des
Deutschen Zentrums Kulturgutverluste,
Magdeburg

Enteignet, entzogen, verkauft

Zur Aufarbeitung der Kulturgutverluste in SBZ und DDR

Herausgegeben von
Mathias Deinert, Uwe Hartmann, Gilbert Lupfer,
Deutsches Zentrum Kulturgutverluste, Magdeburg

DE GRUYTER

Inhalt

▲ Nachwirkungen

▲ Konferenznachlese

▲ Anhang

Grußwort

Sehr geehrte Damen und Herren,
der Umgang einer Gesellschaft mit ihrem Kulturgut ist ein wesentlicher Ausdruck für den Stellenwert, den unsere gemeinsamen europäischen Werte in ihr besitzen. Ihre Pflege ist der Kern unseres kulturellen Gedächtnisses. Unser Denken, unsere Erinnerung und auch unsere Kreativität sind wesentlich an das auf uns überkommene Kulturgut gebunden. Die Auseinandersetzung mit ihm lässt den Respekt vor den Generationen wachsen, die vor uns gewesen sind.

Weil dies ein ganz wesentlicher Grundsatz zivilisierter Gesellschaften ist, müssen uns jede Vernichtung, jeder unrechtmäßige Umgang und jeglicher Missbrauch von Kulturgut zutiefst beunruhigen. Es ist ein wichtiger Teil unserer geschichtlichen Aufarbeitung, dass wir die Ursachen und Wirkungen von Kulturgutverlusten detailliert erforschen.

Die Konferenz „VEB Kunst – Kulturgutentzug und Handel in der DDR" am 30. November 2020 sowie dieses Buch „Enteignet, entzogen, verkauft – Zur Aufarbeitung der Kulturgutverluste in SBZ und DDR" stehen genau in diesem Zusammenhang. Sie sind Ausdruck dafür, dass wir diese Arbeit sehr ernst nehmen.

Der Stiftungsrat des Deutschen Zentrums Kulturgutverluste hat bereits im Jahr 2017 den Auftrag erteilt, Pilotprojekte zur Grundlagenforschung im Hinblick auf den Kulturgutentzug in der Sowjetischen Besatzungszone und in der DDR zu initiieren. Von besonderer Bedeutung ist dabei selbstverständlich die Provenienzforschung in den Museen, Bibliotheken, Archiven und Sammlungen.

Die Arbeit beginnt nicht am Nullpunkt. Im Hinblick auf die Regelungen des Ausgleichsleistungsgesetzes zur Rückgabe beweglicher Sachen beschäftigen sich die Ämter zur Regelung offener Vermögensfragen seit Anfang der 1990er-Jahre intensiv mit solchen Anträgen. Bei den Recherchen in Museen, Bibliotheken und anderen Stellen ist die Erschließung zu SBZ/DDR-Zeiten entzogener Vermögenswerte weit fortgeschritten.

Leider kann nicht jedes Unrecht korrigiert und nicht jeder Verlust ausgeglichen werden. Aber schon das Verständnis der Vergangenheit und die Wiederherstellung des Rechts dort, wo es noch möglich ist, gehören zu den Grundverpflichtungen einer demokratischen und rechtsstaatlichen Gesellschaft. Auch dafür ist dieses Buch ein überzeugender Ausdruck.

Nicht zuletzt, weil ich selbst der von 1990 bis 1994 zuständige Staatssekretär für offene Vermögensfragen in Sachsen-Anhalt war, halte ich die fortlaufende Diskussion und wissenschaftliche Aufarbeitung für unerlässlich.

Ich wünsche diesem Buch eine große und geneigte Leserschaft und versichere, dass das Anliegen des Deutschen Zentrums Kulturgutverluste die ungeteilte Unterstützung des Landes Sachsen-Anhalt genießt.

Ihr
Rainer Robra
Staats- und Kulturminister des Landes Sachsen-Anhalt

Greeting

Dear Sir or Madam,

The way a society deals with its cultural property is an essential expression of the importance it attaches to our common European values. Their preservation is the core of our cultural memory. Our thinking, our memory and also our creativity are essentially bound to the cultural property that have been passed down to us. The confrontation with it allows respect for the generations that have gone before us to grow.

Because this is an essential principle of civilized societies, any destruction, unlawful handling or misuse of cultural property must be of great concern to us. It is an important part of our historical reappraisal that we conduct detailed research into the causes and effects of cultural property losses.

The conference „VEB Kunst – Kulturgutentzug und Handel in der DDR" on November 30, 2020, as well as this book „Enteignet, entzogen, verkauft – Zur Aufarbeitung der Kulturgutverluste in der DDR" [Expropriated, Confiscated, Sold – Coming to Terms with the Loss of Cultural Property in the GDR] are precisely within this context. They are an expression of the fact that we take this work very seriously.

The Board of Trustees of the German Lost Art Foundation already commissioned us in 2017 to initiate pilot projects for basic research with regard to the confiscation of cultural property in the Soviet occupation zone and in the GDR. Of particular importance within this context is, of course, provenance research in museums, libraries, archives and collections.

The work does not begin from scratch. In light of the regulations of the Ausgleichsleistungsgesetz (Compensation Act) on the restitution of movable property, the offices for the settlement of open property issues have been dealing intensively with such applications since the early 1990s. In the course of research in museums, libraries and other offices, the indexing of assets seized during the SBZ/GDR era is well advanced.

Unfortunately, not every injustice can be corrected and not every loss compensated for. But an understanding of the past and the restoration of justice, where it is still possible, are among the basic obli-

gations of a democratic society based on the rule of law. This book is also a convincing expression of this.

Not least because I myself was the state secretary responsible for open property issues in Saxony-Anhalt from 1990 to 1994, I consider the ongoing discussion and scholarly reappraisal to be indispensable.

I wish this book a large and sympathetic readership and assure you that the concern of the German Lost Art Foundation enjoys the undivided support of the state of Saxony-Anhalt.

Yours sincerely,
Rainer Robra
Minister of State and Minister of Culture in Saxony-Anhalt

Geleit

Auch über drei Jahrzehnte nach der Wiedervereinigung Deutschlands ist unser Wissen über die illegitime staatliche Bemächtigung privaten Kunst- und Kulturbesitzes in der Sowjetischen Besatzungszone und in der DDR noch unvollständig. Zu wenig weiß die Öffentlichkeit von den Schicksalen der Menschen, die diesem Unrecht ausgeliefert waren. Zu wenig weiß die Forschung bisher auch über die genauen historischen Vorgänge, über die daran Beteiligten sowie über die Wege, die entzogene Kulturgüter genommen haben.

Die Geschehnisse in der Sowjetischen Besatzungszone und die SED-Diktatur in der DDR gehören zum gemeinsamen geschichtlichen Erbe des wiedervereinigten Deutschlands. Dass dieses Erbe nicht allein Sache der ostdeutschen Bundesländer ist, verdeutlichen einmal mehr die auf der Herbsttagung des Deutschen Zentrums Kulturgutverluste im November 2020 und zusätzlich in diesem Sammelband vorgestellten Forschungserkenntnisse. Der Entzug von Kulturgut und die damit verbundenen Kulturguttransfers betreffen den Osten wie den Westen Deutschlands. Beides muss in einem epochenübergreifenden und auch internationalen Kontext betrachtet werden, wie die auf der Tagung dargestellte Provenienzgeschichte der Beneman-Kommode mit ihrem Bezug zur deutschen Besetzung Frankreichs zeigt. ✐

✐ Vgl. Beitrag von Margaux Dumas und Xenia Schiemann, S. 213.

Notwendig ist eine fundierte Auseinandersetzung mit den organisierten Kulturgutentziehungen in der Sowjetischen Besatzungszone und der DDR. Besonders wichtig ist dabei die Perspektive derjenigen, die den verwerflichen Machenschaften des Kulturgutentzugs ausgesetzt waren. Forschung und Aufarbeitung sind kein Selbstzweck, weil jeder Entziehungsfall mit einem menschlichen Schicksal verbunden ist.

Der Stiftungsrat des Deutschen Zentrums Kulturgutverluste, in dem Bund, Länder und Kommunen vertreten sind, hat im Dezember 2020 die Fortführung der Grundlagenforschung zu Kulturgutentziehungen in der Sowjetischen Besatzungszone und der DDR für das Jahr 2021 beschlossen. Möglich wurde dieser Beschluss durch die Bereitstellung zusätzlicher Bundesmittel. Das

schafft eine solide Grundlage dafür, die notwendige Wissensbasis auszubauen, und unterstreicht zugleich den Willen, unrechtmäßige Kulturgutentziehungen weiter konsequent aufzuarbeiten. Die kritische und selbstkritische Befassung auch mit diesem Teil der Vergangenheit unseres Landes ist unverzichtbar, um das Bewusstsein für den Wert von Demokratie, Freiheit und Rechtsstaatlichkeit zu schärfen.

Mein Dank gilt allen Beteiligten der Konferenz und den Autorinnen und Autoren des vorliegenden Bands, die mit ihrem Engagement einen entscheidenden Beitrag dazu geleistet haben, dem Vergessen, Verdrängen und Verharmlosen historischen Unrechts fundiertes Wissen und informierten Austausch entgegenzusetzen.

Monika Grütters MdB
Staatsministerin für Kultur und Medien 2013–2021

Preface

Even more than three decades after the reunification of Germany, our knowledge of the illegitimate state seizure of private art and cultural property in the Soviet occupation zone and in the GDR remains incomplete. Too little is known to the public about those who suffered this injustice. Researchers also know too little about the exact historical events, about those who participated in them, and about the paths that confiscated cultural property has taken.

The SED dictatorship of the GDR and the events in the Soviet occupation zone are part of the common historical heritage of the reunified Germany. The research findings presented at the autumn conference of the German Lost Art Foundation in November 2020 and additionally in this anthology demonstrate that this heritage is not the sole responsibility of the eastern German federal states. The confiscation of cultural property and the associated cultural property transfers affect both the east and the west of Germany. These events must be considered across different eras and in an international context, as shown by the provenance history of the Beneman Commode presented at the conference and its relationship to the German occupation of France. ✐

✐ Cf. article by Margaux Dumas and Xenia Schiemann, p. 213.

What is needed is a research-based examination of the organized confiscations of cultural property in the Soviet occupation zone and the GDR. The perspectives of those who were subjected to the reprehensible practice of cultural property confiscation are particularly important. Research and reappraisal are not merely an end in themselves, because every case of confiscation is linked to a human story.

In December 2020, the Foundation Board of the German Lost Art Foundation, in which the federal state and local levels are represented, decided to continue foundational research on cultural property confiscations in the Soviet occupation zone and the GDR for the year 2021, a decision which was made possible by the provision of additional federal funding. This funding creates a solid foundation for expanding the necessary knowledge base and at the same time underscores the desire to continue to systematically address unlawful seizures of cultural property. A critical and self-critical approach to this part of our country's past is indispensable for raising awareness of the value of democracy, freedom and the rule of law.

I would like to thank all those involved in the conference and the authors of this volume for their dedication. Their research, knowledge and sharing of ideas have made a crucial contribution to countering the forgetting, suppression and trivialization of historical injustice.

Monika Grütters, Member of the German Bundestag
Minister of State for Culture and the Media 2013–2021

Vorwort der Herausgeber

Staatliches Handeln und staatliche Willkür in der DDR waren und sind Gegenstand kaum mehr zählbarer wissenschaftlicher Untersuchungen und bisweilen leidenschaftlich ausgetragener öffentlicher Debatten. Die Auflösung der Behörde des Bundesbeauftragten für die Unterlagen des Staatssicherheitsdienstes der ehemaligen Deutschen Demokratischen Republik (BStU) und die Eingliederung ihrer umfangreichen und nach wie vor brisanten Aktenbestände in das Bundesarchiv zum 17. Juni 2021 gaben erneut Anlass zu kontroversen Diskussionen, zumindest im östlichen Teil Deutschlands. Recht wenig Aufmerksamkeit erfährt dabei jedoch der staatlich betriebene, systematische Entzug privaten Kunst- und Kulturbesitzes in der Sowjetischen Besatzungszone (SBZ) sowie in der DDR. Abgesehen von der frühen, grundlegenden Dissertation des Berliner Juristen Ulf Bischof zur Kunst und Antiquitäten GmbH *⌘* gab es dazu bis vor Kurzem nur wenige wissenschaftliche Untersuchungen.

⌘ Ulf Bischof: Die Kunst und Antiquitäten GmbH im Bereich Kommerzielle Koordinierung. Berlin 2003

⌘ Die meisten dieser Ämter sind inzwischen aufgelöst, vgl. Verzeichnis der Anschriften des Bundesamtes für zentrale Dienste und offene Vermögensfragen und der Behörden für den Bereich Regelung offener Vermögensfragen (Stand Juli 2021). Hg. v. BADV, Berlin 2021. Online jeweils aktuell unter https://www.badv.bund.de/DE/OffeneVermoegensfragen/Behoerdenverzeichnis/start.html

Für die Ämter zur Regelung offener Vermögensfragen auf Landes- und auf lokaler Ebene, die für den Vermögensentzug in der SBZ und in der DDR zuständig waren beziehungsweise sind, *⌘* stellten Kunstwerke und andere Kulturgüter eher eine Randerscheinung dar. Ihre Arbeitsgrundlage bildeten Gesetze, die in der letzten Volkskammer der DDR und dann im Deutschen Bundestag verabschiedet wurden und vor allem Verfahren zur Rückgabe von Grundstücken, Immobilien und Betrieben regelten.

Der damalige Präsident der Klassik Stiftung Weimar, der Jurist Hellmut Seemann, brachte 2012 bei einem Vortrag in Güstrow das juristische Dilemma einer nicht in allen Punkten – nämlich unter anderem in den kulturpolitischen Auswirkungen nicht – bis in die letzte Konsequenz durchdachten Gesetzgebung in schonungsloser Deutlichkeit auf den Punkt: „Hinter dem nur für Nicht-Juristen monströsen Namen ‚Entschädigungs- und Ausgleichsleistungsgesetz‘ (EALG) verbirgt sich nämlich ein auch für Juristen durchaus monströses gesetzliches Regelwerk: Es ist kein gesetzgeberisches Meisterwerk, trägt die Zeichen eines faulen Kompromisses sichtbar im Gesicht, ist kulturpolitisch unverantwortlich und eigentlich

nur aus historischer Perspektive zu verstehen."⌀ Es muss kaum noch gesondert erwähnt werden, dass für die öffentliche Wahrnehmung, vor allem im Westen Deutschlands, der Kulturgutentzug zwischen Dresden und Rostock, zwischen Magdeburg und Frankfurt an der Oder kaum eine Rolle spielte und spielt.

Allerdings bedeutet dies nicht, dass auf diesem Feld seit der deutschen Vereinigung 1990 nichts passiert wäre. In der Anwendung des „Gesetzes zur Regelung offener Vermögensfragen" (Vermögensgesetz, VermG) sowie des „Entschädigungs- und Ausgleichsleistungsgesetzes" (EALG) haben zahlreiche ostdeutsche Museen, Bibliotheken und Archive Zehntausende von Kunstwerken, Büchern, Archivalien und andere Objekte an die früheren Eigentümer:innen oder an deren Erb:innen zurückgegeben. Dies geschah meist ohne großes Aufsehen, ohne mediale Begleitung und wurde in der Öffentlichkeit kaum wahrgenommen. Für die oftmals personell und finanziell schlecht ausgestatteten öffentlichen Sammlungen bedeutete dies einen großen, mancherorts kaum zu bewältigenden Aufwand und bisweilen den Verlust wichtiger Exponate. Trotzdem wurde die gesetzliche Aufgabe meist professionell bewältigt.

Eine besondere Rolle, quantitativ wie qualitativ, spielten die Sammlungen der bis 1918 regierenden Fürstenhäuser in Mecklenburg, Sachsen und Thüringen sowie der Hohenzollern. Die Familien waren zwar bereits in der Weimarer Republik enteignet, danach aber entschädigt worden, unter anderem auch mit Kunstwerken, die dann in ihr Privateigentum übergingen.⌀ Letztere wurden nach dem Ende des Zweiten Weltkrieges von der Roten Armee konfisziert und manche museumswürdigen Stücke und manche Zimelien landeten schließlich in Sammlungen und Bibliotheken der DDR. Die Suche nach solchen Objekten, die gleich nach der deutschen Vereinigung einsetzte, war eine Mammutaufgabe, die Verhandlungen mit den Adelsfamilien waren es nicht weniger – umso bemerkenswerter, dass es zu gütlichen Einigungen kam.

Als die Anfang 2015 von Bund, Ländern und Kommunen gegründete Stiftung Deutsches Zentrum Kulturgutverluste im Jahr 2017 von ihrem Stiftungsrat den Auftrag erhielt, sich des Themas Kulturgutentzug in der Sowjetischen Besatzungszone und der DDR gezielter anzunehmen, wurde schnell klar, dass zunächst vor allem intensive Grundlagenforschung zu leisten war. Zu wenig

⌀ *Hellmut Seemann: Restitution – Nur Last oder auch Lust der Wiedervereinigung? Ein kritischer Erfahrungsbericht aus der Klassik Stiftung Weimar, in: Museumsgut und Eigentumsfragen. Die Nachkriegszeit und ihre heutige Relevanz in der Rechtspraxis der Museen in den neuen Bundesländern, hg. von Dirk Blübaum, Bernhard Maaz, Katja Schneider, Halle (Saale) 2012, S. 15–25, hier S. 17*

⌀ *Sog. Fürstenenteignung und Fürstenabfindung 1926*

Wissen gab es über Mechanismen, Strukturen, Akteur:innen und Wege. Die daraufhin vom Deutschen Zentrum Kulturgutverluste sukzessive initiierten und in Kooperation mit verschiedenen Partnern realisierten Projekte tragen ganz wesentlich dazu bei, die wissenschaftliche Auseinandersetzung mit dem Kulturgutentzug in der SBZ und in der DDR anzuregen beziehungsweise auf eine neue Stufe zu heben. Inzwischen wissen wir dank dieser Forschungsprojekte viel mehr, beispielsweise über die Aktion „Licht" der Staatssicherheit, über fragwürdige Zugänge in exemplarisch untersuchten ostdeutschen Museen und über Akteur:innen der Kunsttransfers. Quellen im Bundesarchiv und bei der Stasi-Unterlagen-Behörde wurden erschlossen und digitalisiert, sodass Forscher:innen genauso wie Betroffene inzwischen deutlich bessere Recherchemöglichkeiten haben.

Allerdings gibt es immer noch Themen, deren Dimension sich gerade erst entfaltet. Dazu gehört der bisher kaum bekannte staatliche und auch private Kunsthandel in der DDR, auf den die Herbstkonferenz 2020 des Deutschen Zentrums Kulturgutverluste ihren Fokus richtete. Dazu gehören weiterhin die vielfältigen Beziehungen einschlägiger DDR-Organe wie der Kommerziellen Koordinierung zu Kunsthandlungen und Auktionshäusern im sogenannten westlichen Ausland: Noch wissen wir recht wenig darüber, in welchen privaten Sammlungen und möglicherweise auch öffentlichen Museen und Bibliotheken die Kulturgüter aus dem Osten letztendlich landeten. Dazu gehört schließlich auch das Schicksal privater Kunstsammler:innen in der DDR, die immer wieder Opfer staatlicher Willkür wurden.

Es sind Themen, die noch viel Raum für zukünftige Forschungen lassen – Forschungen, die nicht nur Erkenntnisse zum Weg und zum Verbleib einzelner Objekte erbringen können, sondern darüber hinaus zum Funktionieren des florierenden Entzugs- und Transfersystems in der DDR und dessen Einbindung in ein internationales Netzwerk. Diese Forschungen können einen wichtigen Beitrag zu dem leisten, was gerne als Erinnerungskultur bezeichnet wird – und zwar zu einer gesamtdeutschen, keineswegs nur ostdeutschen Erinnerungskultur. In diesem Rahmen können sie an vergessene oder nie wirklich bekannt gewordene Persönlichkeiten erinnern: an private Kunsthändler:innen, an private Sammler:innen mit oftmals gebrochenen Biografien und auch an Museumsleute,

die unter bisweilen sehr schwierigen Umständen integer handelten.

Dieser Band von Provenire, der wissenschaftlichen Publikationsreihe des Deutschen Zentrums Kulturgutverluste, versammelt Beiträge unserer Herbstkonferenz 2020, die eigentlich im großen Saal der Nationalen Akademie der Wissenschaften Leopoldina in Halle an der Saale stattfinden sollte, dann jedoch wegen der sich Ende November 2020 wieder zuspitzenden Pandemie in den digitalen Raum verlagert werden musste. Es handelt sich jedoch um keinen reinen Tagungsband, denn die überarbeiteten Konferenzbeiträge wurden durch eine Reihe zusätzlicher Aufsätze ergänzt. So dürfen wir mit diesem Band eine der ersten umfassenden Publikationen zum Kulturgutentzug im Osten Deutschlands nach dem Ende des Zweiten Weltkriegs vorlegen – kein abschließendes Resümee, sondern eine Zwischenbilanz. Einige der erwähnten Grundlagenforschungsprojekte werden weitergehen, andere werden dazukommen. Nicht zuletzt hoffen wir, dass die von dieser Tagung ausgegangenen Anregungen vielerorts aufgegriffen werden.

Die Verwendung der gendergerechten Schreibweise oder des generischen Maskulinums blieb unseren Autor:innen überlassen. Eine Übernahme historisch-weltanschaulicher Begriffe wie zum Beispiel „Republikflucht" erfolgte in distanzierenden Anführungszeichen. Bei auch heute gebräuchlichen, aber im juristischen Sinne trotzdem nicht ganz korrekten Ausdrücken nahmen wir entstehende Begriffsunschärfen zugunsten besserer Lesbarkeit in Kauf: So hätten wir fast jede Enteignung strenggenommen zur „entschädigungslosen Enteignung" erweitern müssen – wo wir aber Missverständnisse für ausgeschlossen hielten, gaben wir dem kürzeren Begriff den Vorzug, so auch im Titel unseres Sammelbandes.

Wir möchten uns bei allen Autor:innen ganz herzlich für ihre Beiträge bedanken, die zur Drucklegung oftmals aufwendig neu erarbeitet werden mussten, ebenso bei den Bildgeber:innen, beim Verlag de Gruyter, bei der Lektorin und bei allen beteiligten Kolleg:innen des Deutschen Zentrums Kulturgutverluste. Ermöglicht wurde diese Publikation durch die finanzielle Unterstützung der Bundesbeauftragten für Kultur und Medien.

Mathias Deinert, Uwe Hartmann, Gilbert Lupfer

Foreword by the editors

State action and state arbitrariness in the GDR were and are the subject of hardly countable scholarly investigations and sometimes passionately fought public debates. When on June 17, 2021, the "Federal Commissioner for the Records of the State Security Service of the Former German Democratic Republic" (BStU) retired and the Stasi Records Archive with its mass of still explosive files moved to Germany's National Archives, this once again gave rise to controversial discussions, at least in the eastern part of Germany.

However, very little attention has been paid to the state-led, systematic confiscation of private art and cultural property in the Soviet occupation zone (SBZ) and in the GDR. Apart from the early, fundamental dissertation by Berlin lawyer Ulf Bischof on the Art and Antiques Ltd. (Kunst und Antiquitäten GmbH),[1] there has been little scholarly research on the subject until recently.

For the Offices for Unresolved Property Issues at the state and local level, which were or are competent for the indemnification of property lost in the Soviet occupation zone and in the GDR,[2] works of art and other cultural property were rather a side issue. Their work was based on laws passed in the last People's Chamber (Volkskammer) of the GDR and then in the German Bundestag, which primarily regulated procedures for the restitution of land, real estate and businesses.

In 2012, at a lecture in Güstrow, the then president of the Klassik Stiftung Weimar, the lawyer Hellmut Seemann, brought the legal dilemma of a legislation that had not been thought through to the last consequence in all respects – namely, among other things, in its cultural policy implications – to the point in unsparing clarity: "Behind the name 'Compensation and Equalization Payments Act' (EALG), which is monstrous only for non-lawyers, lies a set of legal rules that is also monstrous for lawyers: It is not a legislative masterpiece, bears the signs of a rotten compromise visibly on its face, is irresponsible in terms of cultural policy, and can really only be understood from a historical perspective."[3] It hardly needs to be mentioned separately that for public perception, especially in western Germany, the confiscation of cultural property between Dresden and Rostock, between Magdeburg and Frankfurt an der Oder, hardly plays or played a role.

[1] Ulf Bischof: Die Kunst und Antiquitäten GmbH im Bereich Kommerzielle Koordinierung. Berlin 2003

[2] Most of these offices have since been dissolved; see Directory of Addresses of the Federal Office for Central Services and Unresolved Property Issues and the Authorities for the Regulation of Unresolved Property Issues (as of March 2021), ed. by BADV, Berlin 2021. Online at https://www.badv.bund.de/DE/OffeneVermoegensfragen/Behoerdenverzeichnis/start.html

[3] Hellmut Seemann: Restitution – Nur Last oder auch Lust der Wiedervereinigung? Ein kritischer Erfahrungsbericht aus der Klassik Stiftung Weimar, in: Museumsgut und Eigentumsfragen. Die Nachkriegszeit und ihre heutige Relevanz in der Rechtspraxis der Museen in den neuen Bundesländern, ed. by Dirk Blübaum, Bernhard Maaz, Katja Schneider, Halle (Saale) 2012, S. 15–25, here p. 17

However, this does not mean that nothing has happened in this field since German unification in 1990. In application of the "Act on the Settlement of Unresolved Property Issues" (Vermögensgesetz, VermG) and the "Compensation and Equalization Payments Act" (EALG), numerous East German museums, libraries and archives have returned tens of thousands of works of art, books, archival materials and other objects to their former owners or to their heirs. In most cases, this happened without much publicity or media coverage and was hardly noticed by the general public. For the public collections, which were often poorly staffed and financed, this meant a great deal of work, which in some places could hardly be managed, and sometimes the loss of important exhibits. Nevertheless, the legal task was mostly handled professionally.

The collections of the princely houses in Mecklenburg, Saxony, and Thuringia as well as those of the Hohenzollerns, which ruled until 1918, played a major role, both in terms of quantity and quality. Although the families had already been expropriated during the Weimar Republic, they were subsequently compensated, among other things with works of art, which then became their private property. ✐ The latter were then confiscated by the Red Army after the end of World War II, and some museum-worthy pieces and cimelia finally ended up in collections and libraries of the GDR. The search for such objects, which began immediately after German unification, was a mammoth task, the negotiations with the noble families no less so – all the more remarkable that amicable agreements were reached.

✐ *So-called expropriation of the princes in 1926.*

When the German Lost Art Foundation, founded by the Federal Government, the states (Länder) and the local authorities at the beginning of 2015, received a mandate from its Foundation Board in 2017 to address the topic of cultural property confiscation in the Soviet occupation zone and the GDR, it quickly became clear that the first thing to do was to conduct intensive historical context research. There was too little knowledge about mechanisms, structures, actors and paths. The projects successively initiated by the German Lost Art Foundation and realized in cooperation with various partners have made a significant contribution to stimulating the scholarly research of the confiscation of cultural property in the Soviet occupation zone and in the GDR, or to raising it to a new level. In the meantime, thanks to these research projects, we know much more, for example about the "Operation Light" of the State Security, about questionable access

in East German museums investigated by way of example and about actors involved in the art transfers. Sources in the Federal Archives and at the Stasi Records Archive have been made accessible and digitized, so that researchers and those affected now have much better research options.

However, there are still topics whose dimensions are only just beginning to unfold. These include the hitherto little-known state and private art trade in the GDR, which was the focus of the German Lost Art Foundation's autumn conference 2020. It also includes the manifold relationships of relevant GDR organs such as the Commercial Coordination with art dealers and auction houses in so-called Western countries: We still know very little about in which private collections and possibly also public museums and libraries the cultural property from the East ultimately ended up. This also includes the fate of private art collectors in the GDR, who were repeatedly the victims of arbitrary state action.

These are topics that still leave much room for future research – research that can not only provide insights into the path and whereabouts of individual objects, but also into the functioning of the flourishing confiscation and transfer system in the GDR and its integration into an international network. This research can make an important contribution to what is often referred to as a culture of remembrance – a culture of remembrance for the whole of Germany, and by no means just for East Germany. Within this framework, they can remind us of forgotten or never really known personalities: of private art dealers, of private collectors with often broken biographies, and also of museum people who acted with integrity under sometimes very difficult circumstances.

This volume of Provenire, the scholarly publication series of the German Lost Art Foundation, brings together contributions from our autumn conference 2020, which was supposed to take place in the great hall of the German National Academy of Sciences Leopoldina in Halle an der Saale, but then had to be moved to the digital space due to the pandemic coming to a head again at the end of November 2020. However, this is not a pure conference volume, as the revised conference papers have been supplemented by a number of additional essays. Thus, with this volume, we are privileged to present one of the first comprehensive publications on the confiscation of cultural property in eastern Germany after the end of World War II – not a concluding

résumé, but an interim balance. Some of the historical context research projects mentioned will continue, others will be added. Last but not least, we hope that the suggestions emanating from this conference will be taken up in many places.

The use of gender-appropriate spelling or the generic masculine was left to our authors. Historical and ideological terms such as "Republikflucht" (desertion from the republic) were used in distancing quotation marks. In the case of terms that are also in use today, but which are nevertheless not entirely correct in the legal sense, we accepted the resulting blurring of terms in favor of improved readability: Thus, we would have had to expand almost every expropriation strictly speaking to "expropriation without compensation" – but where we considered misunderstandings to be impossible, we gave preference to the shorter term, as in the title of our anthology.

We would like to sincerely thank all authors for their contributions, which often had to be elaborately reworked for printing, as well as the image providers, the publisher de Gruyter, the editor, and all participating colleagues of the German Lost Art Foundation. This publication was made possible by the financial support of the Minister of State for Culture and the Media.

Mathias Deinert, Uwe Hartmann, Gilbert Lupfer

Kulturgutentziehungen in SBZ und DDR
Grundlagenforschung durch Kooperationsprojekte

Mathias Deinert

Confiscation of cultural property in the Soviet occupation zone and the GDR.
Historical context research in cooperation projects
Regardless of the legal situation, even 30 years after the end of the GDR there
remains a need for systematic research into the confiscation of cultural assets
by the state in the Soviet occupation zone between 1945 and 1949 and in the
GDR from 1949 to 1990. There has been insufficient critical examination of
the historical events, of the methods of the involved authorities, institutions
and stakeholders, and of the history of the victims and the transfers of their
collections. We know of many individual cases—but we are generally unaware
of the precise extent, the relations and structures involved.

The 2013 coalition agreement on forming a German federal government
expressly stipulated a reappraisal of the confiscation of cultural property in the
Soviet occupation zone and the GDR. Accordingly, this reappraisal became one
of the areas of activity of the German Lost Art Foundation when it was estab-
lished in Magdeburg in 2015. How has the Foundation addressed this challenge
since then? What has happened so far? And what can we expect in the future?

The following text provides a brief overview of the initial situation and
the current status of the work carried out by the Department for Provenance
Research of the German Lost Art Foundation regarding research on the Soviet
occupation zone and GDR. The report covers in particular cooperation projects
on the historical context that have been carried out so far, the results of which
are documented in the Foundation's Proveana database.

How the societal, professional and political discourse on this intra-German
topic—which raises issues of museum ethics not only nationally but also inter-
nationally—will unfold cannot yet be determined.

Als das Deutsche Zentrum Kulturgutverluste 2015 seine Arbeit aufnahm und vom Stiftungsrat⌀ unter anderem den Auftrag erhielt, ein Forschungs- und Förderkonzept für den Bereich SBZ/DDR zu entwickeln, begann man nicht völlig bei null: Innerhalb der Konferenz nationaler Kultureinrichtungen (KNK), die von 23 herausragenden staatlichen Institutionen der fünf neuen Bundesländer gebildet wird, hatte eine Arbeitsgruppe bereits seit Längerem die Frage erörtert, wie sich die Museen und Sammlungen nach den zahlreichen Rückübertragungsverfahren der Vermögensämter ab 1990 mit den verbliebenen Nachkriegserwerbungen auseinandersetzen sollten. Dazu waren nämlich keineswegs alle Unsicherheiten

⌀ *Konstituierende Sitzung des Stiftungsrates am 22. Januar 2015 mit TOP 7.3: Entwicklung eines Förderkonzeptes zu Kulturgutverlusten in der SBZ/DDR*

1

beseitigt – im Gegenteil. Die Frage des rechtmäßigen und einvernehmlichen Erwerbs blieb bei vielen bestehen oder kam überhaupt erst auf. Unabhängig von der juristischen Beurteilung galt es auch, diese Zugänge museumsethisch zu bewerten.

Die Arbeitsgruppe der KNK hatte dem Zentrum bei seiner Gründung Ergebnisse ihrer verschiedenen Treffen übergeben, darunter neben Tagungsprotokollen und einem Rechtsgutachten auch ein Eckpunktepapier und eine Denkschrift.[1] In beiden waren Aufgaben benannt, deren Lösung die AG als dringend notwendig festgestellt hatte: so etwa die Aufarbeitung wichtigen Aktenmaterials, das immer noch unzugänglich schien, wie beispielsweise – für Fragen der Provenienzforschung – die Stasi-Unterlagen, oder das weder erfasst noch erschlossen war, darunter die Akten des Staatlichen Kunsthandels der DDR oder der Kunst und Antiquitäten GmbH, jenes bekannten Exportunternehmens, das der Kommerziellen Koordinierung unterstellt war.[2] ⌗ Weiterhin empfahl die AG den ständigen Wissensaustausch und die Vernetzung aller auf dem Gebiet Forschenden.[3]

Der Stiftungsrat des Deutschen Zentrums Kulturgutverluste beschloss daraufhin auf seiner 4. Sitzung am 6. Februar 2017, dass noch keine Provenienzforschung wie im Bereich NS-Raubgut durchgeführt werden solle, sondern zunächst durch Grundlagenforschung eine Basis geschaffen werden müsse, um ermittelte Entzugsfälle richtig einordnen zu können, um deren Häufigkeit, Planmäßigkeit und Motivation zu kennen, um die Quellensituation in den Archiven zu erfassen und schließlich zu erwägen, welche Konsequenzen aus den Erkenntnissen der Forschung gezogen werden sollten – ungeachtet der bereits abgeschlossenen juristischen Bewertung der 1990er-Jahre und des Ablaufs sämtlicher Antragsfristen für Betroffene des Kulturgutentzugs. ⌗

⌗ www.bundesarchiv.de/DE/Content/Downloads/Meldungen/20180601-kua-findbucheinleitung.pdf oder www.bundesarchiv.de/DE/Content/Meldungen/20170621-kunst-und-antiquitaeten.html (18.10.2021)

⌗ Vgl. Beiträge von Mathias Deinert, S. 287, und Joëlle Warmbrunn, S. 298.

Überblick 2017 bis 2020

Diese Grundlagenforschung sollte nicht abhängig sein von der Zufälligkeit eingehender Anträge, sondern geplant erfolgen können. Deshalb entschied sich der Stiftungsrat für die Form sogenannter Kooperationsprojekte. Das Zentrum findet hierfür Institutionen, die zur Bearbeitung eines bestimmten Desiderates Sachkenntnis mitbringen, thematische Vorarbeit geleistet haben, über spezielle

Quellenbestände verfügen oder einen besonderen Zugang zur Forschungsaufgabe haben. Gemeinsam und gleichberechtigt entwickeln beide als Partner dann ein Projekt, das einen vorher klar definierten Wissensmangel im Forschungsbereich abdeckt. Ab 2017 startete das Zentrum folgende Kooperationen:

Die MfS-Aktion „Licht" 1962 | *wissenschaftlicher Partner:* Hannah-Arendt-Institut für Totalitarismusforschung e. V. (HAIT), TU Dresden | *Laufzeit:* September 2017 bis Oktober 2019[4]

Der wissenschaftlichen Aufarbeitung der Aktion „Licht" hatte schon die KNK-Arbeitsgruppe hohe Priorität beigemessen. Die streng geheime Öffnung Tausender Safes, Schließfächer und Bankdepots durch das MfS im Januar 1962 war seit dem Ende der DDR nur bruchstückhaft aus den Medien bekannt. Es gab kaum Anhaltspunkte, inwieweit die öffentlichen Sammlungen – ob als Geschädigte oder als Begünstigte – von dieser Aktion betroffen waren, da das MfS zwischen Februar und Dezember 1971 alle verbliebenen Unterlagen zu dieser Geheimoperation vernichtet hatte, um sie auch künftig geheim zu halten.[5]

Unter Zugrundelegung der bereits bekannten Übergabeliste des MfS ans Finanzministerium und der Berichte weniger Zeitzeugen war man immer von sehr großen Mengen aufgefundenen Kulturgutes ausgegangen, von denen nur der tatsächlich verwertbare Anteil dokumentiert worden war.[6] Als entscheidende Erkenntnis resultierte aus diesem Projekt, dass die allermeisten geöffneten Schließfächer, Tresore und Verschläge leer vorgefunden worden waren. Dass das Aufspüren und Verwerten von Kunst und Kulturgut allenfalls als willkommener Anlass für die hochgeheime Unternehmung gedient hatte, wurde als zweite sehr bedeutsame Erkenntnis aus diesem Projekt gewonnen. Der eigentliche Zweck der Aktion „Licht" war gewesen, die Tragfähigkeit, Verlässlichkeit und Loyalität der Machtstrukturen im SED-Staat zu prüfen. Gleichzeitig hatte sie zum Ziel gehabt, dem Finanzsektor, allen voran dem Finanzminister, eklatante Defizite nachzuweisen und das eigene Ministerium, das MfS, zu profilieren, es als unverzichtbar und effizient herauszustellen. Des Weiteren erbrachte das Projekt Hinweise auf mehrere, bisher namentlich nicht bekannte Gutachter, die zur Schätzung der Funde verpflichtet worden waren. Auch wissen wir im Ergebnis endlich, wo Teile der Beute, die nicht für Devisen ver-

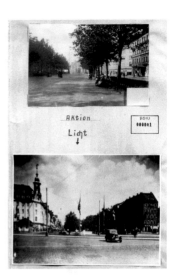

Die Aktion „Licht" ist nun gut untersucht. Die Stasi-Unterlagen halten aber noch immer Rätsel bereit: Aus welchem genauen Grund diese einzelne Fotoseite archiviert wurde, bleibt unbekannt. BStU, MfS BV Ddn Abt XX Fo 10280, Bl. 1

kauft worden waren, verblieben sind: Ein Konvolut etwa gelangte in die Berliner Staatsbibliothek. Hans Lülfing (1906–1991), der die Handschriftenabteilung des Hauses leitete, war als Gutachter für Autografen vom MfS dienstverpflichtet worden. Ob es Verhandlungsgeschick war, Beharrlichkeit oder ein Winkelzug, es gelang ihm, der Staatsbibliothek hochkarätige Handschriften aus Kunst und Wissenschaft zu sichern. Funde dagegen, die für unbedeutend gehalten wurden, landeten ohne Herkunftsnachweis in verschiedenen Archiven, beispielsweise im heutigen Sächsischen Hauptstaatsarchiv – Staatsarchiv Leipzig.[7]

Unser zweites Projekt erarbeiteten wir mit dem BStU. Dass diese exzeptionelle Aktenüberlieferung auf ihren Nutzen für die Provenienzforschung geprüft werden musste, verstand sich von selbst. Üblicherweise müssen Anfragen an die Stasiunterlagenbehörde personenbezogen erfolgen, weil das Ministerium für Staatssicherheit personenbezogen archivierte und nicht sachthematisch – was den Zugang für all jene Forschungsvorhaben erschwert, bei denen historische Beteiligte des Kulturgutentzugs anfangs noch unbekannt sind. Deshalb ging es bei diesem Projekt darum, die Recherchemöglichkeiten in relevanten Stasiunterlagen so zu erweitern, dass sie für Fragestellungen der Provenienzforschung nützlich werden. Kern des Projektes war also die Erarbeitung eines geeigneten Findhilfsmittels:

Erstellung eines Spezialinventars für ausgewählte Aktenbestände des MfS zu Entziehungen von Kunst- und Kulturgut in SBZ und DDR unter dem Aspekt der Provenienzforschung | *wissenschaftlicher Partner*: Der Bundesbeauftragte für die Unterlagen des Staatssicherheitsdienstes der ehemaligen DDR (BStU), Berlin | *Laufzeit*: September 2017 bis Februar 2018 und April 2018 bis September 2019[8]

Das Spezialinventar, Ergebnis und Abschlussbericht in einem und weit über 600 Seiten stark, ist als gedruckte Publikation erhältlich sowie als PDF auf der Website des Bundesarchivs und in unserer Forschungsdatenbank *Proveana*.⌗ Mit dem erarbeiteten Findbuch kann nunmehr eigenständig sachbezogen recherchiert werden.

⌗ *www.stasi-unterlagen-archiv.de/ informationen-zur-stasi/publikationen/ publikation/auf-der-suche-nach-kulturgutverlusten/ oder www. proveana.de/de/link/lit00000115*

Signatur	Art und Anlagegrund der Akte	Zeitraum	Sonstiges
MfS AU 1964/87	EV gegen mehrere Personen u. a. wegen ungesetzlichen Handels mit Antiquitäten, Verstoß gegen Zoll- und Devisengesetz und Verletzung des Kulturgutschutzgesetzes	1983/84	[Name 34] soll »geschütztes Kulturgut« im Wert von ca. 365 TM illegal in den Westen gebracht haben (15/20). Akte enth. Hinweise auf Wohnungsdurchsuchung und Beschlagnahmen 1984 in der Wohnung von [Name 34] und einer Gärtnerei (1/76 ff.; 7/50 f.); ZWF vom VEB Antikhandel Pirna vom 12.6.1984 (2/186 ff., 474; 3/79; 4/294; 10/167, 182); Liste der Beschlagnahmen (4/44); Gutachten der Staatlichen Museen zu Berlin mit Hinweis auf »geschütztes Kulturgut« (10/197, 205); Angaben zu Gemälden etc. (2/35 ff.); Einschätzung vom Kunstgewerbemuseum Köpenick (2/476); Einschätzung der Nationalgalerie Berlin zu 43 Gemälden (3/131); Fotodokumentation zu an die Nationalgalerie übergebenen Bildern (3/142 ff.); Hinweise auf »geschütztes Kulturgut« (2/54, 159, 176) wie eine Schmuckschatulle (Truhe) und »4 Schachteln mit Einschubgläsern für Laterna Magica« (15/137); ZWF von 1986 (3/49); weitere Beschlagnahmen (4/442; 9/36 ff.) mit Fotos (Bd. 12); ZWF der Beschlagnahme von Antiquitäten bei [Name 14] (5/263, 272) mit Fotos der beschlagnahmten Antiquitäten (Bd. 11).
MfS AU 1964/87, Band 5	EV wegen ungenehmigter Ausfuhr von DDR-Kulturgut u. a.	1984	[Name 14] wurde als ehemaliger DDR-Bürger am 20.2.1984 auf der Transitstrecke Richtung West-Berlin verhaftet. Akte enth. eine Liste der beschlagnahmten Gegenstände (5/71); ZWF (5/263, 272); Anklageschrift vom 19.9.1984 und das Urteil zu 3 Jahren Freiheitsentzug v. 24.10.1984 (Bd. 6).
MfS AU 10611/87	UV wegen eigener Bereicherung aus KuA-Beständen (verurteilt zu 10 Jahren Freiheitsentzug und 30 TM Geldstrafe und 54 TM Schadensersatz)	1986/87	EV wurde über HA XVIII/7 mit Schalck vom MAH abgestimmt und anschließend koordiniertes Vorgehen mit HA IX vorgeschlagen (1/24, 42). Diverse Protokolle zu Beschlagnahmen, Wertberechnungen und teilweisen Rückgaben - sowohl an [Name 128] als auch die geschädigte KuA (1/219 ff., 2/45 ff., 68 ff., 107, 132 ff., 234; 3/41 ff., 225, 227; 5/49; 8 und 11/passim; 13/7, 61; Fotos in Bd. 9, 10 und 12 passim). Einbindung der KuA zur Preisbewertung (3/203 ff., 227). Enth. auch diverse Einschätzungen zu KuA-Kollegen und Geschäftspartnern (1/78 ff.); Hinweis auf Rechtsanwaltsvertretung durch Kanzlei Gysi (13/44, 105); Fotos der Lagerräume Mühlenbeck (4/143); Inventurlisten von KuA (5/39 ff.); Kaufvertrag KuA - Fa. Antik-Shop West-Berlin mit 120 Einzelposten im Gesamtwert von fast 130 000 DM (5/229 ff.), Fotos zweier Bilder und eines Pokals, die [Name 128] verkaufte (6/168 f.). Bd. 6 enth. Befragungsprotokolle von KuA-Mitarbeitern, die Einzelheiten zum Betriebsregime in Mühlenbeck schildern (passim).
MfS AZI 985/89	IM-Akte »Friedrich«	1986/87	IM-Akte von [Name 128] enth. Hinweise auf schlecht laufendes Antiquitätengeschäft der KuA in Mariazell/Österreich, dessen Ware unter Verlust nach Mühlenbeck zurückgeführt wurde (II/16 f.); auf Kalkreuth-Gemälde »Alpenlandschaft«, das vermutlich aus Diebstahl stammte (Schloss Mosigkau? - II/21); auf illegalen Verkauf eines als geschütztes Kulturgut eingestuften Gemäldes von Grützner mit einer Mönchabbildung in die BRD (II/42); auf Manipulationen eines im Auftrag von Antikhandel Pirna agierenden Aufkäufers, inkl. Export höherwertiger Antiquitäten nach Holland (II/114).

Unser drittes Kooperationsvorhaben setzten wir mit dem Museumsverband Brandenburg um. In den Blick genommen wurden Museumsbestände, um herauszufinden, wie und wodurch unterschiedliche Arten des historischen Entzugs in heutigen Sammlungen erkennbar sind. Auch der Abschlussbericht für dieses Projekt wurde, wie die beiden vorigen, nach der Datenschutzprüfung in die *Proveana* hochgeladen⌀.

Ein Beispiel für Akteninhalte, die vorher mit einfacher Rechercheanfrage an den BStU nicht ermittelbar waren.[9]

⌀ www.proveana.de/de/link/pro10000313

Zwischen Schlossbergung und Kommerzieller Koordinierung. Pilotprojekt zur Untersuchung kritischer Provenienzen aus der Zeit der SBZ und DDR in brandenburgischen Museen | *wissenschaftlicher Partner:* Museumsverband des Landes Brandenburg e. V., Potsdam | *Laufzeit:* Oktober 2017 bis September 2018[10]

Wenn nun erneut darauf Bezug genommen wird, dass der Abschlussbericht erst nach einer datenschutzrechtlichen Prüfung in der Forschungsdatenbank zu sehen ist, deutet dies schon eine der Hürden an, die eine Provenienzforschung für die Zeitspanne 1945 bis 1990 nehmen muss: Selbst bei einer Veröffentlichung für ein Fachpublikum sind datenschutzrechtliche Belange im Blick zu be-

halten und Personennamen sowie ihnen zuordenbare private Informationen, die nicht öffentlich bekannt sind oder nicht einvernehmlich gegeben wurden, zu anonymisieren.

Das Projekt des Museumsverbandes Brandenburg hat uns einen detaillierten Überblick verschafft, wie sich SBZ- und DDR-Entzugskomplexe in vier Museen unterschiedlicher Größe heute abbilden: Um Vorgänge auf verschiedenen Verwaltungsebenen nachvollziehen zu können, waren als Fallbeispiele ein ehemaliges Bezirksmuseum (Frankfurt/Oder), zwei Kreismuseen (Eberswalde und Neuruppin) sowie ein Stadtmuseum (Strausberg) ausgewählt worden.

Wir wissen nun, welche Informationen sich aus den Inventaren und der Eingangsdokumentation ablesen lassen und welche nur aus den Korrespondenzen; welche Entzugskontexte in welchen Häufigkeiten zu erkennen sind und wie sich die Rückgabepraxis nach Wende und Wiedervereinigung aus Museumssicht darstellt. Wir gewannen zudem eine ungefähre Vorstellung, wie viel Objekte in den heutigen Sammlungen überhaupt als fragwürdig angesehen werden müssen. In den untersuchten Häusern waren es bis zu acht Prozent des Bestands, die auf den ersten, flüchtigen Blick als problematisch erkannt wurden – selbst nach den Rückerstattungsverfahren der Vermögensämter.

Dieses Projekt machte auch deutlich, wie selten nach 1990 aus öffentlichen Sammlungen Objekte rückgefordert wurden, die sowohl nach damaliger als auch heutiger Rechtsauffassung gar nicht ins Eigentum der staatlichen Institutionen übergegangen waren. Sie hatten dort nur unter treuhänderischer Verwaltung gestanden, weil sie beispielsweise von sogenannten Republikflüchtigen stammten oder von offiziell Ausgereisten, die Teile ihres Umzugsgutes aufgrund der Kulturgutschutzgesetze nicht hatten ausführen dürfen. Dies lässt vermuten, dass viele der rechtmäßigen Eigentümer oder ihre Rechtsnachfolger von ihrem Eigentum aktuell nichts oder nichts mehr wissen.

Die weiteren Kooperationen seien an dieser Stelle nur überblicksartig aufgeführt – denn über sie berichten die Projektwissenschaftler in der vorliegenden Publikation ausführlich selbst:

Die Moritzburg in Halle (Saale) als zentrales Sammellager für Kunst- und Kulturgut, das in der Provinz Sachsen durch die sogenannte Bodenreform enteignet und entzogen wurde | *wissen-*

schaftlicher *Partner:* Kulturstiftung Sachsen-Anhalt, Gommern | *Laufzeit:* September 2018 bis November 2019 und Februar 2020 bis Oktober 2021[11] 🔗

Repräsentative Studie zu den Übergaben staatlicher Institutionen und Organisationen an das Museum für Deutsche Geschichte der DDR | *wissenschaftlicher Partner:* Stiftung Deutsches Historisches Museum (DHM), Berlin | *Laufzeit:* Oktober 2018 bis November 2020[12] 🔗

Umgang der Verwaltungsinstanzen im ehemaligen Bezirk Schwerin mit Kulturgut aus Flüchtlings-Rücklässen von 1945 bis 1989 | *wissenschaftlicher Partner:* Museumsverband in Mecklenburg-Vorpommern e. V., Rostock | *Laufzeit:* Februar 2019 bis Februar 2021[13] 🔗

Die Rolle und Funktion des Staatlichen Museums Schwerin zwischen 1945 und 1990 beim Umgang mit entzogenen Kulturgütern auf dem Gebiet des ehemaligen DDR-Bezirks Schwerin | *wissenschaftlicher Partner:* Staatliche Schlösser, Gärten und Kunstsammlungen Mecklenburg-Vorpommern (SSGK MV), Schwerin | *Laufzeit:* Februar 2020 bis Januar 2022[14] 🔗

🔗 *Vgl. Beitrag von Jan Scheunemann, S. 201.*

🔗 *Vgl. Beitrag von Doris Kachel, S. 45.*

🔗 *Vgl. Beitrag von Antje Strahl und Reno Stutz, S. 103.*

🔗 *Vgl. Beitrag von Michael Busch, S. 81.*

Grundsätzlich waren bei allen Enteignungswellen, Entzügen und staatlichen Konfiskationen die Museen, Bibliotheken und sonstigen öffentlichen Sammlungen nur mittelbar Begünstigte. Wenn hingegen diese Institutionen Gutachter stellten, die beispielsweise das Umzugsgut von Ausreisenden bewerteten, so hatten sie durch ihre Einschätzung ganz unmittelbar Einfluss darauf, ob Stücke als schützenswert deklariert wurden und damit ihren Institutionen treuhänderisch zufielen oder nicht. Über die Abläufe und auch die tatsächlichen Handlungsspielräume hierbei erwarten wir aus dem letztgenannten Projekt nähere Erkenntnisse.

Unseren Kooperationsprojekten fehlte bislang der Blick nach Westen, wohin die zahlreichen Kulturgüter aus der SBZ und der DDR gegen Devisen verkauft wurden. Im Jahr 2020 hat das Zentrum dieses Wissensdefizit zum Anlass genommen, betreffende Institutionen im Westteil Deutschlands anzusprechen. Zwei Grundlagenforschungsprojekte konnten schließlich entwickelt und inzwischen begonnen werden:

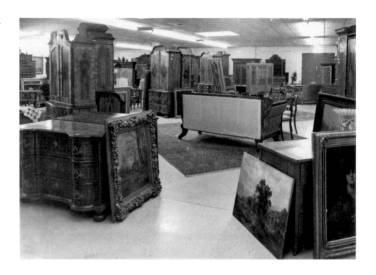

Die Geschäftsbeziehungen zwischen der Kunst und Antiquitäten GmbH der DDR und westlichen Auktionshäusern im Zeitraum von 1973 bis 1990: Mechanismen – Netzwerke – Objekte | *wissenschaftlicher Partner:* Institut für Kunstwissenschaft und Historische Urbanistik/Fachgebiet Kunstgeschichte der Moderne, TU Berlin | *Laufzeit:* Dezember 2020 bis November 2022[15]

Geschäfte mit dem Osten? Pilotprojekt zur Untersuchung kritischer Provenienzen aus der SBZ und der DDR in nichtstaatlichen Museen des Freistaats Bayern | *wissenschaftlicher Partner:* Landesstelle für die nichtstaatlichen Museen in Bayern, München | *Laufzeit:* Februar 2021 bis Januar 2022 und Februar 2022 bis Januar 2023 (zwischenzeitlich unterbrochen)[16]

Transparenz und Nachhaltigkeit

Alle Themenfelder des Deutschen Zentrums Kulturgutverluste finden sich detailliert dokumentiert in seiner Forschungsdatenbank *Proveana*.[17] ⌗ Sie ist und bleibt ein typisches Work in Progress, in das die Forschungsdaten, die uns aus Projekten zufließen, nach und nach als Datenbankeinträge eingespeist werden. Nach Beendigung eines Projekts und der datenschutzrechtlichen Prüfung wird jeweils der Abschlussbericht in der *Proveana* veröffentlicht. Die Suchfunktion auch auf den Volltext dieser Berichte auszuweiten ist allen registrierten Nutzern mit berechtigtem wissenschaft-

⌗ www.proveana.de

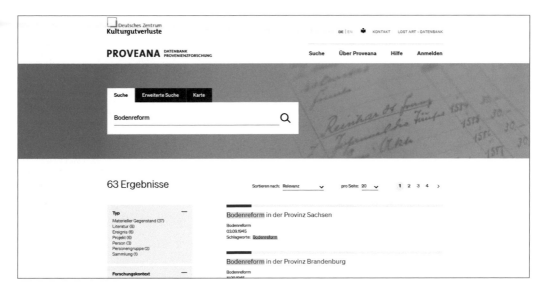

Suche mit der Forschungsdatenbank Proveana, Bildschirmfoto: Deutsches Zentrum Kulturgutverluste

lichem Interesse möglich, die einen erweiterten Zugang beantragt und erhalten haben.

Die Datenbank funktioniert gerade für den Bereich SBZ/DDR projektübergreifend, das heißt, dass perspektivisch auch Daten und Fakten etwa aus der Sekundärliteratur oder Angaben von Betroffenen in der Datenbank beleggestützt mit dokumentiert werden können. Sie wird dadurch mit der Zeit zu einem Abbild des Wissensstandes zu Zeitereignissen, Akteuren, Orten und Objekten des Kulturgutentzugs.

Unabhängig von laufenden Projekten steht allen Praktikern des Fachgebietes der virtuelle Raum „Kulturgutverluste SBZ/ DDR" im „Portal Provenienzforschung" des Zentrums zur Verfügung. Als Kommunikationsplattform dient er neben der Bekanntgabe von Neuigkeiten, Terminen und Forschungsmaterial besonders dem fachlichen Austausch untereinander. Bisher nutzen bereits über 70 Registrierte dieses Forum, das Bibliotheks- und Museumsmitarbeitern ebenso offensteht wie freien Provenienzforschern, Projektmitarbeitern wie auch allen Interessierten, die zu dem Themengebiet arbeiten, forschen oder Weiterführendes beizutragen haben.

* provenienzforschung.commsy. net/commsy.php?cid=1770964*

Die Tätigkeiten des Deutschen Zentrums Kulturgutverluste im Bereich SBZ/DDR sind auf seiner Internetseite zu finden. Die bekannte *Lost-Art*-Datenbank jedoch spielt für den gesamten Themenkomplex aktuell keine Rolle: Anders als es die gesellschaft-

* www.kulturgutverluste.de/Webs/ DE/Forschungsfoerderung/ Projektfoerderung-Bereich-SBZ-DDR/Index.html*

Ein Blick in den themenbezogenen Projektraum im „Portal Provenienzforschung", Bildschirmfoto: Deutsches Zentrum Kulturgutverluste

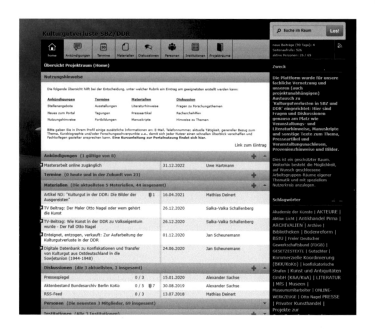

liche Debatte vermuten lässt, sind die Rechtsgrundlagen für aufgefundene Stücke aus Entzugstatbeständen oder Translokationen zwischen 1945 und 1990 völlig andere als für NS-Raubgut und sogenanntes Beutegut. Die juristischen Tatsachen konnten die museumsethischen Erwägungen zu solchen Beständen gleichwohl nicht beenden. Vielmehr lässt sich aufgrund der Sensibilisierung, die sich während der letzten Jahre gegenüber verfolgungsbedingt entzogenem Kulturgut und Sammlungsgut aus kolonialen Kontexten entwickelt hat, ein steigendes Problembewusstsein auch gegenüber nicht einvernehmlichen musealen Erwerbungen nach 1945 und eine kritischere Haltung gegenüber Rechtstatsachen wie der Verfristung von Herausgabeansprüchen oder der Ersitzung von Eigentumsrechten beobachten.[18] Inwiefern sie Einfluss auf den politischen Gestaltungswillen ausüben wird, bleibt abzuwarten.

Mathias Deinert

Mathias Deinert ist wissenschaftlicher Referent im Fachbereich Provenienzforschung am Deutschen Zentrum Kulturgutverluste Magdeburg.

Der Text geht auf einen Vortrag der Herbstkonferenz am 30. November 2020 zurück, der vom Autor für diesen Band angepasst wurde.

Endnoten

[1] Ulf Bischof: „Gutachten im Auftrag der Konferenz Nationaler Kultureinrichtungen zu Besitzverschiebungen in der ehemaligen DDR zwischen 1949 und 1989 in deren Folge Kunstgegenstände in deutsche Museen gelangt sind", Typoskript, 23 Blätter, Berlin 2015. – „Eckpunktepapier der Arbeitsgruppe 1949–89 hinsichtlich der Provenienzforschung für die Zeit 1949 bis 1989", Typoskript, 3 Blätter, o. D. [2015]. – „Denkschrift der in der Konferenz nationaler Kultureinrichtungen (KNK) zusammengefassten Museen hinsichtlich der Provenienz-Forschung für [die] Zeit 1949 bis 1989", Typoskript, 4 Blätter, o. D. [2015]. – Alle diese Dokumente sind dem Zentrum anlässlich seiner 2. Herbstkonferenz am 21. November 2016 zum Thema „Entziehungen von Kulturgütern in SBZ und DDR. Der Stand der Forschung und die Perspektiven" in Berlin von der Arbeitsgruppe übergeben worden.

[2] Inzwischen sind diese beiden Bestände durch das Bundesarchiv erschlossen worden: Betriebe des Bereichs Kommerzielle Koordinierung, Teilbestand Kunst und Antiquitäten GmbH (1974–2002), Bestand DL 210. Bearb. von Anne Bahlmann, Falco Hübner, Bernd Isphording und Stefanie Klüh, Bundesarchiv, Berlin 2017. Staatlicher Kunsthandel der DDR „VEH Bildende Kunst und Antiquitäten" (1974–2002), Bestand DR 144. Bearb. von Anne Bahlmann, Falco Hübner, Bernd Isphording und Stefanie Klüh, Bundesarchiv, Berlin 2017.

[3] Ausführlich hierzu s. Mathias Deinert: Die Forschung zu Kulturgutentziehungen in SBZ und DDR. Aufgaben und Möglichkeiten des Deutschen Zentrums Kulturgutverluste, in: Museumsblätter – Mitteilungen des Museumsverbandes Brandenburg, Heft 31 (Dezember 2017), S. 82–87.

[4] Hierzu s. auch Thomas Widera: Die MfS-Aktion „Licht" 1962, in: Provenienz & Forschung, Heft 01/2019, S. 12–17. Ders.: Die MfS-Aktion „Licht" 1962. Entnahme von Kunst- und Kulturgut aus Banktresoren, in: Museumsblätter – Mitteilungen des Museumsverbandes Brandenburg, Heft 35 (Dezember 2019), S. 44–47.

[5] Hierzu s. Ulf Bischof: Die Kunst und Antiquitäten GmbH im Bereich Kommerzielle Koordinierung (Dissertation an der Juristischen Fakultät der Humboldt-Universität zu Berlin), Berlin 2003 (Reihe: Schriften zum Kulturgüterschutz, Cultural Property Studies. Hg. von Wilfried Fiedler, Erik Jayme, Kurt Siehr), S. 354.

[6] Hierzu s. bspw. Heinz Wießner: Archivalienraub im Staatsauftrag. Die Beschlagnahme von Archivbeständen im Landesarchiv Altenburg durch das Ministerium für Staatssicherheit im Januar 1962, in: Michael Gockel, Volker Wahl (Hg.): Thüringische Forschungen. Festschrift für Hans Eberhardt zum 85. Geburtstag am 25. September 1993, Weimar u. a. 1993, S. 600–612, oder Andreas Förster: Schatzräuber. Die Suche der Staatssicherheit nach dem Nazigold (1. Ausg. 2000), Berlin 2016, S. 11 und 24–27.

[7] Zu allen Ergebnissen im Detail sei auf den Abschlussbericht verwiesen, der Nutzern mit erweitertem Zugang in der Forschungsdatenbank *Proveana* unter www.proveana.de/de/link/pro00000021 zur Verfügung steht.

[8] Hierzu s. auch Helge Heidemeyer: Spuren von Kulturgutentziehungen in den Akten des Ministeriums für Staatssicherheit. Zur Erstellung eines Spezialinventars, in: Provenienz & Forschung, Heft 01/2019, S. 6–11.

[9] Auf der Suche nach Kulturgutverlusten. Ein Spezialinventar zu den Stasi-Unterlagen. Bearb. von Ralf Blum, Helge Heidemeyer und Arno Polzin. Hg. vom Bundesbeauftragten für die Unterlagen des Staatssicherheitsdienstes der ehemaligen DDR und dem Deutschen Zentrum Kulturgutverluste, Berlin 2020, S. 41, im Original ohne Markierungen.

[10] Hierzu s. auch Alexander Sachse: „… komme nicht mehr zurück in die DDR". Pilotprojekt zur Recherche kritischer Provenienzen aus der Zeit zwischen 1945 und 1990 in brandenburgischen Museen, in: Provenienz & Forschung, Heft 01/2019, S. 18–25. Ders.: Schlossbergung, Republikflucht, Kommerzielle Koordinierung. Kritische Provenienzen aus der Zeit der SBZ und DDR, in: Museumsblätter – Mitteilungen des Museumsverbandes Brandenburg, Heft 35 (Dezember 2019), S. 18–37. Mathias Richter: Geplündert, verlassen, beschlagnahmt. Bei bis zu acht Prozent der Kulturgüter in Brandenburgs Museen ist unklar, wem sie gehören – Neue Studie des Museumsverbandes, in: Märkische Allgemeine Zeitung (8.5.2019), S. 12. Online unter https://www.maz-online.de/Nachrichten/Kultur/Brandenburgs-Museen-Bei-bis-zu-acht-Prozent-der-Kulturgueter-unklar-wem-sie-gehoeren (10.1.2021).

[11] Hierzu s. auch Jan Scheunemann: Die Moritzburg in Halle (Saale) als Zentrallager für enteignetes Kunst- und Kulturgut aus der Bodenreform, in: Provenienz & Forschung, Heft 01/2019, S. 26–33. Ders.: Bodenreform und Museum. Sicherstellung, Bergung und Verwertung von enteignetem Kunst- und Kulturgut in der SBZ und DDR, in: Kunst und Recht, Heft 6/2019, S. 165–169. Ders.: Kunst- und Kulturgutenteignungen im Zuge der Bodenreform. Das Beispiel Sachsen-Anhalt, in: Museumsblätter – Mitteilungen des Museumsverbandes Brandenburg, Heft 35 (Dezember 2019), S. 38–43.

[12] Hierzu s. auch Brigitte Reineke: Grundlagenforschung zu Kulturgutverlusten in SBZ und DDR im Deutschen Historischen Museum, in: Provenienz & Forschung, Heft 01/2019, S. 65. Christopher Jütte, Doris Kachel: Zwischenbericht zum Forschungsprojekt, Berlin 2019, online auf der Website des Deutschen Historischen Museums https://www.dhm.de/fileadmin/medien/relaunch/sammlung-und-forschung/Provenienzforschung/Zwischenbericht_Kurzfassung_Juette_20200224.pdf (10.1.2021).

[13] Hierzu s. auch Antje Strahl, Reno Stutz: Umgang der Verwaltungsinstanzen im ehemaligen Bezirk Schwerin mit Kulturgut aus Republikflüchtigen-Rücklässen von 1945 bis 1949 [sic!], in: Mitteilungen des Museumsverbandes in Mecklenburg-Vorpommern 29 (2020), S. 6–9. Dies.: „Zurückgelassen" – Der Verbleib des Eigentums ehemaliger Republikflüch-

tiger wird untersucht, in: Stier und Greif. Heimathefte für Mecklenburg-Vorpommern 4 (2020) 2, S. 64 f.

[14] Hierzu s. auch Torsten Fried: Von Ausreisen und Gutachten. Akten im Staatlichen Museum Schwerin, in: Museumsblätter – Mitteilungen des Museumsverbandes Brandenburg, Heft 35 (Dezember 2019), S. 48–51.

[15] Zum Ausgangspunkt dieses Projektes s. Xenia Schiemann: Die Geschäftsbeziehungen zwischen der Kunst und Antiquitäten GmbH der DDR und dem Londoner Auktionshaus Christie's (Teil I), in: Kunst und Recht 22 (2020) 2, S. 49–54. Dies.: Die Geschäftsbeziehungen zwischen der Kunst und Antiquitäten GmbH der DDR und dem Londoner Auktionshaus Christie's (Teil II), in: Kunst und Recht 22 (2020) 3/4, S. 77–81.

[16] Hierzu s. Marlen Topp, Mathias Deinert: Geschäfte mit dem Osten? Geplantes Pilotprojekt zur Untersuchung kritischer Provenienzen aus der SBZ und der DDR in nichtstaatlichen Museen des Freistaats Bayern, in: Museum heute, Heft 58 (Dezember 2020), S. 74–76.

[17] Proveana – Datenbank Provenienzforschung (https://www.proveana.de), online seit 2020.

[18] Vgl. hierzu bspw. Alfred Grimm: Ein Schmetterling kehrt zurück! In der DDR entzogen – vom Freistaat Bayern zurückgegeben: Das Bayerische Nationalmuseum restituiert ein „Schlossbergungsobjekt", in: aviso – Zeitschrift für Wissenschaft und Kunst in Bayern, Heft 1/2016, S. 44–47. Online unter https://www.stmwk.bayern.de/download/13555_aviso_1_2016_barrierefrei.pdf (10.1.2021). Swantje Karich: Recht, das Unrecht ist, in: Blau – Ein Kunstmagazin, Nr. 23 (November 2017), S. 69–73.

Besatzungszeit und junge DDR

Brünn – Wittenberge – Potsdam. Mehrfach enteignete Objekte im Fremdbesitz der Stiftung Preußische Schlösser und Gärten

Ulrike Schmiegelt-Rietig

Brno—Wittenberge—Potsdam. Repeatedly expropriated objects in the possession of the Stiftung Preußische Schlösser und Gärten (Prussian Palaces and Gardens Foundation)
Since 2004, researchers of the Stiftung Preußische Schlösser und Gärten have been working on identifying third-party property in the collections, researching the origin of objects and returning them to their rightful owners or their heirs. The research equally concerns property expropriated as a result of Nazi persecution and losses sustained in the Soviet occupation zone and as a result of GDR injustice. The latter must also be examined for earlier provenance, since repeated expropriation, although not regular, can be proven in individual cases.

The essay traces the path of two multiply expropriated objects. The paintings belonged to the Jewish collector Irene Beran and were confiscated in Brno in the winter of 1941/42, then probably sold by the German authorities in the "Protectorate of Bohemia and Moravia", subsequently seized by the local Soviet Military Administration (SMA) at the Wittenberge checkpoint in Brandenburg, and probably were included in the collections of Staatliche Schlösser und Gärten Potsdam-Sanssouci (State Palaces and Gardens, Potsdam-Sanssouci) around 1950. While in this case it was possible to identify the owner and determine her heirs, other objects from the same confiscation are still being researched.

Die Stiftung Preußische Schlösser und Gärten (SPSG) begann bereits 2004 mit einer systematischen Erforschung der Herkunft jener Objekte, die nach 1933 in ihre Sammlungen gelangt waren. Von Anfang an suchten die Forscher:innen der SPSG nicht nur nach NS-verfolgungsbedingt entzogenen Kulturgütern, sondern auch nach solchen Objekten, die als Folge der Bodenreform in der SBZ ihren Eigentümer:innen fortgenommen worden waren und entweder direkt aus sogenannten Schlossbergungen 𝒫 stammten oder nachfolgend über den Kunsthandel in die Sammlungen gelangt waren. Damit gehörte die SPSG zu den ersten Institutionen überhaupt, die sich proaktiv dieser Thematik annahmen. Seither wurden zahlreiche Objekte, die sich als Folge insbesondere der Bodenreform in den Sammlungen der SPSG befanden, identifiziert und den Eigentümer:innen oder deren Rechtsnachfolger:innen zurückgegeben.

𝒫 Vgl. Beitrag von Thomas Rudert, S. 28.

Häufig wurden, ungeachtet der gesetzlichen Grundlagen, aufgrund des Bewusstseins einer moralischen Verpflichtung selbst solche Objekte restituiert, für die nicht fristgerecht Ansprüche angemeldet worden waren.

Unter den als Fremdbesitz identifizierten Objekten in den Sammlungen der SPSG befinden sich auch solche, die zuerst durch das NS-Regime und ein zweites Mal in der SBZ/DDR enteignet oder entzogen wurden. Ein besonders interessanter Fall soll im Folgenden geschildert werden.

Im Sommer oder Herbst 1948 ließ die Sowjetische Militär-Administration (SMA) für das Land Brandenburg am Kontrollpunkt Wittenberge zahlreiche Gemälde und Grafiken beschlagnahmen. Sie sollten aus der sowjetisch besetzten Zone über die Demarkationslinie nach Westen gebracht werden, aber es fehlten hierfür die notwendigen Genehmigungen.[1] Die Identität der Person(en), in deren Besitz die Werke aufgefunden wurden, konnte bislang nicht geklärt werden.

Die SMA beauftragte das Brandenburgische Handelskontor, eine dem Ministerium für Wirtschaft und Arbeit nachgeordnete Behörde, mit der „Verwertung" der „beschlagnahmten Gegenstände".[2] Zunächst bot das Brandenburgische Handelskontor die Kunstwerke dem Brandenburgischen Ministerium für Volksbildung, Wissenschaft und Kunst zum Kauf an, das den Erwerb ablehnte, „weil angeblich keine Verwendung für die Bilder" bestand.[3] Daraufhin wandte sich ein Vertreter des Handelskontors am 1. Dezember 1948 unter Umgehung des Dienstweges direkt an den Ministerpräsidenten des Landes Brandenburg, Karl Steinhoff, da es „sicherlich im Interesse des Landes" wäre, diese Bilder der Allgemeinheit zu erhalten.[4] Das Angebot war zudem kostengünstig: Falls die Landesregierung die Kunstwerke insgesamt übernähme, müsste das Handelskontor nur 20 Prozent des geschätzten Wertes an die SMA abführen, erläuterte der Autor. Offenbar hatte das Ministerium den Schätzpreis für zu hoch befunden und die Transaktion deshalb abgelehnt. Das Handelskontor warb nachdrücklich für eine Übernahme des „Bilderschatzes" durch die Landesregierung, wenn auch viele nicht „für die Aufnahme in ein Museum geeignet" seien. Eine schnelle Entscheidung sei allerdings nötig, da die Bilder im Kreislager Wittenberge des Revisionsverbandes „nicht gut aufgehoben" wären.[5] In der Folge entsandte das Ministerium sei-

nen Museumsreferenten, Carl Heidemann, zur Besichtigung und erneuten Schätzung der Objekte nach Wittenberge. Er setzte den Wert des Bestands um beinahe 60 Prozent niedriger an als zuvor geschätzt, da höchstens fünf Bilder museumswürdig seien.[6]

Offenbar gab es noch weitere Bedenken gegen den Erwerb der Kunstwerke, nämlich die Frage des Eigentumsübergangs. Dies ist einem Aktenvermerk vom 28. Dezember 1948 zu entnehmen. Hier wurde auf die Hoheitsrechte der sowjetischen Besatzungsmacht verwiesen. Da die SMA sowohl die Beschlagnahme als auch den nun anstehenden Verkauf veranlasst habe, sei davon auszugehen, dass sie „kraft ihres Besatzungsrechts das Eigentum der beschlagnahmten Gegenstände an sich gezogen" habe. Aus diesem Grund könne das von der SMA beauftragte Brandenburgische Handelskontor wirksam Eigentum an den Kunstwerken übertragen.[7] Die Frage der Herkunft stellte sich offensichtlich keiner der Beteiligten.

Aus den Akten des Brandenburgischen Landeshauptarchivs geht nicht direkt hervor, wie die Verhandlungen endeten, doch ist davon auszugehen, dass die Landesregierung die Kunstwerke erwarb und zumindest einen Teil davon an die Schlösserverwaltung abgab. Schließlich befinden sich bis heute Kunstwerke aus dieser Transaktion in den Sammlungen der SPSG.

Mindestens zwei der Werke hatten bereits einen weiten Weg hinter sich, als sie in Wittenberge beschlagnahmt wurden. In den 1920er- und 1930er-Jahren waren sie Eigentum einer jüdischen Sammlerin in Brünn gewesen. Bei einem der beiden Gemälde, dem *Porträt einer Dame* von Hugo von Habermann, gelang 2006 der Nachweis, dass es Eigentum der Porträtierten war. Es handelt sich um Irene Beran (1886–1979), Ehefrau des Brünner Textilunternehmers Philip Beran (1880–1942). Noch ein weiteres Gemälde, Thomas Theodor Heines *Schäfchen*, wurde im Jahr 2019 als ehemals der Sammlung Irene Berans zugehörig erkannt.[8] Bis dahin hatte das Werk des Mitbegründers der Satirezeitschrift *Simplicissimus* als Eigentum des Brünner Textilunternehmers Hermann Feinberg gegolten, der wie die Berans aufgrund seiner jüdischen Herkunft zu den Verfolgten des NS-Regimes gehörte.[9] Ob sich noch weitere Objekte aus dem Eigentum Irene Berans unter den Werken aus der Beschlagnahme der SMA in Wittenberge in den Sammlungen der SPSG befinden, konnte bisher nicht festgestellt werden, ist aber nicht auszuschließen.

Das Porträt einer Dame *zeigt Irene Beran. Hugo von Habermann,*
1921, Eigentum Max Beran, Öl auf Leinwand, 98,5 × 69,5 cm

Thomas Theodor Heine, Schäfchen, 1905, SPSG, GK I 50364, Öl auf Holz, 84 x 83 cm

Philip und Irene Beran, geb. Subak, heirateten 1905. Philip Beran arbeitete bereits in dem erfolgreichen Textilunternehmen seines Vaters mit, das unter anderem die österreichische Armee mit Stoffen für die Uniformen belieferte. Das Paar trug eine bedeutende Kunstsammlung zusammen, die, soweit bekannt ist, vor allem Werke zeitgenössischer Künstler enthielt, beispielsweise ein frühes Gemälde Oskar Kokoschkas und Zeichnungen der wichtigsten Vertreter der Wiener und der Münchener Secession, wie Gustav Klimt und Franz von Stuck, aber auch einige ältere Werke.[10] Leider ist die Sammlung nicht gut dokumentiert; die einzigen verbliebenen Zeugnisse sind einige zeitgenössische Ausstellungskataloge.[11] Die wenigen bekannten Fakten deuten darauf hin, dass Irene Beran die treibende Kraft beim Aufbau der Sammlung war, als deren Eigentümerin sie auch offiziell stets genannt wurde. Dafür, dass sie über beträchtliche Summen verfügen konnte, spricht ihr Erwerb eines Hauses in Brünn Mitte der 1920er-Jahre.

Anfang der 1920er-Jahre verliebte Irene Beran sich in ihren Schwager, den Maler und jüngeren Bruder Philips, Bruno Beran

(1888–1979). Ausgebildet in Wien, München und Paris, knüpfte Bruno Beran nach dem Ersten Weltkrieg an die Münchener Kontakte an und teilte sich zeitweise ein Atelier mit Hugo von Habermann.[12] 1929 führte die Weltwirtschaftskrise zum Ruin des Textilunternehmens der Berans. Die Familie übersiedelte in eine Wohnung in jenem Haus, das Irene Beran wenige Jahre zuvor erworben hatte.[13] Ihre Kunstsammlung behielt sie und stellte die Werke weiterhin öffentlich aus.[14] Sie begleitete Bruno Beran immer häufiger auf seinen Reisen, und als er sich ein Atelier in Paris einrichtete, folgte sie ihm dorthin. 1935 wurde die Ehe von Irene und Philip Beran geschieden. Philip Beran blieb in der Wohnung in Brünn und bei ihm mit größter Wahrscheinlichkeit ein Teil von Irene Berans Kunstsammlung, darunter auch ihr Porträt von Habermann und vermutlich auch Heines *Schäfchen*. Einen kleineren Teil, vornehmlich wohl Arbeiten Bruno Berans, nahm Irene Beran mit nach Paris.[15] Die Kunstwerke überdauerten Krieg und Shoah in der Obhut von Irene Berans Tochter Hermine, die durch Heirat Schweizer Staatsangehörige und als solche vor der Verfolgung durch die Nationalsozialisten geschützt war. Irene und Bruno Beran flohen später von Paris nach Kanada. Philip Beran blieb in Brünn. Er wurde am 5. Dezember 1941 nach Theresienstadt und von dort am 15. Januar 1942 nach Riga deportiert und ermordet.[16]

Wie nun gelangten die Bilder Irene Berans von Brünn nach Wittenberge? Der genaue Weg der Werke lässt sich aus den wenigen bisher bekannten Dokumenten nicht rekonstruieren. Es gibt jedoch Indizien, wie er verlaufen sein könnte.

Zwischen 1946 und 1948 arbeitete in Karlsruhe die Tschechoslowakische Mission für die Restitution in die Tschechoslowakei unter der Leitung von Major Henry Reis daran, den Verbleib von Kulturgütern zu ermitteln, die während der deutschen Besatzung von den verschiedenen Besatzungsbehörden des „Protektorats Böhmen und Mähren" beschlagnahmt und verschleppt worden waren, und deren Rückführung zu betreiben. Im Rahmen ihrer Tätigkeit stellte die Mission Listen zur Vorlage bei der amerikanischen Militärregierung in Deutschland für die Monuments, Fine Arts and Archives Section (MFA&A) zusammen. Einige dieser Recherche- und Rückführungsverlangen basierten auf Angaben (ehemals) tschechoslowakischer Staatsbürger:innen, die den Krieg und die Shoah überlebt hatten und nun ihr Eigentum zurückforderten. Der größere Teil der tsche-

chischen Restitutionsforderungen bezog sich jedoch auf Verluste unbekannter tschechischer Eigentümer:innen, die ihre Ansprüche wohl zum weit überwiegenden Teil nicht mehr selbst geltend machen konnten. Auf einer dieser Listen der „Bilder und Kunstgegenstände, welche während der Okkupation der Tschechoslowakischen Republik durch das s.g. Vermögensamt beim Deutschen Staatsminister in Böhmen und Mähren bzw. durch die Gestapo beschlagnahmt und an unbekannte Orte verschleppt wurden" stehen unter der Nummer 9491 „Habermann, Dame im Pelz" und unter der Nummer 9594 „T. H. Deutsch, Zwei Mädchen mit Lamm".[17] Die fehlerhafte Angabe des Künstlers dürfte auf eine falsche Übertragung zurückgehen. Daraus lässt sich schließen, dass die Tschechoslowakische Mission ihre Listen anhand von Dokumenten der deutschen Besatzungsbehörden erstellte. Die als laufende Nummern ausgewiesenen Zahlenfolgen am Beginn jeder Zeile sind tatsächlich nicht fortlaufend, sondern es gibt Lücken in der Nummerierung, mitunter ist die Reihenfolge vertauscht, und in einem Fall wurde eine Nummer zweimal vergeben. Vermutlich war also die Vorlage fragmentiert und nicht mehr einwandfrei lesbar, oder es handelte sich um eine gegenüber dem Urdokument veränderte Fassung, in die nicht mehr alle Nummern Eingang gefunden hatten. Möglicherweise hatten auch die Ersteller:innen versucht, ihre Spuren zu verwischen, und Dokumente vernichtet. Der Aufbewahrungsort dieser Akten konnte bislang nicht ermittelt werden.[18]

Irene Berans Haus in Brünn, in dem Philip Beran vermutlich bis zu seiner Deportation lebte, wurde in Abwesenheit der Eigentümerin durch einen Treuhänder zwangsweise an den „Auswanderungsfonds für Böhmen und Mähren" verkauft. Der Verkauf wurde am 27. November 1941 vollzogen, also unmittelbar vor Philip Berans Deportation.[19] Der „Auswanderungsfonds" war eine Einrichtung der „Zentralstelle für jüdische Auswanderung", deren Aufgabe die Verwaltung und Verwertung eingezogener jüdischer Vermögen war. Beschlagnahmte Wohnungen wurden von den Mitarbeitern unmittelbar geräumt, die Einrichtungen entweder in Sammellager gebracht und von dort aus, mitunter auch direkt aus den Wohnungen heraus, an Deutsche veräußert. Die Erlöse wurden auf ein spezielles Konto des „Auswanderungsfonds" überwiesen.[20]

Neben der „Zentralstelle" konnten auch Gestapo-Leitstellen aus Prag und Brünn bei „Straffälligkeit" der Verfolgten, beispiels-

weise wegen unerlaubter Landesflucht, jüdische Vermögen be-
schlagnahmen. Eine der Meldekarten Bruno Berans (mit Ehefrau
Irene) trägt den Vermerk „der Protektoratsangehörigkeit verlustig
erklärt",[21] eine übliche Maßnahme bei unerlaubtem Auslandsauf-
enthalt. Der Besitz der so Bestraften fiel an das Reich. Er wurde
von der Gestapo eingezogen und zur Verwertung an das im De-
zember 1941 eingerichtete „Vermögensamt beim Reichsprotektor
in Böhmen und Mähren" übergeben.

Dessen Beamte überwachten die Räumung der beschlag-
nahmten Wohnungen. Wertvolle Gegenstände wurden in Sonder-
listen eingetragen, in separate Lager gebracht, geschätzt und zum
Verkauf angeboten.[22] Einer späteren Einschätzung zufolge traten
als Erwerber:innen „vielfach […] reichsdeutsche Interessenten
auf. Besonders soll der Berliner Kunsthandel, daneben auch der
aus dem übrigen Reichsgebiet, zu den häufigsten Käufern gerech-
net haben."[23] Sehr wertvolle Objekte wurden mitunter vom Ver-
kauf ausgenommen und an Museen im „Protektorat", aber auch
im Reichsgebiet gegeben.[24] Vereinzelt wurden Erwerbungen deut-
scher Kunsthändler:innen aus dem „Protektorat" nach dem Krieg
auch in der amerikanisch besetzten Zone aufgefunden, wie im Fall
des Wiesbadener Antiquitätenhändlers Peter Flory, der während
des Krieges an der Verwertung jüdischen Eigentums in Prag be-
teiligt gewesen war.[25]

Es ist davon auszugehen, dass auch Irene Berans Kunstsamm-
lung beschlagnahmt und verwertet wurde. Das bezeugen die iden-
tifizierbaren Objekte in den Listen der Tschechoslowakischen Mis-
sion. Teile der Sammlung könnten so als Besitz eines Kunsthändlers
in den östlichen Teil Deutschlands gelangt sein. Diese Annahme
passt zu dem Bestand an Kunstwerken, der 1948 auf dem Trans-
port nach Westen in Wittenberge beschlagnahmt wurde, denn
dabei handelte es sich kaum um Umzugsgut eines Flüchtlings,
sondern viel wahrscheinlicher um den Besitz eines Kunsthändlers,
den dieser vor dem Zugriff der sowjetischen Besatzungsmacht in
Sicherheit bringen wollte.

Die Geschichte der Bilder aus der Kunstsammlung Irene Be-
rans zeigt einmal mehr, wie komplex die Wege der Werke sein
können und wie sehr die Forschung zu einzelnen Objekten auf
Kenntnisse angewiesen ist, die nur durch Grundlagenforschung
bereitgestellt werden können. Es ist zu hoffen, dass es noch gelin-

gen wird, die Person(en) zu identifizieren, die die Objekte über die Demarkationslinie zu bringen versuchte(n). Falls es sich tatsächlich um einen oder mehrere Händler:innen handelte, könnte dies für die Provenienzforschung von erheblicher Bedeutung sein.

Die Geschichte der Gemälde ist mit der Übernahme um 1950 durch die Staatlichen Schlösser und Gärten Potsdam-Sanssouci 🔗 nicht zu Ende: Aufgrund der bekannten Fakten entschied die SPSG sich für die Rückgabe des Werks von Hugo Habermann. Das Porträt Irene Berans konnte 2006 an ihren Sohn zurückgegeben werden, der damals noch hochbetagt in London lebte. Auch Heines *Schäfchen* soll nach Abschluss der Recherchen den rechtmäßigen Eigentümern übergeben werden. Zu hoffen ist dies schließlich für die übrigen Objekte aus der Beschlagnahme, zu denen immer noch geforscht wird.

🔗 *1995 in der Stiftung Preußische Schlösser und Gärten Berlin-Brandenburg aufgegangen*

Ulrike Schmiegelt-Rietig
Ulrike Schmiegelt-Rietig ist wissenschaftliche Mitarbeiterin der Stiftung Preußische Schlösser und Gärten Berlin-Brandenburg.

Endnoten

[1] Sicherstellung und Rückführung von verlagerten Kunstgegenständen, Brandenburgisches Landeshauptarchiv (im Folgenden: BLHA) Rep. 205 A Nr. 910, Bl. 7.

[2] Ebd.

[3] Ebd., Bl. 8.

[4] Ebd.

[5] Ebd.

[6] Ebd., Bl. 6.

[7] Ebd., Bl. 7.

[8] Diese Entdeckung ist einem Hinweis von Sophie Lillie zu verdanken, die im Auftrag des Enkels von Irene Beran Recherchen zur Rekonstruktion der Sammlung durchführt.

[9] Sonderausstellung Th. Th. Heine, in: Münchener Neue-Secession. XIII. Ausstellung in München 1927. Nr. 422.

[10] Rudolf Beran, A tale of two portraits. http://brunoberan.com/history/a-tale-of-two-portraits?LMCL=qENb3_ (6.1.2021)

[11] Handzeichnungssammlung Irene Beran. Ausgestellt in der Galerie Würthle, Wien, I. Weihburggasse 9, 4. Feber–3. März 1928. Mit einem Vorwort von Arthur Roessler. Außerdem: Mährischer Kunstverein, Gemälde und Plastiken aus Brünner Privatbesitz (1850–1930), 12.10.–2.11.1930, Brünn 1930.

[12] http://brunoberan.com/history/a-tale-of-two-portraits?LMCL=qENb3_ (6.1.2021).

[13] Ebd. Moravský zemský archiv v Brně, B 392, Vystěhovalecký fond, úřadovna Brno, box nr. 806, ref. Nr. Sp-V-279.

[14] So im Mährischen Kunstverein in der bereits erwähnten Ausstellung 1930.

[15] http://brunoberan.com/history/a-tale-of-two-portraits?LMCL=qENb3 (6.1.2021).

[16] https://www.holocaust.cz/de/opferdatenbank/opfer/76767-filip-beran/ (7.1.2021).

[17] NARA Records Concerning the Central Collecting Points ("Ardelia Hall Collection"): Wiesbaden Central Collecting Point, 1945–1952, Wiesbaden Administrative Records – Restitution Claim Records – Claim: [Czechoslovakia]-Miscellaneous; https://www.fold3.com/image/231925060; https://www.fold3.com/image/231925082 (7.1.2021).

[18] Vom Einsatzstab Rinnebach, den Heydrichs Nachfolger Kurt Daluege im Oktober 1942 einrichtete, existieren noch Listen beschlagnahmter Kunstgegenstände. S. Cathleen M. Giustino: Pretty Things, Ugly Histories. Decorating with Persecuted People's Property in Central Bohemia, 1938–1958, in: Leora Auslander, Tara Zahra (Hg.): Objects of War. The Material Culture of Conflict and Displacement, Ithaca/London 2018, S. 78–110, hier S. 86 f.

[19] Moravský zemský archiv v Brně, B 392, Vystěhovalecký fond, úřadovna Brno, box nr. 806, ref. Nr. Sp-V-279.

[20] Die Mechanismen der Enteignung beschreibt ausführlich Monika Sedláková: Die Rolle der sogenannten „Einsatzstäbe" bei der Enteignung jüdischen Vermögens, in: Theresienstädter Studien und Dokumente 10 (2003), S. 275–305. https://www.ceeol.com/search/article-detail?id=203008 (21.12.2020). Grundsätzliches dazu auch bei Mečislav Borák: Verspätete Gerechtigkeit. Die Restitution von enteignetem Kulturgut in Tschechien, in: Osteuropa, 56 (2006), S. 247–262.

[21] Moravský zemský archiv v Brně, B 392, Vystěhovalecký fond, úřadovna Brno, box nr. 806, ref. Nr. Sp-V-279.

[22] Sedláková 2003, S. 279.

[23] BA, B 323, Nr. 491, Bl. 86.

[24] Borák 2006, S. 248.

[25] NARA M1949, Records of the Monuments, Fine Arts, and Archives (MFA&A) Section of the Reparations and Restitution Branch, Office of Military Government, U.S. Zone (Germany) [OMGUS], Hesse, Declaration Nr. 00691 v. 30.5.1946, Bl. 4–9; https://www.fold3.com/image/293110389 und folgende (6.1.2021).

Die Verkäufe von Werken aus der sächsischen Schlossbergung im Dresdner Albertinum 1946–1950

Thomas Rudert

The sales of art from the Saxon "palace salvage" in the Dresden Albertinum 1946–1950

The land reform ordered by the Soviet Military Administration (SMAD) in its zone of occupation, which began in September 1945, was concerned with the destruction of the rural aristocracy as a social class. For this reason, the expropriations were not limited to land and agricultural inventory, but also targeted the basic necessities of life, such as residential buildings and their furnishings, often accompanied by deportations. The expropriations related to valuable movables of all kinds are still referred to in research today with the contemporary, highly ambivalent term of "Schlossbergung" (palace salvage).

In the Free State of Saxony, more than a thousand castles and manor houses were expropriated along with their movable furnishings. As a result, the victims of land reform lost tens of thousands of objects: Works of art, libraries, archives, furniture, watches, jewelry, technical valuables and much more.

There were competing ideas about how to deal with the expropriated works. The SMAD and the KPD/SED cadres of the Saxon state administration acting on its behalf sought to sell as many works as possible in order to finance the land reform. The employees of Saxon museums and other cultural institutions who were involved as experts—and who had not initially been involved in the actual expropriations—wanted the most valuable works to be incorporated into the holdings of their institutions.

Between 1946 and 1950, more than ten thousand objects from the palace salvage were sold at the Albertinum in Dresden. This article examines the historical circumstances under which the sales that must be judged as contrary to today's rule of law, began and under which they ended. In addition, the sales are analyzed using significant examples on the basis of a favorable source situation from various points of view: Provenance, appraisers, sellers, appraisal and sale prices, acquirers.

Die sogenannte Schlossbergung ab September 1945 als Teil der Bodenreform in der Sowjetischen Besatzungszone war keine Aktion der Museen, weder von deren Mitarbeitern initiiert, noch – was den Enteignungsvorgang selbst angeht – unter deren maßgeblicher Beteiligung durchgeführt. Ab Herbst 1945 zielte die Einbindung von aktiven oder ehemaligen Museumsmitarbeitern auf deren fachwissenschaftliche Kompetenz bei der Bewertung enteigneter Werke vor Ort. Denn für den professionellen Um-

gang mit dem Schlossbergungsgut bedurfte es eines kunsthistorischen, denkmalpflegerischen und museologischen Zugangs. Das bewegliche Inventar von 1155 enteigneten Schlössern, Guts- und Herrenhäusern zu begutachten, setzte kompetentes Personal in erheblicher Zahl voraus. Dabei wurden – nachdem die Enteignungen bereits vollzogen waren – im Freistaat Sachsen häufig auch Fachleute als freie Mitarbeiter tätig, die wegen einer tatsächlichen NSDAP-Mitgliedschaft oder einer von der sowjetischen Besatzungsmacht unterstellten Nähe zum NS-Regime 1945/46 aus dem Museumsdienst entlassen worden waren.[1]

Diese engste Einbindung in historische Vorgänge, deren ungerechten, ethisch höchst bedenklichen Ausgangspunkt sie weder verantworteten noch auch nur beeinflussen konnten, prägte die Situation der ostdeutschen Museen über das Ende der DDR und das Inkrafttreten des Entschädigungs- und Ausgleichsleistungsgesetzes 1994 hinaus – bis heute. Denn auch die aktuelle Gesetzgebung und die darauf fußende Rechtsprechung haben den juristisch und ethisch unbefriedigenden Umgang mit Bodenreform und Schlossbergung keineswegs beendet, sondern perpetuierten ihn in wesentlichen Aspekten.[2]

In Dresden bestanden sehr unterschiedliche, ja konkurrierende Vorstellungen zum Umgang mit den enteigneten und buchstäblich zu Tausenden nach Dresden transportierten Werken. Die Dresdner Sammlungen und das für sie verantwortliche Ressort der entstehenden sächsischen Landesverwaltung wollten im Herbst 1945 die qualitätvollsten Werke den Museen für deren Neuanfang sichern, denn die brutalen Enteignungen und der Abtransport von Museumsbeständen durch die Trophäenbrigaden der Roten Armee hatten deren Arbeitsfähigkeit, ja Existenz gefährdet.[3] Die sächsische Landesbodenkommission (LBK) hingegen wollte möglichst viele Werke zu Höchstpreisen verkaufen. Die Erlöse daraus sollten dem „Bodenreformstock"[4] zufließen, also der Finanzierung der Bodenreform dienen.

Der im sächsischen Ministerium für Volksbildung unter anderem für die Neueröffnung der Dresdner Museen zuständige Ministerialdirektor Will Grohmann hatte bereits am 14. Oktober 1945 angewiesen, „herrenlose Privatsammlungen" – womit vor allem museumswürdige Schlossbergungsobjekte gemeint waren, ohne

✐ Abkürzung für „Sowjetische Militär-Administration in Deutschland"

dies aus Rücksicht auf die reale Machtkonstellation und die anders orientierten Vorstellungen von SMAD ✐ und KPD im Herbst 1945 explizit so zu formulieren – gemeinsam mit kriegsbedingt ausgelagerten Museumsbeständen aus jenen zahlreichen Schlössern und Herrenhäusern zurückzuführen, die als museale Bergungsdepots gedient hatten.[5] Damit wären all diese Werke der Schlossbergung in die Verfügung der Dresdner Sammlungen gelangt, was formal zunächst auch der Beschlusslage der sächsischen Landesverwaltung entsprochen hätte. Die Gesamtverantwortung für das enteignete bewegliche Inventar oblag demnach dem Volksbildungsministerium.[6] Gleichzeitig und buchstäblich in derselben Verordnung war jedoch auch die „Verwertung" solcher enteigneten Werke ausdrücklich vorgesehen,[7] allerdings nicht unter der Ägide des Ressorts für Volksbildung, sondern jener für Finanzen und Land- und Forstwirtschaft.

In dieser widersprüchlichen Konstellation war der Grundkonflikt, der den historischen Gesamtvorgang der Schlossbergung in Sachsen von Beginn an prägte, bereits strukturell angelegt. Denn es war unvermeidlich, ja lag in der Natur der Sache selbst, dass die Beurteilung von Objekten als museumswürdig, also unverkäuflich, gerade auf die potenziell hochpreisigen Werke zielen würde, was die „Verwertung" mit der Aussicht auf maximalen Gewinn also unterlief. Noch während die Enteignungen vor Ort in vollem Gange waren, hatte deshalb Innenminister Kurt Fischer (KPD), der starke Mann der sächsischen Landesverwaltung, schon am 10. November 1945 eine geheime Verordnung erlassen, die im Widerspruch zur Beschlusslage der Landesverwaltung den polizeilichen Zugriff auf wertvolle Objekte aus der Schlossbergung anwies mit dem Ziel, diese zu verkaufen.[8]

Formaljuristisch gedeckt waren diese und weitere in ähnliche Richtung zielende Anweisungen nicht, weder durch die Bodenreform-Verordnung selbst noch durch einen der publizierten Befehle der SMAD. Doch kann als sicher vorausgesetzt werden, dass Fischer seine Aktivitäten in enger Fühlung mit der SMAD abgestimmt hatte. Dies gilt ausdrücklich auch für die Verkäufe, die diskret spätestens 1946 begonnen hatten. Multifunktionär Fischer – unter anderem als sächsischer Innenminister und Chef der LBK – war bereits seit Jahren Bürger der UdSSR, Oberst der Roten Armee,

Dr. Kurt Fischer (1900–1950)

sowjetischer Geheimdienstler und Mitglied der KPdSU; er war ein verdeckt agierender Vertreter der SMAD.[9]

Sein direkter Gegenspieler in Dresden – wenn auch in einer machtpolitisch asymmetrischen Konstellation und von Anfang an chancenlos – war Hans Geller[10], der im Grenzbereich zwischen Kulturpolitik und Museen in zwei Führungspositionen tätig war. Er agierte vom 1. April 1946 bis 31. März 1948 als „Intendant" für die Dresdner Staatlichen Sammlungen, also als eine Art Verwaltungs-direktor, dessen Einsetzung von der SMAD befohlen worden war, und spätestens seit Mai 1946 und bis zum 30. April 1948 zugleich als sächsischer Landesbeauftragter für die Schlossbergung.

Obwohl beruflich ursprünglich gar nicht aus musealem Umfeld stammend – vor seiner Tätigkeit für die Dresdner Sammlungen war

Hans Geller (1894–1962)

Geller Bankbeamter und betrieb nebenher einen Wein- und Spiri-tuosenhandel –, versah er seine beiden schwierigen Ämter mit gro-ßer Umsicht und enormem Fleiß. Grundiert war seine Tätigkeit von hohem christlichen Ethos, dem er sich als Mitglied der Herrnhuter Brüdergemeine zeitlebens verpflichtet fühlte und das auch die NS-Herrschaft nicht hatte verunsichern können. Doch gerade dieses bürgerlich-konservative Amtsverständnis machte den Intendanten und Schlossbergungsbeauftragten Geller inkompatibel mit den po-litischen Nachkriegsverhältnissen in Dresden und Sachsen. Dass die SMAD einer ganz anderen, einer stalinistischen Herrschafts-logik folgte, wurde von den noch in Dresden verbliebenen Mu-seumsleuten lange nicht wahrgenommen. Ebenso wenig sichtbar war für sie die beschriebene enge, auch personelle Verflechtung zwischen Besatzungsmacht und kommunistischen Amtsträgern der entstehenden Landesverwaltung. Nicht nur Geller arbeitete in der Überzeugung, man erwarte von ihm die Anknüpfung an die Dresdner bürgerliche Museumstradition der Zeit vor 1933 – was sich schnell als verhängnisvoller Irrtum herausstellen sollte.[11]

Im Laufe des Jahres 1947 war diese widersprüchliche Konstel-lation mehrfach zu offenen Konflikten eskaliert. Mit Beschluss vom 13. Januar 1948 reagierte deshalb die Landesverwaltung auf Initia-tive Fischers – Präsident Rudolf Friedrichs war 1947 verstorben, und der spätere Generaldirektor der Staatlichen Kunstsammlungen Dresden, Max Seydewitz, war ihm für die SED als Ministerpräsi-dent nachgefolgt – und entzog dem Ministerium für Volksbildung und damit den Dresdner Sammlungen die Entscheidungsbefug-

nis über die Objekte der Schlossbergung weitgehend. Sie wurde stattdessen mit sofortiger Wirkung der LBK übertragen.[12] Direkte Folge war die Entlassung Gellers zum 31. März 1948 als Intendant und zum 30. April 1948 als Schlossbergungsbeauftragter. Nun war der Verkauf von Objekten aus der Schlossbergung durch die LBK, gegen den bisher sowohl Geller als auch die Dresdner Museumsleute für die qualitätvollsten Werke von Fall zu Fall erfolgreich interveniert hatten, ungehindert möglich. Hiervon hat die LBK in den folgenden mehr als zwei Jahren hemmungslos Gebrauch gemacht. Durchgesetzt hatte all dies noch Kurt Fischer, bevor er Anfang Juli 1948 in Berlin Chef des Innenressorts der SBZ wurde, freilich ohne dadurch in Dresden wesentlich an Einfluss zu verlieren.[13] Sein Nachfolger als Innenminister wurde zunächst bis 1949 Wilhelm Zaisser und schließlich Artur Hofmann bis zur Auflösung der Länder 1952 ⌀.

⌀ *Sog. Verwaltungsneugliederung zu einem zentralistischen Aufbau mit 14 Bezirken und 216 Kreisen*

Unmittelbar nach Gellers Entlassung begannen die systematischen und umfangreichen, nun nicht mehr verdeckt praktizierten Verkäufe von Schlossbergungsobjekten im Dresdner Albertinum. Das dazugehörige Verkaufsbuch der LBK hat sich erhalten, sodass ein werkgenauer Überblick möglich ist. Die erste Eintragung datiert mit dem 30. April 1948 exakt auf dem Entlassungstag Gellers. Doch gilt dieser erste Eintrag des Verkaufsbuches nicht dem frühesten Verkauf, was bedeutet, dass zwischen den grundsätzlich

Albertinum an der Brühlschen Terrasse in Dresden (um 1930)

chronologisch notierten Verkäufen von Fall zu Fall frühere Vorgänge nachgetragen worden sind. Der früheste Vorgang von 1946 findet sich unter Nr. 3180 etwa in der Mitte des Buches und hält den Verkauf einer Briefmarkensammlung aus Dittmannsdorf fest, die den überdurchschnittlich hohen Schätzwert von 4.000 RM im Verkauf auch erzielte. Schätzer und Verkäufer in einer Person war der Dresdner Briefmarkenhändler Alfred Arendt.[14] „Teilen einer Briefmarkensammlung"[15] aus Dittmannsdorf galt auch der mit Abstand höchste Preis der gesamten Verkaufsaktion von 28.381 DM/Ost, ebenfalls von Arendt geschätzt und über ihn veräußert.

Im Verkaufsbuch sind zwischen dem nicht präziser benannten Erstdatum 1946 und dem 10. August 1950 insgesamt 6151 einzelne Verkaufsvorgänge dokumentiert. Diese betreffen Gemälde, Grafiken, Möbel, Schmuck und Edelmetalle, Glas, Geschirre aus Porzellan oder Silber, Pelze, Briefmarkensammlungen und Tischwäsche, aber auch Zieloptik für Jagdwaffen, Ferngläser sowie Radio- und Fotoapparate – also alles, was bei der Schlossbergung in den enteigneten Immobilien „angefallen" war. Dieses Spektrum zeigt den überaus aggressiven Charakter der Vollstreckung über die Bodenreformverordnung hinaus, ja häufig auch im augen-

Nachweisbuch über Verkäufe aus der Schlossbergung im Dresdner Albertinum

Nachweisbuch über Verkäufe aus der Schlossbergung im Dresdner Albertinum

fälligen Widerspruch zu ihr. So sollten das persönliche Eigentum der Betroffenen sowie die übliche Ausstattung eines bürgerlichen Haushaltes nach den geltenden Durchführungsbestimmungen de jure von den Enteignungen ebenso ausgeschlossen sein wie Ahnenbilder ohne musealen Wert, wovon man aber – wie das Verkaufsbuch dokumentiert – regelmäßig abwich.

Da sehr häufig mehrere Werke konvolutweise unter einer Nummer veräußert wurden, dokumentiert das Buch in den 6151 Verkaufsvorgängen den Verlust von mindestens 10.000 Einzelobjekten. Erlöst wurde dabei eine Summe von deutlich mehr als 700.000 Mark; bis zur Währungsreform im Juni 1948 waren dies Reichsmark (RM), danach Deutsche Mark DM/Ost.

Umfangreiche Konvolute gingen an Behörden, ohne dass deren Ressortzuständigkeit eine inhaltliche Begründung dafür liefern würde. Von zwei solcher Übernahmen profitierte das sächsische Innenministerium: Nr. 3184-3266 (18. Dezember 1947) sowie Nr. 3267-3397 (8. März 1948). Bei diesen mehr als 200 Objekten handelte es sich vor allem um wertvolle Herren- und Damenuhren und sonstige Gegenstände aus Gold und Silber sowie um teils hochpreisigen Schmuck, häufig mit Edelsteinen. Schätzer dieser beiden Konvolute war Herbert Smy für die alteingesessene Dresdner Firma Smy, die bereits seit den 1890er-Jahren mit Goldwaren und hochwertigen Uhren gehandelt hatte.

Neben dem Innenministerium erwarb auch das Ministerium für Land- und Forstwirtschaft wertvollen Schmuck konvolutweise, so zwischen 5. März 1948 und 3. September 1948 (Nr. 654-1141) insgesamt 488 Stücke. Dazu gehörte ein Brillantgliederarmband für 4.000 RM, das aus Schloss Milkel stammte (Milkel 522/23). Bemerkenswert ist, dass mit dem Weggang von Kurt Fischer aus Dresden 1948 auch die Zentralverwaltung des Innern als Käuferin im Dresdner Albertinum offen in Erscheinung trat, also jene Behörde, der Fischer bis zu seinem frühen Tod nunmehr in Berlin vorstand. Vom künftigen Innenministerium der DDR wurden unter seiner Verantwortung zahlreiche hochwertige antike Teppiche übernommen. Weitere institutionelle Erwerber waren die Gesellschaft zum Studium der Sowjetunion (die spätere Gesellschaft für Deutsch-Sowjetische Freundschaft), das Polizeipräsidium Berlin, aber auch die Volkssolidarität Dresden,

der zahlreiche Möbel zunächst gegen Bezahlung, später unentgeltlich überlassen wurden.

Einige Erwerbungen offenbaren unabhängig von der grundsätzlich rechtsstaatswidrigen Basis, auf der sie fußten, eine nachvollziehbare zeitgenössische Logik. So etwa, wenn ein Bechstein-Flügel aus Schloss Krobnitz (Schloss Krobnitz, Nr. 1) am 3. November 1948 für 450 DM/Ost an die Staatliche Hochschule für Theater und Musik auf der Dresdner Mendelssohnallee 34 verkauft wurde (S. 57, Verkauf Nr. 1229); oder wenn am 10. Juni 1949 eine Kirchenglocke aus Schloss Purschenstein für 90 DM/Ost von der dortigen Kirchgemeinde Neuhausen/Erzgeb. übernommen wurde (S. 168, Verkauf Nr. 3659).

Die Landesbodenkommission stützte sich bei den Verkäufen auf die Kompetenz eines überschaubaren, aus Dresden und Berlin stammenden Kreises von Kunsthändlern verschiedener Sparten oder sonstigen Spezialisten, die etwa Pelze, Radioapparate, optische Geräte oder Flügel und Klaviere schätzten. Dieser Personenkreis agierte mitunter auch als Käufer, allerdings erheblich seltener. Die Dresdner Firmen Arthur Herrnsdorf und Söhne, Wilhelm Gehrisch und Karl Büch fungierten häufig wechselseitig miteinander als Schätzer und Käufer. Gelegentlich traten Händler aber bei Ankäufen auch als ihre eigenen Schätzer auf.

Als professionelle Akteure sind nachweisbar (Auswahl):
 Alfred Arendt, Dresden (Briefmarken)
 Wilhelm Axt, Dresden/Pillnitz, allg.
 Baumbach, Berlin?, allg.
 Karl Büch, Dresden, allg.
 Benno Döhnert, Dresden? (Bechstein-Flügel)
 Fiedler und Sohn, Dresden? (Pelze)
 Wilhelm Gehrisch, Dresden, allg.
 Arthur Herrnsdorf und Söhne, Dresden, allg.
 Kaaker, Dresden? (Radioapparate)
 E. Krauß, Berlin? (Gemälde)
 Hellmuth Krüger, Berlin? (Porzellan)
 Heinrich Kühl, Dresden (Gemälde, Werke auf Papier)
 Herbert Meier, ?, (Klaviere)
 Dr. Pestel, Berlin? (Fotografien, optische Geräte)

Schiffel, Dresden/Pillnitz?, allg.

Herbert Schmieder, Dresden?, (Möbel)

Hede Schönert, Dresden (Möbel)

Herbert Smy, Dresden (Uhren, Schmuck, Edelmetalle)

Leo Spik, Berlin (Möbel)

Konrad Strauß, Berlin, allg.

Werner, Dresden? (Radioapparate)

Neben institutionellen Erwerbern begegnet eine illustre Reihe von Privatkäufern, die also offenkundig zu jener reduzierten Öffentlichkeit zählten, der die SMAD das Privileg des Zutritts zu den Depoträumen der Schlossbergung im Albertinum, im Residenzschloss und im Johanneum eingeräumt hatte (Auswahl):

Hans Geller, Dresden, ehem. Schlossbergungsbeauftragter

Herbert Gute, Dresden, Ministerialdirektor Volksbildungsministerium

Eugen Hoffmann, Dresden, Bildhauer/ Maler

Erhard Jenckel, Dresden, Kriminalkommissar

Franz Jensch, Dresden, Politiker (CDU)

Erich Karcz, Dresden, Oberkommissar, kurzzeitig Schlossbergungsbeauftragter nach Geller

Joseph Keilberth, Dresden, Dirigent

Karl Kohn, Dresden, Erster Staatsanwalt

Bernhard Kretzschmar, Dresden, Maler, Akademieprofessor

Fritz Löffler, Dresden, Kunsthistoriker

Olga Mattausch, Verwaltungsleiterin der Dresdner Staatlichen Sammlungen

Rudolf Mauersberger, Dresden, Kreuzkantor

Wilhelm Zaisser, Dresden, Innenminister, Chef der LBK

Diese Liste spricht im Kontext der Dresdner Nachkriegsgeschichte für sich selbst und soll hier deshalb nicht näher analysiert werden. Hinzuweisen wäre lediglich auf das Fehlen vieler an der Schlossbergung Beteiligter, die also auf Ankäufe verzichtet hatten; ganz im Gegensatz zum geschassten Schlossbergungsbeauftragten Geller, der fast genau ein Jahr nach seiner Entlassung selbst als Käufer aktiv wurde.[16] Angesichts der Tatsache, dass Geller im Amt vehement die Interessen nicht nur der Sammlungen, sondern, wo möglich, auch der Bodenreformopfer vertreten hatte und Verkäufen offen

und mit hohem persönlichen Risiko entgegengetreten war, ist dies ein irritierendes Verhalten. Es offenbart nicht nur beispielhaft die persönliche Widersprüchlichkeit der damaligen Akteure unter Diktaturbedingungen, sondern auch die changierende Ambivalenz des historischen Vorgangs „Schlossbergung" insgesamt.

Im August 1950 endeten die Verkäufe, nachdem die LBK ihre strategische Ausrichtung im Umgang mit den Objekten der Schlossbergung grundlegend geändert hatte. Auf ihrer Sitzung am 8. September 1950 fällte sie die sich schon länger anbahnende Entscheidung, alle noch in Dresden vorhandenen Werke in das Eigentum der Dresdner Staatlichen Sammlungen zu überführen. Diese Übergabe in mehreren Schritten mit zunehmender juristischer Verbindlichkeit begann Anfang 1950, nachdem es bereits ab 1948 leihweise Überlassungen gegeben hatte.[17] Dies geschah wahrscheinlich nicht nur in Reaktion auf laufende polizeiliche Untersuchungen von Kunstdiebstählen, sondern auch angesichts grundsätzlicher Kritik, die bereits 1947/48 von den Siegermächten Großbritannien und Luxemburg namens des Hauses Wettin artikuliert worden war. Am 29. September 1950 schließlich übereignete der sächsische Innenminister Artur Hofmann als letzter Chef der LBK vor deren Auflösung 1952 das verbliebene Schlossbergungsgut auch formal an die Dresdner Sammlungen.[18] In deren Bestand blieben die Werke – unabhängig von ihrer Qualität auch solche in großer Zahl, die

Artur Hofmann (1907–1987)

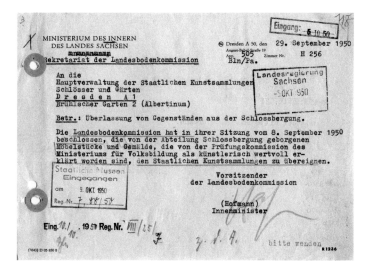

Ministeranweisung zur finalen Übereignung von noch in Dresden vorhandenen Werken aus der Schlossbergung an die Staatlichen Sammlungen, 29. September 1950

von den Sammlungen nie als museumswürdig reklamiert worden waren –, bis sie einige Jahrzehnte später wiederum in den Fokus möglicher Veräußerungen gerieten, diesmal in der Verantwortung der SKD und auf dem westeuropäischen Kunstmarkt zur Devisenbeschaffung 🖉.

Vgl. Beiträge von Jan Scheunemann, S. 201, Margaux Dumas und Xenia Schiemann, S. 213, Christopher Jütte, S. 224, Bernd Isphording, S. 234, sowie Alexander Sachse, S. 245.

Nicht nur von landes- und sammlungshistorischem, also inzwischen akademischem Interesse sind die umfangreichen Dresdner Veräußerungen aus der sächsischen Schlossbergung der Jahre 1946 bis 1950. Sie beinhalten vielmehr auch aktuelle forschungspraktische und juristische Aspekte von erheblicher Relevanz.

Für die Provenienzforschung der SKD ist das Verkaufsbuch und sind die darauf bezogenen Sachakten der sächsischen Ministerien des Innern, für Volksbildung und für Land- und Forstwirtschaft entscheidende historische Quellen, wenn auch ex negativo. Denn all jene Werke, deren Veräußerung dort definitiv nachgewiesen ist, können sich heute nicht mehr in den Dresdner Schlossbergungsbeständen befinden. Relevant sind diese Verkaufsunterlagen aber auch für die Opfer der Bodenreform beziehungsweise deren Erben. Denn die Identität der Objekte ist in den meisten Fällen ohne Weiteres recherchierbar; das Verkaufsbuch nennt in der Regel offen deren Herkunftsorte sowie die Schlossbergungsnummern. So sind die objektgenaue Identifizierung, die Feststellung von Schätz- und Verkaufspreisen sowie die Rückverfolgung bis zu den Enteignungen vor Ort im Herbst 1945 für die meisten der etwa 10.000 verlorenen Objekte möglich, was, wenn auch nicht für physische Restitutionen, so doch für die Gewährung von finanziellen Ausgleichsleistungen 🖉 entscheidend sein kann.

🖉 Gemäß Ausgleichsleistungsgesetz (AusglLeistG)

Thomas Rudert
Thomas Rudert ist wissenschaftlicher Mitarbeiter bei den Staatlichen Kunstsammlungen Dresden.

Endnoten

[1] Für eine wohl weitgehend vollständige Liste des in Sachsen beteiligten Personals vgl. Anne Miksch: Die Sicherung und Nutzung kultureller Werke der ehemaligen Herrensitze des Großgrundbesitzes in Sachsen (Herbst 1945 bis Ende 1949). Ein Beitrag zum Problemkreis des Kulturerbes in der antifaschistisch-demokratischen Umwälzung, Phil. Diss. A, Karl-Marx-Universität Leipzig 1979, Bd. 2, Dok. 14. Vgl. auch Thomas Rudert, Gilbert Lupfer: Die „Schlossbergung" in Sachsen als Teil der Bodenreform 1945/46 und die Staatlichen Kunstsammlungen Dresden, in: Dresdener Kunstblätter 2/2012, S. 114–122, hier S. 122.

[2] Ohne dies hier auch nur in seinen Grundzügen ausführen zu können, sei verwiesen auf Constanze Paffrath: Macht und Eigentum. Die Enteignungen 1945–1949 im Prozeß der deutschen Wiedervereinigung, Köln/Weimar/ Wien 2004, passim, sowie auf Hellmut Seemann: Restitution – nur Last oder auch Lust der Wiedervereinigung? Ein kritischer Erfahrungsbericht aus der Klassik Stiftung Weimar, in: Museumsgut und Eigentumsfragen. Die Nachkriegspraxis und ihre heutige Relevanz in der Rechtspraxis der Museen in den Neuen Bundesländern, im Auftrag der KNK hg. v. Dirk Blübaum, Bernhard Maaz, Katja Schneider, Halle 2012, S. 15–25.

[3] Vgl. Thomas Rudert: Auf Messers Schneide. Vom schwierigen Neuanfang in den Dresdner Staatlichen Sammlungen für Kunst und Wissenschaft nach dem Ende des Zweiten Weltkrieges, in: „So fing man einfach an, ohne viele Worte". Ausstellungswesen und Sammlungspolitik in den ersten Jahren nach dem Zweiten Weltkrieg, hg. von Julia Friedrich, Andreas Prinzing, Köln 2013, S. 186–213.

[4] Vgl. Archiv SKD, 02/VA 46, Bd. 1, fol. 7.

[5] Vgl. Rudert, Lupfer 2012, S. 118.

[6] Vgl. Archiv SKD, 02/VA 46, Bd. 1, fol. 7, Absatz I der Verordnung.

[7] Vgl. ebd., Absatz III der Verordnung.

[8] SächsHStA DD, 11401 LRS, Ministerium für Volksbildung, Nr. 141, unpag.

[9] Vgl. Michael Richter, Mike Schmeitzner: „Einer von beiden muß so bald wie möglich entfernt werden". Der Tod des sächsischen Ministerpräsidenten Rudolf Friedrichs vor dem Hintergrund des Konfliktes mit Innenminister Kurt Fischer 1947, Leipzig 1998, S. 66–99.

[10] Zur Biografie Hans Gellers vgl. SLUB, Mscr.Dresd.App. 2390 (Nachlass Hans Geller), Nr. 22-25 (Tagebücher), Nr. 931-1094 (Schlossbergung und Intendanz); SächsHStADD, 19117 Personalunterlagen sächsischer Behörden, Gerichte und Betriebe ab 1945, Karton Nr. 89: Personalakte Hans Hellmuth Geller.

[11] Vgl. Thomas Rudert: Museale Praxis zwischen Besatzungsmacht und kulturellem Anspruch. Die Eröffnung des Pillnitzer Zentralmuseums des Landes Sachsen am 6. Juli 1946, in: Jahrbuch der Staatlichen Kunstsammlungen Dresden, Bd. 36 (2010), S. 192–203.

[12] Vgl. Gesetz- und Verordnungsblatt Land Sachsen, 4. Jg. 1948, Nr. 2, S. 29.

[13] Vgl. Richter, Schmeitzner 1998, S. 76.

[14] SächsHStA DD, 11377 LRS, MdI Nr. 4250, fol. 146.

[15] Ebd., fol. 143, Nr. 3101 (1. Mai 1949). Die folgenden Hinweise auf einzelne Verkaufsvorgänge entstammen dieser Quelle und sind über die laufenden Nummern zu ermitteln. Auf darüber hinausgehende Einzelnachweise wird aus Platzgründen verzichtet.

[16] Hans Geller erwarb am 8. Februar 1949 sechs teils hochpreisige und kunsthistorisch relevante Möbel: eine Kommode (Reichstädt Nr. 5) für 300 DM/Ost, einen Schrank (Siebeneichen Nr. 56) für 800 DM/Ost, ein Schreibpult (Kreisdepot Görlitz Nr. 9) für 120 DM/Ost, zwei Stühle (Cunewalde Nr. 7, Sornßig Nr. 11) für zusammen 85 DM/Ost sowie einen „Lutherstuhl" (Cunewalde Nr. 8) für 50 DM/Ost.

[17] Vgl. etwa Archiv SKD, 02/VA 46, Bd. 1, fol 57.

[18] Vgl. ebd., fol. 118.

Staatliche Akteure

Übergabe-Übernahme-Protokoll: Kulturgut aus Entziehungskontexten?
Die Einlieferungen staatlicher Institutionen und Organisationen in das Museum für Deutsche Geschichte der DDR

Doris Kachel

Handover and takeover protocol: Cultural property from confiscation contexts? Transfers from state institutions and organizations to the GDR's Museum of German History

Transfers from government bodies, public authorities, organizations and public institutions of the GDR to the country's central history museum, the Museum für Deutsche Geschichte (MfDG) in East Berlin, were the primary focus of a two-year research project. Following its founding in 1952, the museum's collection grew exponentially, particularly in the early phase of its development. The many object movements that took place in the post-war era in the Soviet occupation zone and the GDR, for example through the distribution of items confiscated in the course of the land reform correlate with transfers of art and cultural property to the MfDG by government agencies.

From October 2018 to November 2020, a cooperation between the Deutsches Historisches Museum (German Historical Museum, Berlin) and the German Lost Art Foundation examined the state-controlled transfer of cultural property in the Soviet occupation zone and the GDR in a "Representative study on transfers from state institutions and organizations to the GDR's Museum of German History". Alongside the acquisition practices of the MfDG, the study focused on the networks of players in politics, public authorities and the museum landscape who were responsible for these transfers. The project both categorized the many government agencies involved, such as ministries, district councils, administrative districts, cities and municipalities, the Volkspolizei (People's Police) and mass organizations, and examined objects originating from the various specific confiscation contexts of the Soviet occupation zone and the GDR, such as expropriations from owners of manor houses in the course of the land reform or confiscations of property in connection with defections from the GDR.

In der Datenbank des Deutschen Historischen Museums (DHM) sind mehr als 78.500 Objekte verzeichnet, die als Übergaben und Schenkungen in das Museum für Deutsche Geschichte (MfDG) in Ost-Berlin gelangten.[1] Häufig standen staatliche Institutionen und Organisationen der DDR hinter diesen Einlieferungen,

Überweisungen, Übereignungen oder Übergaben. Die sich daraus ergebenden Fragen über die Herkunft der Objekte bildeten den Schwerpunkt des Grundlagenforschungsprojektes, das von 2018 bis 2020 am DHM in Kooperation mit dem Deutschen Zentrum Kulturgutverluste durchgeführt wurde.[2] 🔗

🔗 Vgl. Projekt-Eintrag in Proveana, PURL https://www.proveana.de/de/link/pro00000023.

Das Projekt widmete sich der Erwerbungspraxis des MfDG, insbesondere in seiner Aufbauphase in den 1950er- und 1960er-Jahren. Zudem wurde versucht, Netzwerke der Akteure und ein System der Objektbewegungen zu entschlüsseln. Ein wesentliches Augenmerk richtete sich auf Übergaben von Objekten, die aus den spezifischen Entziehungskontexten der Sowjetischen Besatzungs-zone (SBZ) und der DDR stammen.

Das MfDG wurde nach einer längeren Planungsphase offiziell im Januar 1952 gegründet und galt als zentrales Geschichtsmuse-um der DDR. Es verfügte zunächst hauptsächlich über die Samm-lung des Berliner Zeughauses, die fast ausschließlich aus Militaria bestand. Das Museum war als wissenschaftliche Institution dem Staatssekretariat für Hochschulwesen, ab 1967 dem Ministerium für Hoch- und Fachschulwesen unterstellt und im Sinne der mar-xistisch-leninistischen Geschichtsschreibung ausgerichtet. Somit übte die SED einen starken Einfluss aus. Im Zuge der Wiederver-einigung wurden die Sammlungen des MfDG dem Deutschen His-torischen Museum übertragen.

In der Aufbauphase des Museums für Deutsche Geschichte wurden große Anstrengungen unternommen, um schnell eine um-

Das Museum für Deutsche Geschichte im ehemaligen Zeughaus nach der Frontsanierung im Jahr 1961

fangreiche Anzahl von Exponaten zu beschaffen. Infolge des Zweiten Weltkrieges war es zudem zu zahlreichen Translokationen von Kunst- und Kulturgut in der SBZ und der DDR gekommen, unter anderem durch Verlagerungen und Rückführungen von Museumsgut, die Verteilung von Bodenreformbeständen und „herrenlosem Gut" sowie die Zurücklassung von Objekten sogenannter Republikflüchtiger ✐.

✐ Vgl. Beiträge von Antje Strahl und Reno Stutz, S. 103, Regine Dehnel und Michaela Scheibe, S. 112, sowie Cora Chall, S. 123.

Für das Projekt relevante Institutionen und Organisationen

Unter den staatlichen Einlieferern in das MfDG konnten das Ministerium der Finanzen, Abteilung Tresorverwaltung, und das Ministerium für Staatssicherheit ermittelt werden. Bei den Räten der Gemeinden, Städte, Kreise und Bezirke sind beispielsweise der Magistrat von Groß-Berlin, die Räte der Gemeinden Hohen Neuendorf und Kleinmachnow und der Rat des Kreises Bad Salzungen zu nennen. Des Weiteren sind die Untergliederungen der Volkspolizei, der SED, wie das Zentralkomitee (ZK) oder das Politbüro, die Generalstaatsanwaltschaft Groß-Berlin und die Zollverwaltung der DDR hervorzuheben.

Wiederholt kamen auch öffentliche Einrichtungen als Einlieferer vor, die nach 1945 in umgenutzten Schlössern und Herrenhäusern untergebracht worden waren, darunter eine Heilstätte

Eine Auswahl der staatlichen Stellen als Einlieferer von Objekten an das MfDG

in Langenstein (Harz) oder auch die Zentralschule in Marxwalde (heute Neuhardenberg)[3]. Zu den überweisenden Massenorganisationen der DDR gehörten der Freie Deutsche Gewerkschaftsbund und der Kulturbund der DDR. Überdies sind zahlreiche Museen als Einsender zu nennen, wie das Märkische Museum, die Staatliche Galerie Moritzburg in Halle oder das Kulturhistorische Museum in Stralsund.

Diesen Einlieferungen und ihren vielfältigen Hintergründen galt es, so umfassend wie möglich nachzugehen. Die Annäherung an die Provenienzen erfolgte von zwei Seiten: zum einen über die Prüfung der Einlieferer in den Inventarbüchern und der Museumsdatenbank und andererseits über Hinweise aus der MfDG-Überlieferung im DHM-Hausarchiv. Insgesamt wurden im Projektzeitraum rund 590 Akten in 16 Archiven gesichtet, etwa 200 im DHM-Hausarchiv.

Diverse Institutionen und Organisationen sollten den Aufbau des Museums unterstützen. Auf einer Tagung des Wissenschaftlichen Rates des MfDG am 1. März 1952 wurde eine entsprechende Anregung des Mitgliedes Hermann Weidhaas protokolliert: „Wir müssen für unsere Arbeit die ländlichen Bürgermeister usw. mobilisieren. Sie wissen, wo sich wertvolle Originale (Möbel, Bilder usw.) befinden. Auf diese Weise könnte man solche wertvollen Stücke dem Museum zuführen."[4] Fred Oelßner, ab 1950 Mitglied des Politbüros des ZK der SED, betonte auf derselben Sitzung: „Werden auch zuerst noch in großem Maße Schrift und Bücher herangezogen werden müssen, so sollte man sich doch bemühen, soweit es möglich ist, Originale zu beschaffen. [...] Es liegen viele wertvolle Stücke in den Landes- und Heimatmuseen, in den Archiven und Bibliotheken verstreut. Hier sollte ein Austausch vorgenommen werden. Z. B. fand sich eine Sammlung der Reichsabschiede aus dem 18. Jahrhundert in einer Unterhaltungsbibliothek eines Erholungsheimes."[5]

Im Dezember 1953 wurde in einem Arbeitsplan die „Sicherstellung" von Bodenreformbeständen zu einer wichtigen Aufgabe der Abteilung Sammlung des MfDG erklärt. Darin heißt es: „Entsprechend der Anregung von Prof. Dr. Weidhaas betrachten wir es als unsere Aufgabe, Kunstwerte aus der Bodenreform sicherzustellen. Um die Erfüllung dieser Aufgaben zu gewährleisten, werden freie Mitarbeiter in der Abteilung zunächst in einem Bezirk

der DDR (wahrscheinlich Halle) die noch vorhandenen Bestände erfassen. [...] Diese Arbeiten sind nur in enger Zusammenarbeit mit dem Staatssekretariat für Hochschulwesen, dem Kulturbund und den Heimatmuseen zu erledigen."[6]

Während der 1950er- und 60er-Jahre wurden laut Berichten im DHM-Hausarchiv in der gesamten DDR Erwerbungsdienstreisen unternommen. Auffallend oft wurden die südwestlichen, grenznahen und ländlichen Regionen aufgesucht, um eventuell noch unentdecktes Gut ausfindig zu machen. Bemerkenswert ist zudem die entscheidende Rolle von Vermittler:innen einzelner Objekte und Hinweisgeber:innen vor Ort. In manchen Fällen erhielt das MfDG die Informationen zu Bodenreformbeständen auch aus dem Kulturministerium, von Museen oder dem ZK der SED. Um Bestände zu ermitteln, war die Kontaktaufnahme zu den Räten der Gemeinden oder Kreise essenziell. Im Ergebnis der Dienstreisen wurde um 1955 eine sogenannte Hinweiskartei zur systematischen Beschaffung von Objekten im MfDG etabliert.[7] Vermutlich wurden Angaben zu Objekten und Informationsquellen in bestimmten Orten, Einrichtungen oder Organisationen notiert, vorwiegend auf Grundlage von Dienstreiseberichten. Leider war die Hinweiskartei bisher nicht aufzufinden.

Im Zuge der Recherchen konnten verschiedene staatliche Institutionen, Organisationen, Amtsträger:innen und Einzelpersonen, die an der Verteilung von Bodenreformbeständen mitgewirkt hatten, ausgemacht werden:

1. Räte von Gemeinden, Städten, Kreisen und Bezirken: Bürgermeister:innen wussten über den Verbleib von Objekten Bescheid, auch durch die Verzeichnisse des nicht landwirtschaftlichen Inventars von Schlössern und Herrenhäusern.

2. Museen: Beispielsweise waren Heimatmuseen den Räten unterstellt, und manche erhielten selbst Objekte aus der Bodenreform, die sie dann weiterverteilten. Das MfDG spielte in der Museumslandschaft der 1950er- und 60er-Jahre eine herausragende Rolle, und so kam es zu zahlreichen Ablieferungen an das zentrale Geschichtsmuseum, im Gegenzug unterstützte das MfDG kleinere Häuser beim Aufbau von Sammlungen oder bei Ausstellungen.

3. Sammelstellen und Depots: Ein erwähnenswerter Anteil der Einlieferungen kam über die Staatliche Galerie Moritzburg in Halle,

in der sich das Hauptdepot für Kunst- und Kulturgüter befand, welche im Zuge der Bodenreform in der Provinz Sachsen, dem späteren Sachsen-Anhalt, enteignet worden waren.[8]

4. Ministerien der DDR: Die Abteilung Tresorverwaltung beispielsweise, die 1953 im Ministerium der Finanzen der DDR gebildet worden war, überwies eingezogene Kunst- und Kulturgüter an Museen und veräußerte zudem viele der in Schloss Moritzburg bei Dresden und Umgebung beschlagnahmten Kulturgüter an öffentliche Sammlungen.[9]

5. Öffentliche Einrichtungen: Schlösser und Herrenhäuser wurden in erster Linie sozialen Zwecken dienstbar gemacht und zu Ferienheimen, Heilstätten, Schulen und Kinderheimen. Oftmals verblieben nach 1945 noch Kunst- und Kulturgüter sowie Gutsbeziehungsweise Herrschaftsarchive vor Ort und wurden vielfach an Museen, Bibliotheken und Archive überwiesen.

6. Kulturbund der DDR: Die Mitglieder waren vor Ort gut vernetzt. Kontaktaufnahmen mit den jeweiligen Ortsgruppen des Kulturbundes oder Lehrer:innen, häufig Mitglieder des Kulturbundes, waren für den Objekterwerb hilfreich. So erfolgten teilweise erste Vorarbeiten zum Beispiel in Form von Umfragen nach museumswürdigen Objekten in den Gemeinden. Das MfDG arbeitete oftmals mit dem Rat der Gemeinde oder des Kreises und dem Kulturbund zusammen.

Meist waren mehrere staatliche Stellen an einer Übergabe beteiligt. In vielen Fällen zeigte sich, wie umfassend lokale und regionale Behörden, Institutionen und Massenorganisationen zusammenarbeiteten und mitwirkten, um museale Objekte an das Leitmuseum in Berlin zu übergeben. Den Räten, vor allem den Finanzabteilungen, fiel auch die Verwaltung des staatlichen Eigentums zu. Darunter fallen Rückläufe von „Republikflüchtigen", eingezogene Gegenstände aus Strafverfahren sowie erbenlose Nachlässe. In die Übergabevorgänge solcher Objekte war oftmals auch die Volkspolizei involviert.

Drei exemplarische Vorgänge vermitteln einen Eindruck, wie vielfältig die Erwerbungshintergründe der staatlichen Einlieferungen waren:

Fallbeispiel 1: Rat des Kreises Belzig

Das MfDG erhielt Anfang 1954 einen Hinweis aus dem Ministerium für Kultur, dass sich im Belziger Museum und in Privathand Stilmöbel aus Bodenreformbeständen befinden sollten. Das Schreiben kam von Lieselotte Kramer-Kaske, die ab 1954 für die Hauptabteilung Kulturelle Massenarbeit im Ministerium für Kultur tätig war.[10] Nachdem sich das MfDG mit dem Rat des Kreises Belzig, bei dem Objekte der Bodenreform erfasst waren, und dem Belziger Museum verständigt hatte, übersandte die Leiterin der Kulturabteilung des Rates am 20. August 1954 ein Verzeichnis mit Immobilien, deren Inventar für das MfDG interessant sein konnte, darunter das Spezialkinderheim im Brandenburger Mahlsdorf und die Oberschule in Wiesenburg.[11] Im Juni 1955 besichtigte ein MfDG-Mitarbeiter die alten Möbelbestände des Kinderheimes und fand unter anderem einen Schreibschrank,[12] der für das Museum geeignet schien. Als Ersatz sollte ein „moderner" Schrank dienen, der vom Heim gekauft wurde und dessen Rechnung das MfDG beglich. Auch in Wiesenburg wurde ein Möbelstück ausgewählt.[13]

Beide Einrichtungen befanden sich in Immobilien, die von der Bodenreform betroffen waren. Es liegt somit nahe, dass die Objekte aus diesem Kontext stammen. Die MfDG-Inventarbucheinträge lassen keine Rückschlüsse auf Objekte aus einem Schloss und einem Gutshaus zu.

Fallbeispiel 2: Magistrat von Groß-Berlin

In den Akten des DHM-Hausarchivs lassen sich Übergaben durch den Magistrat von Groß-Berlin, vornehmlich vom Hauptamt Kunst, in den 1950er-Jahren nachweisen. In einem Übergabeverzeichnis wird als Herkunftsort von Gegenständen das Ermelerhaus in Berlin angegeben. Dort befand sich ein Depot des Magistrats, unter anderem mit „herrenlosem Bergungsgut" und beschlagnahmten Objekten von staatlichen Grundstücken und Gebäuden in Berlin und aus Brandenburg sowie Beständen des Märkischen Museums und Werken aus Hermann Görings ehemaligem Landsitz Carinhall in der Schorfheide.[14] Als Korrespondenzpartner beim Magistrat trat ein Herr „Wittich" auf. Heinrich Wittig war zunächst als Mitarbeiter der Abteilung Volksbildung, Referat Rückführung von Museumsgütern, bei Kurt Reutti tätig, der sich in der Nachkriegszeit für die Sicherung

*MfDG-Karteikarte der Empire-
Kommode, die 1952 dem MfDG
vom Magistrat von Groß-Berlin
übergeben wurde*

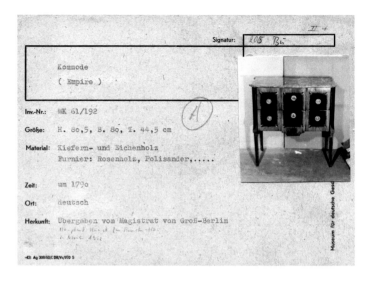

*Brandstempel auf der Rückwand
der Empire-Kommode aus dem
Ermelerhaus*

*Provenienzmerkmal in einer Schub-
lade der Kommode*

von Kunst und Kulturgütern eingesetzt und beim Magistrat von
Groß-Berlin die „Zentralstelle zur Erfassung und Pflege von Kunst-
werken" gegründet hatte. Später war Wittig als Sachbearbeiter im
Referat Bildende Kunst mit der Verwaltung von Kunstwerken be-
auftragt, die im Ermelerhaus verwahrt wurden.[15] Im Sommer 1952
erstellte er eine Inventarliste über die in der Bergungsstelle des
Ermelerhauses noch verbliebenen Objekte, um am 24. September
Kurt Schifner von der Staatlichen Kommission für Kunstangelegen-
heiten zu melden, dass er inzwischen eine Verteilung von Objekten
unter anderem an das Märkische Museum, das Kunstgewerbemu-
seum und das Museum für Deutsche Geschichte vorgenommen ha-
be.[16] Die Museen konnten die Objekte selbst auswählen.[17]

Exemplarisch sei hier auf eine Kommode verwiesen, die zwar
erst 1961 inventarisiert wurde, aber im November 1952 überge-
ben worden war.[18] Bei der Sichtung wurden drei relevante Pro-
venienzmerkmale entdeckt: ein Brandstempel „R.M.f.V.u.P." – das
Reichsministerium für Volksaufklärung und Propaganda –, die Auf-
schrift „Wittich" und in den Schubladen jeweils eine handschriftlich
notierte „69", die Listennummer im Inventar des Ermelerhauses.[19]
Naheliegend ist, dass die Kommode zur Ausstattung des Ministeri-
ums gehörte und im Zuge der Bergungsmaßnahmen in öffentlichen
Gebäuden abgeholt wurde.

Eine Weiterverfolgung der vom Magistrat übergebenen Ob-
jekte ist zwingend notwendig, da es sich hier um NS-verfolgungs-

bedingte Entzüge handeln könnte, etwa im Zusammenhang mit den Beschlagnahmungen von Einrichtungsgegenständen der „M-Aktion" in den besetzten Gebieten oder der „Aktion 3".

Fallbeispiel 3: Kulturhistorisches Museum Stralsund

Im Jahr 1959 verhandelten das Kulturhistorische Museum Stralsund und das MfDG einen Tausch musealer Objekte, darunter ein Renaissance-Fassadenschrank. Zwei Waffen des MfDG, die aus der Sowjetunion zurückgeführt worden waren, bildeten 1961 die Gegengabe.[20] Die wechselseitige Unterstützung führte dazu, dass sich die Direktorin des Stralsunder Museums noch im Herbst des Jahres erneut an das MfDG wandte, um unter anderem auf ein ehemaliges Herrenhaus in Altenhagen hinzuweisen. Dort befänden sich mehrere alte Möbel, die aufgrund des bereits „reichlichen Möbelvorrates" eher dem MfDG zusagen könnten. Bei Interesse solle es sich beim Rat der Gemeinde Altenhagen melden.[21] Von den im Tauschverfahren übernommenen Möbelstücken wurden 1998 und 2006 zwei Schränke nach § 5 (Rückgabe beweglicher Sachen) des Ausgleichsleistungsgesetzes zurückgegeben. Sie waren im Rahmen der Bodenreform in Mecklenburg-Vorpommern enteignet worden.

Die umfangreiche Studie präsentiert noch viele weitere Fälle und soll auch als Grundlage für die Provenienzforschung an anderen Museen auf dem Gebiet der ehemaligen DDR dienen.[22] 🔗

https://www.arbeitskreis-provenienzforschung.org/arbeitsgruppe-sbz-ddr/

Doris Kachel
Doris Kachel ist seit 2013 als Provenienzforscherin tätig, inzwischen als wissenschaftliche Mitarbeiterin für Provenienzforschung an der Akademie der Künste in Berlin.

Der Text geht auf einen Vortrag der Herbstkonferenz am 30. November 2020 zurück, der von der Autorin für diesen Band angepasst wurde.

Förderung des Grundlagenprojekts „Repräsentative Studie zu den Übergaben staatlicher Institutionen und Organisationen an das Museum für Deutsche Geschichte der DDR" von Oktober 2018 bis November 2020.

Endnoten

[1] Die Retrodigitalisierung sämtlicher Objekte des Bestandes ist noch nicht abgeschlossen und wird fortlaufend weitergeführt.

[2] Das erste Projektjahr wurde von Christopher Jütte, das zweite von der Autorin des Beitrages bestritten.

[3] Zu diesem Übergabefall wurde ein Provenienzdossier erstellt, da hier durch die Autorin ein Doppelentzug nachgewiesen werden konnte.

[4] DHM-HArch, MfDG/41, Bl. 28.

[5] Ebd., Bl. 26 f.

[6] DHM-HArch, MfDG/433, Bl. 174.

[7] Vgl. DHM-HArch, MfDG/418, Bl. 307 f. und 385 sowie MfDG/Rot/vorl. 029.

[8] Siehe hierzu die Untersuchungen von Jan Scheunemann. Vgl. u. a.: Die Moritzburg in Halle (Saale) als Zentrallager für enteignetes Kunst- und Kulturgut aus der Bodenreform, in: Deutsches Zentrum Kulturgutverluste: Provenienz & Forschung Heft 1/2019, 2019, S. 26–33.

[9] Vgl. Projektabschlussbericht, Kapitel 3.1.1 a) in der Forschungsdatenbank Proveana unter https://www.proveana.de/de/link/pro00000023.

[10] Vgl. DHM-HArch, MfDG/Rot/vorl. 029.

[11] Vgl. DHM-HArch, MfDG/595.

[12] Der Schrank (Inv.-Nr. K 56/139) wurde laut Museumsdatenbank 1996 aus der DHM-Sammlung ausgesondert und in ein Auktionshaus eingeliefert.

[13] Dieser Abschnitt basiert auf: DHM-HArch, MfDG/Abt. Slg.-Fundus/vorl. 6.1 und MfDG/Rot/vorl. 027, Bl. 298 f.

[14] Vgl. BArch DR 1/5825.

[15] Vgl. GStA PK, NL Kurt Reutti, Nr. 7, Bildnr. 64 und LAB, C Rep. 120, Nr. 1240.

[16] Vgl. BArch DR 1/5825.

[17] Vgl. LAB C Rep. 120, Nr. 3086.

[18] Vgl. DHM-HArch, MfDG/Rot/vorl. 001.

[19] Vgl. BArch DR 1/5825.

[20] Vgl. DHM-HArch, MfDG/Rot/vorl. 54.

[21] Vgl. DHM-HArch, MfDG/Abt. Slg.-Fundus/vorl. 250.

[22] Erfreulicherweise konnte zudem für den weiteren Austausch im Bereich der SBZ/DDR-Provenienzforschung im zweiten Projektjahr auf Initiative von Christopher Jütte, Carolin Faude-Nagel und Doris Kachel, mit Unterstützung von Mathias Deinert, eine AG SBZ/DDR im Arbeitskreis Provenienzforschung e. V. etabliert werden.

Die Tresorverwaltung des Ministeriums der Finanzen der DDR zwischen 1949 und 1959

Ronny Licht

The vault administration of the Ministry of Finance of the GDR between 1949 and 1959

The vault administration division of the East German Ministry of Finance (MdF) was the central disposal agency for art and cultural property as well as valuables seized after 1949.

The necessary research into its role in the state-organized transfer of art and cultural property as well as valuables within and especially out of the GDR is still in its early stages. Although the MdF was not the confiscating authority, it did act as an impetus for the executive branch to carry out seizures on site. It passed laws and guidelines for the development of seizure sources, the subsequent release procedures and the again subsequent cultural-political and mercantile utilization. This was done in close coordination with the cultural authorities at various levels, namely the State Commission for Art Affairs (StaKuKo) and, from 1954, the Ministry of Culture (MfK).

In the following essay, the structure, tasks, and objectives of the vault administration as a department and organizational unit of the MdF during the 1950s will be discussed in more detail for the first time.

Von Beginn der Staatsgründung an gingen die Finanz- und die Kulturpolitik der DDR immer wieder unrühmliche Allianzen ein. Dass Kunst- und Kulturgut systematisch aus dem Verkehr gezogen und ins westliche Ausland verkauft wurde, geschah unter maßgeblicher Beteiligung des Ministeriums der Finanzen der DDR (MdF), genauer der Abteilung Tresorverwaltung.

Zwar verfolgte die SED bereits seit ihrer Gründung 1946 den Anspruch, die Kultur auf den politischen Kurs zu bringen und auch in den Museen und Ausstellungshäusern ein Geschichtsbild zu etablieren, das als Legitimation für die marxistisch-leninistische Ausrichtung der Partei und des späteren SED-Staates dienen konnte.[1] Doch bildeten sich bereits wenige Monate nach dem Entstehen der Staatlichen Kommission für Kunst und Kultur (StaKuKo)[2] im Jahr 1951 Schnittstellen in der Zusammenarbeit mit der staatlichen Finanzbehörde, die dieser Maxime widersprachen.

So kam es etwa im Februar 1951 zu gemeinsamen Überprüfungen des Inventars der Staatlichen Museen zu Berlin, um „die

Das Kurzwort StaKuKo oder Stakuko geht zurück auf die Namenskurzform „Staatliche Kunstkommission".

Vgl. Beiträge von Thomas Widera, S. 171, sowie von Uwe Hartmann, S. 181.

Substanz durch einzelne Stichproben sowie durch systemische Sichtung ganzer Komplexe auf ihre Vollständigkeit hin [zu prüfen]".[3]

Im darauffolgenden Herbst fand erstmals eine Zusammenarbeit mit dem MdF zum Zwecke der Begutachtung von Tresorinhalten durch Sachverständige statt. Das MdF tritt in kleineren staatlich organisierten Entzugsvorgängen in den archivalischen Quellen schon früher in Erscheinung: durch Übergabelisten von beschlagnahmender Polizei und weiteren Behörden sowie in Übergaben des MdF an Museen.

Die Abteilung Tresorverwaltung

Die Tresorverwaltung war die zentrale Verwertungsstelle für alle nach 1949 eingezogenen respektive gepfändeten Wertgegenstände und „Kostbarkeiten".[4] Nach Auflösung der im September 1947 gegründeten Bankenkommission Ende des Jahres 1950 übergab

Organigramm der Tresorverwaltung 1953, nach: BArch DN 1/2191, Stellenplan für die Tresorverwaltung vom 3. Juli 1953

man die Verwaltung der Tresore sowie deren Inhalt an die Deutsche Notenbank und damit an das MdF.[5] Als selbstständige Abteilung wurde die Tresorverwaltung 1953 eingerichtet.[6] Eine eigens hierfür gebildete Stellenplankommission war schon 1952 zusammengetreten und im März 1953 wurden insgesamt 17 Stellen genehmigt.[7]

Die besonderen und vielseitigen Aufgaben der Abteilung Tresorverwaltung bedurften einer streng vertraulichen Behandlung. Auf Weisung des Zentralkomitees der SED sollte nur ein möglichst kleiner Personenkreis davon Kenntnis erhalten. Bereits im Juli 1953 übernahm die Tresorverwaltung die Verwertung von Edelmetallwaren und Kostbarkeiten wie Teppichen, Briefmarkensammlungen und dergleichen.[8]

Es ist davon auszugehen, dass „Eysoldt" der erste Leiter der Tresorverwaltung war.[9] Ab dem Jahr 1957 ist der Name „Harder" in Verbindung mit der leitenden Position dokumentiert, zwei Jahre später findet sich der Name „Wilhelm Meier" in den Unterlagen.[10]

Als einer der Hauptreferent:innen tritt zwischen 1953 und 1956 besonders der Name „Wilhelm Tümmel"[11] in Erscheinung, wohl ein MdF-Mitarbeiter, der zuvor in den Hauptabteilungen Valuta und Kreditwesen beschäftigt war. Um das Jahr 1956 taucht in den Archivalien neben Tümmel der Name „Jochmann" als Hauptreferent der zweiten AG Wertpapiere auf.[12] Für die Kontrolle der Arbeitsgruppen, welche für die Objektgattungen Bücher, Noten, Protokolle und Briefmarken zuständig waren, wurde die Stelle eines Referenten geschaffen, der dem Oberreferenten der Arbeitsgruppen für die Objektgattungen Bilder, Plastiken sowie sonstige Kunstwerke und Edelmetalle untergeordnet war. Um die technische Leitung von Räumungsmaßnahmen in den Tresorräumen⊘ hatte sich ein weiterer Referent zu kümmern.

⊘ *Sicherung und Räumung der Tresore früherer NS-Reichsdienststellen*

Vermutlich blieb die Struktur der Tresorverwaltung als Abteilung zwischen den Jahren 1953 und 1955 relativ konstant. Mit dem Aufstieg Willy Rumpfs zum Finanzminister der DDR (1955–1966) kam es zu einer erneuten Umstrukturierung im MdF und zu Neubesetzungen verschiedener Posten. Im Zuge der Neuausrichtung wurde die Tresorverwaltung in die Hauptabteilung Valuta integriert, deren Leitung 1952 und 1953 mit dem Namen „Hentschel" in Verbindung steht.[13] Erst für das Jahr 1959 ist ein detaillierter Stellenplan für die nunmehr als Sektor bezeichnete HA⊘ Valuta

⊘ *Abkürzung für „Hauptabteilung"*

D. m Buchhaltung

Sektor Tresorverwaltung Berlin, den 19.12.1959

Stellenplan des Sektors Tresorverwaltung

	Name	Planstelle Soll	Ist
1. Sektorenleiter	Maier, Wilhelm	E 7	E 7
2. Sekretärin	Hollstein, Hildegard	V	V
3. Hauptreferent und Stellvertreter des Sektorenleiters	Tümmel, Wilhelm	E 1o	E 1o
4. Oberreferent	Tertel, Erna	I	I
5. Referent	Rohde, Elli	II	II
6. Oberreferent	Zaumseil, Fritz	I	I
7. Referent	Stehr, Walter	II	II
8. Oberreferent	Hinz, Ursula	I	I
9. Sachbearbeiter	Pilgrimm, Gerhard	V	V
1o. Sachbearbeiter	Schumann, Erich	IV	IV
11. Sachbearbeiter	Barth, Walter	IV	IV
12. Kraftfahrer	Noack, Richard	K 2	K 2
13. Heizer	Dibbern, Karl	VI	VI
14. Putzfrau (Halbtagskraft)	Feske, Liesbeth	XII	XII

greifbar.[14] Hieraus ergeht eine vollständige Neubesetzung der auf mittlerweile 14 Positionen reduzierten Abteilung. Nur Tümmel blieb Hauptreferent und war nun Stellvertreter des Sektorenleiters Wilhelm Meier.

Aus der engen Verstrickung der Tresorverwaltung in die Veräußerung von Kostbarkeiten jeglicher Art und der Zuständigkeit für Beschaffung von Devisen lässt sich die Eingliederung in die Hauptabteilung Valuta als logischen Schritt erklären – deren Kernaufgaben waren ebenfalls die Beschaffung, Bewirtschaftung und Verwaltung von Devisen und die Einflussnahme auf den Außenhandel.[15]

Anzahl, Inhalt und Standorte der Tresore

Eine verlässliche Aussage zur Anzahl der durch das MdF verwalteten Tresore lässt sich bisher nicht treffen. Vermutlich verfügte es Anfang der 1950er-Jahre über 44 Tresore und Tresorräume.[16] Im Laufe des Jahrzehnts wurden die restlichen Tresore aus ehemaligen Banken in das MdF-Gebäude verlagert. Vermutlich mit Beginn des Jahres 1953 fand eine größer angelegte Inventur der Tresore im Ministerium in der Unterwasserstraße 5–10 in Berlin-Mitte statt.[17] Diese erfasste Informationen zu den Bezeichnungen der verschiedenen Tresore, den darin enthaltenen Safe-Kästen, Schränken und Kisten, aber auch zu Anzahl und Art der Inhalte sowie vermutlichen Hinterlegern. Insgesamt wurden 21 Tresore, eine Goldkammer sowie ein Kellerdepot inspiziert[18] und folgende Inhalte dokumentiert: Archivalien und Autografen, Briefe und Briefmarken, Bücher, Edelmetall, Fotos, Fotoapparate und Zubehör, Kunst, Kunstgewerbe und Gebrauchsgegenstände im weiteren Sinne, Naturalien, Münzen, Notenblätter, optische Geräte, Schmuck, Textilien, Urkunden, Werkzeuge und Zeicheninstrumente.

Für die Jahre 1956 bis 1959 ist anhand von Kurzbilanzen eine Aufteilung des Guts nach Objektgattungen nachzuverfolgen: Der „K-Tresor" umfasste ausschließlich Schmuck, der „G-Tresor" nur Briefmarken. Unter „C-Tresor" waren „Glas und Porzellan", „Optik", „Bilder", „Teppiche", „Münzen", „Kunsthandel" und „Diverse" gelistet.[19]

Auf einer 1951 verfassten Aufstellung über ca. 4.500 Positionen sind als Hinterleger:innen lediglich rund 200 Personen, Firmen, Vereine und Körperschaften namentlich erwähnt, darunter einige, die auf einen jüdischen Hintergrund verweisen oder diesen vermuten lassen.[20] Es besteht der Verdacht, dass manche der gelagerten Stücke NS-verfolgungsbedingt entzogenes Kulturgut waren. So erscheint der Name Bokofzer in einer entsprechenden Namensliste der Zentral- und Landesbibliothek Berlin (ZLB). Käthe Bokofzer könnte in einer familiären Verbindung zu Erwin Bokofzer gestanden haben, der in einem 1934 erschienenen Verzeichnis „nicht arischer" Rechtsanwälte in Deutschland aufgeführt ist.[21]

Gesetzliche Grundlagen und Quellen für den Erwerb

War das MdF auch nicht die beschlagnahmende Behörde, so gab es doch wichtige Impulse für die Entzugsvorgänge und erließ präzise Verordnungen über den Umgang der eingezogenen Objekte. Hauptquellen, aus denen die eingelagerten Wertgegenstände stammten, waren neben den Inhalten der Depots und Safes geschlossener Banken, Sparkassen[22] und insbesondere der Deutschen Notenbank vor allem „herrenlose" Nachlässe und Besitz aus Beschlagnahmen. Obwohl offiziell in der Rechtsauffassung des Marxismus-Leninismus die Zwangsvollstreckung eher ambivalent betrachtet worden war, fanden auch in der DDR Entzugsvorgänge aufgrund von Steuerschulden[23] und Strafurteilen sowie Pfändungen wegen Steuerschulden statt.[24] Nachdem festgestellt worden war, dass gepfändete Edelmetallgegenstände – sogenannte Kostbarkeiten – und sonstige Wertgegenstände auf Versteigerungen und Verkäufen „aus freier Hand" von „Wiederverkäufer[n] und Privatpersonen" erworben worden waren, die zur Übernahme laut DDR-Gesetzgebung nicht befugt waren, erließ die Justizministerin Hilde Benjamin (1902–1989) 1954 persönlich die Anordnung, dass in der DDR wegen Steuerrückständen gepfändete „Kostbarkeiten" von den Gerichtsvollzieher:innen nach Ablauf einer Frist von drei Wochen dem MdF zugesandt werden mussten. Damit konnten diese ausschließlich durch das Ministerium in Berlin verwertet werden.[25]

Nachlässe und die zurückgelassenen Gegenstände von „Republikflüchtlingen" stellten eine weitere wesentliche „Einnahmequelle" für das MdF respektive den Staatshaushalt dar. Die Rücklässe von „Republikflüchtigen" waren der Anlass für eine erste normative Grundlage der DDR. ⊘ Die Verordnung zur Sicherung von Vermögenswerten wurde am 17. Juli 1952 erlassen.[26] Überdies dienten auch Anzeigen und Strafurteile als Rechtfertigung für den Entzug und die zeitnahe Einlieferung des beschlagnahmten Gutes in das Ministerium der Finanzen.

⊘ *Vgl. Beitrag von Antje Strahl und Reno Stutz, S. 103.*

Zugang von Kunst- und Wertgegenständen

Als gesetzliche Legitimation für die Annahme und Behandlung eingezogener Gegenstände und Waren kann der im Gesetzblatt Nummer 118 festgehaltene Beschluss vom 21. August 1952 über die Ordnung der Materialversorgung angenommen werden.[27] Auf diesem Gesetzblatt basierte eine vom MdF ausgegebene Rundverfügung vom 12. Oktober 1953.[28] Demnach konnte alles beschlagnahmt werden, was den Mitarbeiter:innen staatlicher Organe vor Ort als wertvoll genug erschien. Berechtigt zur Beschlagnahme waren Mitarbeiter:innen der Justiz, der Hauptverwaltung der Deutschen Volkspolizei, der Abteilung Staatliches Eigentum des Ministeriums des Innern, der Organe der Staatssicherheit, des Amtes für Zoll und Kontrolle des Warenverkehrs, der Deutschen Notenbank sowie der Räte der Bezirke, Kreise und Gemeinden.[29] Neben Gerichtsvollzieher:innen[30] und Nachlasspfleger:innen waren zudem Fundbüros, Pfandleihen⌘ und andere Dienststellen beziehungsweise Personen für Sicherstellungsvorgänge im weitesten Sinne berechtigt.[31]

⌘ *Vgl. Beitrag von Heike Schroll, S. 69.*

 Das Spektrum der als wertvoll beurteilten Gegenstände reichte von Produktionsmitteln wie Maschinen, Metallen, Schnittholz oder Rohstoffen über Nahrungs- und Genussmittel und andere Waren des sogenannten Bevölkerungsbedarfs bis hin zu landwirtschaftlichen Erzeugnissen, Saat- und Pflanzgut sowie gebrauchten Konsumtionsmitteln.[32] Selbst für eingezogene Medikamente und „Schrott aller Art", wie es unter § 2 (2) heißt, fand sich in den Niederlassungen der darauf spezialisierten volkseigenen Handelszentralen Verwendung. Bücher, Noten und archivwürdige Objekte waren der Abteilung Volksbildung des jeweiligen Kreisrats für die weitere Verwendung zu übergeben. Die anschließende Herausgabe von Gegenständen geschah entweder zur Überarbeitung oder zum Verkauf und erfolgte per Übergabe-Übernahme-Protokoll, welches im Wertausgangsbuch und in der Lager- und Debitorenbuchhaltung erfasst wurde.[33]

 In der Regel enthalten die Übergabelisten an das MdF auch eine Spalte für den Taxwert. Im Zuge einer groß angelegten Aktion gegen früheren beweglichen Besitz des Hauses Wettin und dessen Umfeld zum Zwecke des Zugriffs auf die Kunst- und Wertgegenstände zwischen 1949 und 1951 wurden bei einem Pfarrer Objek-

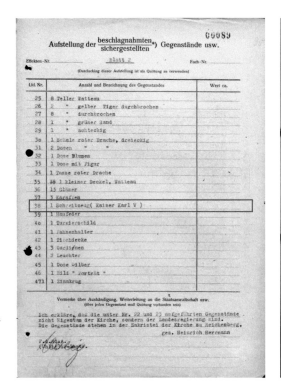

Protokoll der Beschlagnahme im Zuge der Ermittlungen gegen das vormals regierende Haus Wettin bei Pfarrer Heinrich Herrmann in Reichenberg bei Dresden, 4. April 1950. Unter Position 38 ist das Kaiser Karl V. zugeschriebene Schreibzeug gelistet. HStAD 11378-961, S. 88–90

Auszug der Aufstellung der zu übergebenden Kunstgegenstände aus Moritzburg durch die Volkspolizei an das MdF vom 25. April 1950, BArch DN 1/34014

te im Wert von mehreren Millionen Mark beschlagnahmt.[34] Auf der Übergabeliste sind drei Objekte vermerkt, deren Wert zum Zeitpunkt der Einlieferung aufgrund der Einzigartigkeit nicht beziffert werden konnte. Das kaiserliche Schreibzeug befindet sich heute in der Sammlung des Berliner Kunstgewerbemuseums. Über den Verbleib des Altars und des Madonnenbildes ist nichts bekannt.

Binnenmarkt und Außenhandel

Die Verwertung über den Export gegen „harte Devisen oder Westmark" organisierten der Deutsche Innen- und Außenhandel (DIA), der Deutsche Buch-Export und -Import und andere Außenhandelsorganisationen, die mit Auktionshäusern und Kunsthandlungen im westlichen Ausland zusammenarbeiteten.[35]

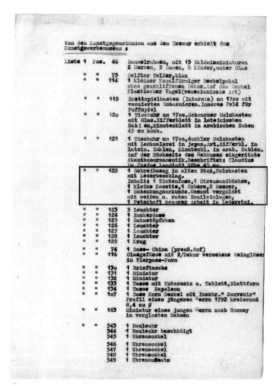

Die Übergabeliste an das Kunstgewerbemuseum Berlin vom 16. Juli 1953 enthält das kaiserliche Schreibzeug und wurde vom damaligen Leiter, Martin Klar, persönlich angenommen. SMB-ZA II/VA 1191

Den Absatz innerhalb der DDR wickelte die Tresorverwaltung größtenteils über den staatlichen und privaten Groß- und Einzelhandel ab, aber auch über Handwerksbetriebe, volkseigene und private Industriebetriebe sowie Auktionshäuser.[36] Gemeinsam mit dem Ministerium für Handel und Versorgung (MHV), dem Ministerium für Kultur (MfK), dem Magistrat von Groß-Berlin und der staatlichen Handelsorganisation (HO) wurde vermutlich 1952/53 beschlossen, die eigens geschaffenen Einzelhandelsgeschäfte für den staatlichen Kunsthandel, den staatlichen Briefmarkenhandel und den staatlichen Münzhandel in günstigen Geschäftslagen der DDR-Großstädte zu eröffnen.[37]

In den HO-Filialen war das Angebot von Kostbarkeiten aus Edelmetall vor konsumreichen Feiertagen besonders groß. So sollten für das Weihnachtsfest 1953 sämtliche Gegenstände auf Übergabelisten festgehalten werden, auf denen neben der Gegenstandsbezeichnung Feingehalt und Gewicht der Objekte verzeichnet waren. Penibel wurden im Wareneingangsbuch der Tresorverwaltung Stückzahl und andere Daten zum Warenein- und -ausgang

notiert. Gegenstände, bei denen vor der Abgabe an die HO eine sogenannte Bearbeitung notwendig war, wurden nach der Registrierung durch das MdF über die Deutsche Handelszentrale (DHZ) in die dafür vorgesehenen Betriebe gesandt. Alle anderen Stücke wurden zur Schätzung umgehend den Sachverständigen übergeben.[38] Der endgültige Ladenpreis kam auf Grundlage der verbindlichen Preisfestsetzung des MdF für Gold und Silber vom 17. März 1953 und der Wertermittlung der DHZ Schmuck zustande.[39]

Auf den Stücken, die in den Inlandsverkauf gehen sollten, wurden Provenienzmerkmale wie Gravuren, Monogramme und Insignien im Prozess zwischen Annahme und Veräußerung schon früh beseitigt.

In Absprache mit dem Leiter der Hauptabteilung Valuta, Hentschel, wurden die gesamten Edelmetallbestände aus den Tresorräumen im Januar 1953 einer entsprechenden Behandlung unterzogen.[40] Dass auch museale Objekte darunter waren, lassen die Spuren der beseitigten Monogramme und Insignien erahnen. War die Beseitigung der Provenienzmerkmale – und damit der Verkauf – nicht möglich, wurden die Objekte im VEB Hüttenwerk Halsbrücke eingeschmolzen.

Dieser Weg könnte auch in die entgegengesetzte Richtung beschritten worden sein. In einem Vermerk des MdF-Mitarbeiters Weschke wird detailliert beschrieben, wie Sammlermünzen nachzuprägen sind: Der jeweils geltende Münzfuß der Originalexemplare müsse eingehalten werden, um eine möglichst genaue Übereinstimmung von Feingehalt und Raugewicht zu erzielen. Nach Möglichkeit sollte die Münze mit Originalstempeln und in der Originaltechnik geprägt werden, um eine Prüfung durch Fachleute zu erschweren. Da sich Weschke der Schwierigkeiten und des damit verbundenen Aufwands bewusst war, empfahl er zunächst Nachprägungen von Münzen nach dem Jahr 1871. Dies hatte den Vorteil, dass hierfür lediglich eine Münzprägemaschine der Kölner Fabrik Diedrich Uhlhorn von 1857 notwendig war. Zudem entfiel die notwendige Nachahmung von altersgemäßer Patina, da Reichsmünzen mit glänzender Oberfläche höhere Preise unter Sammlern erzielten.[41]

Mit der geheimen Aktion „Licht" des Ministeriums für Staatssicherheit (MfS) im Januar 1962 ⨍ erreichte der Organisationsgrad der Tresorverwaltung schließlich einen Höhepunkt im Hinblick auf

⨍ Vgl. Projekteintrag in Proveana, PURL https://www.proveana.de/de/link/pro00000021

den Entzug von Kunst- und Kulturgut. Gleichwohl die Aufarbeitung noch Generationen beschäftigen wird, verweisen die bisherigen Erkenntnisse bereits auf die enge Verstrickung von MfS und Tresorverwaltung. In den 1970er-Jahren wurde die Tresorverwaltung im Zusammenhang mit der Kunst und Antiquitäten GmbH tätig, ⌀ die Kunst- und Kulturgut ins westliche Ausland exportierte und der Abteilung Kommerzielle Koordinierung des Ministeriums für Außenhandel angegliedert war.[42]

⌀ *Vgl. Beiträge von Jan Scheunemann, S. 201, Margaux Dumas und Xenia Schiemann, S. 213, Christopher Jütte, S. 224, Bernd Isphording, S. 234, sowie Alexander Sachse, S. 245.*

Ronny Licht
Ronny Licht ist als Kunsthistoriker und Museologe in Berlin und Leipzig tätig.

Endnoten

[1] Jan Scheunemann: Gegenwartsbezogenheit und Parteinahme für den Sozialismus: Geschichtspolitik und regionale Museumsarbeit in der SBZ/DDR 1945–1971, Berlin 2009, S. 17 ff.; Jochen Staadt (Hg.): „Die Eroberung der Kultur beginnt!": die Staatliche Kommission für Kunstangelegenheiten der DDR (1951–1953) und die Kulturpolitik der SED, Frankfurt a. M./Berlin/ Bern/Wien 2011, S. 26.

[2] Vorläufer der StaKuKo war die Staatliche Kommission für Kunst und Literatur; 1954 ging die StaKuKo in das Ministerium für Kultur über.

[3] BArch DN 1/40098, Bericht über die Überprüfung des Inventars der Staatlichen Museen [...], 27.3.1951.

[4] http://www.badv.bund.de/DE/OffeneVermoegensfragen/Archive/ AfRArchiv/Tresorverwaltung/start.html.

[5] BArch DN 1/3364, Bericht der Tresorverwaltung im Ministerium der Finanzen, die gemäß dem Übergabeprotokoll am 8.9. an den Unterzeichnenden überging; BArch DN 1/2191, Auflösung der Banken-Kommission, Abteilung Verwaltung des ehemaligen Reichsbankvermögens, 13.12.1950.

[6] BArch DN 1/3439.

[7] BArch DN 1/2191, Stellenplan für die Tresorverwaltung, 7.3.1953.

[8] BArch DN 1/3439, Schreiben vom 21.7.1953.

[9] BArch DN 1/ 2191, Stellenplan für die Tresorverwaltung, 7.3.1953.

[10] BADV-AfR, Tresorverwaltung 4, Bericht über die Tätigkeit der Abt. Tresorverwaltung des Ministeriums der Finanzen für das Jahr 1957, 15.2.1958.

[11] BADV-AfR, Tresorverwaltung 4, Vermerk – Betreff: Verwertung von Porzellan- und Glaswaren, 26.11.1956.

[12] BArch DN 1/3439, Anweisung für die Wirtschaftsführung und Rechnungslegung der Abt. Tresorverwaltung, 4.1.1956.

[13] BArch DN 1/3439.

[14] BADV-AfR, Tresorverwaltung 4, Stellenplan des Sektors Tresorverwaltung, 19.12.1959.

[15] BArch DN 1/34177, Vorläufiger Geschäftsverteilungsplan des Ministeriums der Finanzen der Deutschen Demokratischen Republik, VII. Bestimmungen über die Hauptabteilung Valuta, S. 13, wohl November 1952.

[16] BArch DN 1/2191, Vorläufige Tresorordnung, Anlage 1: Tresorliste, 20.3.1953.

[17] BArch DN 1/3368, Tresorliste, wohl 1951.

[18] Bezeichnungen der Tresorräume: Goldkammer, Hochtresor, Keller 43, Tresor 128, Tresor 5, Tresore B bis H, Tresore J bis P, Tresore R bis T.

[19] BADV-AfR, Tresorverwaltung 4, Kurzbilanz für Januar 1956.

[20] Es handelt sich um die Namen Edith Abraham, Georg Arendt, den Nachnamen Beschütz (Stolpersteine mit diesem Namen sind in Hamburg verlegt), Margarete Blümlein, Käthe Bokofzer, Mehlin Reichert, Willi Rose, Eugen Tobison, Fritz Zucker.

[21] Vgl. Zentral- und Landesbibliothek, http://raubgut.zlb.de/index.php/Detail/Object/Show/object_id/72703; siehe ebd., http://raubgut.zlb.de/index.php/Detail/Entity/Show/entity_id/4527 (22.7.2018).

[22] BArch DN 1/3368, Aushändigung von Schließfachinhalten und Verwahrstücken […] bei den geschlossenen Kreditinstituten, 27.2.1951.

[23] BADV-AfR, Tresorverwaltung 18, Rundverfügung Nr. 192/53, Behandlung der wegen Steuerschulden gepfändeten Kostbarkeiten, 2.10.1953.

[24] Vgl. Hans-Georg Knothe: Die Geschichte des Zwangsvollstreckungsrechts in der ehemaligen DDR, in: Deutsche Gerichtsvollzieher-Zeitung. Zeitschrift für Vollstreckungs-, Zustellungs- und Kostenrecht. Organ des Deutschen Gerichtsvollzieherbundes (DGVB), Bd. 125, München/Berlin 2010, 9, S. 161–172, hier S. 161.

[25] BADV-AfR, Tresorverwaltung 17, Rundverfügung des Ministeriums der Justiz, Nr. 11/54, Betr.: Verwertung von gepfändeten Edelmetallgegenständen, Kostbarkeiten und sonstigen Wertgegenständen […], vom 1.12.1954.

[26] Gesetzblatt der Deutschen Demokratischen Republik, 2. Halbjahr, Nr. 84–182, Jg. 1952, hg. von der Regierungskanzlei der DDR, Berlin 1952, S. 616.

[27] BADV-AfR, Tresorverwaltung 17, Rundverfügung vom 10.12.1953; Gesetzblatt Nr. 118, 21.8.1952.

[28] BADV-AfR, Tresorverwaltung 17, ebd.

[29] BADV-AfR, Tresorverwaltung 17, Anweisung über die Ablieferungspflicht von dem Staate verfallener Edelmetallgegenstände und anderer Kostbarkeiten, 28.8.1953.

[30] BADV-AfR, Tresorverwaltung 17, Rundverfügung vom 1.12.1954.

[31] BADV-AfR, Tresorverwaltung 17, Anweisung über die Ablieferungspflicht […], 28.8.1953.

[32] BADV-AfR, Tresorverwaltung 17, Rundverfügung vom 10.12.1953.

[33] BADV-AfR, Tresorverwaltung 17, Vermerk: Betr. Behandlung von Wertgegenständen und Kostbarkeiten bei der Abt. Tresorverwaltung des Ministeriums der Finanzen, 15.12.1953.

[34] Ronny Licht: Wettiner Provenienzen in Berliner Museen – Untersuchung zu Erwerbs- und Verwertungsstrategien von Kunst- und Kulturgut durch das Ministerium der Finanzen der DDR, Masterarbeit; einzusehen beim Deutschen Zentrum Kulturgutverluste in Magdeburg, S. 59.

[35] BArch DN 1/3439, Abteilung Tresorverwaltung des MdF, […] Teilaufgabe: Verwertung […], wohl 1952/53.

[36] BArch DN 1/3439, ebd.

[37] BArch DN 1/3439, ebd.

[38] Siehe ebd. Hier namentlich „Exner" und „Selig" erwähnt.

[39] Der HO-Preis (HOP) ermittelte sich 1953 über festgelegte Schlüssel. Für Silber galt: Handelsabgabepreis (HAP) × Index (170 bzw. 165 bzw. 175) + DM 0,70 je Gramm Feinsilbergehalt. Für Gold galt hingegen: HAP × Index 165 × DM 65,00 je Gramm Feingoldgehalt. Der HOP war gleichbedeutend mit dem Verbraucherendpreis (VEP).

[40] BADV-AfR, Tresorverwaltung 17, ebd.

[41] BADV-AfR, Tresorverwaltung, 18, Vermerk vom 16.7.1954, Betr.: Nachprägung von Münzen für Sammelzwecke.

[42] Ulf Bischof: Die Kunst und Antiquitäten GmbH im Bereich Kommerzielle Koordinierung, Berlin 2003, S. 348.

Die Pfandleihanstalt in Berlin, Hauptstadt der DDR – „Export von Antiquitäten, Raritäten und nostalgischen Waren"

Heike Schroll

The pawn office in Berlin, capital of the GDR: "Export of antiques, rarities and nostalgic items"
After the Second World War, the Städtische Pfandleihanstalt (Municipal Pawn Office) in the Soviet occupation zone of Berlin already resumed operations in October 1945—from late 1950 onwards as Pfandleihanstalt Berlin and, according to its statutes, as a non-profit entity. Subordinate to the fiscal authority of the Magistrate, the pawn office sold items that had not been redeemed, lost property, but also consignments of items received from estate administrators and acquisitions from the homes of defectors or emigrants. From 1974 to 1980 it was also involved in the art trade in the GDR and the acquisition of foreign currency, and was one of the preferred partners of Kunst und Antiquitäten GmbH (Art and Antiques Ltd.), serving as a reliable supplier primarily of furniture and clocks, but also of pianos and grand pianos, photographica, porcelain and crystal. Works of art were less common. Due to the limited availability of written records, it is rarely possible to conduct research into specific objects or works through the Berlin State Archive; documenting the whereabouts of cultural objects that may have been traded during this period is difficult. For provenance researchers, references to Berlin's pawn office nonetheless offer an opportunity to assess corresponding documents, and they provide leads for further research.

Im Kunsthandel der DDR spielte der 1973 gegründete Außenhandelsbetrieb (AHB) Kunst- und Antiquitäten GmbH (KuA) bekanntlich eine herausragende Rolle für die Devisenerwirtschaftung – doch woher kam seine Handelsware?

⌀ Vgl. Beitrag von Bernd Isphording, S. 234.

Mitte der 1970er-Jahre wurde die Pfandleihanstalt Berlin zu einer wichtigen Quelle.[1]

Die Städtische Pfandleihanstalt Groß-Berlin hatte zum 20. April 1945 ihren Betrieb zunächst eingestellt. Das Dienstgebäude in der Jägerstraße 64 war stark beschädigt und kurze Zeit später von sowjetischen Truppen besetzt; die Pfänder im Wert von 2 Mio. Reichsmark wurden am 4. Juni 1945 weitgehend beschlagnahmt und verbracht. Als städtische Mitarbeiter das Gebäude am 27. Juli 1945 wieder betreten durften, fanden sie die Tresore und Lagerräume leer.[2]

*Briefköpfe der Pfandleihanstalt
Berlin, LAB C Rep. 106-02-02*

*⚭ Abkürzung für „Berliner
Verkehrsbetriebe (Ost)" bis 1968*

Am 1. Oktober 1945 nahm die Städtische Pfandleihanstalt Berlin im Dienstgebäude Elsässer Straße 74/Linienstraße 98 erneut ihre Tätigkeit auf.[3] Als Geschäftsgrundlage dienten vorerst Bestimmungen aus dem Jahr 1834 und die Preise von 1939, bis mit der „Verordnung über die Pfandleihanstalt Berlin" vom 25. November 1950 eine neue Regelung in Kraft trat.[4] Sie bestimmte die Pfandleihanstalt als „städtische Anstalt ohne eigene Rechtspersönlichkeit" und untersagte „wegen des sozialen Charakters" eine Gewinnerzielung. Der neuen Satzung nach unterstand die Pfandleihanstalt der Aufsicht der Abteilung Finanzen des Magistrats, die auch den Direktor bestimmte. Am 18. Dezember 1950 übernahm die Pfandleihanstalt das Fundbüro der Volkspolizei, 1951 auch das Fundbüro der BVG⚭.[5] Nach einer kurzen Interimszeit von 1952 bis 1956, in der sie als wirtschaftlich selbstständige Abteilung der Sparkasse der Stadt Berlin angegliedert war,[6] unterstand die Pfandleihanstalt wieder der Abteilung Finanzen des Magistrats.

Als sich in den 1950er-Jahren das Pfandgeschäft kontinuierlich rückläufig entwickelte, begann die Suche nach geschäftlichen

Alternativen: Seit 1955 bestand bei der Pfandleihanstalt eine Gebrauchtwaren-Verkaufsstelle für die Verwertung von verfallenen, nicht versteigerten Pfändern, von nicht abgeholten Fundsachen, von Hinterlegungen aus der Pfandkammer (für Steuerschulden), von eingelieferten Stücken vom DDR-Amt für Zoll und Kontrolle des Warenverkehrs (AZKW, bis 1959) und von eingelieferten Stücken der Magistratsbereiche Verwaltungsstelle für Sondervermögen/Verwertungsstelle für beschlagnahmte Waren[7] (bis 1958) sowie der Magistratsstelle Staatliches Eigentum, die mit dem Gut aus amtlich geräumten Wohnungen, etwa in Fällen von „illegalem Verlassen der DDR" oder „Staat als Erbe"[8], befasst war.

⚬ *Vgl. Beitrag von Antje Strahl und Reno Stutz, S. 103.*

Der „Handel mit Gebrauchtwaren" war in der DDR über Preisanordnungen geregelt, die im Gesetzblatt veröffentlicht wurden.[9] Es gab jedoch Sonderregelungen, die die Pfandleihanstalt zu diesem Zeitpunkt aus dem Antiquitätenhandel mehr oder weniger heraushielten: So durften einerseits verfallene Edelmetallpfänder und Kostbarkeiten – „Silber, Gold und Brillanten" – nicht versteigert oder verkauft werden, sondern waren an die Tresorverwaltung des Ministeriums der Finanzen der DDR (MdF) abzugeben.[10] Seit 1958 galt andererseits die Festlegung, dass von der Magistratsabteilung Staatliches Eigentum bei zu räumenden Wohnungen mit entsprechendem Inventar das erste Angebot dem „VE Kunsthandel" zu machen war, der den „größten Teil der Ware (überwiegend hochwertige Antiquitäten), an wohlhabende Bürger der DDR verkaufte".[11]

⚬ *Abkürzung für „Volkseigentum", hier: „Volkseigene(r)"*

Zum 1. Januar 1960 wurde die Pfandleihanstalt der Abteilung Örtliche Versorgungswirtschaft des Magistrats nachgeordnet und konzentrierte sich weiterhin auf die Geschäftsbereiche „Pfandleihe, Fundbüro und ... den Verkauf von Gebrauchtwaren (angekaufte Pfänder, Fundsachen und RF-Wohnungen)"[12], das heißt, die Wohnungen von sogenannten Republikflüchtigen. Einlieferungen von Nachlässen durch Nachlasspfleger sind ab 1960 belegt.[13]

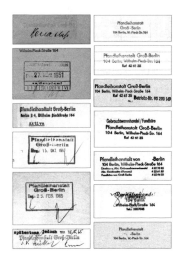

1970 übernahm der Wirtschaftsrat des Bezirkes die Zuständigkeit für die Pfandleihanstalt, die sich zu diesem Zeitpunkt in einer tiefen Krise befand: Ein Zufall – bei einer Wohnungsauflösung war ein abwesender Untermieter übersehen und dessen Eigentum mit verkauft worden – hatte im Rahmen der nachfolgenden Untersuchungen Machenschaften bei der Verwertung von Nachlasswohnungen ans Licht gebracht, die einen zweifachen Direktorenwechsel und grundlegende Änderungen in der Geschäftsführung

Stempel der Pfandleihanstalt Berlin, 1951–1980, LAB C Rep. 106-02-02

zur Folge hatten. Es wurde festgestellt, dass für den Geschäftsbereich Gebrauchtwaren über gut zwei Jahrzehnte hinweg weder eine sichere Nachweisführung noch eine auf Betriebsanweisungen oder Regelungen fußende Arbeitsweise praktiziert worden war. Während der gesamten 1960er-Jahre wurde „in der Buchhaltung … nicht kontinuierlich gearbeitet". Die Verhältnisse im Gebrauchtwarenlager konnten bestenfalls als unübersichtlich bezeichnet werden; die Waren lagerten teils in offenen Kisten und Säcken, Bestandsverzeichnisse wurden nicht geführt. Dass es für Vorabkäufe durch Betriebsangehörige bei der Auflösung von Wohnungen keine Regelungen gab, öffnete breite Möglichkeiten für einen illegalen privaten Handel.[14]

Direktor Wilhelm Vogler, der diese Missstände zu verantworten hatte, wurde 1970 durch Klaus Pockrandt ersetzt, der erste innerbetriebliche Regelungen erließ. So wurde nun für die Abteilung Gebrauchtwaren konkret festgelegt: „Im Jahre 1971 ist der Bestand an Hausrat, Büchern und Bildern in der Lagerkartei zu führen. Grundlage für die Einrichtung der Lagerkartei ist eine körperliche Bestandsaufnahme."[15]

Doch die Kundenzahl im Verkauf sank weiterhin; die Menge an hochwertigen Fundgegenständen ging zurück; außerdem bestand eine Konkurrenz zur HO, die ebenfalls mit Gebrauchtwaren handelte. Die wirtschaftliche Situation der Pfandleihanstalt war ernst. Im Mai 1972 wurden beim zuständigen Stadtrat die von Pockrandt in seiner bisherigen Amtszeit erreichten Ergebnisse zwar als zufriedenstellend bilanziert, andererseits aber auch Möglichkeiten zur „Entwicklung der einzelnen Leistungsarten, insbesondere des Gebrauchtwarenhandels" gesucht: Man überlegte, künftig auch „Gebrauchtwaren aus den Betrieben VEB✐ Rewatex, VE Dienstleistungskombinat und VEB Schuhreparatur" zu übernehmen und in einem extra angemieteten Laden zu verkaufen. Außerdem sollte der Pfandleihanstalt ein eigener Lkw zugewiesen werden, damit sie flexibler war, und es sollte – nach dem Beispiel des Gebrauchtwarenhandels in Leipzig und Dresden – die Funktion „Aufkäufer" eingerichtet werden. Für den Umgang mit Waren aus Nachlass- und RF✐-Ankäufen wurde erneut und dringend eine Betriebsanweisung angemahnt, da hier immer noch kaum nachvollziehbare Vorkommnisse zu verzeichnen waren.[16] Und bemerkenswerterweise scheiterte Pockrandt nach knapp drei Jahren Tätigkeit im Zusam-

✐ Abkürzung für „Volkseigener Betrieb"

✐ Abkürzung für „Republikflucht", „Republikflüchtling(e)" und „republikflüchtig"

menhang mit einem Disziplinarverfahren genau wegen so einer
Unregelmäßigkeit bei der Auflösung einer Nachlasswohnung. Er
wurde abgesetzt und Walter Schimke übernahm sein Amt 1973.

Erst dieser Direktorenwechsel brachte die Umsetzung von über-
fälligen Maßnahmen und die Inkraftsetzung notwendiger Grund-
satz- und Führungsdokumente: Lagerordnung, Schlüsselordnung,
Kassenordnung, Funktionspläne für Beschäftigte – all das wurde
nun eingeführt. Es wurde festgelegt, Möbel getrennt vom Hausrat
zu lagern und im Abziehbildverfahren mit Schildchen für Inventar-
nummern zu versehen.[17] Käufe durch Betriebsangehörige wurden
limitiert.[18]

Im selben Jahr war mit der KuA ein Unternehmen des DDR-
Außenhandels entstanden, das „den alleinigen Export und Import
mit bildender und angewandter Kunst, Volkskunst und Antiqui-
täten und Gebrauchtwaren antiquarischen Charakters" zur Auf-
gabe hatte. Zur Sicherung des Außenhandelsmonopols in diesem
Bereich übernahm die KuA schrittweise die bisherigen Exportge-
schäfte anderer DDR-Außenhandelsbetriebe in diesem Segment
und die Firma Antikhandel Kath aus Pirna. Einen erheblichen Teil
der Handelsware sollten zudem die DDR-Museen beisteuern,
die sich allerdings nachdrücklich weigerten, ihre Bestände herzu-
geben.[19]

Es mussten andere Geschäftspartner gefunden werden – und
die Pfandleihanstalt Berlin war verhandlungsbereit. Beim Wirt-
schaftsrat des Bezirkes Berlin, Bereich Material- und Außenwirt-
schaft, traf man sich im Juni 1974 mit einem der Geschäftsführer
der KuA, Joachim Farken, und den Herren Schäfer und Hecken-
dorf vom Bereich Fundbüro/Gebrauchtwarenhandel der Pfand-
leihanstalt, um eine künftige Zusammenarbeit zu besprechen. „Zur
Sicherung zusätzlicher NSW-Exporte" – das heißt, ins Nichtsozia-
listische Wirtschaftsgebiet – gab es eine wesentliche Festlegung:
In Abänderung des seit 1958 geltenden Verfahrens, wonach bei
zu räumenden Wohnungen die Abteilung Staatliches Eigentum
dem VE Kunsthandel das erste Angebot machte, wurde nun der
Pfandleihanstalt das Erstkaufsrecht an Antiquitäten eingeräumt.
Eine Arbeitsgruppe Gebrauchtwarenexport sollte gebildet und
die 5. Etage im Dienstgebäude Wilhelm-Pieck-Straße 172 für die
„ausgesuchte Ware" des Raritätenhandels freigeräumt werden –

dort firmierte der Raritätenhandel nun auch offiziell. Sollte die Fläche nicht ausreichen, stellte die KuA für das kommende Jahr die Nutzung einer Leichtbauhalle in Schildow/Mönchmühle bei Mühlenbeck in Aussicht. Die Tatsache, dass man von Beginn an den Containerversand plante, mag als Indiz für das vorgesehene Handelsvolumen dienen.[20]

So entstand 1974 der erweiterte „Bereich Gebrauchtwarenhandel (mit Exportgruppe, auch ‚Raritätenhandel')", der innerhalb der Pfandleihanstalt zunächst vom Gruppenleiter Wischer bis 1976, danach bis 1980 von Dieter Blum verantwortet wurde. Der zügige Ausbau des Raritätenhandels begann. Auf Grundlage einer Vereinbarung zwischen der Pfandleihanstalt und der KuA vom 30. Juni 1975 wurden „Wettbewerbsvereinbarungen" und Jahresprotokolle mit einem festen jährlichen Volumen von „Antiquitäten und exportfähigen Gebrauchtwaren für den Export" ins nicht sozialistische Ausland festgelegt, das die Pfandleihanstalt zu liefern sich verpflichtete.

Bei Erfüllung dieses Warenvolumens stellte die KuA Prämien in Aussicht, die bei Übererfüllung nochmals aufgestockt wurden. Gesonderte Regelungen galten für Uhren (Regulatoren, Wiener Freischwinger, Standuhren, Westminsteruhren, Boxen), für die es Stückprämien gab. Die Pfandleihanstalt sollte diese Gelder zur Prämierung derjenigen Mitarbeiter verwenden, die „an der Bereitstellung der Waren für den zusätzlichen Export direkt oder indirekt beteiligt" waren. Der Preisentwicklung für Antiquitäten wurde Rechnung getragen. Die KuA passte die An- und Verkaufspreise regelmäßig an.[21]

1975 wurde für das neu eingerichtete Außenlager in Stendal zur „Steigerung des Exportplanes" ein zusätzlicher Einkäufer angeworben, um „antike Möbel, Uhren, Kristall, Keramik usw. aufzukaufen".[22] Ein weiteres Lager der Pfandleihanstalt befand sich in Berlin-Blankenburg.[23] In den direkten Geschäftsbeziehungen zwischen Pfandleihanstalt, KuA und internationalen Kunden kam es immer wieder zu Missverständnissen und Unklarheiten bezüglich der Vollständigkeit von Lieferungen und bestehenden Vollmachten. Für eine bessere Abwicklung erhielt die Pfandleihanstalt von dem AHB⌀ eine Aufstellung der Kunden, die berechtigt waren, Ware direkt in Empfang zu nehmen und zu transportieren. 1974 umfasste die Liste 44 Firmen aus den Niederlanden, Belgien, den

⌀ *Abkürzung für „Außenhandelsbetrieb"*

Jahresprotokoll mit dem Jahresplan für 1976, LAB C Rep. 106-02-02, Nr. 6

Berlin, den 9.3.1976

Jahresprotokoll

Auf der Grundlage der Vereinbarung zwischen der Pfandleih-
anstalt Berlin und dem AHB Kunst und Antiquitäten GmbH vom
3o.6.75 wird für das Jahr 1976 folgendes festgelegt:

1. Zu Ehren des IX. Parteitages der SED setzen sich beide
 Vertragspartner das Ziel, im Jahre 1976 einen Export in
 das NSW an Antiquitäten und Gebrauchtwaren aus dem Wa-
 renaufkommen der Hauptstadt der DDR Berlin in Höhe

 von 1 Mio VM

 zu erreichen.

2. Der Magistrat von Groß-Berlin erhöht die Zahl der Arbeits-
 kräfte um 5 VbE im Bereich der Exportabteilung und unter-
 stützt die Pfandleihanstalt bei der Beschaffung von Lager-
 kapazitäten.

3. Kunst und Antiquitäten stellt der Pfandleihanstalt

 1 Kastenwagen FIAT NC 75
 1 Barkas B 1ooo

 zur Erhöhung der Ankaufstätigkeit für Export im Rahmen eines
 Nutzungsvertrages zur Verfügung.

4. Einschlägige Fachliteratur wird auf Anforderung durch die
 Kunst und Antiquitäten GmbH zur Verfügung gestellt bzw. Ein-
 sichtnahme gewährleistet.

Pfandleihanstalt von Kunst und Antiquitäten
Groß Berlin GmbH Berlin

.................. 13.3.76
Schimpke Schuster

USA, der BRD, West-Berlin, Italien, Großbritannien, der Schweiz und Liechtenstein.[24]

Seit 1979 wurde die juristische Umbildung der Pfandleihanstalt in einen volkseigenen Betrieb (VEB) angestrebt, was einerseits im Finanz- und Zahlungssystem der DDR begründet war. Hier passte eine juristische Person wie die Pfandleihanstalt mit einem seit 1950 unverändert geltenden Rechtsstatus nicht mehr hinein. Es gab zum Beispiel immer wieder Probleme mit der Staatsbank der DDR bzw. dem Berliner Stadtkontor bei der Kontoführung. Andererseits drängte die „Durchsetzung der Gesetzlichkeit in der

Pfandleihanstalt Berlin" nach weiteren Änderungen. Ein erneuter Direktorenwechsel 1980 auf Heinz Hirschmeier fand vor diesem Hintergrund statt.

Die Pläne zur Umbildung der Pfandleihanstalt Berlin in einen VEB führten zu einer umfassenden Inventur sämtlicher Bestände und Handelswaren in den Jahren 1979 und 1980. Die Inventurlisten zeigen detailliert die Breite der vorhandenen Warenbestände, von alltäglichen Gebrauchsgegenständen, Werkzeugen, Elektrogeräten bis hin zu den „Antiquitäten, Raritäten und nostalgischen Waren". Die Inventur ergab keine nennenswerten Beanstandungen. In der Abteilung Export fehlten lediglich ein Kaffeeservice, ein Rundfunkgerät und eine Apothekerwaage. Eine Überprüfung ergab, dass die Waage bereits 1978 in den Export verkauft worden war; die anderen Gegenstände im Gebrauchtwarenhandel.[25]

Im Januar 1980 wurden die „Prinzipien der materiellen Verantwortlichkeit durch die Mitarbeiter der Pfandleihanstalt" für verbindlich erklärt, was bedeutete, dass „bei Verlusten oder Fehlbetrag die volle persönliche Haftung oder bei gemeinsamen Arbeiten die kollektive Haftung" eintrat.[26] Das Thema rief im Juni 1980 sogar den Berliner Generalstaatsanwalt auf den Plan, um zu gewährleisten, dass „künftig bei der Sicherung und Herausgabe von Pfandgegenständen, die aus strafbaren Handlungen stammen", die rechtlichen Regelungen und „strafrechtlichen und strafprozessualen Bestimmungen strikt eingehalten werden". Offenbar war das bisher so nicht geschehen. Man behielt sich ausdrücklich Ermittlungen gegen die Pfandleihanstalt „im Interesse des Schutzes des sozialistischen Eigentums" vor. Um bei den Ankäufen Objekte zu erkennen, die aus strafbaren Handlungen stammten, erhielt der Leiter An- und Verkauf nunmehr regelmäßig „Fahndungsinformationen" der Volkspolizei. Auch seitens der Generalstaatsanwaltschaft wurde angeregt, den Rechtsstatus der Pfandleihanstalt zu überprüfen, was „für die Geltendmachung von Schadensersatzansprüchen unerlässlich" war.[27]

Zwar hatte der Direktor der Pfandleihanstalt bereits im Mai 1980 den entsprechenden Antrag beim zuständigen Vertragsgericht gestellt, als „Haus für Gebrauchtwaren Berlin – Gebrauchtwaren – Raritätenhandel – Beleihung – Fundbüro" in das Register der volkseigenen Wirtschaft – HRC 🖉 eingetragen zu werden, doch ist das nicht umgesetzt worden. Im September schlug Hirschmeier dann

🖉 *Abkürzung für „Handelsregister C"*

Inventuraufnahmeliste 1979, LAB C
Rep. 106-02-02, Nr. 8

VEB Gebrauchtwaren Berlin als Namen vor – u. a. mit der Aufgabe, erbenlose Nachlasswohnungen zu räumen und dann für den „Export von Antiquitäten, Raritäten und nostalgischen Waren" zu sorgen.[28] Stattdessen hob der Magistrat am 26. November 1980 alle Regelungen auf und legte die Angliederung der Pfandleihanstalt Berlin als selbstständigen Betrieb an den VE Dienstleistungsbetrieb Berlin fest. Die Aufgabe „Sicherung eines angemessenen Exporterlöses aus dem Gebrauchtwarenhandel" bzw. der Handel mit Raritäten bestand dort weiterhin; die Zusammenarbeit mit der Kunst und Antiquitäten GmbH wurde fortgesetzt.

Von einer Involvierung der Pfandleihanstalt Berlin in den Kunsthandel der DDR bzw. die Erwirtschaftung von Devisen kann erst ab 1974 ausgegangen werden. Von 1974 bis 1980 gehörte die Pfandleihanstalt zu den zuverlässigen Lieferanten der KuA und beschaffte vor allem Möbel und Uhren, aber auch Pianos und Flügel, außerdem Photographica, Porzellan und Kristall. Werke der bildenden Kunst stellten eher die Ausnahme dar.

Die geringe archivische Überlieferung ist im Falle konkreter Werks- und Objektrecherchen sicher nur in Einzelfällen auswertbar.

Da in den 1950er- und 1960er-Jahren keine regelgerechte Buchhaltung oder Nachweisführung praktiziert und ein Handel mit Waren durch Betriebsangehörige nicht festgehalten wurde, ist eine Dokumentation zum Verbleib von eventuell in diesen Jahren gehandelten Kunst- und Kulturgütern äußerst schwierig.

Für die Provenienzforschung ist der Hinweis auf Verkäufe des VE Kunsthandels an „vermögende DDR-Bürger" bis 1974 insofern relevant, als damit eventuelle schriftliche Hinweise eingeordnet werden können.

Die Entwicklung des Raritätenhandels ab 1980 beim VE Dienstleistungsbetrieb Berlin bleibt weiteren Forschungen vorbehalten.

Heike Schroll
Heike Schroll ist Stellvertretende Direktorin am Landesarchiv Berlin.

Endnoten

[1] Die Quellenlage ist mit 10 Akten sehr übersichtlich. Die Überlieferung gelangte im Mai 2002 von der DISOS GmbH an das Landesarchiv Berlin. Die Akten waren dort im Rahmen der Archivierung von Schriftgut liquidierter DDR-Unternehmen mit Treuhandbeteiligung beim Schriftgut des VE Dienstleistungskombinat Berlin verwahrt worden, dem die Pfandleihanstalt 1980 angegliedert worden war. Die Einordnung in die Tektonik des Landesarchivs erfolgte unter der Repositurnummer C Rep. 106-02-03 Pfandleihanstalt Berlin. Das VE Dienstleistungskombinat hat für seinen Geschäftszweig Gebrauchtwarenhandel/Raritäten/Antiquitäten zum Datum der Währungsunion am 1. Juli 1990 die „Möbelmarkt Mitte GmbH" gebildet.

[2] Vgl. LAB C Rep. 106-02-02, Nr. 1.

[3] Vgl. Jahresbericht für 1950, in: LAB C Rep. 106-2-02, Nr. 3.

[4] VOBl. I Nr. 62.

[5] Vgl. Jahresberichte für 1950 und 1951, in: LAB C Rep. 106-2-02, Nr. 3.

[6] Magistratsbeschluss 1083/1952, in: LAB C Rep. 100-05, Nr. 869.

[7] Vgl. Lieferlisten für 1952/53, in: LAB C Rep. 105, Nr. 44809.

[8] Vgl. Jahresberichte, in: LAB C Rep. 106-02-02, Nr. 3.

[9] Vgl. z. B. Preisanordnung Nr. 845 vom 18.11.1957, in: GBl. DDR I/76/57.

[10] Anlagenblatt zu den Inventuren per 31.12.1968, in: LAB C Rep. 106-02-02, Nr. 5.

[11] Vgl. Protokoll des Wirtschaftsrates des Bezirkes Berlin über eine Aussprache mit der Gebrauchtwaren GmbH und dem Gebrauchtwarenhandel der Pfandleihanstalt am 12.6.1974, in: LAB C Rep. 106-02-02, Nr. 6.

[12] Finanz-Revisionsbericht vom 9.10.1962, in: C Rep. 106-02-02, Nr. 5.

[13] Vgl. Bilanz per 31.12.1960, in: LAB C Rep.106-02-02, Nr. 3.

[14] Vgl. dazu Protokolle der Staatlichen Finanzrevision, in: LAB C Rep. 106-02-02, Nr. 5.

[15] Vgl. Protokoll der Jahresbilanz 1970, in: LAB C Rep. 106-02-02, Nr. 5.

[16] Gesprächsprotokoll vom 9.5.1972, in: LAB C Rep. 106-02-02, Nr. 5. Vgl. auch: Anordnung über den Handel mit Gebrauchtwaren vom 8. November 1972 (GBl. DDR II/70/72).

[17] Protokoll zur Finanzrevision 25.9.1972, in: LAB C Rep. 106-02-02, Nr. 5.

[18] Erst 1980 wurde geprüft, ob der Verkauf von „Exportartikeln" an Beschäftigte zulässig bleiben soll.

[19] Vgl. Findbücher zu den Beständen des Bundesarchivs. Betriebe des Bereiches Kommerzielle Koordinierung. Teilbestand Kunst- und Antiquitäten GmbH (1974–2002). Bestand DL 210, Berlin 2017, S. 5.

[20] Vgl.: Protokoll des Wirtschaftsrates des Bezirkes Berlin über eine Aussprache mit der Gebrauchtwaren GmbH und dem Gebrauchtwarenhandel der Pfandleihanstalt am 12.6.1974, in: LAB C Rep. 106-02-02, Nr. 6. Die KuA wird hier – offenbar irrtümlich – als „Gebrauchtwaren GmbH" bezeichnet.

[21] Beispiele in: LAB C Rep. 106-02-02, Nr. 6.

[22] Abschlussarbeit R. H. 1975 an der Betriebsschule Marxismus-Leninismus des Magistrats. In: LAB C Rep. 904-059, Nr. 133.

[23] Vgl. LAB C Rep. 106-02-02, Nr. 6 „Zusammenarbeit mit der Kunst- und Antiquitäten GmbH, Internationale Gesellschaft für den Ex- und Import von Kunstgegenständen und Antiquitäten, 1974–1980".

[24] Vollständige Liste in: LAB, C Rep. 106-02-02, Nr. 6.

[25] Vgl. detaillierte Inventurlisten in: LAB C Rep. 106-02-02, Nr. 8 „Umbildung der Pfandleihanstalt Berlin in einen volkseigenen Betrieb (VEB), 1979–1980".

[26] Vgl. LAB C Rep. 106-02-02, Nr. 9.

[27] Protokoll einer Beratung des Generalstaatsanwalts von Berlin, Hauptstadt der DDR, vom 18.6.1980. In: LAB C Rep. 106-02-02, Nr. 7.

[28] Vgl. LAB C Rep. 106-02-02, Nr. 8.

Objektübernahmen und Handlungsspielräume
Zwei Fallbeispiele am Staatlichen Museum Schwerin

Michael Busch

Object acquisitions and scope for action. Two case studies at the State
Museum of Schwerin
The Staatliches Museum Schwerin (State Museum of Schwerin), which has
been organizationally part of Staatliche Schlösser, Gärten und Kunstsammlun-
gen Mecklenburg-Vorpommern (State Palaces, Gardens and Art Collections of
Mecklenburg-West Pomerania) since 2018, added about 10,000 pieces to its
holdings between 1945 and 1990. Two to three percent of these are of unclear
provenance. Inventories and accession books provide initial clues; above all, the
acquisition types "transferred by," "donation," or "from the estate" point to a
possibly problematic origin. In individual cases, there are direct indications that
objects came to the museum through the People's Police (Volkspolizei) or the
Ministry for State Security. As part of the current historical context research, it
was discovered that five paintings were given to the museum in 1987 by a pa-
per factory, which came from the estate of the former factory owner. They had
probably survived in the attics of the family's former homes, which had been
converted into hospitals in the GDR.

The second part of the article deals with the diverse expert activities of
the museum staff since 1958, who were not only called in for court cases or in-
surance claims, but also had to judge the harmlessness of the export of cultural
property in almost 600 departure proceedings of GDR citizens. The right of first
refusal, which was laid down in the 1953 Cultural Property Protection Act, gave
the museum the opportunity to acquire objects that were not allowed to be ex-
ported from the GDR. Among other things, three paintings by the Mecklenburg
painter Rudolf Bartels came to the museum in this way. The personal union of
the appraiser and the purchaser for the museum proved to be problematic here,
which could lead to a lack of objectivity when there was a great deal of freedom
in terms of content.

„Das Staatliche Museum Schwerin nimmt in der Rangfolge der
Museen der DDR den dritten Platz ein. An Geltung wird es nur
von den Museen Berlins und Dresdens übertroffen."[1] Diese selbst-
bewusste Einschätzung seines Direktors Walter Heese gründete
sich nicht nur auf den Sammlungsbestand des Museums, es galt
über die Grenzen der DDR hinaus als wichtiger Ansprechpartner
für Ausleihe sowie gemeinsame Ausstellungen und sein Gesamt-
charakter als „international".[2]

Nach erfolgreichen Ausstellungen in Mexiko (1979), den USA (1983), Japan (1981), Stockholm und im Pariser Louvre (1982) wurden die Verantwortlichen des Museums, nun unter Direktor Hans Strutz, vom Ministerium für Kultur gebeten einen Leihvertrag zu entwickeln, der Modell für andere Museen werden sollte, um „die Ausleihen von Kunstwerken aus Museumsbeständen der DDR an Botschaften, besonders im nichtsozialistischen Ausland, einwandfreien vertragsrechtlichen Bedingungen zuzuführen".[3] Bis 1964 war der Rat der Stadt Schwerin die vorgesetzte Dienststelle, 1964 wurde das Museum durch den Rat des Bezirks als nachgeordnete Dienststelle übernommen.[4]

Inventare und Zugangsbücher

Die Sammlungen des Staatlichen Museums Schwerin[5] umfassen heute mehr als 100.000 Kunstwerke: Gemälde, Arbeiten auf Papier, Plastiken, Münzen und vieles mehr. In der Zeit von 1945 bis 1990 kamen laut Zugangsbüchern etwa 10.000 Stücke in das Museum. Von diesen Objekten haben etwa zwei bis drei Prozent eine unklare Provenienz.[6] Am augenfälligsten ist hierbei der Erwerbsstatus „Überwiesen durch". Vor allem vom Ministerium für Volksbildung wurden in den Jahren 1952 und 1953 Objekte an das Museum überwiesen – beispielsweise 25 Radierungen und Lithografien, unter anderem von William Woolett (1735–1785)[7] –, für die in der Rubrik Vorbesitzer „sichergestellt" eingetragen wurde. Im Falle eines zweitürigen Mahagonischranks wurde das Ministerium für Volksbildung als Vorbesitzer und unter „Art der Erwerbung" eingetragen. 24 Gemälde, die 1953 auf Gut Steinhausen sichergestellt und ebenfalls vom Ministerium überwiesen worden waren, wurden in einem Restitutionsverfahren 1997 den Nachfahren des ehemaligen Besitzers zurückgegeben.[8] Ebenso zu überprüfen sind beispielsweise eine Grafik und ein Ölgemälde, die 1949 die Commerzbank Schwerin überwies, wo sie vermutlich in einem Tresor aufgefunden worden waren,[9] Überweisungen der Stadt Güstrow, die 1950 zwei Ölgemälde aufgrund der Durchführungsverordnung vom 21. Februar 1947 zum Gesetz Nr. 4 zur Sicherung des Friedens vom 16. August 1946✐ sichergestellt hatte,[10] oder ein Barockschrank und zwei weitere Möbelstücke, die im Dezember 1963 durch den Rat des Kreises Ludwigslust an das Museum

✐ Hinter dieser „Friedenssicherung" verbirgt sich die Einziehung privaten Vermögens der Inhaber sequestrierter Betriebe.

82

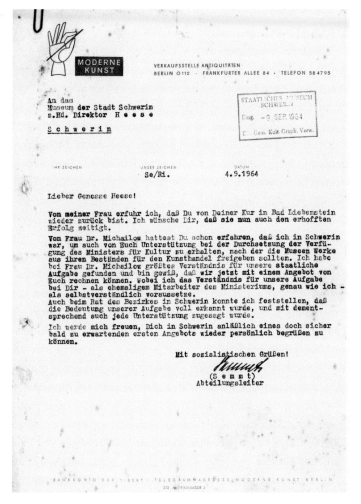

überwiesen wurden. Als Vorbesitzer ist jeweils der Rat des Kreises genannt.[11]

1953 kam es in Plau zu einer Beschlagnahmung einer größeren ostasiatischen Sammlung, der Besitzer Hugo Köppen wurde zu Vermögenseinzug und einer Freiheitsstrafe verurteilt. 🖉 Beim Museum wurde angefragt, ob Interesse an der 108 Stücke umfassenden Sammlung bestehe, anderenfalls werde das Gut über die Deutsche Notenbank in Schwerin dem Staatlichen Kunsthandel (HO) in Berlin O 122, Stalinallee 366, zugeführt. Das Museum übernahm am 14. September 1953 die gesamte Sammlung, die sich aber in die Neukonzeption des Museums nicht einfügte. Im Juli 1957 bot man die Sammlung der Ostasiatischen Abteilung der Staatlichen

🖉 Hugo Köppen starb 1954 im Haftkrankenhaus Leipzig.

Museen Berlin in der Bodestraße an, deren zuständiger Kurator Voigt hocherfreut zusagte.[12]

Auch die Volkspolizei trug in den 50er- und frühen 60er-Jahren hin und wieder zur Vergrößerung des Museumsbestands bei: Am 2. Juni 1960 konnte die damalige stellvertretende Direktorin Dr. Ingeborg Michailoff im Zugangsbuch ein Bildnis der Anna von Buggenhagen verzeichnen, der Vorbesitzer ist mit „unbekannt" angegeben, überwiesen wurde das Ölgemälde durch die Bezirksbehörde der Deutschen Volkspolizei in Schwerin.[13] Eine genaue Unterscheidung des Besitzübergangs – ob durch Beschlagnahme, Einziehung und Wegnahme oder durch Bergung infolge der Bodenreform – ist nur selten möglich,[14] gebräuchlich ist der Begriff „Bodenreformgut".

Eine genauere Bezeichnung der Erwerbung von Objekten findet sich im Falle des Schweriner Architekten K., der 1956 „Republikflucht" beging und von dem zwei Stücke, ein Meisterbrief der Seifensieder vom 8. April 1718 und der Bürgerbrief für Gregorius Jahn vom 12. Dezember 1749, dem Museum durch die „Treuhänder" übergeben wurden.[15]

Besonders bemerkenswert erscheint es, wenn das Ministerium für Staatssicherheit ganz offen als Geber verzeichnet ist. Im Jahre 1962 überwies das MfS, Bezirksverwaltung Schwerin, eine Haararbeit unter Glas aus dem ausgehenden 18. Jahrhundert und im Juli 1961 zwei Ölgemälde, *Am Näerofjord bei Gudvangen* von Paul Karl Themistokles von Eckenbrecher (1842–1921) aus dem Jahre 1901 und eine *Gebirgslandschaft* aus dem Jahr 1886 von Joseph Jansen (1829–1905).[16] Am 17. Juni 1982 gelangte eine Anfrage aus Goslar bezüglich von Eckenbrecher ans Schweriner Museum; der damalige Direktor Dr. Hans Strutz gab im Juli bereitwillig Auskunft über die beiden im Besitz des Museums befindlichen Stücke, auch über das Werk, das durch Überweisung des MfS an das Haus gekommen war.[17]

Der „Fall Bausch"

Im Zugangsbuch III des Museums findet sich 1987 der Eintrag über den Erwerb von fünf Ölgemälden; in den Spalten „Erwerb" und „Vorbesitzer" ist die Notiz vermerkt: „Übergabe aus den VEB-Feinpapierfabriken Neu Kaliß am 3.2.1987, ehemaliger Eigentümer

Familie Bausch, Besitzer der Fabrik vor 1945".[18] Bei den Gemälden handelt es sich um ein Porträt des Schweden Evert Horn von 1615 sowie um vier Porträts aus dem 19. und 20. Jahrhundert von Mitgliedern der Gründerfamilien Schoeller und Bausch: Dorothea Jung und Karl Feldhoff (beide um 1825), Hermann Bausch (1926) und ein sitzender Mann mit Zwicker (1921), bei dem es sich aller Wahrscheinlichkeit nach um Theodor Christian Bausch handelt, den Caspar Ritter porträtierte.

Die Papierwerke Neu Kaliß bestanden schon seit 1872 und waren in den 1920er-Jahren eine der modernsten und renommiertesten Feinpapierfabriken Europas.[19] Ihre Spezialität waren fälschungssichere und Spezialpapiere.[20] Nach dem Krieg blieb Joachim Bausch im Westen, Rudolf Bausch wurde nach seiner Rückkehr aus amerikanischer Kriegsgefangenschaft vom NKWD 🔗 inhaftiert und starb im April 1946 im Lager Neubrandenburg-Fünfeichen.[21] Die Leitung des Betriebes lag jetzt bei Viktor Theodor Bausch. Er hatte 1934 kurze Zeit in Gestapo-Haft gesessen, da er seine sozialdemokratischen Freunde Carlo Mierendorff und Theodor Haubach durch Posten im Betrieb zu schützen suchte; beide überlebten den Krieg und die NS-Zeit nicht.[22] Die Zeit nach dem Krieg schildert die Frau Viktor Bauschs, Erika von Hornstein-Bausch, detailliert in ihren Erinnerungen „Der gestohlene Phoenix":[23] Nachdem das Werk am 1. September 1945 die Produktion wiederaufgenommen hatte, kam im März 1946 der Demontagebefehl 🔗 – die gesamte Anlage sollte zerlegt und in Kisten verpackt werden. Dies geschah jedoch so unsachgemäß durch die dafür beorderten 2.000 Mann eines Strafbataillons, dass diese ausgetauscht und „nach Sibirien verbannt" wurden.[24] Noch im Jahr 1946 kam aus Moskau überraschenderweise der Befehl zum Wiederaufbau der Fabrik, der am 4. September 1946 mit dem Wiederaufbaubefehl Nr. 159 der SMAM 🔗 konkretisiert wurde.[25] 1949 war das schier Unmögliche vollbracht und im Selbstbau eine 45 Meter lange und 150 Tonnen schwere Papiermaschine aus Ersatzteilen aus der gesamten SBZ errichtet worden. Sogar Filteranlagen aus dem zerbombten Hotel Adlon hatten Viktor Bausch und seine Ingenieure verbaut.[26] Kurz nach Inbetriebnahme der neuen Papiermaschine wurde die Familie von der Enteignung, die bereits am 30. November 1948 aufgrund des Befehls Nr. 124 der SMAD 🔗 beschlossen worden war, in Kenntnis gesetzt.[27] Viktor Bausch wurde mit einem konstruierten

🔗 *Abkürzung für Народный комиссариат внутренних дел (russisch: Volkskommissariat für innere Angelegenheiten), die sowjetische Geheimpolizei*

🔗 *Zurückgehend auf den Alliierten Kontrollratsbeschluss vom 26. März 1946 zum 1. Industrieplan für Deutschland*

🔗 *SMA Mecklenburg, Befehl Nr. 159/46 vom 4. September 1946 über den Wiederaufbau der Papierfabrik „Schoeller & Bausch" in Neu Kaliß*

🔗 *SMAD-Befehl Nr. 124/45 vom 30. Oktober 1945 über die Beschlagnahme und provisorische Übernahme einiger Eigentumskategorien in Deutschland*

Steuerverfahren über angeblich 350.000 DM/DDR Steuerschulden zur Flucht in den Westen getrieben.[28] Die Spuren des noch verbliebenen Mobiliars und des Hausrats verlieren sich, aus den Villen wurden Krankenhäuser. Unter Umständen haben die fünf Gemälde dort die nächsten Jahre zugebracht, vielleicht auch auf dem Dachboden: In einem Gutachten für eine Unbedenklichkeitserklärung zur Ausfuhr von Umzugsgut aus der DDR nach Leer/Ostfriesland aus dem Jahre 1988 taucht ein Gemälde auf, *Heimkehr des verlorenen Sohnes*, vermutlich 17. Jahrhundert, das der Antragstellerin aus Neu Kaliß einst überlassen wurde, nachdem es der Verwalter des dort nun ansässigen Krankenhauses auf dem Dachboden gefunden hatte, und es somit, laut Einschätzung der Gutachterin, Volkseigentum war. Das Bild wurde in Kategorie III eingestuft, die Entscheidung des Rates des Kreises🖉 Ludwigslust vom Ende des Jahres 1988 konnte bisher noch nicht gefunden werden. Im Museum befindet sich das Stück nicht, wahrscheinlich wird es seinen Weg nach Leer in Ostfriesland angetreten haben.[29]

🖉 *Objekte der Kategorie III durften laut „Verordnung über den staatlichen Museumsfonds" der DDR vom 12. April 1978, GBL der DDR 14/1978, S. 165, bedenkenlos ausgeführt werden, die Kategorien II und I bezeichneten überregional und national bedeutsame Objekte, die der DDR erhalten bleiben sollten.*

Die Familie Bausch stellte nach 1990 einen Restitutionsantrag, die Villen erhielt sie zurück, die Fabrik nicht. Die fünf Porträts halten einen Dornröschenschlaf.

Fälle wie den der Familie Bausch wird es künftig möglicherweise öfter geben. Die Verfahren nach dem Gesetz zur Regelung offener Vermögensfragen (1990) oder dem Entschädigungs- und Ausgleichsgesetz (1994), die die gesetzlichen Grundlagen für eine Restitution legen, sind zwar abgeschlossen und die Antragsfristen längst abgelaufen. Mit der zunehmenden Provenienzforschung an den Museen der neuen Bundesländer wird aber vermutlich das eine oder andere in den Depots zutage gefördert, das „die Integrität des Inventars beeinträchtigt".[30] Wie umgehen mit diesem „Zuvielbesitz", der unter Umständen nur marginale kunsthistorische Bedeutung hat und aus kunst- und sammlungshistorischen Gründen in Dauerausstellungen nicht einbezogen werden kann, für die Museen aber erheblichen konservatorischen Aufwand bedeutet.[31] Sicher kann nicht an eine einfache Adaption oder Orientierung an der Washingtoner Erklärung gedacht werden – dafür ist die Lage zu unterschiedlich.[32] Dennoch gilt es, für die Zukunft gerechte und faire Lösungen zu finden.[33]

Die Gutachtertätigkeit des Museums

Ein besonderes Augenmerk sollte die Provenienzforschung der Zeit von 1945 bis 1990 auch auf die Gutachtertätigkeit der Museumsmitarbeiter legen, ein Bereich, in dem sie mit staatlichen Vorgaben konfrontiert beziehungsweise in staatliches Handeln eingebunden waren.[34] Die Gutachtertätigkeit richtete sich vorerst nach der „Verordnung zum Schutze des deutschen Kunstbesitzes und des Besitzes an wissenschaftlichen Dokumenten und Materialien" vom 2. April 1953.[35] Danach war generell die Ausfuhr von Kunstwerken, Dokumenten, Materialien und Objekten von allgemeinem kulturellem Wert sowie besonderer historischer Bedeutung genehmigungspflichtig.[36] Der DDR beziehungsweise den betreffenden staatlichen Institutionen stand laut § 4 des Kulturgutschutzgesetzes ein Vorkaufsrecht „im Falle der mit einer Ausfuhr verbundenen Veräußerung" zu, das mehr und mehr zu einem generellen Vorkaufsrecht bei nicht genehmigter Ausfuhr interpretiert wurde.

Im Schweriner Museum finden sich im Archiv neben einem eigenen Bestand „Gutachten über Kunstgegenstände zur Ausfuhr aus der DDR", der über den Zeitraum 1963 bis 1989 reicht, verstreut in Akten und Ordnern weitere Gutachten.[37] Das älteste erhaltene Gutachten wurde 1958 vom Restaurator des Museums, Weise, ausgefertigt und bescheinigte einem Genrebild von Jean Didier aus dem späten 19. Jahrhundert die Unbedenklichkeit der Ausfuhr.[38] Doch nicht nur Mitarbeiter des Museums beteiligten sich als Sachverständige gemäß § 3 der Kulturgutschutzverordnung von 1953 an den Genehmigungsverfahren. 1965 beschwerte sich der Direktor des Museums, Walter Heese, in einem Brief an die Stadträtin Steinhübel darüber, „daß zur Abgabe von Expertisen über Kunstgut (Gemälde, Plastiken, antike Möbel), das zur Ausfuhr bestimmt ist, sehr oft ein Herr Drewing als Fachmann fungiert. Drewing ist kein Fachmann. Expertisen über Kunstgut, welcher Art auch immer, darf nur das Staatliche Museum Schwerin ausstellen. Ich muß Dich bitten, Deine Dienststelle anzuweisen, daß sich private Antragsteller zur Antragstellung zur Erlangung einer Ausfuhrgenehmigung an die Direktion des Staatlichen Museums Schwerin zu wenden haben."[39]

Nicht nur in Ausreiseverfahren wurden die Gutachter des Staatlichen Museums herangezogen, sondern auch für Wertbe-

stimmungen in Scheidungsprozessen,[40] von Versicherungen und in Strafprozessen.[41] Und selbstverständlich war das Museum erster Ansprechpartner bei aufgefundenen Bildern.

Wegen des Verfahrens bei der Begutachtung von Kulturgut aufgrund einer „Ständigen Ausreise" aus der DDR, so der Terminus der DDR-Bürokratie, scheint es im Laufe der Jahre immer wieder zu Unstimmigkeiten gekommen zu sein, vor allem zwischen Zoll und Rat des Bezirks sowie zwischen Zoll und Museum.[42] Bis Ende 1988 gab es in der DDR keine Rechtsgrundlage dafür, einen „Antrag auf ständige Ausreise" in die BRD stellen zu können. Offiziell existierte nicht einmal eine zuständige Stelle. Die meisten wendeten sich an die Abteilung Inneres beim Rat des Kreises, des Bezirkes oder des Stadtbezirkes.[43]

In einem Schreiben des Direktors Hans Strutz vom 29. November 1977 an den Leiter des Binnenzollamtes, Krüger, wird eine grundsätzliche Angelegenheit angesprochen: Mitarbeiter des Zolls verwiesen Antragsteller wegen Gutachten über Geschenksendungen immer wieder an das Museum: „Das widerspricht den Bestimmungen und den bestehenden Festlegungen. Das Staatliche Museum ist nur befugt, Gutachten auszustellen, wenn es sich um Umzugs- und Erbschaftsgut handelt. Diese Gutachten werden von uns im Auftrag des Rates der Stadt, Abt. Kultur ausgefertigt. Geschenksendungen unterliegen rechtlich und leitungsmäßig Ihrem Verantwortungsbereich [...] Deshalb darf es nicht sein, daß Bürger von einer zur anderen Einrichtung geschickt und verärgert werden."[44]

Häufig trat auch der Fall ein, dass Bürger der DDR nicht wussten, dass sich schützenswertes Kulturgut in ihrem Besitz befand, sondern erst der Zoll, der die Liste mit dem auszuführenden Eigentum vom jeweiligen Rat bekam, darauf aufmerksam machte und dann häufig unter Zeitnot, wie auch von den Mitarbeitern des Museums bemängelt wurde, gehandelt werden musste. „Der Demütigung des langen Wartens auf die Ausreise folgte die Demütigung der würdelosen Eile."[45] Beispielhaft sei hier ein Fall vom 24. September 1974 genannt. Der Zoll bemängelte die Ausfuhrliste und stellte einen Schreibschrank und einen Mörser infrage. Daraufhin wandte sich die Bürgerin aus Ludwigslust an den Rat des Bezirks Schwerin; Ausreise und Verladung sollten bereits am 15. Oktober

Antrag auf Ausfuhrgenehmigung für einen Mahagoni-Schreibschrank und einen Mörser aus Messing, Staatliche Schlösser, Gärten, Museen und Kunstsammlungen Mecklenburg-Vorpommern

1974 stattfinden. Ihr Schreiben wurde an das Museum in Schwerin zur Bearbeitung weitergeleitet, das wandte sich am 27. September 1974 an die Betreffende, die Unbedenklichkeitsbestätigung, unterschrieben vom Direktor des Museums, Hans Strutz, für die beiden Dinge datiert vom 3. Oktober 1974. In diesem Fall konnten die Zeitvorgaben eingehalten werden, obwohl Begutachtungen außerhalb der Stadt bei so kurzen Fristen häufig Schwierigkeiten bereiteten.[46]

Mit der Annahme der UNESCO-Konvention über Maßnahmen zum Verbot und zur Verhütung der unzulässigen Einfuhr, Ausfuhr und Übereignung von Kulturgut⌀ durch die DDR am 10. Juni 1974 verschärften sich Ton und Maßnahmen bei der Begutachtung.[47] Die DDR nahm den in der Präambel formulierten Grundsatz, das Kulturgut eines Landes vor Diebstahl, der heimlichen Ausgrabung und der gesetzwidrigen Ausfuhr zu schützen, zum Anlass, ihre eigene Kulturgutschutzpolitik restriktiver auszugestalten. In einem

⌀ Das Übereinkommen ist auf der 16. Tagung der UNESCO-Generalkonferenz in Paris am 14. November 1970 verabschiedet worden.

Briefwechsel mit einem Erben in Freiburg/Breisgau, der wiederholt um Auskunft zu einem in Boizenburg geerbten Schreibsekretär bat, findet sich eine Randnotiz des Direktors vom Januar 1976: „Der Brief wird nicht beantwortet, da gegenüber unserer Antwort vom 30.05.74 keine veränderte Situation vorliegt, die eine Ausfuhr ermöglicht. Im Gegenteil!"[48] Auffallend ist auch, dass in den ersten Jahren nach der Annahme der UNESCO-Konvention mehr Stücke in der DDR bleiben mussten, während bis dahin größtenteils Unbedenklichkeitsbescheinigungen ausgestellt worden waren.[49] Auch scheint der Ton in den Gutachten ab 1974 schärfer, häufiger ist von „Nippes", „protzigen" Stücken und dergleichen zu lesen.[50]

Darüber hinaus wollte man nun vonseiten des Museums umfassender über das Umzugsgut informiert werden: In einem Begleitschreiben zu einem Gutachten, das der Leiter der Abteilung Kultur beim Rat der Stadt, Hansgeorg Haselein, am 23. Juli 1975 angefordert hatte, gab Hans Strutz zu bedenken: „Bei der Begutachtung wurde festgestellt, daß weitere Gegenstände, die zur Ausfuhr vorgesehen sind, einer Überprüfung bedurften. [...] Es scheint uns ratsam, daß alle eingereichten Listen der Bürger generell überprüft werden, da meine Mitarbeiter ansonsten nicht befugt sind, entsprechende Einsicht in das Umzugsgut zu nehmen. Auf diese Weise kann wertvolles Kunstgut verloren gehen. Die Bürger müßten darüber informiert werden, daß den Museumsmitarbeitern bis auf Bücher alle Dinge vorzustellen sind. Ich mache darauf aufmerksam, daß trotz bestimmter Fortschritte bei der Regelung des Genehmigungsverfahrens von den zuständigen Zollorganen mehrfach den Bürgern die Auskunft erteilt wurde, daß sie ihr bewegliches Eigentum ausführen könnten. Das ergab Komplikationen bei der Gutachtertätigkeit."[51]

Dieser Wunsch wurde umgesetzt, nunmehr erreichten das Museum die kompletten Umzugslisten der Ausreisenden, die akribisch durchgesehen und bearbeitet wurden. Handelte es sich „um Gebrauchsgegenstände, die nicht der Begutachtung unterliegen", wurden diese entsprechend in den Listen gekennzeichnet – bis hin zu Aschenbechern, Garderobenhaken oder Filtertüten entging nichts den wachsamen Augen der Gutachter.[52]

Besonders interessant für die Provenienzforschung sind jene Objekte, denen das Museum keine Unbedenklichkeit bescheinigte und um die es sich selbst bemühte, häufig mit Erfolg. Bürgern, die

ausreisen wollten, schien mehr oder weniger klar gewesen zu sein, dass Kulturgut einer Begutachtung unterlag und nicht alles mit in „den Westen" genommen werden konnte. Dabei scheint es mit den Gutachtern zu Absprachen darüber gekommen zu sein, was für das Museum besonders reizvoll und was den Ausreisenden besonders lieb und teuer war.[53]

Auf diesem Wege kaufte das Museum die *Junge Holländerin am Klavier* von Walter Firle (1859–1929) an. Die Vorbesitzerin aus Schwerin konnte außer diesem Gemälde alles weitere mitnehmen; die endgültige Ausfuhrliste enthielt an die 100 Positionen, darunter auch eine Porzellanminiatur aus der ersten Hälfte des 19. Jahrhunderts. Am 27. Februar 1974 bestätigte Direktor Fritz Schwarzer, der Vorgänger von Dr. Strutz, „daß diese Dinge keinen museal-künstlerischen Wert besitzen und gegen ihre Ausfuhr in die BRD keine Bedenken bestehen".[54]

Wünsche des Museums wurden mehr oder weniger direkt geäußert. Am 21. Januar 1976 wurde der Rat der Stadt in einem Ausreiseverfahren darüber informiert, dass „das Museum die Möbel von musealem Wert gerne erwerben möchte",[55] in einem anderen, dass man einen Glaslüster in Absprache mit den Besitzern von der Liste genommen habe und diesen nun gern erwerben würde, da „er für die Ausstattung des Schweriner Schlosses in Frage käme".[56] Über den Ankauf von ausreisenden Bürgern sind drei Gemälde des mecklenburgischen Malers Rudolf Bartels (1872–1943) in den Besitz des Museums gekommen. 1971 kam ein Gutachten zu dem Ergebnis, dass „dieses Gemälde mit bestem Wissen und Gewissen nicht zur Ausfuhr zugelassen wird". Weiter schrieb die damalige Direktorin Ingeborg Michailoff: „Ich würde mich freuen, wenn ich Sie persönlich noch einmal aufsuchen könnte, um mich mit Ihnen über das Bild zu unterhalten." Das Resultat der Unterredung war die Schenkung des *Stilllebens mit Muschel, Blumentopf und Bällen*, entstanden um 1912, an das Museum. In einem Dankesbrief tröstete die Direktorin den bisherigen Besitzer: „Ich möchte Ihnen sehr herzlich im Namen des Museums danken, daß Sie uns das Stilleben von Rudolf Bartels, das aus Gründen der gesetzlichen Bestimmungen über die Ausfuhr von Kunstgut aus der DDR bei Ihrer Übersiedlung in die BRD nicht in das Umzugsgut einbezogen werden kann, als Geschenk überlassen. Ich weiß, daß Sie gerade an diesem Bild sehr hängen. Aber vielleicht ist es Ihnen ein Trost, daß dieses

Eine „Wunschliste" des Schweriner Museums, 1979, Staatliche Schlösser, Gärten, Museen und Kunstsammlungen Mecklenburg-Vorpommern

Erläuterungen zum Gutachten des Erbschaftsgutes von Herrn 282 Hagenow,

Zu unserem Gutachten gehören die umfangreichen Listen über das gesamte auszuführende Kulturgut. Wir haben nur bestimmte Positionen daraus hervorgehoben, deshalb ergibt sich ein unreales Bild.

Zu den Gemälden:
Die angekreuzten Bilder wären für Hagenow interessant (für uns nicht). Natürlich sind es keine außergewöhnlichen Stücke, aber sie sind sehr typisch für die Zeit.
Nr. 23 – in Elfenbein eingelegte Miniaturen, die besonders reizvoll sind.

Möbel:
Auch diese Arbeiten sind nicht außergewöhnlich. Der Eckschrank ist ein sehr gutes Biedermeierstück und wäre für unser Schloß geeignet, ebenso die Armlehnstühle. Die beiden Truhen sind sehr schön, die eine ist datiert. Solche Stücke werden natürlich immer seltener. Wir benötigen die Truhen nicht, evtl. die datierte. Aber für Hagenow wären sie sehr geeignet.

Uhren:
Sehr gute Arbeiten. Nicht unbedingt für uns notwendig, aber es wäre schade, wenn sie ausgeführt würden.

Metall:
Für den aufgeführten Akt würden wir uns interessieren.

Porzellan:
Wäre für uns interessant, besonders auch der Steingutkrug (33) und die Zinnkanne (34).

Der Kunsthandel würde sofort alle Stücke erwerben, die von uns nicht gekauft werden können. Es ist letztlich natürlich auch eine Frage der Finanzen und der Einstellung zu der ganzen Sache.

Schwerin, d. 22.2.1979

Bild nun der Bevölkerung zugänglich gemacht wird und viele sich daran erfreuen können." Dieser Brief erleichterte dem ehemaligen Besitzer den Abschied, „von dem mir sehr werten Bilde. Ich bin sicher, daß das schöne Stück, wenn es erst in der kostbaren Sammlung des Staatlichen Museums hängt, vielen Besuchern Freude bereiten wird."[57]

Ein weiterer Bartels, *Topf mit blühenden Alpenveilchen*, kam 1979 an das Museum. Der Vorbesitzer, ein Pastor aus Schwaan, durfte an die 40 Radierungen, Ölgemälde und andere Objekte ausführen, die *Alpenveilchen* erwarb das Museum und „sah daher von einer Gutachtergebühr ab". Als der bisherige Eigentümer die For-

malitäten beim Binnenzollamt Schwerin erledigte, wollte er die Gelegenheit nutzen, um seinen Bartels im Museum anzusehen; doch „leider sei das Museum ja bis auf weiteres geschlossen", wie er der Gutachterin durchaus freundlich mitteilte.[58]

Die prominenteste Erwerbung eines Bartels fällt in das Jahr 1980. Die Gutachterin teilte dem Rat des Bezirkes Schwerin, Mitglied des Rates und Leiter der Abt. Kultur, Tober, am 26. August 1980 mit: „Wie ich Sie bereits mündlich informierte, hat Frau Erika Schult dem Staatlichen Museum Schwerin eine Winterlandschaft des bedeutenden mecklenburgischen Malers Rudolf Bartels geschenkt. Wir möchten daher von einer Gutachtergebühr absehen, denn das Bild hat mindestens einen Wert von 3.000 M.!" Mit demselben Datum findet sich ein Brief an Erika Schult in Güstrow, der Witwe von Friedrich Schult, einem engen Freund Ernst Barlachs und Ersteller von dessen Werkverzeichnis: „Da sich eine günstige Gelegenheit für den Transport des Bildes nach Schwerin ergab, habe ich den Bartels so schnell abholen lassen und hoffe, daß Sie der helle Fleck an der Wand nicht zu sehr schmerzt. Sehr herzlich möchte ich mich, auch im Namen von Direktor Dr. Strutz, nochmals für das schöne Bild bedanken, bedeutet es doch für unsere Sammlung mecklenburgischer Malerei eine wertvolle Bereicherung." Die Liste der Gegenstände, die ausgeführt werden durften, ist über 25 Seiten lang, darunter auch Schmuck und Silber, das unüblicherweise vom Museum mitbegutachtet wurde, was dem Rat lapidar mitgeteilt wurde. Das Silber sei „ohne besonderen künstlerischen Wert", der Schmuck ebenso, die Möbel seien zwar von antiquarischem Wert, „finden sich aber häufig in unserem Territorium und sind in besserer Qualität im Historischen Museum".[59] Auch in diesem Fall scheinen Absprachen getroffen worden zu sein, die unter den gegebenen gesetzlichen Bedingungen durchaus in beiderseitigem Interesse gewesen sein konnten.

Gern hätte das Museum weitere Gemälde von Bartels angekauft. Am 28. Oktober 1977 schrieb Direktor Strutz an eine Familie in Güstrow, man „habe vor kurzem erfahren, daß sich in Ihrem Besitz ein Gemälde des mecklenburgischen Malers Rudolf Bartels befinden soll". Strutz äußerte den Wunsch, es zu erwerben. Die so angeschriebene Familie reagierte am 2. November 1977 erschrocken – man besitze kein Bild – und wollte wissen, woher die Information stamme. In seiner Antwort vom 23. November 1977

bedauerte der Direktor, „daß wahrscheinlich ein Irrtum vorliegt. Da wir mit unserer Anfrage nicht beabsichtigen, daß es eventuell zu Unstimmigkeiten zwischen Ihnen und dem Vermittler kommt, möchten wir von einer Angabe des Namens absehen." Der Informant blieb ungenannt.[60]

Mit der vierten Durchführungsbestimmung zum Kulturgutschutzgesetz – Tätigkeit der Kulturgutsachverständigen – vom 24. August 1984 änderten sich die Kompetenzen des Direktors, er war nun nicht mehr weisungsberechtigt, die Schwierigkeit aber blieb bestehen: In der Regel waren die Gutachter auch die Ankäufer eines Museums, was Zweifel an ihrer Objektivität entstehen lässt.[61] Zudem hatten sie einen relativ großen Spielraum bei der Definition geschützten Kulturguts. So blieb es in der Regel den Gutachtern überlassen, ob Kulturgut die DDR verlassen konnte oder ob es innerhalb der Staatsgrenzen verbleiben musste und unter Umständen als Schenkung oder Ankauf den Weg ins Museum fand.

Michael Busch

Michael Busch ist wissenschaftlicher Projektmitarbeiter der Staatlichen Schlösser, Gärten und Kunstsammlungen Mecklenburg-Vorpommern.

Förderung des Grundlagenprojekts „Die Rolle und Funktion des Staatlichen Museums Schwerin zwischen 1945 und 1990 beim Umgang mit entzogenen Kulturgütern auf dem Gebiet des ehemaligen DDR-Bezirks Schwerin" von Februar 2020 bis Januar 2022.

Endnoten

[1] Schreiben des Direktors Heese an den Rat des Bezirkes Schwerin, Abt. Kultur vom 28.9.1967, Archiv des SMS, Ordner 32, Rat des Bezirks 1957 bis 1967.

[2] Bericht des Direktors Walter Heese an den Rat der Stadt Schwerin, Abt. Kultur, von 1963, Archiv des SMS, ebd.

[3] Aktennotiz des Direktors Dr. Hans Strutz über ein Telefonat mit der Genossin Helga Wiegand (vormals Fehr) vom 18.11. (o. J.) Der Leihvertrag mit der Botschaft der DDR in Paris datiert vom 31.3.1984, Archiv des SMS, Ordner Sammelsurium.

[4] Schreiben des Direktors Theo Piana an die Abteilungsleiter des Museums vom 17.3.1961, Archiv des SMS, Ordner 32, Rat der Stadt ab 1957 bis 1972; Konzeption für den Aufbau und das Wirken des Bezirksmuseums von Hans Strutz, Stellvertreter des Vorsitzenden des Rates des Bezirkes Schwerin, vom 25.3.1964 und Brief von Hans Strutz an Walter Heese, Direktor des Staatlichen Museums, vom 26.3.1964, Archiv des SMS, Ordner 32, Rat des Bezirks ab 1957 bis 1967. Dieser Hinweis fehlt bei Wolf Karge: Landes- und Regionalgeschichte in Mecklenburgs Museen, in: Anke John (Hg.): Köpfe, Institutionen, Bereiche. Mecklenburgische Landes- und Regionalgeschichte seit dem 19. Jahrhundert, Lübeck 2016, S. 225–255.

[5] Das Museum ist Teil der Staatlichen Schlösser, Gärten und Kunstsammlungen Mecklenburg-Vorpommerns.

[6] Aus dieser Zeit stammen vier Zugangsbücher I (1.1.1920–13.12.1972), II (19.1.1973–4.12.1984), III (6.1.1985–1.10.1987), IV (1.10.1987–18.12.1990). Ab Dezember 1957 wurden die Zugänge mit der namentlichen Nennung des Bearbeiters versehen; auch die genaue Datierung des Erwerbs, die am 4.10.1939 aufgegeben worden war, wurde wiedereingeführt.

[7] Zugangsbuch I, Jahresnummern 52023 bis 52046.

[8] Zugangsbuch I, Jahresnummern 53010 bis 53033, mit „R" gestempelt.

[9] Zugangsbuch I, Jahresnummern 49039 bis 49040.

[10] Regierungsblätter für Mecklenburg 1947, S. 26. Vgl. auch Harald König: Die Entziehung und Verlagerung von Kulturgütern als offene Vermögensfrage. Lösungswege des Gesetzgebers im Zuge der Wiedervereinigung, in: Dirk Blübaum, Bernhard Maaz, Katja Schneider (Hg.): Museumsgut und Eigentumsfragen. Die Nachkriegszeit und ihre heutige Relevanz in der Rechtspraxis der Museen in den neuen Bundesländern, Workshop und Erfahrungsaustausch Schloss Güstrow 18. und 19. April 2012, Halle 2013, S. 27–36, hier S. 30.

[11] Zugangsbuch I, Jahresnummern 63108 bis 63110.

[12] Schriftverkehr SMS mit dem Staatlichen Museum in Berlin 1957 sowie Liste der übernommenen Gegenstände in Archiv SMS, Ordner 94, Verwahrungen, Leihgaben, E2d 46. Vom Verfasser des Beitrages wurde ein Antrag auf Akteneinsicht bei der BStU gestellt.

[13] Zugangsbuch I, Jahresnummer 60035.

14 So zutreffend Alexander Sachse: Schlossbergung, Republikflucht, Kommerzielle Koordinierung. Kritische Provenienzen aus der Zeit der SBZ und DDR, in: Museumsblätter. Mitteilungen des Museumsverbandes Brandenburg, Heft 35, Dezember 2019, S. 18–37, hier S. 22. Siehe hier auch die unterschiedlichen Kategorien kritischer Provenienzen, Bodenreform, (Schloss-)Bergung, Plünderung, „Republikflucht", Besitzwechsel im Zusammenhang mit der Kulturgutschutzgesetzgebung, Einlieferung durch staatliche Institutionen, Staatlicher Kunsthandel und die Kunst und Antiquitäten GmbH, die im vorliegenden Text vorausgesetzt und nicht mit den einzelnen gesetzlichen Grundlagen aufgeführt werden.

15 Zugangsbuch I, Jahresnummern 56001 und 56002.

16 Zugangsbuch I, Jahresnummern 61072 und 61073. Am 26.11.2020 wurde vom Verfasser Antrag auf Akteneinsicht bei der BStU gestellt, am 11.12.2020 wurde der Antrag wunschgemäß an die Außenstelle Schwerin übermittelt. Eine Antwort von dort steht zum Zeitpunkt der Abfassung des Beitrages noch aus.

17 Schreiben des Direktors Dr. Hans Strutz an Prof. Dr. S. G. in Goslar vom 5.7.1982, Archiv des SMS, Ordner XI, Gemälde, Angebote Ankäufe, Auskünfte. Beim zweiten Werk handelte es sich um *Auguste Victoria am Näerofjord, 1900.*

18 Zugangsbuch III, Jahresnummern 87/34 bis 87/38.

19 Johann Viktor Bausch: Eine der renommiertesten Feinpapierfabriken Europas. Zur Geschichte der Firma Felix Schoeller & Bausch in Neu Kaliß, in: Mecklenburg, Zeitschrift für Mecklenburg-Vorpommern, 47. Jg., Heft 10/2005, S. 18 f.; Hans Joachim Bötefür: 200 Jahre Papier aus Neu Kaliß 1799–1999, Ludwigslust 1999, S. 5–9; Gerhard Beckel: 100 Jahre Feinpapierfabriken Neu Kaliß. Ein Beitrag zur Geschichte des VEB Feinpapierfabriken Neu Kaliß, Ludwigslust 1971, S. 7–27.

20 Thomas Bausch: Papierfabrik Neu Kaliß – die „Bausch Zeit" 1871–1950, in: Elde Kurier, 8. Jg., 35. Woche, 31.8.1999, S. 18 f.

21 Ebd., S. 18.

22 Christian Moeller: Ein vergessener Widerstandskämpfer. Der Papierfabrikant Viktor Bausch aus Neu Kaliß, in: Mecklenburg-Schwerin delüx, Regionalmagazin, 13. Jg., Heft 3/2008, S. 22.

23 Erika von Hornstein: Der gestohlene Phoenix, erw. Ausg., Frankfurt a. M. 1993 (1956).

24 Ebd., S. 151. Die Erinnerungen mit Formulierungen wie „der Iwan" (S. 216), „Russen, Russen, hingestreckt auf das Stroh der Panjewagen, schauten sie mit steinernen Urweltgesichtern zu uns empor." (S. 12) oder „Wenn Russen kamen, wir rochen es schon vorher." (S. 52) sind heute nur schwer lesbar. Dennoch liefert der Bericht recht genau Nachricht über die verschiedenen Einquartierungen sowjetischer Truppenteile in den ehemaligen Fabrikantenvillen und die Plünderungen und macht deutlich, warum vonseiten der Familie nach 1990 kaum noch mit der Existenz von Stücken aus dem ehemaligen Familienbesitz gerechnet wurde.

[25] Abgedruckt in: Hornstein 1993, S. 178 f.

[26] Bausch 1999, S. 19; Bötefür 1999, S. 15.

[27] Abgedruckt bei von Hornstein 1993, S. 321.

[28] Bötefür 1999, S. 15.

[29] Gutachten und Schreiben an den Rat des Kreises Ludwigslust, Abt. Kultur, vom 18.10.1988, Archiv des SMS, Gutachten über Kunstgegenstände zur Ausfuhr aus der DDR, Nr. 2.0007, 1984 bis 1988, S. 285 f.

[30] So der ehemalige Direktor der Klassik Stiftung Weimar, Hellmut Seemann: Restitution – nur Last oder auch Lust der Wiedervereinigung? Ein kritischer Erfahrungsbericht aus der Klassik Stiftung Weimar, in: Blübaum 2013, S. 15–25, hier S. 17.

[31] Cornelia Munzinger-Brandt: Diskussion über „Zuvielbesitz" und leere Räume. Fallbeispiele und Lösungsansätze zur Restitution von Museumsgut in den neuen Bundeländern, in: Blübaum 2013, S. 79–89, hier 85–87.

[32] Gilbert Lupfer: Zeitgeschichte und Eigentumsfragen. Zur Gemengelage in den Zugängen eines ostdeutschen Museums seit dem Kriegsende 1945, in: Blübaum 2013, S. 42–44, hier S. 43.

[33] Seemann 2013, S. 17.

[34] Vgl. hierzu Torsten Fried: Von Ausreisen und Gutachten. Akten im Staatlichen Museum in Schwerin, in: Museumsblätter. Mitteilungen des Museumsverbandes Brandenburg, Jg. 35, Dezember 2019, S.48–51, hier S. 49.

[35] GBL der DDR I 46/53, S. 522f.

[36] GBL der DDR I, 14/78, S. 165, oder im Gesetz zum Schutz des Kulturgutes der Deutschen Demokratischen Republik – Kulturgutschutzgesetz – vom 3.7.1980, GBL I der DDR, 20/80, S. 191.

[37] Der Bestand „Gutachten über Kunstgegenstände zur Ausfuhr aus der DDR", Aktennummern 2.0002 bis 2.0007, umfasst 557 Gutachten mit über 1800 Blatt.

[38] Schreiben des Restaurators Weise an den Rat der Stadt Schwerin, Abt. Kultur vom 13.3.1958, Archiv des SMS, Ordner 32, Rat der Stadt ab 1957 bis 1972.

[39] Brief von Direktor Walter Heese an Frau Stadtrat Steinhübel, Rat der Stadt Schwerin, Abt. Kultur, vom 11.8.1965, Archiv SMS, ebd.

[40] Mehrere Schreiben aus dem Jahre 1974 an das Kreisgericht Schwerin Stadt, Archiv des SMS, Ordner XI, Gemälde, Angebote, Ankäufe, Auskünfte.

[41] Briefwechsel mit dem Kreisgericht Schwerin von 1980, Archiv des SMS, Schriftwechsel Allg. A–K, ab 1975; Gutachten für den Militärstaatsanwalt Schwerin vom 22.11.1979 und Gutachten über Kunstgegenstände zur Ausfuhr aus der DDR 2.0004, 1979 bis 1980, S.143 f.

[42] Mündliche Auskunft einer damaligen Gutachterin des Museums, Telefonat am 15.7.2020.

[43] Ilko-Sascha Kowalczuk: Die Überwindung der deutschen Teilung durch Flucht und Ausreise. Eine historische Einordnung, in: Jana Göbel, Matthias Meisner (Hg.): Ständige Ausreise. Schwierige Wege aus der DDR, Berlin 2019, S. 16–32, hier S. 22–27.

[44] Schreiben Hans Strutz an Gen. Krüger vom Binnenzollamt vom 29.11.1977, Archiv des SMS, Ordner Schriftwechsel Allg. A–K, ab 1975.

[45] Kowalczuk 2019, S. 28.

[46] Archiv des SMS, Schriftwechsel und Gutachten, in: Gutachten über Kunstgegenstände zur Ausfuhr aus der DDR 2.0002, 1979 bis 1980, S. 214–216.

[47] GBL der DDR II, 20/74, S. 399.

[48] Archiv des SMS, Gutachten über Kunstgegenstände zur Ausfuhr aus der DDR 2.0003, 1975 bis 1978, S. 17.

[49] Archiv des SMS, ebd. und 2.0004, 1979 bis 1980. Vgl. Fried 2019, S. 50.

[50] Gutachten vom 20.8.1975, Archiv des SMS, Gutachten über Kunstgegenstände zur Ausfuhr aus der DDR 2.0002, 1963 bis 1975, S. 275.

[51] Schreiben Hans Strutz vom 23.7.1975, Archiv des SMS, ebd., S. 263.

[52] Schreiben Hans Strutz vom 14.9.1978 an den Rat der Stadt Schwerin, Archiv des SMS, Gutachten über Kunstgegenstände zur Ausfuhr aus der DDR 2.0003, 1975 bis 1978, S. 380–388; Schreiben vom 17.11.1978, ebd., S. 417–428; Gutachten vom 24.8.1983, Gutachten über Kunstgegenstände zur Ausfuhr aus der DDR 2.0006, 1975 bis 1989, S. 100–105.

[53] Gespräch mit einer ehemaligen Gutachterin vom 15.7.2020.

[54] Schreiben Direktor Schwarzers vom 27.2.1974, Archiv des SMS, Gutachten über Kunstgegenstände zur Ausfuhr aus der DDR 2.0002, 1963 bis 1975, S. 127.

[55] Schreiben der Gutachterin vom 21.1.1976 an den Rat der Stadt Schwerin, z. Hd. Koll. Niemann, Archiv des SMS, Gutachten über Kunstgegenstände zur Ausfuhr aus der DDR 2.0003, 1975 bis 1978, S. 6.

[56] Schreiben der Gutachterin vom 17.9.1976 an den Rat des Bezirkes, Gen. Horst Tober, ebd., S. 125a.

[57] Briefwechsel vom November 1971 von Dr. Ingeborg Michailoff mit dem Besitzer des Bildes, das sich im Bestand des Museums befindet und die Inventarnummer G 2874 trägt. Archiv des SMS, Ordner XI, Gemälde, Angebote, Ankäufe, Auskünfte.

[58] Brief von Hans Strutz vom 16.4.1979 an den Rat des Kreises Bützow und Brief des Pastors an die Gutachterin vom 19.4.1979, Archiv des SMS, Gutachten über Kunstgegenstände zur Ausfuhr aus der DDR 2.0004, 1979 bis 1980, S. 47 und S. 50. Das Bild hat die Inventarnummer G 3206.

[59] Gutachten und Schriftverkehr zur Ausreise Erika Schult vom 26.8.1980, Archiv des SMS, Gutachten über Kunstgegenstände zur Ausfuhr aus der DDR 2.0004, 1979 bis 1980, S. 245–272. Im Normalfall war der Rat des Bezirks, Abt. Finanzen, für die Einschätzung von Edelmetallen und Schmuck zuständig. So Hans Strutz in einem Gutachten vom 7.11.1977, Archiv des SMS, Gutachten über Kunstgegenstände zur Ausfuhr aus der DDR 2.0003, 1975 bis 1978, S. 280.

[60] Archiv des SMS, Ordner Schriftwechsel Allg. A–K, ab 1975.

[61] Deutscher Bundestag, Dritte Beschlussempfehlung und dritter Teilbericht des 1. Untersuchungsausschusses nach Art. 44 des Grundgesetzes, Bonn, 3.3.1993, Drucksache 12/4500.

Flucht und Ausreise

Zum Verbleib von Kunst- und Kulturgut aus den Rücklässen „Republikflüchtiger" – eine Grundlagenstudie im ehemaligen Bezirk Schwerin

Antje Strahl, Reno Stutz

On the whereabouts of art and cultural property from the remains of illegal emigrants. A basic study in the former GDR district of Schwerin
Between 1945 and 1989, several million people left the territory of the Soviet occupation zone or the GDR for West Berlin and the western occupation zones or the Federal Republic of Germany without having reported this legally to the authorities beforehand. In many cases, they only took with them what they could carry in a suitcase. While previous research has focused in particular on how the GDR authorities dealt with abandoned real estate and private businesses, the project funded by the German Lost Art Foundation focused on the treatment of art and cultural property in refugee estates in the former GDR district of Schwerin. After reviewing a large number of files, inventory books, museum card indexes and other historical material, it can be stated that the directories on refugee estates contain only few references to art and cultural property. Rather, in addition to real estate, livestock, and agricultural equipment, they are mostly simple household goods, most of which were released by the authorities for distribution to institutions such as schools, clubs, or children's homes, or for sale at low prices to neighbors and residents. The low proportion of art and cultural property can be explained by the population and economic structure of the district: A very high proportion of the inhabitants in the agricultural region and in the small agrarian towns were refugees from the former German eastern territories. Art and cultural property of value were handed over to the museums of the district after an appropriate expert valuation.
In dealing with the research topic, the handling of bequests from abandoned estates and manors, the so-called Schlossbergung (palace salvage), was explicitly excluded.

Von 1945 bis 1989 flohen mehrere Millionen Menschen aus der Sowjetischen Besatzungszone (SBZ) beziehungsweise der DDR in den Westen. Aus Sicht der DDR-Behörden galt dies als Straftatbestand. Ab 1962 bestand die Möglichkeit, insbesondere für Rentner, die DDR legal zu verlassen.

Die „Republikflucht" wurde in den letzten Jahrzehnten gründlich erforscht. Eine intensive Betrachtung erfuhr auch die Nutzung der in der SBZ/DDR zurückgelassenen Immobilien und Betriebe sowie diesbezügliche Eigentumsverhältnisse. Die Mög-

lichkeit der Rückübertragung im Zuge der Tätigkeit der Landesämter für die Regelung offener Vermögensfragen (LARoV) beförderte diese Untersuchungen. Demgegenüber stellen Nachforschungen zum Verbleib des zurückgelassenen privaten Hausrates und dem darin befindlichen Kunst- und Kulturgut[1] ein Desiderat dar. Gleiches gilt für den Umgang kommunaler und staatlicher Einrichtungen sowie der Verwaltungs-, Polizei- und Justizbehörden mit den Rücklässen und deren Überführung in Volkseigentum. Auch über die Verfahren und Wirkungsmechanismen bei der Übergabe von Gegenständen mit kulturellem Wert aus privaten Haushalten an Museen sowie deren Umfang ist bisher kaum etwas bekannt.

Die im Zuge des Projekts erarbeitete Grundlagenstudie untersucht den unrechtmäßigen Entzug von Eigentum vor dem Hintergrund der „Republikflucht" im ehemaligen Bezirk Schwerin. Im Fokus standen die Fragen: Worum handelte es sich bei Flüchtlingsrücklässen? Befand sich Kunst- und Kulturgut darunter? Wie, wo und von wem wurden die Rücklässe erfasst, verwaltet, begutachtet, bewertet oder veräußert? Was geschah damit unmittelbar, wohin gelangte es später, wo befindet es sich heute? Gibt es Kennzeichen, Erfassungslisten oder andere Archivalien, die zu seiner Aufspürung, Erforschung, Dokumentation dienen können? Wo sind Teile solcher Rücklässe 1990 nachweisbar, was geschah nach 1990 damit, wie sind sie heute – zum Beispiel innerhalb öffentlicher Sammlungen – erkennbar, ermittelbar, einzuordnen?

Darüber hinaus sollte untersucht werden, welche Gesetze und Verordnungen jeweils gegolten haben und welche gesetzlichen Grundlagen heute für das damals abhanden gekommene Kunst- und Kulturgut gelten oder fortgelten, beispielsweise Ersitzung, Verjährung, Rehabilitierungs- oder Vermögensgesetze.

Untersuchungsgebiet

Zum Bezirk Schwerin gehörten der Stadtkreis Schwerin und die Landkreise Bützow, Gadebusch, Güstrow, Hagenow, Ludwigslust, Lübz, Parchim, Perleberg, Schwerin und Sternberg. 1958 lebten im Bezirk 634.060 Menschen. 1989 waren es 595.200.

Bis 1945 war Westmecklenburg weitgehend ein agrarisch geprägtes Gebiet gewesen. Nur die einstigen Residenzstädte Güstrow, Ludwigslust und Schwerin hoben sich von den Acker-

bürgerstädten ab. Ausnahmen bildeten Grabow und Parchim, in denen alteingesessene kleinere Unternehmen angesiedelt waren.

Zwischen 1944 und 1946 verdoppelte sich die Bevölkerung in Mecklenburg durch die Flüchtlingsströme aus den deutschen Ostgebieten. 1946 zählte das Land 896.218 Umsiedler und Vertriebene. Das waren 44 Prozent der Gesamtbevölkerung. Damit verzeichnete Mecklenburg den höchsten Anteil an Flüchtlingen in ganz Deutschland.

Quellen- und Literaturlage

Die Thematik „Republikflucht" ist inzwischen wissenschaftlich gut untersucht, wobei der Fokus vor allem auf die historische, wirtschaftliche und soziale Bedeutung des Exodus für die junge DDR und die strafrechtliche Verfolgung der Fluchten beziehungsweise der Fluchtversuche gerichtet wurde. Wenig Beachtung fand die Frage nach dem Umgang mit dem zurückgelassenen privaten Hausrat der „Republikflüchtigen" und dem sich darunter befindlichen Kunst- und Kulturgut.

Der Stand der Provenienzforschung in Mecklenburg-Vorpommern ist für den Zeitraum von 1945 bis 1989 im Allgemeinen und hinsichtlich des Umgangs mit Flüchtlingsrücklässen im Besonderen unbefriedigend. Die Durchsicht der Sekundärliteratur ergab insgesamt ein ernüchterndes Bild.[2]

Die umfangreichsten Quellenbestände mit mehreren Hundert relevanten Akten fanden sich im Mecklenburgischen Landeshauptarchiv in Schwerin und in der Außenstelle des Archivs des Landkreises Ludwigslust-Parchim in Ludwigslust. Die Hauptstelle dieses Landkreisarchivs in Parchim verfügt über eine umfangreiche Gesetzes- und Verordnungssammlung bezüglich des Umganges mit Flüchtlingsrücklässen. Wertvolles Material birgt auch die Außenstelle des Landkreisarchivs Rostock in Güstrow. In den Archiven des Landkreises Nordwestmecklenburg und in den Stadtarchiven Güstrow, Perleberg und Wittenberge lagert weniger Material, dafür enthält es detaillierte Sachverhalte.

Viele Informationen barg das Staatliche Museum in Schwerin. Von besonderer Aussagekraft waren Akten des Bestandes „Gutachten über Kunstgegenstände zur Ausfuhr aus der DDR". Manch wertvoller Hinweis konnte auch in den städtischen Museen

�® Vgl. Beitrag von Michael Busch, S. 81.

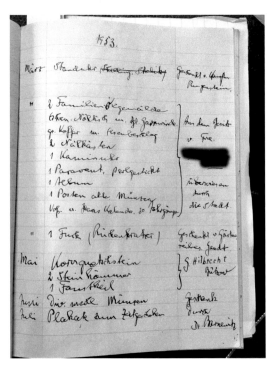

Inventarliste (Auszug) über den Besitz eines „Republikflüchtigen" aus Güstrow, Archiv des Landkreises Rostock, Signatur: G.RdK 20695 (16742, Bd. 4) – Haushaltsauflösungen nach AO/2 Stadt Güstrow

Eingangsbuch des Bützower Museums, 1948 ff., mit Einträgen von März bis Juli 1953

Bützow, Güstrow und Perleberg entdeckt werden. In die Recherche flossen zudem Informationen aus den Beständen der Stiftung Archiv der Parteien und Massenorganisationen der DDR im Bundesarchiv Lichterfelde (SAPMO) mit ein. Zahlreiche Gespräche mit Archivaren, Museologen und Juristen vervollständigten die Materialrecherche.

Ergebnisse

Nach derzeitigem Erkenntnisstand ist davon auszugehen, dass der zurückgelassene Privatbesitz nur wenige bis gar keine Kunst- und Kulturgegenstände enthielt. Dies ist zum einen auf die historische Entwicklung der Region Westmecklenburg und zum anderen auf den großen Flüchtlingszustrom aus den deutschen Ostgebieten zwischen 1944 und 1947 zurückzuführen. Das Gros der wohlhabenden Gutsbesitzer und Gutspächter sowie des Bürgertums hatte sich 1945 vor dem Einmarsch der Roten Armee in die west-

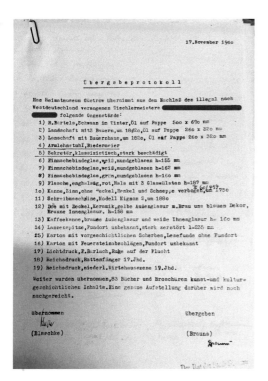

1960 erhielt das Güstrower Museum erneut Stücke aus dem Nachlass eines „Republikflüchtigen". Stadtmuseum Güstrow, Ordner „August-Dietrich S."

lichen Besatzungszonen abgesetzt. Zudem wurden die mecklenburgischen Guts- und Herrenhäuser nicht in die Grundlagenstudie einbezogen, da die Schlossbergung im Fokus anderer DZK-Projekte[1] steht. Kunstgegenstände besaß in den Ackerbürgerstädten und auf dem Land nur ein kleiner Teil der Bevölkerung. Lediglich in den Residenzstädten Güstrow, Ludwigslust und Schwerin, der Vorderstadt Parchim sowie der „Industriestadt" Grabow lebte eine erwähnenswerte Zahl an Bürgern und Beamten, die sich Kunst – in welcher Form auch immer – leisten konnten. Im Gegensatz zu Kunstgut erfuhren Gebrauchsgegenstände durch ihre Aufnahme in ein Museum eine Aufwertung zum Kulturgut.

Enteignungen von Rücklässen „Republikflüchtiger" erfolgten zwischen 1945 und 1989 auf der Grundlage des BGB[2], durch Befehle der SMAD[3] und der SMAM[4] sowie auf der Basis der „Verordnung zur Sicherung von Vermögenswerten vom 17. Juli 1952" und der „Anordnung Nr. 2 über die Behandlung des Vermögens von Personen, die die Deutsche Demokratische Republik nach dem 10. Juni 1953 verlassen haben".

[1] Vgl. Beitrag von Jan Scheunemann, S. 201.

[2] Vgl. §§ 958 und 1911 BGB.

[3] Abkürzung für „Sowjetische Militär-Administration in Deutschland"

[4] Abkürzung für „Sowjetische Militär-Administration in Mecklenburg"

Die mit „Republikfluchten" einhergehende Inbesitznahme und Verwertung von zurückgelassenem Eigentum durch staatliche Stellen oder Privatpersonen lässt aus juristischer Sicht Fragen offen. Insbesondere Formulierungen wie Überführung in Volkseigentum bei gleichzeitiger Betonung, dass es zu keiner Enteignung von „Republikflüchtlingen" und deren Eigentum kommen dürfe, wirken verwirrend. Diese Fragen zu klären muss der weiteren Forschung vorbehalten bleiben.

Bürger, die die Absicht hatten, die Republik illegal zu verlassen, versuchten zum Teil erfolgreich durch die Einlagerung bei Spediteuren oder durch den Hinweis auf Ansprüche von Eltern und Geschwistern Einfluss auf den Verbleib des zurückgelassenen Hausinventars zu nehmen. Auch nach einer gelungenen „Republikflucht" bestand noch die Möglichkeit, mit einer beglaubigten Vollmacht in den Entscheidungsprozess staatlicher Organe über den Verbleib einzugreifen. Waren durch den Eigentümer bevollmächtigte Personen nicht bekannt, wurde staatlicherseits ein Abwesenheitspfleger eingesetzt.

Davon machte auch Hannelore L. aus Wittenberge Gebrauch. 1955 flüchtete sie nach West-Berlin. Am 1. Oktober 1955 ließ sie auf dem Amtsgericht Tempelhof/Kreuzberg eine beglaubigte Vollmacht aufsetzen, durch die sie ihre in Grabow wohnenden Eltern als Eigentümer ihres zurückgelassenen Hausrats einsetzte.[3]

Ein geringer Teil des zurückgelassenen Besitzes wurde in Gebrauchtwarenläden der HO 🖉 verkauft. Die „Nutznießer" von „Republikfluchten" waren in den Dörfern und Kleinstädten die Nachbarn beziehungsweise Einwohner. Sie erhielten bis zum Sommer 1961 vielfach die Möglichkeit, günstig Mobiliar, Haushaltsgegenstände, landwirtschaftliches Gerät und Vieh zu erwerben.

🖉 Abkürzung für „Handelsorganisation"

Ein Teil des verbliebenen Inventars wurde durch die Räte der Städte und die Räte der Gemeinden an staatliche Institutionen wie Kinderkrippen, Kindergärten, Kinderheime, Schulen, Internate, Bibliotheken, Altenheime, Jugend- und Sportklubs, Theater usw. abgegeben. Staatliche Dienststellen wie die Polizei, Parteien, Militär oder das MfS werden bei diesen Übergaben nur selten als Akteure erwähnt.

Gut dokumentiert ist das Verfahren im Fall von Elisabeth M., die im Februar 1953 ihre Heimatstadt Bützow verließ. Der von ihr zurückgelassene Hausrat wurde beschlagnahmt und am 8. Februar

Der aufklappbare Nähtisch mit Intarsien und die Runddeckeltruhe aus dem Besitz der „Republikflüchtigen" Elisabeth M., Heimatmuseum Bützow „Krummes Haus", Ordner „Ankauf, Schenkung, Belege"

1953 in einem Inventarverzeichnis festgehalten. Während der nächsten Wochen erfolgte der Verkauf an Bützower Bürger. Die zu zahlenden Preise waren moderat und lagen zwischen einer Mark für einzelne Wäschestücke und Blusen und 50 Mark für ein Chaiselongue. Insgesamt wurden 708 Mark eingenommen.

Vorab wurden einige Möbel unentgeltlich an verschiedene gesellschaftliche Einrichtungen übergeben. So erhielt die SED den Bücherschrank, die Bibliothek die Bücherregale, die Volksschule zwei Tischlampen. An die Bützower Schulen gingen ein Schrank, ein Schreibsekretär und die Bücher. Das Internat bekam Konserven und Eingemachtes sowie einen Bettbezug. Dem Bützower Museum wurden zwei Nähkästen, eine Uhr und eine Truhe übergeben.

1990 beantragte Elisabeth M. beim LARoV die Rückübertragung mehrerer Kunstgegenstände aus ihrem zurückgelassenen Eigentum. Im Zuge der Wiedergutmachung restituierte das Museum im Oktober 1991 eine Runddeckeltruhe und einen aufklappbaren Nähtisch mit Intarsien.[4]

Der individuelle Spielraum von Personen, die durch den jeweiligen Rat der Stadt oder den Rat der Gemeinde mit der Betreuung oder der Abwicklung von Flüchtlingsrücklässen beauftragt wurden, war beträchtlich. Entsprechend der Persönlichkeitsstruktur konnte dieser eng oder großzügig genutzt werden.

Die wenigen Kunstgegenstände und wertvollen Bücher, die sich in dem zurückgelassenen Flüchtlingsgut befanden, wurden an

die Museen und Bibliotheken vor Ort übergeben beziehungsweise an das Staatliche Antiquariat der Universitätsbuchhandlung nach Rostock versandt. Eine Einflussnahme durch das MfS konnte in keinem der Fälle nachgewiesen werden.

Zwischen 1990 und 2012 hatten die einstigen Besitzer beziehungsweise deren Kinder oder Erben die Möglichkeit, durch Flucht eingebüßte Kunstgegenstände zurückzufordern.

Antje Strahl, Reno Stutz
Antje Strahl ist wissenschaftliche Mitarbeiterin im Universitätsarchiv Rostock. Reno Stutz ist Historiker und Publizist in Mecklenburg-Vorpommern.

Förderung des Grundlagenprojekts „Umgang der Verwaltungsinstanzen im ehemaligen Bezirk Schwerin mit Kulturgut aus Flüchtlings-Rücklässen von 1945 bis 1989" von Februar 2019 bis Februar 2021.

Endnoten

[1] Unter dem Begriff Kulturgut verstehen die Autoren Gegenstände von künstlerischem, geschichtlichem oder archäologischem Wert, die aus Flüchtlingsrücklässen in Sammlungen von Museen überführt wurden. Durch die damit einhergehende museale Inventarisierung, Erforschung der Objektgeschichte und Bestandsaufnahme erfuhren die Exponate eine weitere Aufwertung und sind somit von massenhaft zurückgelassenen privaten Haushalts- und Gebrauchsgegenständen zu unterscheiden.

[2] Lediglich die 1997 von Christian Nieske veröffentlichten Erinnerungen an das bei Bützow gelegene Dorf Zernin und der 2019 in den *Brandenburgischen Museumsblättern* publizierte Aufsatz des Schweriner Museologen Torsten Fried enthalten verwertbares Material. Vgl. Christian Nieske: Republikflucht und Wirtschaftswunder. Mecklenburger berichten über ihre Erlebnisse 1945 bis 1961, Schwerin 2001; Torsten Fried: Von Ausreisen und Gutachten. Akten im Staatlichen Museum Schwerin, in: Museumsblätter. Mitteilungen des Museumsverbandes Brandenburg, H. 35, Potsdam 2019, S. 48–53.

Von großem Wert waren die Arbeiten von Alexander Sachse, auch wenn sie sich auf Bandenburg bezogen. Vgl. Alexander Sachse: „… komme nicht mehr zurück in die DDR", in: Provenienz & Forschung, H. 1, Magdeburg 2019, S. 18–25; ders.: Schlossbergung, Republikflucht, Kommerzielle Koordinierung. Kritische Provenienzen aus der Zeit der SBZ und DDR, in: Museumsblätter. Mitteilungen des Museumsverbandes Brandenburg (2019), Nr. 35, S. 18–37; ders.: „Zwischen Schlossbergung und Kommerzieller Koordinierung" – Pilotprojekt zur Untersuchung kritischer Provenienzen aus der Zeit der Sowjetischen Besatzungszone (SBZ) und der DDR in brandenburgischen Museen, PURL https://www.proveana.de/de/link/pro10000313.

[3] Vgl. Stadtarchiv Wittenberge, Stadt Wittenberge, Vermögensabwicklung L–Z. Republikflüchtige (1955–1960), Nr. 008086.

[4] Vgl. Heimatmuseum „Krummes Haus" Bützow, Hausarchiv, Aktenordner „Ankauf, Schenkung, Belege"; Finanzministerium Mecklenburg-Vorpommern, Regelung offener Vermögensfragen (LARoV), Nr. HRO 2098.

„Hinterlassene Bibliotheken" nach „illegalem Abgang" Vier Beispiele aus drei Jahrzehnten DDR-Geschichte

Regine Dehnel, Michaela Scheibe

"Libraries left behind" after "illegal departure". Four examples from three decades of GDR history
In the summer of 1952, the GDR introduced uniform regulations on the use of the assets of "deserters from the republic." From 1958, these regulations also extended to valuables, works of art and cultural property. Exploitation had to be carried out according to the instructions of the district councils. Books and manuscripts of such origin also found their way into academic libraries directly, via authorized trustees or through other channels. Research at the Staatsbibliothek zu Berlin—Preußischer Kulturbesitz (Berlin State Library, SBB PK) has uncovered new evidence of these events. Book collections left behind by illegal emigrants were also processed by the Zentralstelle für wissenschaftliche Altbestände (ZwA). The activities of this central duplicate office of the GDR, founded in Gotha in 1953 and located at the Deutsche Staatsbibliothek (German State Library) in East Berlin since 1959, are being intensively studied in a long-term research project at the SBB PK funded by the German Lost Art Foundation. The examples presented here deal with the literary scholar Alfred Kantorowicz from Berlin, the pastor and "people's missionary" Martin Helmer, who lived in Zeuthen, the teacher for Old-Greek and Latin Gerhard Rosenhauer from Görlitz, and the doctor Peter Krumbacher from Riesa. Despite recognizable patterns in the handling of the book possessions left behind, the picture so far is strongly characterized by coincidences and individual decisions. The whereabouts of the books can only be determined with the help of a meaningful tradition, especially if it is supplemented by catalogs, accession documents and traces of provenance. A more detailed analysis and evaluation is reserved for further research.

Die DDR führte im Sommer 1952 einheitliche Regelungen über die Verwendung des Vermögens von „Republikflüchtigen" ein.[1] Als solches galt der Besitz, der bei einer Flucht zurückblieb oder später, beispielsweise durch Erbschaft, anfiel. Diverse Verordnungen, Anweisungen und Richtlinien regelten Fragen des landwirtschaftlichen Grundbesitzes, des Wohnraums und der Bankkonten, der Nutzung von Lauben und Schrebergärten. Bücher, Kunstwerke oder sonstiges Kulturgut spielten in den amtlichen Dokumenten zunächst keine Rolle. 1958 hieß es dann: „Wertgegenstände und Kostbarkeiten, wie Gegenstände aus Edelmetall, Edelsteinen, Halbedelsteinen, Gegenstände aus echtem Markenporzellan, echte

Teppiche, wertvolle Bilder, Gegenstände, die einen besonderen Kunstwert haben, Briefmarken und Briefmarkensammlungen sind dem Rat des Kreises – Abteilung Finanzen – besonders zu melden. Die Verwertung dieser Gegenstände erfolgt nach Weisungen des Rates des Kreises."[2]

Forschungen an der Staatsbibliothek zu Berlin – Preußischer Kulturbesitz (SBB PK) brachten neue Indizien des Kulturgutentzugs nach „Republikflucht" zutage. Bücher solcher Herkunft wurden auch von der Zentralstelle für wissenschaftliche Altbestände (ZwA) bearbeitet. Die Tätigkeit dieser zentralen Dublettenstelle der DDR wird in einem vom Deutschen Zentrum Kulturgutverluste geförderten langfristigen Forschungsprojekt an der Staatsbibliothek intensiv aufgearbeitet.[3] ✎ Bei den Recherchen nach weiterverteiltem NS-Raubgut – dem eigentlichen Fokus des Projektes – fanden sich Spuren von Buchbeständen, die in der DDR zurückgelassen worden waren. Vier Beispiele geben Einblicke in die Handhabung dieser Rücklässe. ✎

✎ Vgl. Projekt-Eintrag in Proveana, PURL https://www.proveana.de/de/link/pro10000250.

✎ Vgl. Beitrag von Antje Strahl und Reno Stutz, S. 103.

Der Fall Alfred Kantorowicz – Berlin/Bansin 1957

Der Literaturwissenschaftler und Schriftsteller Alfred Kantorowicz (1899–1979) musste als Kommunist und Jude nach dem Machtantritt der Nationalsozialisten ins Exil gehen. Zum ersten Jahrestag der Bücherverbrennung in Deutschland gründete er in Paris eine „Bibliothek der verbrannten Bücher".

Ende 1946 in den Osten Berlins zurückgekehrt, trat Kantorowicz als Verleger der literarischen Zeitschrift *Ost und West* für eine Vermittlung zwischen den verschiedenen politischen und ideologischen Lagern ein. Nach Gründung der DDR übernahm er eine Germanistikprofessur an der Humboldt-Universität zu Berlin und leitete das Heinrich-Mann-Archiv an der Deutschen Akademie der Künste (DAK) ✎. Seine politischen Hoffnungen aber erfüllten sich nicht. Am 22. August 1957 floh er nach West-Berlin.

Der Polizeipräsident von Groß-Berlin übernahm die „vorübergehende Sicherung des Berliner Wohnhauses von Alfred Kantorowicz".[4] Am 26. September 1957 fand auf Veranlassung des Staatssekretärs für Hochschulwesen und des Präsidenten der

✎ Ab 1974 Akademie der Künste der DDR, 1993 in der Akademie der Künste Berlin aufgegangen

*Alfred Kantorowicz nach einer
Vorlesung an der Freien Universität
in West-Berlin, 1963. Nach seiner
„Republikflucht" lebte er bis 1962 in
München, danach in Hamburg.*

*✂ Otto Nagel, vgl. Beitrag von
Salka-Valka Schallenberg, S. 261.*

*✂ 1992 in der Staatsbibliothek zu
Berlin – Preußischer Kulturbesitz
aufgegangen*

DAK✂ eine Wohnungsbesichtigung statt. Diese nahmen für das
Staatssekretariat Abteilungsleiter Werner Schmidt, für die DAK
der Abteilungsleiter Archive und Publikationen, Theo Piana, wahr.
Anwesend waren zudem Vertreter der zuständigen Volkspolizeiin-
spektion Pankow sowie der vom staatlichen Notariat eingesetzte
Abwesenheitspfleger.[5]

Gemeinsam schlugen Staatssekretariat und DAK anschließend
vor, Kantorowicz' Bibliothek geschlossen der Universitätsbiblio-
thek der Humboldt-Universität zu übergeben. Sein Privatarchiv
sollte die Abteilung Literaturarchive der DAK übernehmen. Nach
Durchsicht würden dem Staatssekretariat, der DAK und der Deut-
schen Akademie der Wissenschaften „die ihre Arbeitsgebiete be-
treffenden Archivalien zur weiteren Verwendung zukommen".[6]

Ungeachtet der Empfehlung wurde die Bibliothek Kantorowicz
jedoch an die Deutsche Staatsbibliothek (DSB)✂ übergeben. Eine
Bestätigung vom 25. März 1958 „über 44 Bücher aus dem Nachlaß
A. Kantorowicz", die aus Kantorowicz' Sommerwohnung in Bansin
auf Usedom stammten, belegt zumindest deren Empfang.[7] Zu die-
sem Zeitpunkt wird die geschlossene Übernahme der Bibliothek
Kantorowicz durch die DSB schon festgestanden haben.

Noch 2010 lagerten die rund 4.000 Bücher aus dem Besitz von
Alfred Kantorowicz unbearbeitet im Außenmagazin der SBB PK in
62 Kisten. Nachdem geklärt war, dass die Sammlung heute Eigen-

Alfred Kantorowicz hinterließ in zahlreichen Bänden seiner Berliner Bibliothek Randbemerkungen und Notizen, so auch in Bodo Uhses 1954 im Berliner Aufbau-Verlag erschienenem Roman Abschied und Heimkehr. *SBB PK 50 MA 53156-1*

tum der Stiftung Preußischer Kulturbesitz ist und eine Zusammenführung der Berliner Bibliothek mit dem Nachlass Kantorowicz' in der Staats- und Universitätsbibliothek Hamburg sich aus Kapazitätsgründen nicht realisieren ließ, wurde der Bestand schließlich von der Abteilung Historische Drucke der SBB PK bearbeitet und mit all ihren nur im Zusammenhang der Sammlung zu würdigenden Provenienzspuren erschlossen.[8]

Der Fall Gerhard(t) Rosenhauer – Görlitz 1958

Am 12. November 1958 teilte ein vom Rat der Stadt Görlitz, Abteilung Verwaltung des staatlichen Eigentums, bestellter Treuhänder „für den nach dem Westen gegangenen Dr. Gerhard Rosenhauer" der Zentralstelle für wissenschaftliche Altbestände mit: „Die in der Wohnung befindliche Bibliothek ist durch die VP.🖉 gesichtet und bestimmt worden, daß ein Teil derselben Ihnen zu übersenden ist".[9] 16 Kisten, die ein auch an der „Absprache betr. Übersendung der Bücher" beteiligter „Herr Dr. Lemper – Görlitz"[10] zur Verfügung stellte, wurden daraufhin durch die Deutsche Spedition zur damals noch in Gotha untergebrachten ZwA transportiert. Handschriftliche Vermerke auf dem Schreiben des Treuhänders, das die ZwA zur Rücksendung der Transportkisten, zur Anfertigung eines Verzeichnisses und zur Bezahlung der Bücher anhielt, lassen unter

🖉 *Abkürzung für „Volkspolizei"*

115

Anschreiben von Herbert Schmidt, Görlitz, an die Landesbibliothek Gotha, SBB PK, Akten DSB, ZwA 1,7, Bl. 49

anderem erkennen, dass die geforderte Aufstellung des Bestandes 3.228 Bücher ergab und diese auch wunschgemäß nach Görlitz übersandt wurde. Leider ist dieses Verzeichnis, bei dem es sich angesichts des Umfangs wohl kaum um eine detaillierte Titelliste gehandelt haben kann, nicht in den Berliner ZwA-Akten enthalten.

Bei Gerhard Rosenhauer dürfte es sich um den 1899 in Dresden geborenen, 1924 in Leipzig promovierten und später als Griechisch- und Lateinlehrer an der Görlitzer Oberschule tätigen Altphilologen handeln, der sich während der heftigen propagandistischen Auseinandersetzungen um die Synode der EKD in Berlin-Weißensee 1958 als bekennendes Kirchenmitglied dem Vorwurf ausgesetzt sah, dem sozialistischen Erziehungsauftrag nur unzureichend nachzukommen. Mit Wirkung zum 31. August wurde der knapp Sechzigjährige aus dem Schuldienst entlassen.[11]

Mangels Titelliste oder anderer Anhaltspunkte konnten bislang kaum Spuren der Bibliothek Rosenhauers entdeckt werden. Über die in der Staatsbibliothek zu Berlin – Preußischer Kulturbesitz erfassten Provenienzdaten zur Bibliothek Kaiser[12] konnte im-

Abkürzung für „Evangelische Kirche in Deutschland"

merhin ein Exemplar der 1950 in Hamburg erschienenen „Fibel für Liebende" identifiziert werden, das den handschriftlichen Namenszug „Rosenhauer" aufweist und vom Sammler Bruno Kaiser im Oktober 1978 in Meiningen erworben wurde. Ob es tatsächlich aus dem Rücklass Gerhard Rosenhauers stammt, ist noch zu klären.[13]

Der Fall Martin Helmer – Zeuthen 1963

Deutlicher greifbar ist die in Zeuthen zurückgelassene Bibliothek des Theologen Martin Helmer (1926–1977).[14] Helmer wirkte von 1955 bis 1962 als Pastor in Berlin-Köpenick an der Stadtkirche St. Laurentius, 1962/63 in St. Marien und St. Nikolai in Berlin-Mitte. 1963 floh er nach West-Berlin.[15]

Die frühesten Helmer betreffenden Schreiben in der Überlieferung der ZwA datieren auf den November 1963 und stammen von deren Leiter sowie der Fachreferentin für Religionswissenschaft der DSB.[16] Beide hatten mit einem Vertreter des Rates der Gemeinde Zeuthen eine Aussprache zur „hinterlassenen Bibliothek des flüchtigen Volksmissionars Martin Helmer". Eine Sichtung der Bücher erfolgte. Während der Leiter der ZwA im Anschluss vorschlug, den gesamten Bestand zu übernehmen, tendierte die Fachreferentin dahin, die theologische Fachliteratur an Ort und Stelle durchzusehen und nur die wenigen für die Deutsche Staatsbibliothek infrage kommenden Titel herauszuziehen.

Die Direktion der DSB plädierte für erstgenannten Vorschlag. Die ZwA transportierte die Bibliothek geschlossen ab. In Berlin wurden drei große Gruppen gebildet und vorläufig aufgestellt: Rara mit 1.042, Theologie mit 1.855 sowie Wissenschaft und Belletristik mit 1.801 Bänden.[17] Der weitere Schriftverkehr verdeutlicht, dass die ZwA die Rara der DSB geschlossen anbieten und nicht angeforderte Titel verteilen sollte. Die Theologica und die Varia sollten von den Fachreferenten der DSB gesichtet werden. Für die Gemeinde Zeuthen war eine symbolische Entschädigung vorgesehen.[18] Damit folgte man seitens der DSB dem offenbar zu dieser Zeit üblichen Verfahren, dass Kosten, die den Räten der Städte oder Gemeinden „bei der Erfassung, Sicherung, Schätzung und Verwertung" von Wohnungseinrichtungen entstanden, kompensiert werden sollten. Eine kostenlose Umsetzung etwa von Möbeln, Hausrat oder sonstigen beweglichen Gegenständen war unzulässig.[19]

Drei besondere Objekte gab die ZwA sofort an die Musikabteilung und die Handschriftenabteilung der DSB weiter, doch leider erwies sich die Ausgabe eines Klavier-Auszugs zu Mozarts *Don Juan* als doch im Bestand vorhanden, ebenso wohl die Vertonung des *Liedes von der Glocke*, und ein „Gesangbuch, eingebunden in lila Samt mit aufgearbeiteter Schnitzereiarbeit (vermutl. Elfenbein)" ist in den Zugangsbüchern der Handschriftenabteilung auch nicht zu identifizieren.[20] Keines der drei Objekte lässt sich heute in den Beständen der SBB PK nachweisen.

Neun Monate später, im August 1964, hatte die DSB von insgesamt 4.698 Bänden 1.292 Exemplare übernommen: 250 Bände moderne Literatur waren eingearbeitet, die bereits erwähnten 1.042 Bände Rara „sichergestellt". Ca. 1.100 Bücher und Broschüren hatte ein Vertreter des Staatssekretariats für Kirchenfragen ausgewählt. „Kirchlich-militaristische" und „kirchlich-faschistische Literatur" hatte man aussortiert und makuliert. Den nicht genauer bezifferten „restlichen Bestand" übernahm das Zentralantiquariat der DDR.[21]

Ein im Bestand der Kartenabteilung identifiziertes Album mit Originalfotografien der Erfurter Reglerkirche, das Martin Helmer bei einer dort veranstalteten evangelischen Jugendwoche 1959 gewidmet wurde, deutete auf die im Betriebsjahr 18 (1964) verwendeten DSB-Signaturen. Bei der Überprüfung von zwölf Zugangsbüchern der Jahre 1963 bis 1965 konnten so 42 weitere Titel identifiziert werden. Glücklicherweise wurde bei den zwischen dem 17. März und dem 27. April 1964 akzessionierten Exemplaren als Lieferant jeweils „Bibliothek Helmer" oder „Helmer, Zeuthen" vermerkt. Martin Helmer zuzuordnende Provenienzspuren fanden sich in keinem der Bände, wohl aber Namenszüge seiner Ehefrau Friedesine, geborene Wenzel, und vor allem seines Schwiegervaters, Kirchenrat Dr. Theodor Wenzel (1895–1954). Die kurz nach der Übernahme bearbeitete moderne Literatur dürfte damit gefunden sein, nicht aber die „Rara", die zunächst unbearbeitet blieben und deren Spur sich damit vorerst verliert.

Widmung für Martin Helmer, SBB PK 18 B 437

Theodor Wenzels Namenszug in einem der Bücher aus dem Besitz von Martin Helmer, SBB PK 18 A 15487

Der Fall Peter Krumbacher – Riesa 1979

Im September 1979 wandte sich die Abteilung Finanzen und Preise des Rates der Stadt Riesa nach dem „illegalen Abgang" eines

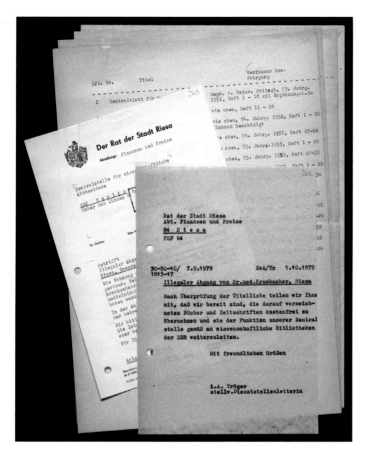

Überlieferung zu Büchern aus
dem Besitz von Peter Krumbacher,
SBB PK, Akten DSB, ZwA 7,175,
Bl. 362–371

Riesaer Arztes mit einem 133 Positionen umfassenden Angebot medizinischer Fachliteratur an die ZwA, um nicht angeforderte Exemplare veräußern oder vernichten zu dürfen. Das Angebot an die ZwA erfolgte auf Anraten der Bibliothek des Kreiskrankenhauses Riesa. Die ZwA antwortete pauschal: Man sei bereit, die aufgelisteten Bücher und Zeitschriften kostenfrei zu übernehmen und an wissenschaftliche Bibliotheken der DDR weiterzuleiten.[22]

Peter Krumbacher, dessen Wohnung von der Stadtverwaltung Riesa geräumt worden war, hatte 1969 in Halle-Wittenberg promoviert.[23] Die Bibliothek, die er zurückließ, enthielt laut Angebotsliste medizinische Gebrauchsliteratur, darunter über 300 Hefte des *Zentralblatts für Gynäkologie* und zwölf Bände der *Zeitschrift für Geburtshilfe*, vor allem aus den 1950er-Jahren. Das älteste Werk, eine *Anatomie des Menschen*, ist 1911 erschienen. Stichproben am Dienstkatalog der ZwA erbrachten keinen Hinweis auf Angebote oder Ab-

gaben durch die ZwA – damit gibt es trotz der erhaltenen Titelliste derzeit kaum eine Chance auf Identifikation dieser Exemplare.

Fazit

Die vorgestellten Beispiele lassen gewisse Muster erkennen. Fast immer sind der zuständige Rat der Stadt oder Rat der Gemeinde sowie die lokale Polizeibehörde in die Verwertung der Bibliotheken involviert, insbesondere die finanzielle Abwicklung wird von behördlich beauftragten Treuhändern übernommen. Eher zufällig beziehungsweise einzelfallabhängig erscheinen dagegen das Einholen von Expertise und die Entscheidung, ob zurückgelassene Buchbestände jenseits der Veräußerung oder Makulierung bestimmten Einrichtungen wie der ZwA geschlossen oder in Teilen angeboten werden. Die Chance solcher Angebote und damit auch die Chance, zusammenhängende (Teil-)Bestände zu identifizieren, steigt mit der Prominenz ihres Eigentümers oder ihrer Eigentümerin beziehungsweise ist abhängig von Initiativen des Umfeldes. Nachvollziehbar ist das Schicksal zurückgelassener Bibliotheken nur mithilfe einer aussagekräftigen Überlieferung. Werden die Bücher verteilt und weiterbearbeitet, sind Kataloge und Zugangsunterlagen oder Provenienzspuren in den Büchern selbst für die Identifikation von erhaltenen Exemplaren entscheidend. Eine genauere Analyse und die Bewertung bleiben weiteren Forschungen vorbehalten.

Regine Dehnel, Michaela Scheibe
Regine Dehnel ist wissenschaftliche Mitarbeiterin in der Abteilung Historische Drucke und Michaela Scheibe ist kommissarische Leiterin der Abteilung Historische Drucke der Staatsbibliothek zu Berlin – Preußischer Kulturbesitz.

Endnoten

1 Vgl. Verordnung zur Sicherung von Vermögenswerten vom 17. Juli 1952 und Verordnung zur Sicherung von Vermögenswerten vom 4. September 1952, in: Gesamtdeutsches Institut, Bundesanstalt für Gesamtdeutsche Aufgaben (Hg.): Bestimmungen der DDR zu Eigentumsfragen und Enteignungen, Bonn 1984, S. 101 f.

2 Anweisung Nr. 30/58 zur Anordnung Nr. 2 vom 20.8.1958 über die Behandlung des Vermögens von Personen, die die Deutsche Demokratische Republik nach dem 10.6.1953 verlassen, in: Gesamtdeutsches Institut 1984, S. 137–141, hier S. 138, Pkt. 5.

3 Zur ZwA vgl. die Darstellung im ProvenienzWiki: https://provenienz. gbv.de/Zentralstelle_für_wissenschaftliche_Altbestände sowie die Tiefenerschließung des Aktenbestandes „Zentralstelle für wissenschaftliche Altbestände" in der Staatsbibliothek zu Berlin: https://provenienz.gbv.de/ Datei:SBB-PK_Akten_DSB_ZwA.pdf (2.11.2020).

4 Otto Nagel an den Polizeipräsidenten von Berlin, 11.9.1957. Akademie der Künste [AdK], Akademie der Künste (Ost), Nr. 13: Aufbau und erste Arbeitsjahre der Abteilung Literaturarchive, Bl. 112 f.; https://archiv.adk. de/objekt/2207538 (2.11.2020)

5 [SHF], Abt. Wiss. Bibliotheken, Museen und Hochschulfilm, Werner Schmidt, Aktennotiz. Bibliothek und Privatarchiv Alfred Kantorowicz, Berlin-Niederschönhausen, Wilhelm-Wolf-Str. 8, 26.9.1957. Ebd., Bl. 117 f.

6 Ebd.

7 DSB, Blume an DAK, Bibliothek, 18.4.1958. AdK, Handakte zum Alfred-Kantorowicz-Archiv (ohne Signatur).

8 Vgl. die ausführliche Beschreibung im ProvenienzWiki: https://provenienz. gbv.de/Alfred_Kantorowicz (4.11.2020).

9 Herbert Schmidt, Görlitz, an LB Gotha, 12.11.1958. SBB PK, Akten DSB, ZwA [DSB, ZwA] 1,7, Bl. 49.

10 Mit hoher Wahrscheinlichkeit handelt es sich um den wie Rosenhauer an lausitzischer Geschichte interessierten Dr. Ernst-Heinz Lemper (1924–2007), der seit 1950 Direktor der Städtischen Kunstsammlungen Görlitz war.

11 Martin Naumann: „Das ist Terror, der auf uns Synodale ausgeübt wird." Die Synode der EKD von 1958 und ihre Wirkung auf die Schlesische Landeskirche, in: Mitteilungen zur Kirchlichen Zeitgeschichte 14 (2020), S. 43–69, hier S. 62 f.

12 Sammlungsbeschreibung zur heute in der SBB PK, Abteilung Historische Drucke, befindlichen Privatbibliothek von Bruno Kaiser: https://provenienz. gbv.de/Bruno_Kaiser (2.11.2021).

13 SBB PK, Abteilung Historische Drucke, 19 ZZ 17867. Katalogdaten mit Provenienzerschließung: https://stabikat.de/DB=1/XMLPRS=N/PPN?PPN= 445386630 (4.11.2020).

[14] Vgl. Catalogus pastorum. Die Pastoren der evangelisch-lutherischen Gemeinde Niedersachswerfen: http://www.glass-portal.privat.t-online.de/cp/nsw/helmer_karl.htm (5.11.2020).

[15] Helmers Flucht findet im Zusammenhang mit der Predigt des US-amerikanischen Bürgerrechtlers Martin Luther King am 13. September 1964 in Ost-Berlin knappe Erwähnung. Vgl. http://marienkirche-berlin.de/glaube/gemeindegeschichte/martin-luther-kings-predigt-in-der-st-marienkirche/ (5.11.2020).

[16] DSB, ZwA, Lang an DSB, Genzel; DSB, Roloff, 5.11.1963; [DSB,] Schott an DSB, Genzel; DSB, Roloff, 5.11.1963. DSB, ZwA 1,38, Bl. 268 f.

[17] DSB, ZwA, Lang an DSB, Genzel; DSB, Roloff, Übernahme der Bibliothek des republikflüchtigen Bürgers Martin Helmer, Zeuthen, 15.11.1963. DSB, ZwA 1,38, Bl. 266.

[18] Vgl. DSB, Genzel an DSB, Roloff; DSB, ZwA, Aktennotiz. Weitere Bearbeitung der Bibliothek Helmer, 25.11.1963. DSB, ZwA 1,38, Bl. 263 f., hier Bl. 264.

[19] Vgl. Anweisung Nr. 30/58 zur Anordnung Nr. 2 vom 20.8.1958 über die Behandlung des Vermögens von Personen, die die Deutsche Demokratische Republik nach dem 10.6.1953 verlassen, in: Gesamtdeutsches Institut 1984, S. 137–138, hier S. 137, Pkt. 4.

[20] Vgl. DSB, Genzel an DSB, Roloff; DSB, ZwA, Aktennotiz. Weitere Bearbeitung der Bibliothek Helmer, 25.11.1963. DSB, ZwA 1,38, Bl. 263 f., hier Bl. 264.

[21] DSB, ZwA, Lang an DSB, Hauptdirektion über DSB, Genzel, 10.8.1964. DSB, ZwA 1,38, Bl. 260–261.

[22] Vgl. Rat der Stadt Riesa, Abt. Finanzen und Preise, Goldmann an DSB, ZwA, 7.9.1979; DSB, ZwA, Tröger an Rat der Stadt Riesa, Abt. Finanzen und Preise, 1.10.1979. DSB, ZwA 7,175, Bl. 363; Bl. 362.

[23] Vgl. [Rat der Stadt Riesa, Abt. Finanzen und Preise, Goldmann] an [DSB, ZwA], [7.9.1979]. DSB, ZwA 7,175, Bl. 364–371, hier Bl. 370, Position 111.

Wege in die Sammlung. Juristische Betrachtung unterschiedlicher Zugangsarten im Fall einer „Republikflucht"

Cora Chall

Ways into the collection. Legal consideration of different types of acquisition in the case of illegal emigration
In 2014, the Klassik Stiftung Weimar received an inquiry from the Thuringian Office for the Settlement of Unresolved Property Issues regarding an application for the retransfer of approximately 80 objects that had already been submitted in 1990. The original owners had left the Soviet occupation zone in 1948 and the GDR in 1960 "without permission." During the research carried out from 2014 onwards, it emerged that a total of almost 500 objects of this provenance were found in the collection of the Klassik Stiftung. It was only with the help of the preserved files in the Goethe and Schiller Archive that it was possible to reconstruct for the most part how the objects had come into the collection. 100 objects had been purchased directly from the owner by the Klassik Stiftung's predecessor institution, the Nationale Forschungs- und Gedenkstätten der Klassischen Deutschen Literatur in Weimar (NFG), before leaving the GDR. Approximately 80 objects were acquired through GDR state agencies after "desertions from the republic," but well over 200 objects had remained with the NFG without any further agreements. This not only raised the question of the actual whereabouts and identification of the objects in the collection, but also of the various claims under public and civil law and their enforceability. Only through extensive research was it possible to clarify the claim for restitution under civil law and lead to a settlement under property law. As a result, 290 objects were returned to the legal successors of the owners.

Während die Klassik Stiftung Weimar seit 2010 ihre Bestände systematisch auf NS-verfolgungsbedingte Kulturgutentziehungen überprüft, hat eine systematische Untersuchung der Sammlungszugänge in Hinblick auf Kulturgutentziehungen während der DDR-Zeit bis heute nicht stattgefunden. Zwar sind die Antragsfristen sowohl nach dem Gesetz zur Regelung offener Vermögensfragen (VermG) als auch nach dem Ausgleichsleistungsgesetz (AusglLeistG) seit über 25 Jahren abgelaufen, doch noch immer sind Verfahren zur Rückübertragung anhängig und den sammlungsführenden Einrichtungen womöglich gar nicht bekannt. Anfragen durch die zuständigen Landesämter zur Regelung offener Vermögensfragen (LaRoV)[1] erfolgen nicht routinemäßig in allen sammlungsführenden Einrichtungen, sondern nur dort, wo Hinweise, die

zumeist durch die Antragsteller erfolgen, einen Verbleib in einer bestimmten Sammlung nahelegen, zum Beispiel aufgrund örtlicher Nähe oder eines speziellen Sammlungszusammenhangs.

Im Januar 2014 erreichte die Klassik Stiftung eine Anfrage zum Verbleib von über 80 Objekten aus zwei früheren Liegenschaften der Schwestern Wiltrud Fickel und Elisabeth Lemke, geb. Fickel, in Römhild, Thüringen. Der zugehörige Antrag auf Rückübertragung war bereits im Sommer 1990 gestellt worden.

Bereits eine erste Recherche in der hauseigenen Datenbank führte zu der Erkenntnis, dass in der musealen Sammlung der Klassik Stiftung eine deutlich größere Menge von Objekten mit der Provenienz Lemke, Römhild, vorhanden war. Um die angefragten Stücke zu identifizieren und die näheren Umstände der Entziehung zu prüfen, wurden umfangreiche Recherchen durchgeführt. Erkenntnisse ergaben sich durch Einsichtnahme in die betreffenden Zugangsbücher sowie den im Goethe- und Schiller-Archiv überlieferten Schriftverkehr zu den Erwerbungen, sodass der Sachverhalt größtenteils rekonstruiert werden konnte.

Die beiden Schwestern waren Eigentümerinnen zweier Wohnhäuser in ungeteilter Erbengemeinschaft. Wiltrud Fickel entschloss sich bereits 1948 zum Umzug nach Westdeutschland, ihre Schwester Elisabeth Lemke blieb mit ihrer Familie zunächst in Römhild. In den beiden Wohnhäusern befanden sich Hunderte antiquarischer Möbelstücke, Kunst- und Gebrauchsgegenstände.

1958 bot Elisabeth Lemke den Nationalen Forschungs- und Gedenkstätten der Klassischen Deutschen Literatur in Weimar (NFG), der Vorgängerinstitution der heutigen Klassik Stiftung, mehrere Objekte zum Kauf an. Es kam zu mindestens einem Ortstermin, in dessen Folge vereinbart wurde, eine größere Anzahl an Objekten nach Weimar zu überführen und dort auf ihren Wert und ihre Verwendbarkeit zu prüfen.[2] Schließlich einigte man sich auf einen Ankauf von 100 Stücken, die im Laufe des Jahres 1959 im Neuerwerbungsbuch des Goethe-Nationalmuseums verzeichnet wurden. Der vereinbarte Kaufpreis wurde an Elisabeth Lemke und ihren Ehemann gezahlt.

Im März 1960 erhielten die NFG ein Schreiben der Eheleute Lemke, in dem es hieß: „Da wir uns entschlossen haben in Westdeutschland zu bleiben, schlagen wir Ihnen vor, unsere [...] Stilmöbel für Ihr Museum zu übernehmen. [...] Wir können Ihnen ver-

Schränkchen mit 30-teiliger Haus-apotheke, verschiedene Hölzer, Papier, Eisen, Messing, um 1700, restituiert

sichern, daß es uns nicht leicht gefallen ist, diese alten Wertstücke aufzugeben, jedoch wäre es uns eine Beruhigung, sie in berufenen Händen zu wissen [...].[3]

Die NFG wandten sich daraufhin erst an das Volkspolizei-kreisamt Hildburghausen und schließlich an den Rat der Stadt Römhild und baten, die Möbel und kunstgewerblichen Gegen-stände ihren Instituten zu überlassen. Die Stadt erklärte sich ein-verstanden und forderte eine Taxliste an. Eine daraufhin gefertig-te Aufstellung vom 2. Mai 1960 enthielt 46 Positionen mit über 80 Objekten, für die ein Wert von insgesamt 3.191,00 DM/DDR mitgeteilt wurde. Es ist davon auszugehen, dass der Betrag an den

19) ein kleiner Teppich	45,–
20) ein Knabenbildnis, Öl a.L., Ende 19. Jh.	100,– "
21) ein Frauenbildnis, Öl a.L., Ende 19. Jh.	80,– "
22) ein kleiner einfacher Tisch	25,– "
23) eine barocke Kommode	110,– "
24) ein Rokoko-Spiegel	90,– "
25) ein Schränkchen mit einer Hausapotheke	75,– "
26) ein Stickbild, Mitte 19.Jh.	40,– "
27) ein großer barocker Schrank mit Schüben und Fächern	240,– "
28) ein klappbaren Spieltisch	50,– "
29) ein Ohrensessel	80,– "
30) ein Biedermeiersessel	80,– "
31) ein Glasschrank mit Nippes aus Glas und Porzellan	300,– "

Rat der Stadt Römhild gezahlt wurde. Diese Liste lag der Anfrage des LaRoV an die Klassik Stiftung im Jahr 2014 bei und bildete die Grundlage der Recherche.

Im Neuerwerbungsbuch des Goethe-Nationalmuseums wurde ein Teil dieser Objekte im Laufe des Jahres 1960 mit den entsprechenden Preisen und der Angabe „Nachlass Lemke" verzeichnet. Ende Dezember wurden noch einmal fast 300 Objekte dieser Provenienz ohne Gegenwert verzeichnet. Aus welchem Grund diese weiteren Stücke in den Bestand übernommen wurden, war zunächst unklar, ein internes Schreiben des damaligen Direktors der NFG vom 14. März 1960 gab jedoch Aufschluss. Darin heißt es: „Wie wir soeben erfahren haben, ist Familie L. republikflüchtig geworden. Der Rücktransport verschiedener für uns wenig geeigneter Gegenstände erübrigt sich demzufolge."[4] Offenbar hatten sich aus den früheren Ankaufsverhandlungen noch einige Stücke zur Ansicht bei den NFG befunden.

Objekte der Provenienz Lemke im Bestand der NFG können demnach in drei Kategorien eingeteilt werden:
1. Erwerbungen direkt von der Familie in den Jahren 1958/59 (100 Objekte)
2. Erwerbungen vom Rat der Stadt Römhild im Mai 1960 (81 Objekte)

3. Objekte, die im Besitz der NFG verblieben, ohne dass hierüber
 weitere Vereinbarungen getroffen wurden oder der Grund für
 die Verzeichnung näher aufgeklärt werden konnte (286 Objekte)
 Es ist nicht ausgeschlossen, dass einige Objekte auch nach Mai
 1960 noch mit Zustimmung des Rates an die NFG übertragen und
 damit enteignet wurden, allerdings ist dies nach derzeitiger Akten-
 lage nicht nachweisbar. Für alle nicht angekauften Objekte muss
 daher angenommen werden, dass sie ohne weitere Vereinbarung
 in der Sammlung verblieben sind.

Die Identifizierung der Objekte war allein aufgrund der Menge
eine Herausforderung. Bis heute ist es nicht gelungen, alle Stücke
in den Beständen zu ermitteln. Mangels ausreichender Beschrei-
bungen in den genannten Quellen und angesichts fehlender Pro-
venienzmerkmale auf den Objekten wird eine vollständige Identi-
fizierung vermutlich nie erfolgen können. Die Rechtsnachfolger der
Antragstellerinnen wurden in den Prozess mit einbezogen, beide
Schwestern sind mittlerweile verstorben.

Die Recherchen zur Identifizierung und zum Verbleib der Ob-
jekte, die sich nach der „Republikflucht" der Lemkes in den Bestän-
den der NFG fanden, ergaben Folgendes:
a) Objekte, die in der Sammlung aufgefunden und identifiziert
 werden konnten (303 Objekte)
b) Objekte, die nicht gefunden oder identifiziert werden konnten
 (55 Objekte)
c) Objekte, die nachweislich zerstört oder gestohlen sind (5 Ob-
 jekte)
d) Objekte, die sich zwischenzeitlich im Besitz (Leihgabe) anderer
 Institutionen befinden (4 Objekte).

Es stellte sich nunmehr die Frage nach der juristischen Aufarbeitung etwaiger Rückübertragungs- oder Herausgabeansprüche.

Fristgerecht beantragt war die Rückübertragung für einen Teil der in der Taxliste genannten Objekte und einige weitere Objekte, die ohne Gegenwert im Erwerbungsbuch eingetragen worden waren.

Jene 100 Objekte, die seitens der NFG in den Jahren vor der „Republikflucht" direkt von der Familie erworben worden waren, enthielt der Antrag auf Rückübertragung nicht, ein Anspruch auf Rückübertragung bestand insoweit auch nicht.

Voraussetzung für Rückübertragungsansprüche nach § 3 Abs. 1 S. 1 VermG in Verbindung mit § 1 Abs. 1 VermG ist ein schädigendes Ereignis gemäß § 1 Abs. 1 VermG, zum Beispiel Enteignung und Überführung in Volkseigentum (§ 1 Abs. 1 Buchst. a VermG) oder Veräußerung durch staatliche Verwalter an Dritte (§ 1 Abs. 1 Buchst. c VermG). Auch Kaufverträge durch die früheren Eigentümer können erfasst sein, wenn diese nach § 1 Abs. 3 VermG aufgrund unlauterer Machenschaften, zum Beispiel durch Machtmissbrauch, Korruption, Nötigung oder Täuschung vonseiten des Erwerbers, staatlicher Stellen oder Dritter, zustande gekommen sind. Zwar handelte es sich bei den NFG um eine staatliche Stelle, die schriftliche Korrespondenz enthält jedoch keinerlei Hinweise darauf, dass bei den 1959 erworbenen Objekten ein solcher Fall vorliegt. Diese Stücke wurden rechtmäßig angekauft.

Für 44 Objekte, die von den NFG nach dem März 1960 vom Rat der Stadt Römhild erworben worden waren, wurde durch das Thüringer LaRoV eine Berechtigung nach § 2 Abs. 1 VermG festgestellt, soweit sie in der Klassik Stiftung oder in anderen öffentlichen Einrichtungen aufgefunden wurden. Durch endgültiges Verlassen des Gebietes der DDR griff die „Anordnung Nr. 2 vom 20. August 1958 über die Behandlung des Vermögens der Personen, die die Deutsche Demokratische Republik nach dem 10. Juni 1953 verlassen".[5] § 1 Abs. 1 dieser Verordnung legte fest, dass das Vermögen betroffener Personen durch staatliche Treuhänder verwaltet wird.

Durch den Verkauf des staatlichen Treuhänders an die NFG wurde das Eigentum an den Gegenständen übertragen und die ursprünglichen Eigentümerinnen somit faktisch entschädigungslos enteignet.[6] Ein gutgläubiger Erwerb gem. § 4 Abs. 2 VermG ist für

staatliche Institutionen wie den NFG und deren Rechtsnachfolger ausgeschlossen.

Es stellt sich jedoch die Frage, ob das Schreiben der Lemkes vom März 1960 an dieser Einschätzung etwas zu ändern vermag. Handelte es sich womöglich in der Aufforderung, die Objekte in die Sammlungen der NFG zu übernehmen, um eine Schenkung, oder wurde das Eigentum daran durch das Zurücklassen aufgegeben? In einem Verwaltungsgerichtsverfahren, das eine der nicht zur Klassik Stiftung gehörenden Einrichtungen angestrebt hat, in deren Besitz sich mehrere der betroffenen Objekte befinden, wurde dies vorgetragen.

Das Verwaltungsgericht führte in seiner Entscheidung hierzu aus, dass aufgrund der bestehenden Treuhandverwaltung eine Verfügung der Eigentümerin überhaupt nicht mehr möglich war.[7] Diese Argumentation ist problematisch, denn zu dem Zeitpunkt, zu dem das Schreiben bei den NFG einging, wussten die staatlichen Behörden wahrscheinlich noch nichts von der „Republikflucht", sie wurden vermutlich erst durch die NFG darüber informiert. Gemäß § 1 Abs. 2 der oben genannten Anordnung vom 20. August 1958 erfolgte die Einsetzung der staatlichen Treuhänder durch das zuständige Fachorgan des Rates der Stadt oder der Gemeinde und bedurfte der Bestätigung durch die staatlichen Behörden. Voraussetzung war somit ein staatlicher Akt, der zu diesem Zeitpunkt wahrscheinlich noch nicht erfolgt war.

Im Ergebnis liegt hier aber dennoch keine Schenkung vor. Die Bitte um Übernahme enthielt gleichzeitig den Hinweis, dass diese nur deshalb erfolgte, weil eine Mitnahme schlichtweg nicht möglich war. Damit fehlt es an der Freiwilligkeit, die einer Schenkung innewohnt. Dazu kommt, dass die NFG offensichtlich selbst nicht von einer Schenkung ausgingen, da sie gegenüber dem staatlichen Treuhänder ihr Kaufinteresse äußerten.[8] Insofern fehlt es bereits an der erforderlichen Einigung. Aus demselben Grund ist auch eine Eigentumsaufgabe (§ 959 BGB) abzulehnen. Die Auslegung der Erklärung ergibt lediglich, dass der Besitz an den Objekten aufgegeben wurde. Hieraus kann nicht grundsätzlich auf eine freiwillige Eigentumsaufgabe geschlossen werden, da es an einer freien Willensbildung fehlte. In der Regel wird daher angenommen, dass eine Eigentumsaufgabe im Sinne des § 959 BGB in den Fällen einer Flucht nicht vorliegt.[9]

Abgelehnt wurde seitens der Behörde ein Rückübertragungsanspruch für Objekte, die zwar nachweislich an die NFG übertragen worden waren, für die aber kein Rückübertragungsantrag gestellt wurde. Voraussetzung für die Rückübertragung ist gemäß § 3 Abs. 1 VermG in Verbindung mit § 30a VermG ein konkreter, rechtzeitig gestellter Antrag. Die Versäumung der Antragsfrist hatte den Verlust des Rückübertragungsanspruchs zur Folge. Ebenfalls wurde ein Anspruch abgelehnt für Objekte, die nicht auffindbar, nicht identifizierbar oder nachweislich zerstört oder gestohlen waren. Mangels Möglichkeit einer tatsächlichen Rückgabe bleibt hier regelmäßig nur ein Entschädigungsanspruch.

Bezüglich der Objekte, die ohne weitere Vereinbarung im Besitz der NFG verblieben sind, hat das LaRoV die Rückübertragung mit der Argumentation abgelehnt, es habe keine Enteignung stattgefunden. Allenfalls hätten die Objekte nach der „Republikflucht" unter staatlicher Verwaltung gestanden. Diese galt jedoch gemäß § 11a VermG spätestens zum 31. Dezember 1992 als aufgehoben. Die Objekte befänden sich daher nach wie vor im Eigentum der Erbengemeinschaft beziehungsweise der Rechtsnachfolger, alle Ansprüche seien zivilrechtlich zu klären. Die Argumentation ist folgerichtig und widerspricht nicht dem vom BGH entschiedenen Vorrang des Vermögensgesetzes vor zivilrechtlichen Ansprüchen[10], da in Fällen, in denen es nicht zu einer Enteignung gekommen ist, der Anwendungsbereich des Vermögensgesetzes überhaupt nicht eröffnet ist. Es bestand daher ein Herausgabeanspruch gemäß § 985 BGB, also des Eigentümers gegen den unrechtmäßigen Besitzer einer Sache. Da jedoch erst mit der Aufhebung der angeordneten Verwaltung Ende 1992 kein Recht zum Besitz mehr bestand, ist dieser Anspruch erst zu diesem Zeitpunkt entstanden und war im Jahr 2014 noch nicht verjährt.[11] Eine fehlende Antragstellung nach VermG schadet daher in diesen Fällen nicht, da für die Durchsetzung zivilrechtlicher Herausgabeansprüche die allgemeinen Verjährungsfristen gelten.

Da aufgrund der Aktenlage für eine Reihe von Objekten nicht festgestellt werden konnte, warum diese in die Sammlung gelangt waren, ging der fehlende Nachweis, dass ein schädigendes Ereignis stattgefunden hatte, zulasten der Antragstellerinnen. Anders als bei der Beurteilung von NS-verfolgungsbedingt entzogenem Kulturgut findet nach dem VermG für alle sonstigen Fälle keine

Beweislastumkehr für das Vorliegen einer unrechtmäßigen Entziehung statt. Im Umkehrschluss musste daher angenommen werden, dass für diese Objekte das Eigentum ebenfalls nicht auf die NFG übergegangen ist.

Die Rechtslage stellte sich daher wie folgt dar:

1. Für Erwerbungen, die vor der „Republikflucht" abgeschlossen waren, ist die Klassik Stiftung rechtmäßige Eigentümerin.
2. Für Erwerbungen nach der „Republikflucht", die über den Rat der Stadt Römhild abgewickelt wurden und im Antrag aufgeführt sind, bestand ein Rückübertragungsanspruch nach dem Vermögensgesetz.
3. Für Erwerbungen nach der „Republikflucht", die über den Rat der Stadt Römhild abgewickelt wurden und nicht im Antrag aufgeführt sind, bestanden keine Rückübertragungsansprüche nach dem Vermögensgesetz.
4. Für Objekte aus dieser Provenienz, die keiner der vorbenannten Kategorien zugeordnet werden können, ist anzunehmen, dass das Eigentum bei den Rechtsnachfolgern der Eigentümerinnen verblieb und ein zivilrechtlicher Herausgabeanspruch bestand.

Zwischen der Klassik Stiftung und den Rechtsnachfolgern der Antragstellerinnen wurde schließlich eine gütliche Einigung getroffen. Die Objekte, für die ein Eigentumsübergang nicht nachzuweisen war, wurden herausgegeben. Nach der „Republikflucht" erworbene Objekte wurden zurückübertragen. Einige Objekte, die im Eigentum der Klassik Stiftung standen, für die mangels Antragstellung aber kein Anspruch auf Rückübertragung bestand, wurden dennoch an die Erben übertragen, da im Gegenzug einige Objekte bei der Stiftung verbleiben sollten, für die ein Herausgabeanspruch bestand. Letztendlich wurden 290 Objekte an die Rechtsnachfolger übergeben, 18 Objekte verblieben in der Stiftung.

Der Fall Lemke zeigt exemplarisch, welche unterschiedlichen juristischen Fragestellungen sich aus den verschiedenen Zugangsarten ergeben. Gleichzeitig verdeutlicht er jedoch auch die Notwendigkeit der proaktiven Provenienzforschung in öffentlichen Sammlungen. Hätte sich die Prüfung auf die Anfrage des LaRoV beschränkt, wären lediglich 44 Objekte rückübertragen worden. Nur die darüber hinausgehende Klärung des gesamten Erwerbungsvorgangs

⌀ Klärung der dinglichen Rechte an Sachen und Wiederherstellung des ordnungsgemäßen Zustandes

konnte den zivilrechtlichen Herausgabeanspruch aufdecken und zu einer sachenrechtlichen ⌀ Bereinigung von immerhin weiteren 246 Objekten führen.

Es bleibt daher zu vermuten, dass die Klärung ähnlicher Fälle eine Aufgabe ist, die sammlungsführende Einrichtungen in den nächsten Jahren noch beschäftigen wird.

Cora Chall

Cora Chall ist Juristin im Bereich Forschung sowie im Justitiariat der Klassik Stiftung Weimar.

Endnoten

[1] In Thüringen „Stelle zur Regelung offener Vermögensfragen", im weiteren Text jedoch vereinfacht LaRoV.

[2] Brief NFG an Herrn und Frau Lemke, 21.11.1958, GSA 150/12, unfol.

[3] Brief Lemke an die NFG, 10.3.1960, GSA 150/371, unfol.

[4] Direktion NFG an Dr. Handrick, Kustos Goethe-Nationalmuseum, 14.3.1960, GSA 150/271, unfol.

[5] GBl. I S. 664, aufgehoben durch die Anordnung zur Regelung von Vermögensfragen, 11.11.1989 (GBl. I S. 247).

[6] Sog. faktischer Enteignungsbegriff: Der bisherige Eigentümer wird durch staatliche Maßnahmen vollständig und endgültig aus seinem Eigentum verdrängt, Sicht eines objektiven Betrachters (BVerwG, 7.3.2012 – 8 C 1.11; BVerwG, 13.4.2016 – C 10.15).

[7] VG Gera, 21.11.2019 – 3 K 1197/16 Ge.

[8] Schreiben NFG an Rat der Stadt Römhild, 19.3.1960: „Für die Übernahme wollen wir Ihnen eine Liste mit spezifizierten Angaben zu jedem Gegenstand (mit Taxwert) vorlegen."

[9] Münchner Kommentar, Oechsler § 978 Rn. 3; Sophie Engelhardt: Nachrichtenlose Kulturgüter, Berlin/Boston 2013, S. 14.

[10] BGH V ZR 83/91, 3.4.1992.

[11] Gem. § 197 Abs. 1 Nr. 2 BGB beträgt die Verjährungsfrist 30 Jahre. Ob zukünftig in vergleichbaren Fällen öffentliche Einrichtungen eine Einrede der Verjährung überhaupt erheben werden, bleibt abzuwarten. Für NS-verfolgungsbedingt entzogenes Kulturgut wurde dies i. d. R. nicht getan, vgl. BGH V ZR 279/10, 16.3.2012.

Privater Kunsthandel

Privater Kunsthandel in der DDR –
Die Dresdner Kunsthandlung Alphons Müller

Claudia Maria Müller

Private art trade in the GDR. Dresden art dealer Alphons Müller
The preserved company files of Dresden art dealer Alphons Müller (1909–1972)
provide detailed insight into the structure and organization of the private art
trade in the GDR. Alphons Müller ran an antique store in Dresden from 1936 to
1972, initially in downtown Dresden, Johann-Georgen-Allee 17, and after the
destruction in Dresden-Blasewitz, Regerstraße 16. After his death in 1972, the
heirs did not receive permission to continue the business, which eventually led
to the relocation of the widow and a son to the Federal Republic. It was not until
1986 that the business was able to reopen in Munich. Not all of the holdings
were allowed to be exported; the paintings in particular fell under the GDR's
Cultural Property Protection Act. They remained with the family in Dresden.
Preserved documents provide information on the procedure of the departure
and the appraisals by the State Art Collections.

The evaluation of the documents confirms once again how the state in-
creasingly controlled the private trade of art and antiquities and steered it
through the mediation of targeted acquisitions in which it earned money by
charging commissions, and how it regulated and restricted the private competi-
tion of the Kunst und Antiquitäten GmbH (Art and Antiques Ltd.).

As a further result of the investigation, it can be stated that through the
private art trade in the GDR—apart from the state doctrine—an exchange about
art and culture in bourgeois circles was still possible, cultivated and embodied.
On closer examination, it becomes clear that the increasing state influence and
nationalization of the private art trade from the 1970s onward was not only
about the urgently needed obtaining of foreign currency, but also about the
dismantling of these structures.

Durch glückliche Umstände haben sich Teile der Geschäftsunter-
lagen[1] des Dresdner Antiquitäten- und Kunsthändlers Alphons
Müller (1909–1972) erhalten.[2] Die Sichtung und Auswertung der
Akten zeigen, dass das Material für die Erforschung und Charakte-
risierung des privaten Kunsthandels in der DDR von allgemeinem
Interesse ist. Überliefert sind unter anderem Informationen zum
Verkauf an Geschäftspartner im Ausland, der in der DDR nur über
staatliche Exportstrukturen möglich war, sowie zur Abwicklung
des privaten Unternehmens in den 1970er-Jahren.

Aufschlussreich in Hinblick auf Rücklässe von Ausreisenden
sind ferner die Unterlagen, welche die Übersiedlung der Witwe

Alphons Müller, 1936

Eva Müller und des Sohnes Emanuel Müller in die Bundesrepublik dokumentieren, eine Folge der erzwungenen Schließung des Geschäftes 1976.

Alphons Müller hatte Sprachen und Kunstgeschichte studiert, mit dem Ziel, als Lehrer zu unterrichten. 1934 wegen fehlender Parteizugehörigkeit aus dem Schuldienst entlassen, entschloss er sich zur Gründung einer Kunsthandlung.[3] In seiner Wohnung in der Holbeinstraße 35 eröffnete er 1936 seine eigene Firma. Schon 1939 mietete Alphons Müller Geschäftsräume in der Johann-Georgen-Allee 17, damals eine der Prachtstraßen Dresdens, in deren Nachbarschaft weitere Kunst- und Antiquitätenhändler ansässig waren. Bei den schweren Bombenangriffen vom 13./14. Februar 1945 wurden sowohl seine Geschäftsräume als auch seine Wohnung zerstört, einige seiner Familienmitglieder kamen ums Leben. Mit seiner Frau Eva fand er damals Zuflucht im Kloster St. Marienstern in der Lausitz. Bald nach Kriegsende begann Alphons Müller mit dem Wiederaufbau seiner Kunsthandlung in Dresden-Blasewitz. Die Regerstraße 16 sollte für die folgenden Jahrzehnte Geschäftsstandort und ab 1953 Lebensmittelpunkt der Familie mit nunmehr zwei Söhnen werden.

Die Zerstörung der Innenstadt ließ auch andere Dresdener Kunsthändler nach neuen Standorten suchen: Johannes Kühl ließ sich im Preußischen Viertel nieder, Max Sinz in Strehlen, Hede Schönert in Loschwitz, Wilhelm Axt in Pillnitz.

Um wieder einen Warenbestand aufzubauen, annoncierte Alphons Müller regelmäßig in den Dresdner Tageszeitungen. Den Geschäftsbüchern ist zu entnehmen, dass oft Privatpersonen aus einst wohlhabenden Haushalten in Blasewitz, Loschwitz, Striesen und Weißer Hirsch ihm Einzelstücke verkauften: Porzellan, Zinn, Leuchter, ab und zu auch Möbel und Gemälde. Außerdem erwarb er Antiquitäten bei öffentlichen Versteigerungen, die im Auftrag der Stadt Dresden meist durch Hermann Küchenmeister und Otto Jahn in einem vormaligen, teilzerstörten Transport- und Lagerhaus am Terrassenufer 10 durchgeführt wurden, das 1960 abgerissen wurde. In der Lausitz, wo seine Familie nach dem Krieg noch mehrere Jahre lebte, kaufte Alphons Müller von Ortsansässigen kunstgewerbliche Objekte. Mitunter erwarb er dort auch Stücke, die wiederum Städter in der Nachkriegszeit gegen Lebensmittel auf Bauernhöfen eingetauscht hatten.

1955 wurde beispielsweise Ferdinand Dorschs Gemälde Begegnung im Park, *1922, für die Gemäldegalerie angekauft. Öl auf Leinwand, 90,5 × 100 cm, Gal.-Nr. 2906, Staatliche Kunstsammlungen Dresden, Albertinum/ Galerie Neue Meister*

Zur Kundschaft Alphons Müllers zählten neben den ortsansässigen Kunstbegeisterten, Sammlern und bekannten Persönlichkeiten wie dem Physiker Manfred von Ardenne, dem einflussreichen Kunsthistoriker Fritz Löffler und dem Denkmalpfleger Hans Nadler auch auswärtige Prominente wie die Schauspielerin Helene Weigel, ihr Schwiegersohn, der Schauspieler Eckhard Schall, der Schauspieler und Musiker Manfred Krug, der Politiker Klaus Gysi und der brasilianische Generalkonsul in München, Mário Calábria, der später Botschafter in der DDR wurde.[4] Sie alle waren leidenschaftliche Sammler, die regelmäßig vor allem aus Berlin nach Dresden kamen, um hier die verschiedenen Kunsthandlungen aufzusuchen. Kunst- und Kulturschaffende aus dem westlichen Ausland reisten ebenfalls gern nach Dresden und setzten ihre DDR-Mark-Gagen in Antiquitäten um, überliefert sind bei Alphons Müller der Manager von Louis Armstrong, die Sänger Salvatore Adamo und Jonny Hill sowie der Dirigent Wolfgang Sawallisch. Und natürlich besuchten maßgebliche Wissenschaftlerinnen und Wissenschaftler der Staatlichen Kunstsammlungen Dresden (SKD) regelmäßig die Kunsthandlung Alphons Müller, darunter Wolfgang Balzer, Anneliese Mayer-Meintschel, Ingelore und Hans-Joachim Menzhausen, Hilde Rakebrand und Friedrich Reichel. Sie erwarben sowohl Stücke für die Museen[5] als auch privat.

Hilde Rakebrand, 1982, SLUB Mscr.
Dresd.App.2588,92

Als ein Beispiel für das private Sammeln sei hier die Direk-
torin des Kunstgewerbemuseums, Hilde Rakebrand, genannt. Sie
sammelte nach ihrer Pensionierung intensiv Jugendstil-Glas. In
den 1960ern war das noch wenig populär, denn seinerzeit wur-
den die Kunstwerke der Jahrhundertwende nicht selten als Zeug-
nisse einer dekadenten Epoche verschmäht. Rakebrand gelang es
durch profundes Wissen und großes persönliches Engagement,
eine hervorragende Sammlung zusammenzutragen. Ihrem Wunsch
folgend, gelangte das beachtliche Konvolut von insgesamt 178 Ob-
jekten nach ihrem Tod 1991 als Vermächtnis an das Kunstgewer-
bemuseum. So manches Stück hatte sie damals bei Alphons Mül-
ler gekauft.[6] Auch andere Objekte, die private Sammlerinnen und
Sammler von ihm erworben hatten, gelangten später als Stiftungen
oder Schenkungen an die SKD, unter anderem mit der Schenkung
Wolfgang Balzer, der Schenkung Fritz und Slava Löffler und dem
Erwerb der Keramiksammlung Josef Horschik.

Allgemein lässt sich feststellen, dass die SKD von 1945 bis
Mitte der 1960er regelmäßig im Dresdner Kunsthandel Einzel-
werke ankauften.[7] Abgesehen von einigen wenigen Ausnahmen,
wie den kontinuierlichen Erwerbungen aus der Galerie Johannes
Kühl, galt jedoch seit Ende der 1950er-Jahre die damals durch die
Staatspolitik vorgegebene Devise, verstärkt DDR-Gegenwarts-
kunst zu sammeln und auf den staatlichen Kunstausstellungen zu
erwerben, insbesondere Werke des sozialistischen Realismus. Die
wenigen Zugänge aus anderen Epochen kamen nunmehr vor allem

über den Staatlichen Kunsthandel, private Schenkungen oder Verkäufe von Privatpersonen in die Museen. Durch diese Bestrebungen wurde der private Kunsthandel als Partner öffentlicher Museen mehr und mehr verdrängt.

Für viele Kunden der privaten Kunsthandlungen war neben dem Erwerb der persönliche Austausch über die Kunst wichtig. Da das Reisen eingeschränkt war und Antikmessen in der DDR nicht stattfanden, hatten diese Begegnungen für beide Seiten ihren besonderen Wert. So hat sich Wolfgang Balzer, der einstige Direktor der SKD (1946–1951), mit Alphons Müller auf Französisch unterhalten. Beide hatten eine Zeit lang in Frankreich studiert und nur noch selten die Möglichkeit, die Sprache anzuwenden.

Regelmäßig kam der ebenfalls in Dresden-Blasewitz lebende Sammler Friedrich Pappermann[8] in der Kunsthandlung vorbei, manchmal auch nur zu einem Plausch. In seinen Erinnerungen fängt er die Stimmung jener Jahre folgendermaßen ein: „Ganz in meiner Nähe entdeckte ich in Blasewitz den Kunsthändler Alphons Müller. […] Er war weniger Kunsthändler als Kunstberater und Kunstenthusiast. Die Käufe wickelten sich mehr als Kunstgespräche ab, wobei die Ökonomie zur beiderseitigen Zufriedenheit nicht zu kurz kam. Ihm verdanke ich manches Wissen und viele Erwerbungen, die heute meine Sammlung zieren und mich an diesen trefflichen Mann erinnern."[9] Friedrich Pappermanns Sammlung ging 1993 als Stiftung an die Städtischen Sammlungen Freital.

Bürgerliches Sammeln entsprach der Ideologie und den Zielen des Arbeiter- und Bauernstaates ebenso wenig wie Privateigentum. „Unter diesen Umständen hätte es eigentlich überhaupt keine Privatsammlungen in der DDR und in den anderen kommunistisch regierten Ländern geben dürfen und können", resümierte Werner Schmidt, von 1990 bis 1997 Generaldirektor der SKD und zuvor jahrzehntelang Direktor des Kupferstich-Kabinetts: „Aber zum Glück gehen Realität und Leben doch eigene Wege."[10]

Ab Ende der 1950er Jahre wurde in dieses Gefüge allerdings zunehmend durch den Staatlichen Kunsthandel der DDR eingegriffen. Zur dringend notwendigen Erwirtschaftung von Devisen wurden für Kunst- und Antiquitätenhändler aus der Bundesrepublik, Belgien, Dänemark, Frankreich, den Niederlanden, Österreich und Schweden „Einkaufstouren" durch die DDR organisiert. Die Waren wurden mit Valuta beim Staatlichen Kunsthandel in Berlin be-

zahlt. Die privaten Unternehmen erhielten nach langer Wartezeit den Betrag aber nur in DDR-Mark, was etwa einem Viertel, später einem Fünftel des Wertes auf dem westeuropäischen Markt entsprach – abzüglich zehn Prozent Vermittlungsgebühren.[11]

Den DDR-Händlern wurden nun regelmäßig Listen mit den Besuchsterminen der Händler aus dem Ausland zugesandt, damit sie sich an diesen Tagen bereithielten und für ein passendes Angebot sorgten. Bis Anfang der 1960er-Jahre scheint der Kontakt zu den ausländischen Kunden unmittelbarer gewesen zu sein. Dies lassen erhaltene Rechnungen und Korrespondenzen von Alphons Müller vermuten. Auch wenn die Interessenten stets in Begleitung eines Mitarbeiters vom Staatlichen Kunsthandel Berlin kamen, bestanden zu einigen ausländischen Kollegen persönliche Verbindungen. So erhielt Alphons Müller über den belgischen Händler Stampaert gelegentlich ausländische Auktionskataloge.

Ab Ende der 1960er-Jahre beeinträchtigte ein weiteres Instrument zur Überwachung den privaten Handel. Die Kunsthändler wurden verpflichtet, sich jeden Ankauf und jede Kommissionsübernahme von Privatpersonen durch die Einliefernden bestätigen zu lassen.[12] Diese Quittungen waren umgehend, spätestens aber innerhalb von 72 Stunden bei der örtlichen Polizei vorzulegen. Vordergründig sollte so der Handel mit gestohlenen Waren erschwert und Hehlerware rascher identifizierbar gemacht werden. Doch die Verordnung zeigt vor allem die Bedeutung des Antiquitätenhandels, der als nunmehr eine der wichtigsten Devisenquellen in den Fokus der Überwachung geriet.

Anfang der 1970er-Jahre wurden die bewährten Praktiken intensiviert und Anzahl sowie Frequenz der Besuche aus dem Ausland deutlich erhöht. So begann gezielt im privaten Handel der Ausverkauf von Kunst- und Kulturgut aus der DDR und damit einhergehend die Zerschlagung jener bürgerlichen Strukturen. Denn in der Folge kam es zu einer enormen, ja übersteigerten Preisentwicklung und einem raschen Verlust an Qualitätsware, was das Sammeln in der DDR stark beeinflusste beziehungsweise erschwerte.

Am 9. August 1972 verstarb Alphons Müller. Vorgesehen war, dass sein Sohn Emanuel das Geschäft fortführen sollte. Doch es gab zwei Hindernisse: die Beschlüsse des Politbüros des ZK der SED

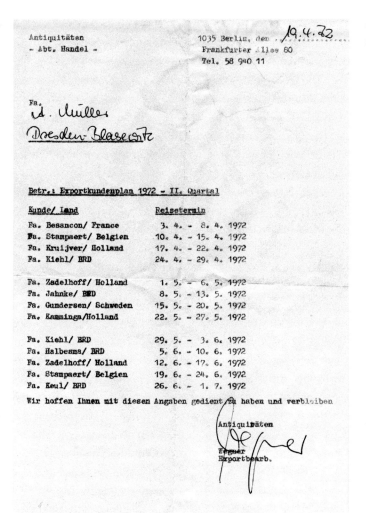

Der Exportkundenplan für Alphons Müller im zweiten Quartal 1972

vom 8. Februar 1972[1], die noch in privater Hand befindlichen Unternehmen zu verstaatlichen,[13] und die Gründung der Kunst und Antiquitäten GmbH[2]. Im Bereich Kommerzielle Koordinierung unter der Führung von Alexander Schalck-Golodkowski war ein staatliches Unternehmen zu Beschaffung von Devisen entstanden, welches Konkurrenz vermeiden respektive ausschalten wollte.[14] Emanuel Müller erhielt keine Genehmigung, die Firma fortzuführen. Eva Müller, die Witwe Alphons Müllers, bekam für eine Übergangszeit eine Ausnahmegenehmigung zur Abwicklung des Geschäftes. Im Februar 1976 musste die Kunsthandlung endgültig geschlossen werden. In Hinblick auf die noch vorhandenen

[1] Unveröffentlichter Beschluss des ZK der SED 104/63 5/72 vom 8. Februar 1972

[2] Vgl. Beiträge von Jan Scheunemann, S. 201, Margaux Dumas und Xenia Schiemann, S. 213, Christopher Jütte, S. 224, Bernd Isphording, S. 234, sowie Alexander Sachse, S. 245.

Waren und die guten Geschäftsbeziehungen ins Ausland war die lange Übergangszeit sicher im Interesse des Staatlichen Kunsthandels gewesen, konnte er darüber doch nach wie vor Valuta einnehmen. Die erzwungene Schließung ersparte der Familie in Dresden vermutlich die Nachstellungen der Steuerfahndung, die vor allem in den 1980er-Jahren viele private Kunsthändler und Sammler in den Ruin trieb. Allein in Dresden-Blasewitz hatte es mit Ernst Gottfried Günther, Helmuth Meißner und Heinz Miech mehrere solcher Fälle gegeben.[15]

Letztlich führte die Schließung in der Konsequenz für einen Teil der Familie zur Übersiedlung in die Bundesrepublik. Ende 1978 reiste Eva Müller aus. Als Rentnerin erhielt sie recht schnell eine Ausreisegenehmigung. Nur so war es dann ihrem Sohn Emanuel möglich, einen Ausreiseantrag auf Familienzusammenführung zu stellen. Dem wurde aber erst fünf Jahre später, im April 1984, stattgegeben.

Bei beiden Übersiedlungen konnten jeweils Kunstgegenstände als privates Umzugsgut ausgeführt werden. Zunächst war allerdings eine detaillierte Auflistung jedes einzelnen, noch so minderwertigen Gegenstandes zwingend notwendig. Danach erfolgte eine mehrtägige Begutachtung und Schätzung durch einen vom Rat des Stadtbezirkes Ost, Abteilung Kultur, bestimmten Schätzer des VEB Dresdner An- und Verkauf in der Bautzner Straße 23. Die Schätzpreise wurden unverhältnismäßig hoch angesetzt. Das war sicher der Tatsache geschuldet, dass man die Gebühr für das Gutachten prozentual nach Schätzwert ermittelte. Der zuständige Schätzer stellte zudem fest, dass etliche Objekte einer wissenschaftlichen Begutachtung durch Museen unterzogen werden mussten und hinsichtlich des Kulturgutschutzgesetzes zu prüfen waren: „Für alle Bilder ist Freigabe von Alte[n] + Neue[n] Meister[n] notwendig. Ebenso alle Möbel und alle Plastiken vom Kunsthandwerk Pillnitz".[16] Es wurden Gutachten durch die SKD erstellt, die wiederum der Stadt Dresden vorzulegen waren und entsprechend in den Listen vermerkt wurden. Die nicht freigegebenen Kunstwerke, vor allem Gemälde, verblieben in Privatbesitz bei der Familie in Dresden.[17] Mit der Ausfuhrsperre war nicht automatisch eine Abgabe an die Museen verbunden, wie auch durch andere Beispiele belegt werden kann.

Nicht nachweisbar ist bisher eine zentral geführte Kartei, in der alle unter das Kulturgutschutzgesetz der DDR gefallenen und mit einer Ausfuhrsperre belegten Kunstwerke erfasst wurden. Nach jetzigem Forschungsstand handelte es sich bei der Feststellung, ob es Objekte sind, die unter das Kulturgutschutzgesetz fallen, um individuelle Entscheidungen der verantwortlichen Museumsmitarbeiterinnen und Museumsmitarbeiter.[18]

Vielleicht sollte man diese Praxis rückblickend nicht nur als Schikane verstehen – wenngleich die Betroffenen sie zweifellos so wahrgenommen haben, insbesondere wenn Kunstwerke an staatliche Institutionen abzugeben waren –, sondern auch als ein Bemühen von Wissenschaftlern und Museen, wichtige Werke zu bewahren. Drohte doch der DDR vor allem Ende der 1970er- und in den 1980er-Jahren durch die zahlreichen Ausreisen von Kulturschaffenden, pensionierten Ärzten und Wissenschaftlern ein Kunstverlust kaum vorstellbaren Ausmaßes, denn gerade diese Kreise hatten sich – zuweilen mangels Alternativen wie Auslandsreisen oder Luxusgütern – besonders dem Sammeln von Kunst gewidmet. Zeitgleich setzte sich die Kunst und Antiquitäten GmbH über das ursprüngliche Anliegen zum Schutz des Kulturgutes hinweg und trieb mit ihrem rabiaten Agieren den Ausverkauf voran.[19]

Erst 1986 konnte der Sohn Emanuel die Kunsthandlung Müller in München wiedereröffnen.

Kunsthandlung Emanuel Müller, München 1986, Archiv Alphons Müller

Claudia Maria Müller

Claudia Maria Müller ist wissenschaftliche Mitarbeiterin bei den Staatlichen Kunstsammlungen Dresden und Enkelin des Kunsthändlers Alphons Müller.

Der Text geht auf einen Vortrag der Herbstkonferenz am 30. November 2020 zurück, der von der Autorin für diesen Band angepasst wurde.

Endnoten

[1] Nach bisheriger Sichtung: Geschäftsbücher, Rechnungen, Korrespondenzen, Gutachten, Fotos, ca. 1,2 lfm. Dazu historische Adressbücher, Branchenbücher, Anzeigen, Journale.

[2] Die Autorin ist eine Enkelin von Alphons Müller.

[3] Vgl. Lebenslauf Alphons Müller, 30. Juni 1949, Archiv Alphons Müller.

[4] Dessen Sammlung mit vielen Werken Dresdener Kunst der 1970er/1980er-Jahre wurde 2020/21 bei Grisebach in Berlin versteigert. Vgl. Grisebach Katalog, Auktion 326, Sammlung Calábria, 4. Dezember 2020.

[5] Insgesamt erwarben die SKD 49 Kunstwerke von Alphons Müller. Neben Ferdinand Dorsch, Begegnung im Park, gehört auch Georg Weitsch, Bildnis Sophie Helene von Thielau und Tochter, 1794, Gal.-Nr. 2978, zum Bestand des Albertinums. Weitere Objekte befinden sich in den Sammlungen des Kunstgewerbemuseums, des Kupferstich-Kabinetts, des Mathematisch-Physikalischen Salons und des Museums für Sächsische Volkskunst.

[6] Vgl. Gisela Haase (Hg.): Jugendstilglas. Sammlung Rakebrand, Dresden 1981. Hilde Rakebrand führte kein Verzeichnis über die Herkunft der erworbenen Objekte, weshalb nicht belegbar ist, welche Stück aus der Kunsthandlung Alphons Müller stammten.

[7] Vgl. Ankaufsunterlagen/Abrechnungen 1953–1990, Aktenbestand Verwaltung 02/Vw, Archiv der Staatlichen Kunstsammlungen Dresden.

[8] Vgl. Rolf Günther, Ilka Melzer: Die Stiftung Friedrich Pappermann Freital: eine Privatsammlung Dresdner Kunst, hg. von den Städtischen Sammlungen Freital, Schloss Burgk, Freital 2003.

[9] Friedrich Pappermann, in: Die Sammlung Friedrich Pappermann in Dresden, Beitrag von Heike Heine. Dresden 1989, S. 11.

[10] Werner Schmidt: Dresdner Privatsammlungen in der DDR, in: Dresdner Heft 49, 1/1997, S. 83.

[11] Vgl. Informationsschreiben und Rechnungen des Staatlichen Kunsthandels Berlin, Frankfurter Allee 84, später Nr. 80, aus den Jahren 1959–1976, Archiv Alphons Müller.
U. a. folgende Händler sind in den Unterlagen aufgeführt. Bundesrepublik Deutschland: Günter Kiehl, München; Belgien: Fa. Stampaert, Gent, Vliegtuiglaan 5, Fa. Les Ateliers Artis, Brüssel, Chaussee De Charleroi 109 a; Dänemark: Firma Wange, Kopenhagen; Niederlande: Fa. Kruyver, Amsterdam, N. Z. Voorburgwal 383; Fa. Roseboom, Zandvoort, Boulevard de Fauvage 14; Fa. van Zadelhoff, Hilversum, Oravelandsweg 152; Schweden: A. Jacobson, Göteborg; Fa. Molvidson, Stockholm, Regierungsgatan 40.

[12] Vgl. Ankaufs- und Kommissionsschein, Archiv Alphons Müller.

[13] Vgl. Beschluss des ZK der SED 104/63 5/72 vom 8.2.1972 und Günter Mittag: Zur Durchführung wirtschaftspolitischer Aufgaben, in: Neues Deutschland, 7.12.1972, S. 3; Michael Fetscher: Die Reorganisation von Eigentumsrechten mittelständischer Unternehmen in Ostdeutschland, Berlin 2000 (Dissertation), https://d-nb.info/959051732/34 (15.1.2021).

[14] Vgl. Ulf Bischof: Die Kunst und Antiquitäten GmbH im Bereich Kommerzielle Koordinierung. Berlin 2003.

[15] Vgl. Bischof 2003, S. 207–209, S. 243–245, S. 253, und Günter Blutke: Obskure Geschäfte mit Kunst und Antiquitäten, Berlin 1994 (2. veränd. Auflage), S. 94–110, 175.

[16] Amtliche Taxierung vom 6.9.1978, Archiv Alphons Müller. Es erfolgten Begutachtungen von Mitarbeitern der SKD der Gemäldegalerien Alter und Neuer Meister, dem Kunstgewerbemuseum und der Skulpturensammlung.

[17] „Wir weisen Sie hiermit nochmals darauf hin, daß folgende Positionen die DDR nicht verlassen dürfen […]". 7.11.1978, Rat des Stadtbezirkes Ost der Stadt Dresden, Abt. Kultur, Archiv Alphons Müller.

[18] Alexander Sachse: Schlossbergung, Republikflucht, Kommerzielle Koordinierung, in: Museumsblätter. Mitteilungen des Museumsverbandes Brandenburg, 12/2019, Nr. 35, S. 27 f.

[19] Vgl. Bischof 2003, S. 363 f.

Magnet für Kunstliebhaber oder Ort der Provokation? Die Galerie Henning in Halle (Saale)

Christin Müller-Wenzel

Magnet for art lovers or place of provocation? Galerie Henning in Halle (Saale)

With its programmatic exhibition profile, Galerie Henning set highlights on the cultural scene of Halle an der Saale during its existence from 1947 to 1961. The gallery focused on German expressionism and European avant-garde, showing work by Pablo Picasso, Joan Miró, Marc Chagall, Max Pechstein, Karl Hofer and Karl Schmidt-Rottluff. Gallery owner Eduard Henning had trained in business management. As early as October 1945, he obtained a license to publish and trade art. He maintained close ties with artists and traveled regularly to Paris, where he established cooperations with Heinz Berggruen and Adrien Maeght. Although he sold works to state collections, his exhibition program could not have stood in greater contrast to socialist realism, and so it was a provocation to the SED (Socialist Unity Party). His gallery was one of the few private endeavors to trade and promote art, first in the Soviet occupation zone and then in the GDR—a community of minds and interests that attracted art lovers and collectors and inevitably found itself in the sights of the State Security Service. His exhibitions were repeatedly prohibited, he was unable to gain print licenses for his catalogs. Despite these bans and public vilifications he refused to submit to the demands of the party, but the construction of the Berlin Wall severed all his connections, causing the gallery to close in December 1961. Eduard Henning committed suicide on June 21, 1962.

„In der DDR darf es keine paradiesischen Inseln der ideologischen Koexistenz geben [...]"

Rolf Friedmann[1]

Einladung zur Eröffnungsausstellung der Galerie Henning

Das kulturelle Leben in Halle an der Saale hatte nach Kriegsende hoffnungsvoll begonnen. Impulse gingen von der Martin-Luther-Universität und dem Städtischen Museum in der Moritzburg aus, aber auch die Kunstschule Burg Giebichenstein spielte eine wichtige Rolle. Wer auf der Suche nach geistigem Austausch war, fand ihn bald in der Galerie Henning, die ihr Domizil in der Albert-Dehne-Straße 2, unmittelbar am Marktplatz, bezog. Am 6. Mai 1947 eröffnete der Kunsthändler und Verleger Eduard Henning (1908–1962) mit der Gemeinschaftsausstellung „Malerei und Grafik – 1. Abteilung", in der es Arbeiten von Heinrich Ehmsen, Karl Hofer, Max Kaus, Hans Orlowski, Max Pechstein und Karl Schmidt-Rottluff zu

entdecken gab. Der Galerist, Fotograf und Verleger brachte dem Publikum in seinen Ausstellungen Künstler:innen nahe, die durch das nationalsozialistische Regime im Bewusstsein eines großen Teils der Menschen kaum mehr existierten – Künstler:innen, deren Werke als „entartet" aus öffentlichen Sammlungen und Museen verbannt, ins Ausland verkauft oder zerstört worden waren. Eduard Henning war es eine Verpflichtung, die Werke der klassischen Moderne würdig zu präsentieren und in private sowie öffentliche Sammlungen zu vermitteln.

Vorstellungen vom Wirken der Galerie Henning sind den anschaulichen Rezensionen von Hermann Goern und Hans Walkhoff zu verdanken. Hermann Goern, der freiberuflich für den *Neuen Weg*, die Tageszeitung der CDU, tätig war, rezensierte die Ausstellungen der Galerie Henning vom Mai 1947 bis Januar 1959. Er berichtete regelmäßig und vor allem positiv über die Präsentationen. Von August 1954 bis Dezember 1961 verfasste Hans Walkhoff für die *Mitteldeutschen Neuesten Nachrichten* Besprechungen, die weit über eine bloße Berichterstattung hinausreichten.

In der grafischen Sammlung des Museums Schloss Moritzburg in Zeitz ließen sich im Rahmen einer Recherche des Museumsverbands Sachsen-Anhalt beispielhaft für die Jahre 1951 bis 1958 Ankäufe von der Galerie Henning nachweisen.[2] Für diesen Zeitraum sind insgesamt 188 Erwerbungen durch den damaligen Direktor Ernst Johannes Günther für eine Gesamtsumme von ca. 4.500 Mark belegt. Von 29 Schöpfer:innen dieser Werke hatte

Eduard Henning, 1940er-Jahre

Die Galerieräume in der Albert-Dehne-Straße 2 in Halle (Saale) mit der Eröffnungsausstellung. Ein Jahr später musste die Galerie einem HO-Laden weichen und fortan fanden die Ausstellungen in der Wohnung der Hennings in der Lafontainestraße 1 statt.

die Galerie Henning Arbeiten ausgestellt, mit acht davon, Ernst Barlach, Max Beckmann, Otto Dix, Lyonel Feininger, Erich Heckel, Franz Marc, Max Pechstein und Renée Sintenis, unterhielt sie einen Briefwechsel. Für 40 Künstler:innen ließ sich bislang kein direkter Bezug zur Galerie rekonstruieren und eine Klärung der Provenienz wäre noch zu erbringen.

Seinen Lebensunterhalt verdiente Eduard Henning allerdings nicht mit den Verkäufen in seiner Galerie, sondern durch seinen Hahn-Verlag, in dem neben mehr als 40 Katalogen weit über 800 ein- und mehrfarbige Kunstkarten und etwa 100 Kartenmappen im Format A6 erschienen waren. Die Kartenmappen dienten als Ergänzung und ab 1952 als Ersatz für die von der Abteilung Kultur der Stadt Halle/Saale nicht mehr genehmigten Ausstellungskataloge.

Durch seine Kontakte und Messebesuche sowie auf zahlreichen Reisen nach Frankreich hatte Eduard Henning Begegnungen mit Gleichgesinnten, die ihm beim Aufrechterhalten des Galeriebetriebs behilflich sein sollten. 1953 lernte der Galerist beispielsweise in Leipzig auf der Messe Michel Dupouey kennen, den Generalsekretär der Vereinigung französisches Buch im Ausland und Projektbeauftragten im französischen Außenministerium, der ihn nach Paris einlud und ihn im Oktober 1955 mit Georges und Fernand Mourlot, den Druckern Pablo Picassos, bekannt machte.[3] Während dieses Aufenthalts begegnete er weiterhin Georges Lambert, dem Manager der prominenten Guilde de la Gravure, und Künstlern wie Georges Braque und Antoni Clavé.[4] Mit den Kunsthändlern Adrien

Auswahl an Katalogen der Galerie Henning im Format A5

Maeght und Heinz Berggruen schloss Eduard Henning Koopera-
tionsvereinbarungen und kaufte bei ihnen Grafik ein, wenn er in
Paris weilte.

Schon im April 1950 war es in Halle an Saale zur ersten Ein-
zelausstellung mit grafischen Blättern von Georges Braque nach
der NS-Zeit gekommen. Auch die 100. Ausstellung der Galerie
Henning im September 1955 war die erste ihrer Art nach 1945:
Speziell Marc Chagall gewidmet, wurden über 60 Farblithografien
präsentiert, darunter Arbeiten aus der Folge *Visions de Paris* von
1954 und Illustrationen zu Boccaccios *Decamerone*. Im Jahr 1956
gab es im Januar Picassos Studien zu *Der Maler und sein Modell*,
im März Farblithografien von Jean Lurçat, im April erneut Arbeiten
von Georges Braque und im November Aquatinta-Radierungen aus

*Die Chagall-Ausstellung im Wohn-
zimmer der Familie Henning*

151

der Serie *Miserere* von Georges Rouault zu sehen. Bis zum Oktober 1961 zeigte die Galerie Henning insgesamt 19 Einzelausstellungen und elf thematische Gruppenexpositionen mit französischer Kunst. Arbeiten von Pablo Picasso wurden in vier Einzelausstellungen im November 1950, im Januar 1956, im März 1959 und im Oktober 1961 präsentiert.[5] Ebenso fanden gegenständliche und abstrakte Bilder, christliche und sinnenfrohe Themen ihren Platz in der Galerie. Das abwechslungsreiche Programm bot den Besuchern die Möglichkeit unvoreingenommener und fantasievoller Kunstbetrachtungen und somit immer neue Entdeckungsreisen.

Seine Galerie, einer der vergleichsweise wenigen Orte privaten kunsthändlerischen Engagements erst in der SBZ und dann in der DDR, war für Eduard Henning eine Geistes- und Interessengemeinschaft, die sowohl bekannte als auch unbekannte Künstler:innen vereinte, Kunstbegeisterte und Sammler:innen anzog und aus diesem Grund bald ins Visier der Staatssicherheit geriet. Der direkte Angriff der SED richtete sich zuerst gegen den Verleger Eduard Henning und nicht gegen den Galeristen. Dem war Folgendes vorausgegangen: Von November bis Dezember 1950 zeigte Eduard Henning zum ersten Mal Grafiken von Pablo Picasso, die durch Werkreproduktionen ergänzt wurden. Das seltene Kunstereignis war der Sammlung Buchheim-Militon, Paris, zu verdanken, wie aus der Ausstellungsrezension in der Tageszeitung *Der Neue Weg* hervorgeht. Hermann Goern verwies in seinem Artikel auch auf die heikle Situation, dass bereits der Name Picasso „sofort eine entscheidende Gegnerschaft auf den Plan" rief.[6] In der Tat war Picasso in der DDR schnell zum prominentesten Opfer der stalinistischen Kulturpolitik und der Realismus-Formalismus-Debatte geworden. Dies sollte den Galeristen Henning jedoch nicht davon abhalten, den im Programm des Künstlers, Schriftstellers, Verlegers und Sammlers Lothar-Günther Buchheim erschienenen Katalog *Pablo Picasso. Das graphische Werk. Sammlung Buchheim-Militon* bei Typographie, Satz und Druck VEB Offizin Haag-Drugulin in Leipzig nachdrucken zu lassen und in seiner Galerie mit einem Stempel versehen zu vertreiben. Ungewöhnlich für die Zeit enthielt das 26-seitige Heft Anzeigen zahlreicher westdeutscher Galerien und Verlage – und ein Inserat aus der DDR: von der Galerie Henning.[7]

Als Eduard Henning für den Juni 1951 mit Hilfe von Lothar-Günther Buchheim erneut eine Picasso-Ausstellung plante und dazu auch einen Katalog, geriet er offenbar in Bedrängnis. Die Ausstellung fand nicht statt, dafür erschien vier Monate später die Broschüre *Pablo Picasso. Aus dem graphischen Werk* in einer Auflage von 1.100 Exemplaren. In der Einleitung erklärte Buchheim, dass es in der Kunst Picassos keinen Formalismus gäbe. Nicht weniger provokant muss das auf die Formentwicklung Picassos ausgerichtete Bildmaterial auf die am sozialistischen Realismus orientierten Funktionäre gewirkt haben und so nahm die Kulturabteilung des Zentralkomitees der SED zu diesem „Vorfall" Stellung. In einem Brief an die Kulturabteilung der Landesleitung Sachsen-Anhalt vom 3. März 1952 bewertete der damalige Leiter der Abteilung, Egon Rentzsch, den Bildteil im Katalog als „eine raffinierte Auswahl der am äußersten formalistischen Arbeiten dieses revolutionären spanischen Künstlers. Wir sind erstaunt, daß die Kulturabt. der Landesleitung dieser Sache noch nicht auf der Spur ist und auch nicht rechtzeitig eingegriffen hat, um diese Provokation zu verhindern. Leider hat die Außenstelle des Amtes für Informationen in Halle die Druckgenehmigung erteilt. Man muß prüfen, ob Unfähigkeit oder Sabotage vorliegt." Nach Ansicht des SED-Funktionärs konnte man es sich „natürlich nicht leisten, in der DDR Picasso zu ‚verbieten'", den Schöpfer der Friedenstaube, des Symbols der Weltfriedensbewegung. Von dem war aber „keine Spur in dieser Broschüre" zu finden.[8] Deshalb wurde die Publikation, von der allerdings schon einige Exemplare in der Galerie, in der Buch- und Kunsthandlung Engewald in Leipzig sowie für 9,80 DM in Westberlin verkauft worden waren, konfisziert.

Die SED-Landesleitung Sachsen-Anhalt, die den Druck des Kataloges genehmigt hatte, kündigte repressive Maßnahmen an: „Zur weiteren Untersuchung dieser Angelegenheit und Überprüfung des gesamten Geschäftsgebarens des Herrn Hennig wurden durch das Amt für Information die entsprechenden Dienststellen der Volkspolizei benachrichtigt. Die Kulturabteilung der Landesleitung Sachsen-Anhalt wird sich in der kommenden Zeit eingehend mit den Ausstellungen der Galerie Hennig beschäftigen. Herr Hennig wird im Allgemeinen als ein sehr redegewandter und skrupelloser Mensch eingeschätzt, der rücksichtslos versucht seine Pläne zu verwirklichen."[9] Nach dieser Affäre gelang es Eduard Henning

nur noch selten, Kataloge zu seinen Ausstellungen herauszugeben. Erst im November 1956, im September 1958 und im Mai 1959 konnte er zu den Ausstellungen von Heinz Fleischer, Erich Mälzner und Ewald Blankenburg wieder Kataloge vorlegen.

Lothar-Günther Buchheim publizierte bereits seit 1950 Broschüren im Eigenverlag. Auch zu der Gemeinschaftsausstellung „Zeitgenössische französische Grafik – Originale und Reproduktionen" im Januar 1951 vertrieb Eduard Henning eine Broschüre von Buchheim, die er zuvor mit einem Stempel seiner Galerie versehen hatte. Die französische Grafik war den Hallenser:innen nicht unbekannt, als von April bis Juli 1957 die Ausstellung „Von Menzel bis Picasso. Handzeichnungen und Graphik des 20. Jahrhunderts aus eigenen Beständen" in der Staatlichen Galerie Moritzburg in Halle gezeigt wurde. Unter den 209 Arbeiten von 113 Künstler:innen befanden sich auch Erwerbungen aus der Galerie Henning wie beispielsweise von Marc Chagall, Georges Braque und Pablo Picasso.[10]

Im September 1957 eskalierte die Situation um die Galerie Henning, als die Werke eines Westberliner Malers gezeigt wurden. Die Schau Heinz Trökes' wurde schließlich zum Anlass genommen, um die gesamte Ausstellungspolitik Eduard Hennings zu verurteilen. Die Presse war vernichtend. Der ehemals stellvertretende Kulturabteilungsleiter des ZK der SED, Georg Kaufmann, schrieb im *Neuen Deutschland* einen polemisierenden Artikel, dessen Schärfe offensichtlich dem Ärger über den großen Erfolg der Galerie entsprungen war. Reinhard Vahlen, der Parteisekretär und stellvertretende Direktor der Kunstschule Burg Giebichenstein, forderte in der Tageszeitung *Freiheit* am 17. Januar 1958: „Standpunkt überprüfen". Die Artikel waren nun direkte Anklagen, und dass die Schließung der Galerie nicht zustande kam, war nur Eduard Hennings diplomatischen Verbindungen zu verdanken. Henning kannte den Außenminister Dr. Lothar Bolz. Dieser war ein leidenschaftlicher Sammler und Mäzen der Galerie. Seine Verbundenheit bewahrte Eduard Henning mehrmals vor einer Schließung durch die Parteifunktionäre der SED. Der Galerist ließ sich von dieser Kritik gegen seine Arbeit jedoch nicht einschüchtern; im November 1958 gab es wieder eine Gruppenausstellung mit vierzehn Künstlern und „Grafik aus Paris".

Mit dem Bau der Berliner Mauer im Jahr 1961 war die Verbindung zu Eduard Hennings Freunden und Kooperationspartnern in Paris und zu Lothar-Günther Buchheim getrennt, seine Wünsche und Vorstellungen konnte er nicht mehr verwirklichen. Die letzte Ausstellung der Galerie im Dezember 1961 zeigte Aquarelle von Brunhilde Keune und war der Endpunkt des Weges, den die Galerie vierzehn Jahre lang konsequent verfolgt hatte. Trotz der Verbote und der öffentlichen Angriffe hatte sich Eduard Henning den Forderungen der SED nicht gebeugt. Dieser neuen Situation fühlte er sich nicht mehr gewachsen und die Galerie schloss noch im selben Monat. Weder seine Frau Christel noch sein Sohn Peter konnten verhindern, dass er am 21. Juni 1962 sein Leben beendete.

Nach dem Tod ihres Mannes beantragte Christel Henning im Juli 1962 die Weiterführung des Galeriebetriebes, was ihr jedoch nicht erlaubt wurde. In der schriftlichen Ablehnung der Abteilung Kultur des Rates der Stadt Halle vom 14. März 1963, die fast ein Jahr auf sich warten ließ, hieß es dazu: „Ein gesellschaftliches Bedürfnis für die Aufrechterhaltung der Kunstgalerie liegt in unserer Stadt nicht vor."[11]

Der Bildhauer Richard Horn in seiner Gedenkrede über Eduard Henning:

> „Es war nicht allein organisatorische Fähigkeit, die die Ausstellungen zu Ereignissen werden ließen, es war der Sinn, das Gespür für das Richtige, das zur richtigen Zeit getan werden mußte, und es war darüber hinaus eine vielleicht unbewußte Begabung, die Werke der Künstler auszusuchen und zu zeigen, die nicht nur Qualität besaßen, sondern die in der damaligen ungeklärten Situation auch die Menschen ansprachen."[12]

Christin Müller-Wenzel
Christin Müller-Wenzel ist als freiberufliche Kunstwissenschaftlerin in Halle (Saale) tätig.

Der Text geht auf einen Vortrag der Herbstkonferenz am 30. November 2020 zurück, der von der Autorin für diesen Band angepasst wurde.

Endnoten

1 Zu den Ausstellungen in der Galerie Henning. Rolf Friedmann: Kunst oder Dekadenz?, in: Monatsheft Kulturspiegel für Halle und Saalkreis, Januar 1958, Heft 1, S. 96–97.

2 Vgl. Mathias Deinert: Provenienzrecherche in Stadt- und Regionalmuseen des Landes Sachsen-Anhalt. Pilotprojekt Oktober 2016 bis Februar 2017. [= Abschlussbericht zum Projekt des Museumsverbandes Sachsen-Anhalt e. V.] Bernburg 2017, Teil „Zeitz" S. 13 und 27–32, in: Proveana – Datenbank Provenienzforschung: Projekt „Erstcheck von Museumsbeständen im Altmärkischen Museum Stendal, Danneil-Museum Salzwedel, Gleimhaus Halberstadt, Museum Aschersleben, Museum Schloss Moritzburg Zeitz", PURL https://www.proveana.de/de/link/pro10000251 (7.7.2021).

3 Vgl. Nationalarchiv des französischen Kulturministeriums: http://www.siv.archives-nationales.culture.gouv.fr (10.1.2017)

4 Ein Reisetagebuch von Christel und Eduard Henning, das die einzelnen Kontakte und Besuche in Frankreich handschriftlich dokumentiert, befindet sich im Nachlass der Familie Henning.

5 Vgl. Christin Wenzel: Kunst oder Dekadenz? Die Galerie Henning in Halle an der Saale von 1947–1961, Magisterarbeit an der Martin-Luther-Universität Halle-Wittenberg, Halle/Saale 2004, hier Katalog der Ausstellungen der Galerie Henning.

6 Vgl. Hermann Goern: Der Maler Picasso. Zur Ausstellung in der Galerie Henning, in: Der Neue Weg 5 (1950) 1969 vom 24.11.1950, S. 3.

7 Vgl. Lothar-Günther Buchheim: Pablo Picasso. Das graphische Werk. Sammlung Buchheim-Militon, Leipzig 1950, hier S. 21.

8 Zitate vgl. Zentralkomitee der SED, Kulturabteilung, Berlin, Egon Rentzsch, an die Landesleitung Sachsen-Anhalt, Kulturabteilung, Halle/Saale, vom 3.3.1952, in: BArch DY 30/84884, Bl. 184.

9 Zitat vgl. SED Landeslandesleitung Sachsen-Anhalt, Abt. Kultur u. Erziehung, an das ZK der Sozialistischen Einheitspartei Deutschlands, Kulturabteilung, Berlin, vom 27.3.1952, in: BArch DY 30/84884, Bl. 194.

10 Die Staatliche Galerie Moritzburg erwarb 1956/57 von der Galerie Henning folgende Blätter: Marc Chagall, Das rote Pferd (Siebdruck, Inv.-Nr. G 3720), Georges Braque, Stierkämpfer (Farblithographie, Inv.-Nr. G 3145) und Schwarzer Krug und Zitronen (Farbradierung mit Aquatinta, Inv.-Nr.: G 3724, im Kat. von 1957 noch als Leihgabe ausgewiesen), Pablo Picasso, Pagenspiele und Le repras frugal (beide gedruckt von Mourlot, Inv. G 3722 u. G 3723).

11 Zitat aus dem Brief des zuständigen Leiters der Abteilung Kultur beim Rat der Stadt Halle/Saale vom 19. März 1963 an Christel Henning. Der Brief befindet sich im Nachlass der Familie Henning.

12 Richard Horn: Gedenkrede zum Tode Eduard Hennings. Das Dokument befindet sich im Nachlass der Familie Henning.

OV „Puppe" – Der staatliche Zugriff auf eine private Spielzeugsammlung in Rudolstadt

Julia Marie Wendl

"Operation Doll". Government seizure of a private toy collection in Rudolstadt

It is now widely known that the government of the GDR applied unusual and unlawful means to acquire foreign currency, including expropriating or confiscating privately owned art and antiques which were then sold, usually to buyers in western countries, through the Kunst und Antiquitäten GmbH (Art and Antiques Ltd., abbreviated as KuA). Private art and antiques dealers were accused of tax evasion; the only way they could meet the horrendous back payments demanded of them was by selling or handing their collections over to KuA. Such was also the fate of Martin and Bettina Wendl, who ran the Antiquitäten-Stube, an antique shop in Rudolstadt, in Thuringia, and owned a lovingly compiled collection of dolls. They had the good fortune to quickly realize the dishonest intentions of KuA and the Ministry of State Security (MfS), and were able to partly foil them thanks to vigorous support from friends and the fearlessness of their lawyer. Of over 200 art dealers and collectors who saw their property confiscated, Bettina and Martin Wendl were among the few who were able to extricate themselves from the attentions of Kommerzielle Koordinierung (Department of Commercial Coordination in the East German Ministry for External Trade) without being incarcerated, and even succeeded in saving parts of their collection. They were, however, forced to sell numerous heirlooms and almost their entire doll collection to the government. Their livelihood was gone, and targeted defamation by the MfS had sowed resentment against them among their fellow citizens. Robbed of their future, the Wendls finally managed to leave the country. But in 1991 Martin Wendl returned with his second wife to open an auction house in Rudolstadt.

Wie viele private Kunsthändler und Sammler in der DDR geriet auch die Familie Wendl in den 1980er-Jahren in den Fokus des Bereichs Kommerzielle Koordinierung (KoKo) im Ministerium für Außenhandel. Martin und Bettina Wendl betrieben seit 1973 die Antiquitäten-Stube in Rudolstadt in Thüringen, welche sich schnell zum Geheimtipp weit über die Stadt hinaus entwickelt hatte. Unter dem Publikum befanden sich finanzkräftige Kundschaft aus Erfurt, Leipzig und Berlin und Prominente wie der Schauspieler Eberhard Esche oder der Schriftsteller Peter Hacks. Die Ausstellungen der liebevoll restaurierten Puppensammlung von Bettina Wendl und die Veröffentlichungen Martin Wendls über Volkskunst hatten viel

Bettina und Martin Wendl mit Tochter Christiane bei der Eröffnung der Antiquitäten-Stube

zur landesweiten Reputation des Geschäftes beigetragen. Dass sie selbst in den Fokus des Bereichs Kommerzielle Koordinierung geraten würden, kam für die Wendls unerwartet: „Wir hatten natürlich von staatlichen Übergriffen und Enteignungen von Sammlungen, vor allem in Dresden, gehört, das wussten wir allerdings nur vom Hörensagen. Wir glaubten, uns könne nichts passieren, da unsere Geschäfte sauber waren."[1]

Ins Visier gerieten sie vermutlich durch öffentliche Präsentationen der Puppensammlung. Das Kulturgutschutzgesetz der DDR enthielt Regelungen, die Sammler auf steuerliche Vergünstigungen hoffen ließen, wenn sie ihre Bestände der Öffentlichkeit zugänglich machten. Während einer solchen Gemeinschaftsausstellung auf Schloss Burgk in Thüringen interessierte sich ein Händler aus dem Westen für die Puppen; wahrscheinlich war dies der Auslöser des OV „Puppe", der den Eigentumsentzug der Familie Wendl zwecks Devisenbeschaffung zum Ziel hatte. Was folgte, war eine quälende Prozedur, die Martin Wendl als „reine Schikane" empfand und die die Familie fast um ihre gesamte Existenz brachte. Obwohl mehr als 200 ähnliche Fälle bekannt sind,[2] in denen das Devisenbeschaffungssystem Alexander Schalck-Golodkowskis Kunsthändlern und -sammlern die Existenz nahm, ist das Schicksal der Wendls fast einzigartig. Sie schafften es nicht nur, der Inhaftierung zu entgehen, sondern auch Teile ihrer Sammlung zu retten und ein Stück weit

Die Visitenkarte der Antiquitäten-Stube, Vorder- und Rückseite

sogar das unlautere Vorhaben der Kunst und Antiquitäten GmbH zu vereiteln. Trotzdem blieb der Familie keine Alternative zur Ausreise in den Westen.

Der erste aus den MfS-Akten bekannte Plan zum OV „Puppe" stammt vom 13. August 1986 und nennt als eines von mehreren Zielen die „Einleitung operativer Maßnahmen zur schnellstmöglichen Feststellung des Wertes der im Besitz befindlichen Antiquitäten und Kunstgegenstände der Vorgangspersonen".[3] Im Frühjahr 1987 wurde von Mitarbeitern des MfS ein detaillierter „Plan des 1. Angriffs" ausgearbeitet, der den Umfang des zwei Tage später beginnenden Vorgangs schon erahnen lässt: Für die Durchführung waren mindestens 30 Personen vorgesehen, die Staatsanwälte nicht mitgezählt, sowie zusätzlich eine Beobachtungsgruppe, Reservekräfte, Zeugen und sogar eine Kindergärtnerin „für den möglichen Transport der jüngsten Tochter von ‚Puppe'".[4] Mit nur zwei Mitarbeitern war die Steuerfahndung in auffallend kleiner Besetzung vertreten, obwohl der Tatvorwurf der Steuerverkürzung als Grund der Untersuchung diente.

Wie im Plan vorgesehen, wurde Martin Wendl mit der Bitte, als Sachverständiger bei der Aufklärung von Antiquitätendiebstählen behilflich zu sein, am Morgen des 8. April 1987 in das Volkspolizeikreisamt gebeten, sodass seine Frau ihn im Ladengeschäft vertreten musste. Es war allgemein bekannt, dass Martin Wendl den Verkauf und die Bücher führte. Als seine Frau die geforderten Dokumente nicht umgehend zur Hand hatte, wurde trotz mehrfacher Bitte, die Rückkehr des Mannes abzuwarten, auf einer weiteren Suchaktion im Privathaus und Lager bestanden. „Ich suchte verzweifelt nach Unterlagen […] Der andere Herr mit dem Berliner

Das Schaufenster der Antiquitäten-Stube in der Kirchgasse Ecke Schloß-aufgang IV

Dialekt interessierte sich aber in erster Linie für den Inhalt unserer Wohnung, die er voll und ganz zu besichtigen wünschte."[5] Nach der Rückkehr in den Laden wurde Bettina Wendl sogleich mit Verdächtigungen und Unterstellungen konfrontiert. Als Martin Wendl viele Stunden später vom Volkspolizeikreisamt zurückkehrte und die gewünschten Papiere umgehend vorlegte, wurden schon Fragen zu den ersten, gleichwohl korrekt versteuerten Privatkäufen gestellt. Seine Frau fuhr in die Wohnung zurück, wo sie bald abgeholt und zur Befragung ins Kreisgericht Rudolstadt gebracht wurde. In der Antiquitäten-Stube war inzwischen eine große Gruppe Menschen mit Staatsanwältin und Durchsuchungsbefehl eingetroffen und auch Martin Wendl wurde abgeführt. Während das Ehepaar verhört wurde, fand die Durchsuchung ohne unbeteiligte Zeugen statt, denn „wenn ein Staatsanwalt dabei sei, wäre das nicht nötig", wurde Bettina Wendl mitgeteilt.[6] Alle Geschäftsunterlagen, viele Privatpapiere, Briefe, Sparbücher, Dokumente, österreichische und DDR-Staatsbürgerschaftsnachweise und Pässe wurden ohne Quittung beschlagnahmt. Die Verhöre dauerten bis ca. 22.45 Uhr. Dass die Wendls am selben Abend noch entlassen wurden, verdankten sie dem Staatsanwalt, erzählt Martin Wendl: „Er wollte den Haftbefehl nicht unterschreiben, solange keine Beweise vorlagen. Und die haben sie ja nicht gefunden."

Derweil durfte die älteste Tochter, die von ihrer Ausbildungsstelle nach Hause kam, die Wohnung nicht betreten und wurde beschattet. Währenddessen wurde sichergestellt, dass sich die

Nachricht über die Festnahme und die angebliche Bereicherung der Wendls „auf dem Rücken des Volkes" in ganz Rudolstadt verbreitete. Als die Nachbarin, die Bettina Wendl gebeten hatte, die jüngste Tochter aus dem Kindergarten abzuholen, ihre Vollmacht zeigen wollte, beeilte sich der Beamte der Kripo Gera, der sie begleitete, seine Klappkarte vorzuzeigen, damit sich die ganze Angelegenheit schnell herumsprach. Schon vier Tage bevor den Wendls die erste geschätzte Schuldsumme von 250.000 Mark offiziell mitgeteilt wurde, hörte ihre Nachbarin davon im Bus. Ebenso machten gezielte Gerüchte den Umlauf, man hätte bei Wendls Tausende Mark in der Wäsche gefunden, andere sprachen von drei Millionen in dicken Bündeln. Nur wenige durchschauten das Spiel von MfS und KoKo. Dennoch erreichte das Paar in jenen schweren Monaten auch eine Warnung: Jemand hatte die Kopie eines Zeitungsartikels der (West-)*Berliner Morgenpost* durch den Briefkastenschlitz geworfen, die über den von der DDR-Regierung organisierten Kunstraub zur Devisenbeschaffung berichtete.

Am Tag nach der Durchsuchung mussten Martin und Bettina Wendl ihre vorläufigen Ausweise beantragen, mit denen sie überall als „suspekte Bürger" identifiziert werden konnten. Als sie zurückkamen, waren bereits zwei Schätzer der Kunst und Antiquitäten GmbH aus Berlin sowie Kripobeamte und deren Chef aus Gera, Mitarbeiter der Staatssicherheit und Beamte der Steuerfahndung vor Ort. „Die Herren bewerteten im Haus und in allen Nebenräumen alle nur etwas älteren (exportfähigen vermutlich) Dinge, egal ob Mobiliar, Sammlungs-, Gebrauchsgegenstände oder persönliches Kinderspielzeug unserer Kinder. Dazu etliche Dinge, die völlig neu waren (z. B. Bilder, Lampe, vermutlich Fehleinschätzungen), und viele Dinge zu solchen Preisen, wie sie (von Herrn Brachhaus 🖉 zugegeben) von ihrer eigenen Firma nicht in dieser Höhe angekauft würden."[7] Alles, was verwertbar erschien, wurde vom VEB (K) Antikhandel (Pirna) in einer dreißig Seiten umfassenden Liste mit 833 Einzelpositionen aufgeführt und mit einer Gesamtsumme von 607.091 Mark bewertet.[8] „Unsere kleine Tochter weinte, da an ihrem eisernen kleinen Puppenbettchen auch eine rote Nummer und an ihrem Eckschrank auch eine Nummer klebte."[9] Wie in vergleichbaren Fällen war der Schätzwert aller gelisteten Objekte in der Summe fast deckungsgleich mit der später festgelegten Steuerschuld. Die angegebenen Werte waren oft weit von den in

🖉 *Siegfried Brachhaus war Sachverständiger, KuA-Mitarbeiter und IM des MfS.*

Rudolstadt erzielbaren Preisen entfernt. „16 Glasbriefbeschwerer (ähnliche verkaufen wir im Laden um ca. 65 Mark) wurden zwischen 400 und 800 Mark pro Stück bewertet."[10] Das Ziel der Aktion war für das Ehepaar Wendl schnell ersichtlich: „Uns wurde geraten, unsere Sammlung gleich an die Kunst und Antiquitäten GmbH zu verkaufen, um die Schuld zu tilgen. Andere Käufer müssten erst von der Behörde abgesegnet werden."

Am 14. April 1987 wurde den beiden eine Sicherungsverfügung in Höhe von 250.000 Mark über ihr gesamtes bewegliches und unbewegliches Vermögen ausgehändigt. Eine Kopie der Bewertungsunterlagen erhielten sie sehr lange nicht. Die Beschattungen hielten an. Aber das Ehepaar hatte während der Befragungen und Verhöre richtig reagiert: Auch nach vielen Wochen konnte man ihnen nichts nachweisen, weshalb am 13. und 14. Mai in der Geraer MfS-Bezirksverwaltung eine Krisensitzung einberufen wurde. Einem Schreiben vom 19. Mai ist zu entnehmen: „Den Gesprächspartnern wurde dargelegt, daß wegen ungenügenden Arbeitsergebnissen der Steuerfahndung Gera im Jahre 1986 durch das MdF Hilfe und Unterstützung zugesagt wurde. Mit dem Sachverhalt Wendl war ein solches Material gegeben, das geeignet ist, ein Beispiel zu schaffen und durch die Steuerfahndung Gera ein Erfolgserlebnis zu erarbeiten."

Unter der darin festgelegten Hauptlinie findet sich auch der Auftrag: „Zum Beschuldigten Wendl, Martin ist die Inhaftierung anzustreben."[11] Ebenso ist herauszulesen, dass einigen „Genossen Finanzbeamten" wohl deutlich gemacht wurde, zu welchen Untersuchungsergebnissen sie zu kommen hatten. Die Wendls mussten von nun an fast fünf Monate lang zwei- bis dreimal wöchentlich zu Verhören nach Gera. Dieser dauerhafte psychische Druck sorgte schließlich dafür, dass Bettina Wendl Vernehmungsunfähigkeit attestiert wurde und Martin Wendl sich fortan den Verhören allein stellen musste.

Am 16. Oktober 1987 wurde die Steuerschuld auf 620.621 Mark festgelegt und eine entsprechende Sicherungsverfügung ausgestellt. Familie Wendl hatte Glück, beim bekannten und unerschrockenen Lobensteiner Rechtsanwalt Christian Drechsler Unterstützung zu finden. Dieser nannte die Summe, welche aus nicht reellen Zeitwerten und zu Geschäftsware deklariertem Privateigentum gebildet und dann auf zehn Jahre zum damaligen

MfS-Operativplan zum Operativ-Vorgang „Puppe", Bezirksverwaltung für Staatssicherheit Abteilung VII, 13.8.1986, BStU, MfS, BV Gera, AOP 814/88, Bd. 1, Bl. 8 (Kopie)

Steuersatz von 90 Prozent rückversteuert sowie mit Zinsen und Strafzahlungen belegt wurde, eine „Milchmädchenrechnung". Er legte am 26. Oktober eine umfangreiche Beschwerde zu zahlreichen rechtlich anfechtbaren Punkten des Vorgangs ein. Zugleich forderte er die Schätzungsunterlagen und die Buchführung an, die ihm immer noch nicht ausgehändigt worden waren, sodass ihm die Vorbereitung der Verteidigung erheblich erschwert wurde.

„Wir hörten mehrere Wochen lang nichts, bis schließlich drei Tage vor Ablauf der Frist ein Anruf kam, in dem uns geraten wurde, den Einspruch zurückzunehmen. Sie drohten uns mit einer weiteren Strafzahlung von 36.000 Mark, da der Ausgang der Beschwerdeverhandlung schon feststünde und für mich mit mindes-

tens zweijähriger Haft enden würde. Wenn wir die Beschwerde zurückzögen und zahlten, würde ich der Haftstrafe entgehen. Uns blieb nichts anderes übrig", so Wendl. Um die Summe aufzubringen, musste Martin Wendls Mutter ein Grundstück in der Jenaer Innenstadt verkaufen und die Familie Geld von Freunden und Bekannten borgen. Ihr Freundeskreis war ihr großes Glück, denn anders wäre die Forderung in der Kürze der Zeit – Zahlungstag war bereits der 2. November 1987 – nicht zu tilgen gewesen. Wer den Wendls Geld lieh, berichtete die Bank dem MfS, das zudem jeweils vermerkte, ob „der Bürger gehört" wurde. Um den Restbetrag aufzubringen und ihre Gläubiger auszuzahlen, mussten die Wendls Antiquitäten – hauptsächlich die begehrten Puppen – im Wert von mehr als 280.000 Mark an die Kunst und Antiquitäten GmbH Berlin am Standort Mühlenbeck verkaufen. „Wenigstens taten wir es zu deren eigenen, überhöhten Schätzpreisen und konnten aussuchen, was verkauft wurde, um somit einzelne liebgewonnene Stücke zu retten", erinnert sich Martin Wendl.

Anschreiben zur eingereichten Beschwerde vom 26. Oktober 1987 und Auszug aus der Rücknahme der Beschwerde vom 26. November 1987

In den folgenden Monaten wurde es offensichtlich, dass die Familie in der DDR keine Zukunft mehr hatte. Die Existenzgrundlage war genommen und die Missgunst der Mitbürger geschürt. Nach einem langwierigen Ausreiseantrag, in dessen Verlauf behördlicherseits nichts unversucht blieb, über Ausfuhrverweigerungen an einige übrig gebliebene Objekte der Sammlung zu kommen, konnte Familie Wendl im Mai 1989 offiziell nach Österreich und von dort in die BRD ausreisen. Dass dies mit schwerem Herzen geschah, zeigt die schnelle Rückkehr: Bereits 1991 eröffnete Martin Wendl mit seiner zweiten Frau Anke Wendl ein Auktionshaus in Rudolstadt. Bettina Wendl blieb in Westdeutschland.

Im Wesentlichen, weil der Anwalt der Wendls damals vermerkte, „daß diese Beschwerderücknahme keine Aufgabe meines [...] dargelegten Rechtsstandpunktes bedeutet", wurden nach einem langjährigen Prozess die Steuerbescheide 1994 für ungültig erklärt.[12] Die der Währungsreform angepasste Entschädigungssumme half beim Kauf der repräsentativen Gründerzeitvilla, die seitdem Sitz des Kunst-Auktionshauses Wendl ist. Eine gewisse

Geschäftsschließung

Ende Februar schließen wir nach fünfzehnjähriger Tätigkeit unser Antiquitätengeschäft.

Bis einschließlich 27. Februar noch Rest-Verkauf

Mittwoch bis Samstag, vormittags.

Wir danken allen Kunden, Bekannten, Freunden und kulturellen Einrichtungen, die uns auch in schweren Stunden tatkräftig unterstützten.

Bettina und Martin Wendl

Antiquitäten-Stube
Stiftsgasse 11
Rudolstadt, 6820

Bettina und Martin Wendl lösten im Februar 1988 ihr Geschäft auf.

Ironie des Schicksals, die, so hofft Martin Wendl, den „beteiligten Genossen" nicht entgangen ist. „Dank meiner Freunde, der österreichischen Staatsbürgerschaft und unseres Anwalts konnte ich der Sache recht glimpflich entgehen. Dieses Glück ist mir bewusst, denn anderen erging es wesentlich schlechter." Trotzdem hat die Zeit ihre Spuren hinterlassen. Nicht nur viele, über Jahrzehnte gesammelte Antiquitäten und Erbstücke sind verloren; die Wut und gleichzeitige Ohnmacht angesichts des skrupellosen Vorgangs, die Erinnerung an die Angst um die Familie und die alternativlose Ausreise steigen bei jedem Blick in die Vergangenheit wieder empor. Schon deshalb ist Martin Wendl der Suche nach verlorenen Einzelstücken nie nachgegangen und möchte mit diesem Zeitzeugenbericht die Beschäftigung mit den Geschehnissen abschließen.

Julia Marie Wendl
Julia Marie Wendl ist Inhaberin des Kunst-Auktionshauses Wendl in Rudolstadt und Tochter der Firmengründer Anke und Martin Wendl.

Endnoten

[1] Soweit nicht anders gekennzeichnet, entstammen alle Zitate den Gesprächen mit Martin Wendl im Zeitraum 1.11.2020 bis 9.1.2021 zur Vorbereitung dieses Zeitzeugenberichts (Gesprächspartnerin: Julia M. Wendl).

[2] Rainer Erices, Nicola Kuhrt, Peter Wensierski: „Da klebt doch Blut dran", in: Der Spiegel 30/2014, S. 40–42, hier S. 40.

[3] MfS: Operativplan zum Operativ-Vorgang „Puppe", Bezirksverwaltung für Staatssicherheit Abteilung VII, 13.8.1986, BStU, MfS, BV Gera, AOP 814/88, Bd. 1, Bl. 8.

[4] „Plan des 1. Angriffs zur Realisierung des OV „Puppe" Re.-Nr. X/618/86 auf der Grundlage des Realisierungsvorschlages vom 1.4.1987", Gera, 6.4.1987, gü-ka (BStU, MfS, BV Gera, AOP 814/88, Bd. 1, Bl. 140–147, Kopie).

[5] Bettina Wendl: Gedächtnisprotokoll, April 1987, S. II.

[6] B. Wendl 1987, S. V.

[7] Martin Wendl: Gedächtnisprotokoll, April 1987, S. II.

[8] Zeitwertfeststellung am 9./10.4.1987 über Gegenstände der Bürger Wendl, Bettina und Martin (Privatkopie).

[9] B. Wendl 1987, S. VII.

[10] B. Wendl 1987, S. VII.

[11] MfS: Information über Absprachen im Bezirk Gera zum Ermittlungsverfahren gegen das Ehepaar Wendl/ Rudolstadt (OV „Puppe" der Abt. VII Gera, EV Einleitung am 8.4.1987 wegen verbrecherischer Steuerverkürzung), Berlin, 19.5.1987, BStU, MfS, BV Gera, AOP 814/88, Bd. 1, Bl. 185–187.

[12] Christian Drechsler: Beschwerderücknahme, Abschrift, 26.11.1987, S. 2.

Staatlicher Kunsthandel

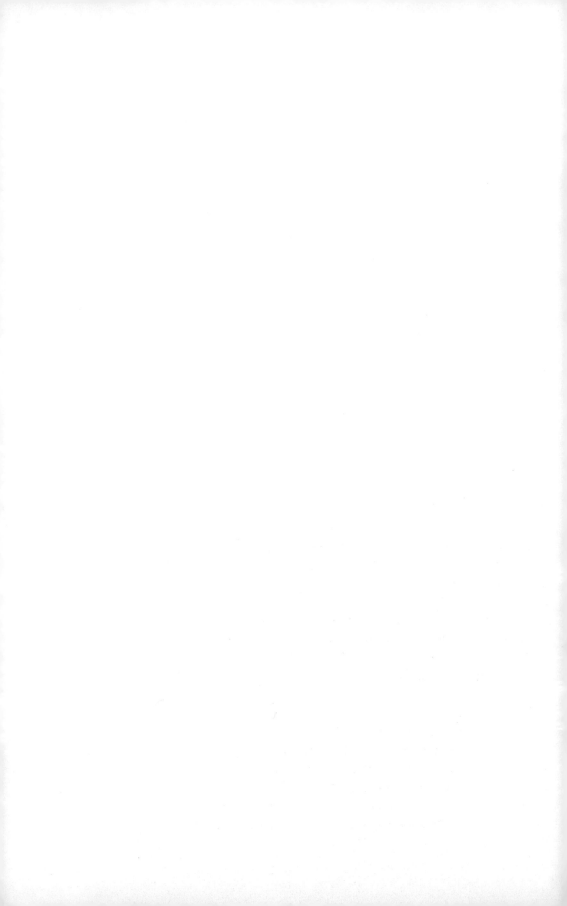

Spurensuche zum Staatlichen Kunsthandel der DDR

Thomas Widera

Tracing the State Art Trade of the GDR
Based on research into the highly secretive "Operation Light" of the Ministry for State Security (MfS) in 1962, in the course of which thousands of safes were opened and emptied throughout East Germany, the article discusses the initial difficulties in the establishment of the Staatliche Kunsthandel der DDR (State Art Trade of the GDR) and sheds light on the role of the MfS. When the Staatlicher Kunsthandel was founded at the end of 1955, East German authorities failed to issue specific regulations for the art and antiques trade, especially with western customers. The head of its only business branch located in Berlin was granted extensive power of attorney. He was able to organize the art trade between East and West in a legal gray area on his own authority in order to generate foreign currency for the state budget. Since dealers and art collectors from abroad were prohibited from buying independently in the GDR and private art dealers were prohibited from selling directly to them, Staatlicher Kunsthandel had a monopoly position. Irregularities did not lead to a review and reorganization until 1962. The arrest of the head and several employees not only revealed the failure of MfS officers, but was also intended to distract attention from a blatant violation of control duties by senior GDR officials.

Die Aktion „Licht" des Ministeriums für Staatssicherheit (MfS) fand wie andere Maßnahmen unter größter Geheimhaltung statt und folgte minutiös ausgearbeiteten Planungen. In der gesamten DDR durchsuchten Mitarbeiter des MfS zeitgleich am 6. und 7. Januar 1962 in Banken und ehemaligen Finanzinstituten – nach eigenen Angaben 3000 Gebäude – Tausende sogenannte herrenlose, seit dem Zweiten Weltkrieg unberührt gebliebene Schließfächer, Tresore und Safes. Ihr Inhalt wurde abtransportiert, beim MfS deponiert und ausgewertet und schließlich größtenteils der Tresorverwaltung des Ministeriums der Finanzen (MdF) zur Verwertung übergeben. Anschließend vernichtete das MfS mehrheitlich die Unterlagen der Aktion.[1]

Die Untersuchungen zur Aktion „Licht" begannen 2017. Dabei rückten nach den Akteuren des MfS und den Mitarbeitern staatlicher Finanzinstitutionen die Strukturen des Kunsthandels in den Fokus des Forschungsinteresses. Doch deutliche Forschungsdesiderata zum Gesamtkomplex des Entzugs von Kunst- und Kulturgut in der SBZ/DDR zwischen 1945 und 1989 betreffen unter

Vgl. Beitrag von Ronny Licht, S. 55.

Vgl. Projekt-Eintrag in Proveana, PURL https://www.proveana.de/de/link/pro00000021.

anderem den Kunsthandel in der DDR. An die Studie Ulf Bischofs über die 1973 gegründete Kunst und Antiquitäten GmbH[2] knüpft keine weitere Untersuchung an. Der Staatliche Kunsthandel insgesamt oder die Geschichte des Volkseigenen Handelsbetriebes (VEH) Bildende Kunst und Antiquitäten wurden nicht wissenschaftlich systematisch bearbeitet.

Ohne Wissensbasis zum Kunsthandel fehlten der Recherche grundlegende Anhaltspunkte zur Verfolgung von Provenienzen der bei der Aktion „Licht" beschlagnahmten Kunstobjekte. Nachweise dazu mussten folglich über die beteiligten Personen erarbeitet werden in der Erwartung, dass sich in der Dokumentation ihrer Aktivitäten Hinweise auf Verkaufswege finden würden. Das gemeinsam von Mitarbeitern des MfS und der Tresorverwaltung des MdF erstellte Übergabe-Übernahme-Protokoll, das auch die etwa 150 Gemälde, 100 Kupferstiche und Radierungen, 110 Handschriften und historische Dokumente umfasst, enthält diesbezüglich keine aussagekräftigen Angaben.[3] Die 100 Blatt umfängliche Niederschrift ist eine Aufzählung aller am 13. Oktober 1962 übergebenen Sachwerte, überwiegend Schmuck, Besteck, Glaswaren und Porzellan; neun Blatt der Liste bezeichnen die Kunstwerke mit Schätzwerten. Diese Zusammenstellung trägt die Unterschriften von Walter Habakuk, dem Leiter der Tresorverwaltung, und seinem Stellvertreter Wilhelm Tümmel sowie die der MfS-Mitarbeiter Otto Schirm und Klaus Pufe.

Das MfS führte Tümmel und Habakuk als Inoffizielle Mitarbeiter (IM).[4] Vonseiten des MdF wurden sie in die möglichst rasche Verwertung des eingelagerten Guts eingebunden. Obwohl sie sich wie alle anderen hohe Deviseneinnahmen durch westliche Käufer versprachen, trugen sie zu erfolgreichen Abschlüssen wenig bei. Sie verfügten über keine direkte Verbindung zu potenziellen Handelspartnern. Erst die Vermittlung eines „Herrn Wischniewski" ermöglichte Verhandlungen „mit zwei belgischen Kaufleuten". Diese interessierten sich für die wertvollsten der auf einige 100.000 DDR-Mark geschätzten Schmuckstücke, von denen sie schließlich drei für insgesamt „25.000,- Dollar" kauften.[5]

Wischniewski hatte verdeckte Geschäfte des MfS mit westlichen Handelspartnern abgewickelt, bevor Alexander Schalck-Golodkowski, der Leiter des Bereichs Kommerzielle Koordinierung (KoKo), seine Tätigkeit aufnahm.[6] Michael Wischniewski, ein

international agierender Geschäftsmann mit einem Firmensitz in Berlin-Weißensee, unterhielt enge Beziehungen zu Simon Goldenberg und Ottokar Hermann; alle drei waren später mit dem Bereich KoKo verflochten.[7] Hermann, Teilhaber und Chef der mit dem MfS verbundenen Intrac S. A. in Lugano, ✑ beschaffte seit 1962 für die DDR Embargoware und transferierte Kunst- und Kulturgut in die Schweiz.[8] Über Wischniewski existieren keine MfS-Akten. Hinweise in MfS-Unterlagen zu Goldenberg legen langjährige Kontakte Wischniewskis zur Hauptverwaltung Aufklärung nahe.[9] Er und Goldenberg bestritten nach 1989 eine Involvierung in den Embargohandel, konnten aber die Anschuldigungen gegen sie im sogenannten KoKo-Untersuchungsausschuss des Deutschen Bundestages nicht ausräumen.[10]

✑ *Vgl. Beitrag von Bernd Isphording, S. 234.*

Anhaltspunkte zu Wischniewski, Goldenberg und Hermann fanden sich weder in einem weiteren Bericht Tümmels zum Verkauf von Kunst- und Kulturgut aus der Aktion „Licht" noch in anderen Quellen.[11] Einträge zur Firma Industrievertretung, die der an der Aktion „Licht" beteiligte MfS-Offizier Günter Wurm 1966 gegründet hatte, führten gleichfalls ins Leere.[12] Dafür, dass sich das MfS tatsächlich direkt oder über Mittelsmänner in den Verkauf von Werten aus der Aktion „Licht" einschaltete, existieren keine sonstigen Belege.

Eine möglicherweise bestehende Absicht konnte nicht umgesetzt werden. Gleichermaßen von MfS und MdF führte die Spurensuche zum Leiter des Staatlichen Kunsthandels der DDR, Curt Belz.[13] Mit ihm arbeiteten die Offiziere des MfS und die Mitarbeiter der Tresorverwaltung im Rahmen ihrer dienstlichen Aufgaben zusammen. Die Tresorverwaltung hatte auf die 1955 erfolgte Gründung der Handelseinrichtung hingewirkt und Belz seitdem regelmäßig Waren aus ihren Eingangsbeständen zum Verkauf übergeben. Belz berichtete seit 1954 unter dem Decknamen „Cube" an das MfS. 1962 erhielt er den Auftrag, eine Übersicht über „die Kunsthändler Berlins und Umgebung" anzufertigen; zuvor hatte er Gutachten zur Bewertung von „Staatsschätzen" aus der Aktion „Licht" verfasst.[14]

Doch die Expertise von Belz überzeugte nicht. Während einer Besprechung bei Finanzminister Willy Rumpf kritisierten maßgebliche Vertreter des Kulturministeriums die Bewertungen und veranlassten eine weitere Schätzung.[15] Auch aus heutiger Sicht ist nicht

nachvollziehbar, welche Kenntnisse den zeitweise im Ministerium für Kultur (MfK) beschäftigten Netzwerker Belz zur Begutachtung von Kunstwerken qualifiziert haben könnten. In der Bewerbung bei der Staatlichen Kommission für Kunstangelegenheiten (StaKuKo) 1952 führte er seine durch den Besuch der Meisterschule für das graphische Gewerbe in Berlin erworbene Befähigung an, die auto-didaktische Weiterbildung und seine Beschäftigung als Grafiker. Größeres Gewicht für seinen beruflichen Werdegang hatten wohl stattdessen politische Referenzen und Beurteilungen des SED-Mitglieds Belz. Der nach 1933 von den Nationalsozialisten ver-folgte und zeitweise inhaftierte Kommunist bekleidete nach 1945 leitende Positionen im Volksbildungsamt Berlin und an der Hoch-schule für Planökonomie, schließlich in der StaKuKo und im MfK.[16] In Anbetracht dessen stellte sich die Frage, weshalb nicht ihm und dem Staatlichen Kunsthandel der Verkauf des Kunst- und Kultur-gutes aus der Aktion „Licht" übertragen wurde.

Der in Konkurrenz zum privaten Kunsthandel gegründete Staatliche Kunsthandel gehörte zur DDR-Handelsorganisation (HO) im Verantwortungsbereich des Ministeriums für Handel und

Vgl. Beitrag von Uwe Hartmann, S. 181.

Versorgung (MHV) und nicht zum MfK.*Die HO, untergliedert in die vier Säulen Lebensmittel, Industriewaren, Warenhäuser und Gaststätten, betrieb seit 1949 Verkaufseinrichtungen in der DDR. Ihre Struktur marginalisierte den Kunsthandel, der ins Großhan-delskontor für Kultur- und Spielwaren eingegliedert war. In dieser inadäquaten Nische fehlten von Anbeginn konkrete Vorschriften für die Geschäftstätigkeit mit Kunst und Antiquitäten, ein folgen-schwerer Fehler. Die vom MHV herausgegebenen Geschäftsbe-dingungen ließen Belz völlig freie Hand bei der Preisgestaltung, sämtliche Fragen zu Handelsspannen und Rabatten blieben aus-geklammert.[17]

Überdies konnte sich Belz mit einer „Sonderverfügung" des Finanzministeriums und des Berliner Magistrats direkt in den Han-del mit westlichen Interessenten einschalten. Im Einvernehmen mit der DDR-Außenhandelsfirma Deutscher Innen- und Außen-handel (DIA) unterlief er deren Zuständigkeit für das Westge-schäft. Da Kunden aus dem Ausland der selbstständige Einkauf von Kunst und Antiquitäten in der DDR ebenso untersagt war wie den privaten Kunsthändlern der unmittelbare Verkauf an sie, mussten alle Geschäfte über den Staatlichen Kunsthandel abge-

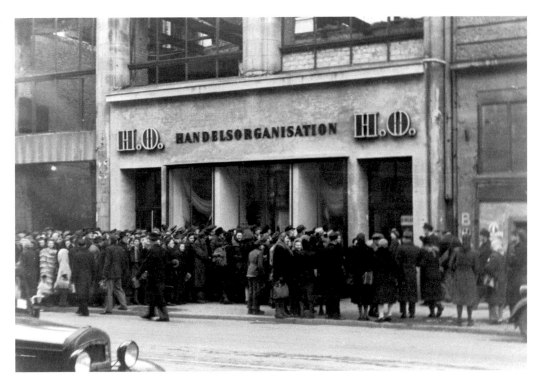

wickelt werden. Dabei legte Belz die Preise fest und stellte die
Rechnungen aus.[18]

HO-Niederlassung in der Leipziger Straße, Berlin, 1953, ullstein bild

Mindestens vier Jahre lang erwirtschaftete er unter den Augen
sechs zentraler Institutionen – MfS, MfK, MdF, DIA, HO und Berli-
ner Magistrat – unbehelligt DDR-Mark und Devisen für den Staats-
haushalt und zum eigenen Vorteil: Von Geschäftsfreunden aus dem
Westen nahm er Geld und andere „Geschenke" an. Alle staatlichen
Stellen verletzten ihre Aufsichtspflicht. Zwar informierten sie sich
in den Jahren gegenseitig über die ihnen auffallenden Unregelmä-
ßigkeiten. Doch mangelhafte Abrechnungen und eigenmächtige
Entscheidungen veranlassten keine Nachfragen, die aufgeworfe-
nen Zweifel an der Ausfuhrberechtigung einiger Kunstwerke keine
Nachprüfungen. Auch wenn niemand Belz den Sachverstand in
Kunstfragen absprechen wollte, hätten die offensichtlichen kauf-
männischen Defizite dringend eine Intervention erfordert. Sogar
als Belz selbst Unzulänglichkeiten des Geschäftsbetriebs themati-
sierte, geschah nichts – vermutlich, weil er damit seinen Wunsch
begründete, den Kunsthandel aus der Zuständigkeit des MHV he-
rauszulösen und dem MfK zu unterstellen. Dafür erhielt er keine

Unterstützung.[19] Besonders auffällig versagte das MfS, das keinen Verdacht schöpfte und die Berichte von „Cube" ohne kritische Nachfragen zur Kenntnis nahm. Er nutzte die Chance, dem MfS den Handel mit Kunst und Antiquitäten in der Grauzone zwischen Ost und West einschließlich der Annahme von Bargeld und der Gewährung erheblicher Kundenrabatte in seiner Version zu erklären. MfS-Offiziere beklagten zwar seine Eigenwilligkeit, aber nicht einmal die Westflucht zweier Mitarbeiter von Belz veranlasste Kontrollen.

Die strukturellen und administrativen Fehlentwicklungen, die den Kunsthandel seit der Gründung begleiteten, beeinträchtigten seine Funktionsfähigkeit als Instrument zur Durchsetzung eines staatlichen Handelsmonopols. Nach einer Aufforderung der DDR-Regierung zur verstärkten Erwirtschaftung von Devisen 1962 löste der neue Abteilungsleiter im MfK, Eberhard Bartke,[20] die Überprüfung und Reorganisation des Staatlichen Kunsthandels aus. Schließlich arbeitete das MfK in eigener Zuständigkeit und ohne Belz auf die Reform hin. Der Zeitpunkt dieser Überlegungen ist auf Basis der Aktenlage momentan so wenig genau zu bestimmen wie die Neugründung des VEH Moderne Kunst im Zeitraum Ende 1962, Anfang 1963.[21]

Jedenfalls war die Berliner Geschäftsniederlassung des Staatlichen Kunsthandels in der Frankfurter Allee in dem Augenblick, als die Tresorverwaltung für das Kunst- und Kulturgut aus der Aktion „Licht" Abnehmer benötigte, nicht arbeitsfähig und wurde erst am 2. März 1963 wiedereröffnet.[22] Zur selben Zeit ermittelte die Kriminalpolizei gegen mehrere Mitarbeiter des Kunsthandels und legte im Resultat ein schwer entwirrbares Netz staatlichen Versagens und persönlicher Vorteilsnahme frei. Vergeblich versuchte der DIA im Oktober 1962 die Kontrolle zurückzugewinnen und den Schaden zu begrenzen. Im MfK wurde parallel dazu über das künftige Personal des VEH Moderne Kunst diskutiert. Anfang Dezember gelang es dem MfS, gegen Vorbehalte Bartkes mit Heinz Gläske neuerlich einen IM zu platzieren.[23] Der Architekt Gläske, 1954 wegen seiner Beteiligung an einer nie völlig aufgeklärten Entführung durch das MfS aus West-Berlin in den Osten übergesiedelt, war zuletzt Leiter des Sonderbaustabes 10 bei der Errichtung der Waldsiedlung Wandlitz gewesen.[24] Aus diesen Umständen und weil Gläske nach einem nicht einmal zweijährigen Interim als Direktor

ausscheiden und die Einrichtung 1967 liquidiert werden musste, ergeben sich prinzipielle Fragen zur Rolle des MfS beim Aufbau des Staatlichen Kunsthandels.

Die überraschende Verhaftung von Belz und einiger Mitarbeiter durch die Kriminalpolizei am 10. Dezember 1962 gehörte dabei zu den größten Peinlichkeiten: Weil Belz' Ehefrau bei ihrer polizeilichen Vernehmung zu einigen bei der Hausdurchsuchung sichergestellten Schriftstücken erklärte, dass ihr Mann für die Sicherheitsorgane arbeite, erfuhr das MfS erst nachträglich durch Mitteilung der Kriminalpolizei von den Vorwürfen gegen seinen Inoffiziellen Mitarbeiter.[25]

Die Anschuldigungen der Staatsanwaltschaft betrafen geschäftliche Manipulationen, illegale Transferaktionen und gesetzwidrige Vorteilsnahme. Sie bedürfen einer gründlichen Prüfung und analytischen Einschätzung. Das Gericht räumte in der Berufungsverhandlung ein, dass Belz bei den Außenhandelsgeschäften keineswegs die staatlichen Interessen verletzt habe, ohne jedoch das Strafmaß von fünf Jahren und sechs Monaten Haft herabzusetzen. Offenkundig sollte die Verurteilung von Belz vom Versagen der staatlichen Be-

Die Kampfgruppeneinheiten, die am 19. Januar 1958 zur Gedenkstätte der Sozialisten in Berlin-Friedrichsfelde marschieren, sind zum Zeitpunkt dieser Aufnahme nur noch wenige Hundert Meter von der repräsentativen Niederlassung des Staatlichen Kunsthandels in der Stalinallee 366 entfernt. Bundesarchiv 183-52473-0016

hörden ablenken. Der Sachverhalt wird sich nur nach eingehender Auswertung der Akten und einer Einordnung der Fakten in den Gesamtzusammenhang bewerten lassen.[26] Die große Relevanz der Unterlagen für die weitere Forschung besteht in ihren, an dieser Stelle nur kurz skizzierten Aussagen über die frühen Strukturen des Staatlichen Kunsthandels in der DDR, über die Verwerfungen bei dessen Aufbau und in erhellenden Einblicken in die Praxis der Ausfuhr von Kunst- und Kulturgut aus der DDR.

Thomas Widera

Thomas Widera war bis Oktober 2019 wissenschaftlicher Mitarbeiter im Hannah-Arendt-Institut für Totalitarismusforschung e. V. an der Technischen Universität Dresden.

Förderung des Grundlagenprojekts „Die MfS-Aktion ‚Licht' 1962" von September 2017 bis Oktober 2019.

Endnoten

1 Vgl. Thomas Widera: Die MfS-Aktion „Licht" 1962, in: Provenienz & Forschung 1 (2019), S. 12–17.

2 Ulf Bischof: Die Kunst und Antiquitäten GmbH im Bereich Kommerzielle Koordinierung, Berlin 2003.

3 Vgl. Übergabe-/Übernahme-Protokoll der Tresorverwaltung, undatiert [bestätigt am 13.10.1962], BStU, MfS, HA XVIII, Bd. 13327, Bl. 18–120.

4 GI Heinrich, BStU ZA, MfS AIM 14296/64 Teil P und Teil A; GI Werner, BStU ZA, MfS AIM 4773/69 Teil P und Teil A.

5 Treffbericht, 14.11.1962, BStU ZA, MfS AIM 14296/64 Teil A, Bl. 334–337.

6 Matthias Judt: Der Bereich Kommerzielle Koordinierung. Das DDR-Wirtschaftsimperium des Alexander Schalck-Golodkowski – Mythos und Realität, Berlin 2013.

7 Zu Wischniewski, Hermann und Goldenberg vgl. Andreas Förster: Eidgenossen contra Genossen. Wie der Schweizer Nachrichtendienst DDR-Händler und Stasi-Agenten überwachte, Berlin 2016.

8 Vgl. Ricardo Tarli: Operationsgebiet Schweiz. Die dunklen Geschäfte der Stasi, Zürich 2015.

9 Vgl. Operativ-Information HA II/9 zu Goldenberg und Wischniewski, 7.12.1982, und Erfassungsvermerke, BStU ZA, MfS HA II 35894, Bl. 19–22.

10 Abweichender Bericht der Berichterstatterin der Gruppe Bündnis 90/Die Grünen im 1. Untersuchungsausschuss Ingrid Köppe, MdB – vorgelegt am 6.5.1994, S. 9, 88 und 94 f.

11 Bericht über den Verwertungsprozess, 4.5.1963, BStU ZA, MfS AIM 14296/64 Teil A, Bl. 349–352.

12 Vgl. Klaus Behling: Genossen im Goldrausch. Ein Stasi-Offizier als Wirtschaftsverbrecher. In: Klaus Behling, Jan Eik: „Attentat auf Honecker und andere besondere Vorkommnisse", Berlin 2017, S. 231–274.

13 Vgl. Hartmut Pätzke: Der Kunsthandel in der Deutschen Demokratischen Republik. In: kritische berichte 3/93, S. 65–73.

14 Aktenvermerk, 12.5.1962, BStU ZA, MfS AIM 6858/62 Teil A Bd. 3, Bl. 6.

15 Treffbericht, 14.11.1962, BStU ZA, MfS AIM 14296/64 Teil A, Bl. 334–337.

16 Personalbogen mit Lebenslauf, 11.8.1952, BStU ZA, MfS AIM 6858/62 Teil 1 Bd. 1, Bl. 22–32.

17 Allgemeine Geschäftsbedingungen für Kunst- und Antiquitäten-Verkaufsstellen des Staatlichen Kunsthandels (HO), 7.11.1955, BArch, DR 1/7977, Bl. 10.

18 Bericht zum Staatlichen Kunsthandel, 17.9.1959, BStU ZA, MfS AIM 6858/62 Teil A Bd. 2, Bl. 105–107.

19 Protokoll über die Aussprache zum Kunst- und Antiquitätenhandel am 20.10.1959, 22.10.1959, BArch, DR 1/7977, Bl. 28–30.

[20] 1926–1990, 1974–1978 Vizepräsident des Verbandes Bildender Künstler (VBK), 1976–1983 Generaldirektor der Staatlichen Museen zu Berlin, 1988 wegen fortgesetzter Kritik an der Kulturpolitik der DDR aus dem VBK ausgeschlossen.

[21] Schreiben Meiers an Pischner, 29.10.1962, BArch, DR 1/7977, Bl. 11–13.

[22] Rechenschaftsbericht VEH Moderne Kunst, 30.9.1963, BArch, DR 1/6247, nicht paginiert.

[23] Bericht über die Aussprache mit Bartke, 5.12.1962, BStU ZA, MfS AP 14400/83 Bd. 1, Bl. 48–50.

[24] Jürgen Danyel, Elke Kimmel: Waldsiedlung Wandlitz. Eine Landschaft der Macht, Berlin 2016, S. 68–71.

[25] Mitteilung der Kriminalpolizei, 17.12.1962, BStU ZA, MfS AIM 6858/62 Teil 1 Bd. 1, Bl. 61.

[26] Heike Schroll: Ost-West-Aktionen im Berlin der 1950er Jahre. Potentiale und Grenzen behördlicher Überlieferungen zum Kunsthandel in der Viersektorenstadt und in der jungen Hauptstadt der DDR. Berlin 2018.

„Urteilen, wählen, kaufen?"
Der Kunst- und Antiquitätenhandel in der DDR zwischen Plan- und Mangelwirtschaft

Uwe Hartmann

"Judge, chose, buy?" Trading art and antiques in the GDR facing planned economy and short supply

To mark the occasion of the fifth anniversary of the Staatliche Kunsthandel der DDR (State Art Trade of the GDR), founded in 1974, the director of this "nationally owned trading company" drew up a balance sheet under the heading "Judge, Choose, Buy." This slogan could have given the impression that the citizens of the GDR had the opportunity, as art trade consumers, to choose from a wealth and variety of products according to subjective and individual quality criteria, in a contrasting way from motor vehicles, household and entertainment electronics, home and craftsmen's supplies, or even with regard to fashionable clothing.

However, with its range of contemporary art—primarily and predominantly from the work of artists in the GDR—the Staatliche Kunsthandel der DDR was only able to cover and serve a narrow segment of demand.

The growing need to acquire older art, the desire to surround oneself with antiques that were not subject to everyday use, could be met less and less, not least because of the growing pressure to export in order to obtain foreign currency and the nationalization and suppression of the private antiques trade.

Ultimately, a bizarre situation arose in the consumer society of the GDR, which was characterized by scarcity and oriented toward the diversity and abundance of the West. With the acquired disposal of means of payment from "non-socialist foreign countries", it was possible to purchase all those things that could not be found, or only in small numbers, in the assortment of the state-owned trading companies, or that were imported from West Germany and other Western European countries—with one exception, however: art and antiques.

Fünf Jahre nach Gründung des Staatlichen Kunsthandels der DDR zog der Generaldirektor dieses „volkseigenen Handelsbetriebs" die Bilanz, dass sich das in den 14 Galerien praktizierte Prinzip der Verkaufsausstellungen als bevorzugte Form des „Kunst-Anbietens" bewährt habe. Einzel- und Gruppenausstellungen wie auch andere Formen dieser Distributionsmethode stellten „sowohl für das Kunstwerk – und damit den Künstler – als auch für den Kunstinteressierten die geeignetste Weise des Kunstverkaufs" dar. „Sicherlich" sei „das ‚Kaufen' für den Staatlichen Kunsthandel wie für jedes

Der Verkaufspavillon „Kunst im Heim" am 5. Januar 1964, Karl-Marx-Allee 45, Berlin, BArch Bild 183-C0105-0005-001

andere Wirtschaftsunternehmen ein wichtiges Kriterium, eine prägende Erscheinung, aber – und hier" läge „das Wesentliche – derjenige, der eine Galerie betritt", solle „nicht nur schlechthin kaufen im Sinne des ‚Haben-Wollens', als Geldanlage oder zur Repräsentation, er soll mehr: er soll urteilen, wählen und dann kaufen".[1]

So offenkundig diese formulierte Zielsetzung für einen privaten Erwerb von Kunstwerken in der sozialistisch verstandenen Wirtschafts- und Werteordnung der DDR eine Abgrenzung gegenüber dem spekulativen Investieren in die Ware Kunst mit der Absicht der Renditesteigerung vollziehen sollte, so offenbarte dieser Slogan doch zugleich einen unüberbrückbaren Widerspruch zur Wirklichkeit der staatlich geplanten Produktion und staatlich gelenkten Konsumtion und somit zur Alltagserfahrung von Leserinnen und Lesern der einzigen Kunstzeitschrift der DDR. ✐

✐ Die Zeitschrift Bildende Kunst erschien von 1947 bis 1991.

Die „hauptsächlichste Aufgabe" des Staatlichen Kunsthandels bestand – so Generaldirektor Weiß – in der „Herstellung eines möglichst persönlichen Verhältnisses weiter Kreise der Bevölkerung zur zeitgenössischen bildenden und angewandten Kunst der DDR". Und „dass dies alles auch selbstverständlich unter ökonomi-

schen Gesichtspunkten" erfolge, sei „kein Widerspruch, sondern eine vernünftige Einheit, Ausdruck dessen, was in der Hauptaufgabe des VIII. Parteitages eindeutig formuliert wurde".[2] Die Erkenntnis, dass sich „nur über den Austausch des Kunstwerks als Ware [...] das Ergebnis des Kunstschaffens in der individuellen Rezeption" realisiert, hatte nun also auch die Kulturpolitik in die Praxis umgesetzt.[3] Weiß räumte ein, dass mit der Gründung des Staatlichen Kunsthandels ein „Nachholebedürfnis" befriedigt worden war. Während zum Zeitpunkt der Gründung der DDR „Bücher und Schallplatten in vielen Wohnungen der Werktätigen noch Raritäten" waren, gehörten sie nun „zum festen Bestandteil unseres Lebens". Im Ergebnis einer „ebenso unermüdlichen Arbeit wie der Volksbuchhandel bzw. der VEB Deutsche Schallplatten haben die Kunstverlage der DDR den Reproduktionen und damit der bildenden Kunst die Wohnungstüren geöffnet. Dem Original dagegen ist dies noch nicht ganz gelungen."[4]

Auf dieses „Nachholebedürfnis" hatte der Maler und Grafiker Bernhard Heisig bereits 1972 hingewiesen. In einem ebenfalls in der Zeitschrift *Bildende Kunst* veröffentlichten Beitrag stellte er die Frage: „[...] wo bleibt der sozialistische Kunsthandel?"[5] Dahinter verbarg sich die Forderung nach der Möglichkeit einer „Erschließung" eines „Markts für den Künstler". Heisig meldete sich in der mit dem Begriffspaar „Weite und Vielfalt" verbundenen andauernden Diskussion über die Entdogmatisierung des offiziellen Kunstbegriffs und -verständnisses[6] mit einem für diese Zeit radikalen Vorschlag zu Wort, indem er ausführte, es sei nötig, dass „nicht allein der Staat als Geldgeber für bildende Kunst in Erscheinung tritt".[7] In einer Zeit, als Parteiführung und Regierung die Verstaatlichung auch der letzten verbliebenen privat geführten Kleinbetriebe und Handelsgeschäfte beschlossen hatten[8] 🔗 und das staatlich sowie institutionell organisierte Auftragswesen nahezu die einzigen Verdienstmöglichkeiten für Künstlerinnen und Künstler in der DDR bot, forderte Heisig, dem „privaten Käufer für bildende Kunst" eine weitaus größere Aufmerksamkeit zu widmen, da er, ebenso wie der Kunstmarkt, „wenngleich latent vorhanden [...] bei uns bisher zu wenig beachtet wurde".[9] Und er wies auf die eingetretenen Folgen der Verdrängung und Verstaatlichung der privaten Kunsthandlungen und Galerien hin: „Wenn man weiter bedenkt, daß früher in einer Großstadt etwa 20 Galerien existierten und bildende Kunst

🔗 *Unveröffentlichter Beschluss des ZK der SED 104/63 5/72 vom 8. Februar 1972 und Beschluss des Präsidiums des Ministerrates der DDR vom 9. Februar 1972*

183

handelten, und heute bestenfalls eine Verkaufsstelle wie ‚Kunst der Zeit' mehr Kunstgewerbe als bildende Kunst handelt, so beleuchtet dies den Sachverhalt eindeutig. Der Deutsche Fernsehfunk als wichtige öffentliche Institution tut trotz bester Möglichkeiten auf dem Gebiet der bildenden Kunst so gut wie nichts. Es bleiben [...] Werbung, Interpretation des Kunstwerkes, Suche nach dem Käufer allein dem Künstler überlassen, wozu er in der Regel wenig taugt. Ihm fehlt der qualifizierte Mittelsmann, der geschulte Kunsthändler, der diese Dinge übernimmt."[10] Natürlich wollte Heisig „nicht den kapitalistischen Kunstmarkt als Lösung des Problems anbieten", doch müsse „festgestellt werden, daß im kapitalistischen Bereich ein Kunstmarkt existiert, der für viele Künstler eine finanzielle Basis bietet".[11]

Ohne sich direkt auf den Beitrag von Bernhard Heisig zu beziehen, griff der Kunstwissenschaftler Klaus Werner wenige Monate später die Diskussion zu den vernachlässigten und weitgehend ungeklärten Fragen des „individuellen Kunstverbrauchs" und der Förderung des „Kaufs von Kunstwerken (Originalen) als individuelle Konsumtion" auf.[12] Klaus Werner zählte als Leiter der Galerie Arkade des Staatlichen Kunsthandels am Strausberger Platz in Berlin von 1974 bis zur seiner Entlassung und der Schließung der Galerie 1981 zu den prägendsten Galeristen in der DDR. Er kritisierte, dass „Wert und Wirkung des geschlossenen Kreislaufes von Produktion – Konsumtion – und Reproduktion im Bereich der bildenden Kunst nicht genügend erkannt" worden seien, und stellte wie Heisig infrage, inwieweit Maßnahmen „der staatlichen Steuerung und Unterstützung" notwendig sind. Als „eine wichtige Voraussetzung für die Einheit von Schöpfertum" sah er „den tatsächlichen Beweis des Bedürfnisses nach Kunst". Dieses Bedürfnis dürfe „nicht das Produkt der Leitung, nicht das Ergebnis einer Funktion an sich sein", es müsse „als lebensnotwendig empfunden werden". Bis auf die „Synthese von Kunstwerk und Städtebau" wäre nach seiner Auffassung „in allen anderen Genres [...] das gesellschaftliche Bedürfnis nach Kunst unzureichend" geblieben – nicht zuletzt, da es „ungenügend und einseitig" gefördert wurde. „An seine Stelle" wären die „Stimulierung durch die Ausstellung, die museale Repräsentation, die Reproduktion oder der verordnete Auftrag" getreten. Vor dem Hintergrund der angestrebten aufeinander abgestimmten Planung von Produktion und Konsumtion war die Entwicklung der gesell-

schaftlichen und individuellen Bedürfnisse eine zentrale Frage in den sozialpolitischen und kulturtheoretischen Diskussionen in der DDR in den 1970er-Jahren.[13]

Dass die Forderungen nach größerer künstlerischer Freiheit und nach Akzeptanz eines stärker ausgeprägten Individualismus auf den Widerstand der Vertreter und Befürworter des bislang herrschenden Systems der Kunstförderung stoßen würden, war zu erwarten. Zur Kunstdoktrin des „sozialistischen Realismus" gehörte die „leitbildhafte und strukturelle Fixierung auf die Arbeiterklasse", und damit ging ihre Einsetzung in eine dreifache Rolle einher: als Auftraggeber, zentrales Thema und Hauptadressat der Kunst – als „herrschende Klasse".[14] Die Konsequenzen, die eine Förderung der individuellen Konsumtion von Kunstwerken zur Folge gehabt hätte, verschwieg Klaus Werner nicht. Sie würden „bis zum Warencharakter der Kunst" reichen, „zur Anerkennung materieller Wertmotive bei der Befriedigung eines ästhetischen Bedürfnisses". Und ebenso wie Bernhard Heisig räumte er ein, dass „wir [...] zweifellos Belastungen des bürgerlichen Managements [unterliegen]. Und das nicht ohne Grund". „Trotzdem", so Werner weiter, halte er „die gesellschaftlich gesteuerte Förderung des Kunstkaufs, die ja nicht zuletzt auch eine Form der gesellschaftlichen Konsumtion" sei, „für eine der schnell zu lösenden Aufgaben".[15]

Die schnell zu lösende Aufgabe wurde mit der Gründung des VEH Bildende Kunst und Antiquitäten 1974 umgesetzt. 1955 war schon einmal ein „Staatlicher Kunsthandel" eingerichtet worden.

Die Niederlassungen des Staatlichen Kunsthandels in der DDR, 1986

185

🖉 ¹ Seit 1961 heißt der Straßen-
abschnitt in diesem Bereich
Frankfurter Allee.

🖉 ² Vgl. Beitrag von Thomas Widera,
S. 171.

🖉 Vgl. Beitrag von Christin
Müller-Wenzel, S. 148.

Dieser spezialisierte Handelsbetrieb bestand aus einem Geschäft in der Berliner Stalinallee 🖉 ¹ und Zweigstellen in Leipzig und Dresden. 🖉 ² Die Einrichtung des staatlichen Kunsthandelsbetriebes für private Kunstsammler ist wie die Gründung des Ministeriums für Kultur 1954 in eine Reihe von Partei- und Regierungsbeschlüssen zu stellen, die als Reaktion auf den 17. Juni 1953 zu Lockerungen führten. Die Gründung des Staatlichen Kunsthandels erfolgte aber auch im Hinblick auf die Situation in der Viersektorenstadt Berlin. Als Gegenmaßnahme zur Einführung der D-Mark in West-Berlin wurde im August 1950 die Aktion „Geschäftsschließungen von Ost-West-Betrieben" zum „Schutz der Währung der Deutschen Notenbank" durchgeführt. Am 5. September 1952 folgte auf Grundlage der vom Magistrat am Vortag erlassenen „Verordnung zur Sicherung von Vermögenswerten" eine „Sonderaktion", in deren Verlauf Betriebe und Geschäfte auf dem Territorium des Ostsektors in treuhänderische Verwaltung genommen wurden, sofern ihre Eigentümer oder Inhaber ihren Wohnsitz in West-Berlin hatten.[16] Infolgedessen war im Ostteil der Stadt das Angebot an Einkaufs- wie an Verkaufsmöglichkeiten für Kunst und Antiquitäten noch weiter ausgedünnt worden.[17] Trotz der kulturpolitischen Entscheidung, einen staatlichen Kunsthandelsbetrieb zu gründen, schien im Ministerium für Kultur keine Aufgabenpriorisierung hinsichtlich der Stärkung des Angebots für private Kunstsammler und -liebhaber vorgenommen worden zu sein. 🖉 In einem internen Vermerk wurden als potenzielle Abnehmer ausschließlich staatliche Institutionen und Ministerien aufgelistet.[18]

Curt Belz hatte im Februar 1957 in einem Interview zwar behauptet, dass „die Zeit, da lediglich die Reichen in Antiquitätenläden herumstöberten", vorbei sei, allerdings ging der Handel mit Antiquitäten und älterer Kunst weitgehend an den privaten Kunsthändlern und den ansässigen Kaufinteressierten vorbei.[19] Und der Staatliche Kunsthandel unter seiner Leitung hatte daran einen maßgeblichen Anteil. Warnungen vor einem „Abfluss" von Kunst- und Kulturgut aus der Sowjetischen Besatzungszone und der DDR in den „Westen" hatte es insbesondere mit Blick auf den unübersichtlichen Stand der Aufbewahrung, der Inventarisierung und des Zustands der im Zuge der Bodenreform und der Schlossbergungen erfolgten „Sicherungen" sowohl von Museumsmitarbeiterinnen und -mitarbeitern als auch von zuständigen Kulturgut- und Denk-

malschutzbehörden in Ost und West gegeben. Der von 1947 bis 1949 als Leiter des Referats Rückführung von Kulturgütern beim Magistrat von Groß-Berlin tätige Kurt Reutti🖉 machte 1951 von West-Berlin aus darauf aufmerksam, dass „aus der sowjetischen Besatzungszone [...] laufend Gemälde, antike Möbel, antikes Silber, Porzellane usw. nach Berlin [kommen], die zum Teil aus Museen, z. T. aus Schloßbesitz der sowjetischen Besatzungszone stammen und die dort illegal verkauft werden". Dem West-Berliner Referat Bildende Kunst wurden nach Aussage Reuttis zwar hin und wieder Warenbegleitscheine zur Genehmigung vorgelegt, aber „die allermeisten Kunstverkäufe" gingen „direkt über die Außenhandelsbanken und werden [...] nicht überprüft".[20] Die Direktorin der Staatlichen Kunstsammlungen Dresden, Gertrud Rudloff-Hille, informierte im August 1952 die Kommission für Kunstangelegenheiten darüber, dass „in Westdeutschland [...] die Ansicht verbreitet" ist, „im Kunsthandel darauf achten" zu müssen, „ob nicht Stücke auftauchten, die von der Sowjetischen Besatzungsmacht hier beschlagnahmt und dann weiter verkauft worden seien. Es wurde mir gesagt, daß kein solcher Fehler habe nachgewiesen werden können. Es darf aber auch unsererseits nichts Derartiges unternommen werden. Kürzlich tauchten in Kamenz Aufkäufer von Köhler & Volkmar auf, die nach ihren Angaben im Auftrag des Zentralinstitutes für Bibliothekswesen in Berlin und der Sonderstelle in Dresden u. a. ‚zur Devisenbeschaffung' Bücher des Stadtarchivs und der Stadtbibliothek ankaufen wollten. Auch sollen Aufkäufer von Gerd Rosen, Westberlin, in der Kamenzer Gegend gewesen sein. Ob mit Erfolg, ist mir unbekannt."[21]

Der West-Berliner Buch- und Kunsthändler Gerd Rosen dürfte einer der aktivsten Akteure auf dem Gebiet des deutsch-deutschen Transfers von Kunst- und Kulturgut zwischen der „Berlin-Blockade" 1948 und dem Bau der Berliner Mauer 1961 gewesen sein. Nicht zuletzt die persönlichen Kontakte zu Curt Belz, zum Sektorenleiter im Ministerium für Kultur, Walter Heese, und zu einer Reihe von Museumsdirektoren in der DDR verschafften ihm gegenüber der Konkurrenz erhebliche Vorteile.[22] Obgleich der staatliche Außenhandel der DDR mit Dumpingpreisen ohnehin schon attraktive Bedingungen für die Einkäufer aus nicht sozialistischen Ländern geboten hatte.[23] Nicht nur dieser Tatsache war der Werbeslogan des Staatlichen Kunsthandels geschuldet, dass der „An- und Ver-

🖉 *Vgl. Beitrag von Doris Kachel, S. 45.*

kauf unserer Zeit entsprechend auf reeller ökonomischer Grundlage" stattfinden würde. Der Staatliche Kunsthandel nahm faktisch von Beginn an eine Monopolstellung ein, weil dem privat geführten Kunst- und Antiquitätenhandel in der DDR schlichtweg der Zugang zu bestimmten Geschäftsbereichen verschlossen blieb.

Während „Kunstgegenstände, die für die Museen bzw. für die einzelnen Institute für Denkmalpflege nicht von Interesse" waren, [...] für den Verkauf (Binnenhandel) [...] bzw. den Direktverkauf gegen freie Devisen" für den Staatlichen Kunsthandel freigegeben wurden, blieb privaten Geschäftsleuten ein Handel mit diesen Stücken verwehrt. Des Weiteren sollte der Staatliche Kunsthandel einen Anreiz bieten, damit Kunst- und Kulturgut, das während der Bodenreform aus Schlössern, Guts- und Herrenhäusern entnommen worden und entgegen den amtlichen Anordnungen in Privatbesitz gelangt war, aufgekauft und exportiert werden konnte.[24] Dies war zweifellos als ein unausgesprochenes Versprechen auf Straffreiheit gedacht und sollte als Angebot eine Alternative zum gefährlichen, aber attraktiveren Verkauf in West-Berlin darstellen. Somit wurden in der DDR gut zehn Jahre nach Durchführung der Bodenreform nach und neben der Überführung des „gesicherten" und „geborgenen" Kunst- und Kulturguts ins „Eigentum des Volkes" – also die Übergabe an Museen, Bibliotheken, Archive und andere staatliche Einrichtungen – zwei weitere, von merkantilen Interessen bestimmte Formen der „Verwertung" praktiziert.[25]

Dem Staatlichen Kunsthandel kam noch eine Aufgabe zu, die ebenso wenig geeignet war, den angepriesenen An- und Verkauf auf „reeller ökonomischer Grundlage" glaubwürdig zu machen. In einem vertraulichen Schreiben vom 1. Februar 1956 hatte die Staatliche Plankommission der DDR das Kulturministerium davon in Kenntnis gesetzt, wie die „Behandlung eingezogener Gegenstände und Waren" vor sich zu gehen habe. „Gegenstände aus echtem Markenporzellan, echte Teppiche, wertvolle Bilder und andere Gegenstände, die einen besonderen Kunstwert haben", so hieß es in der Verfügung, „sind dem Staatlichen Kunsthandel (HO), Berlin O 112, Stalinallee 366 – soweit möglich über die Filialen der Deutschen Notenbank – zuzuleiten."[26] Dies bedeutete, dass nun auch Kunstgut, das von „Republikflüchtigen" zurückgelassen worden war, nicht an Museen und andere Kultureinrichtungen übergeben wurde, sondern dass es über den Staatlichen Kunsthandel in den Verkauf gelangte.

Als der Maler Gerhard Richter die DDR verlassen hatte, wurde ein Inventarverzeichnis der Gegenstände erstellt, die er in seiner Wohnung in der Wiener Straße 91 in Dresden zurückgelassen hatte. Die für diese Gegenstände erzielten Verkaufserlöse wurden ebenfalls handschriftlich eingetragen. An vorletzter Position – vor „ca. 8 Ztr. Briketts" – ist der Eintrag „38 Gemälde, 117,–" zu lesen.[27] Der Verbleib dieser Werke ist weitestgehend unbekannt und ungeklärt. Der Journalist Jürgen Schreiber nennt den „gelernten Bäckermeister" Bernhard Stübner – „ein schillernder Charakter, um das Mindeste über ihn zu sagen" –, der „aus der Backstube zum ‚Staatlichen Kunsthandel' nach Dresden wechselte. Von da führte der Weg in ein volkseigenes Kunstgeschäft an der Ost-Berliner Karl-Marx-Allee". Nach Stübners Schilderung fanden sich 15 Werke von Richter „bei einer Bestandsaufnahme im Keller des ‚Staatlichen Kunsthandels'".[28]

Verbunden mit den beiden beschriebenen Aufgabenerweiterungen sollte der Staatliche Kunsthandel weiter ausgebaut werden. Die Schließung der Grenze mit dem Mauerbau am 13. August 1961 veränderte allerdings auch die Bedingungen des Kunst- und Antiquitätenhandels in der DDR und erforderte neue Geschäftsmodelle und -methoden für den Export in das nicht sozialistische Wirtschaftsgebiet. 1962 wurden im Kulturministerium Überlegungen zur Reorganisation des Handelsbetriebes angestellt.[29] Nach der Verhaftung von Curt Belz und weiterer Mitarbeiter im Dezember 1962 und ihrer Verurteilung „wegen Untreue zum Nachteil des sozialistischen Eigentums" wurden Zukunftsplanungen allerdings gegenstandslos und es erfolgte die Liquidation des Staatlichen Kunsthandels.[30]

In dem DEFA-Spielfilm „Hände hoch oder ich schieße" von 1966, der erst 2009 seine Kinopremiere erlebte, ⬦ gibt es eine Szene, die in Leipzig in einem staatlichen Antiquitätengeschäft spielt. Hier treffen sich alte Bekannte mit einer kriminellen Vergangenheit wieder: ein paar Gauner im Ruhestand, die zur Karriereförderung eines kleinstädtischen Kriminalpolizisten ein Denkmal vom Marktplatz stahlen, das sie nun verkaufen wollen, und der Kunstexperte und Leiter der Filiale. Diese Szene verweist in ihrer Überspitzung auf das breite Misstrauen gegenüber dem staatlich organisierten An- und Verkauf von Kunst und Antiquitäten.

Auktionskatalog, Dezember 1976

⬦ www.defa-stiftung.de/filme/filme-suchen/haende-hoch-oder-ich-schiesse/

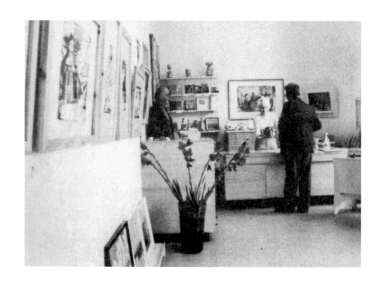

*Eine Niederlassung des Staatlichen
Kunsthandels in Schwerin.
Die Galerie am Dom auf einer zeit-
genössischen Postkarte*

Als Alternative bot sich der Genossenschaftsgedanke an. So-
wohl in den 1950er- als auch in den 1970er-Jahren hatten sich
Künstlerinnen und Künstler in der DDR in Genossenschaften zu-
sammengeschlossen, um gemeinsam Ausstellungen durchzuführen
und ihre Werke zu verkaufen.³¹ Doch konnten zwei Anforderun-
gen, die an einen „sozialistischen Kunsthandel" in der DDR gestellt
wurden, mit diesem alternativen Modell nicht erfüllt werden – der
An- und Verkauf von Kunstwerken vorangegangener Epochen und
Zeitstile und der Export ins – vornehmlich nicht sozialistische –
Ausland.

Die Aufmerksamkeit, die prominente Maler, Grafiker und Bild-
hauer aus der DDR 1977 mit ihren auf der „documenta 6" aus-
gestellten Werken erfuhren, weckte beziehungsweise verstärkte
die Erwartung von Kunst- wie von Wirtschaftsfunktionären der
SED, dass es eine „Marktlücke" für diese in den Jahren zuvor ge-
schmähte oder ignorierte künstlerische Produktion geben könnte.
Aus heutiger Sicht erscheint es gleichermaßen tragisch wie kurios,
dass die folgenreiche Vereinbarung, die 1976 zwischen dem Mi-
nisterium für Außenhandel und dem Ministerium für Kultur abge-

*⌀ Alexander Schalck-Golodkowski
unterschrieb in jenen Jahren nur mit
seinem Adoptionsnamen.*

schlossen und – von Alexander Schalck⌀ und Werner Rackwitz –
unterzeichnet wurde, die gegensätzlichen Positionen der Vertreter
des Museumswesens, des Verbandes Bildender Künstler sowie
der Denkmalpflege hinsichtlich des Schutzes des kulturellen Erbes
und der Verfechter einer Devisenwirtschaft um jeden Preis

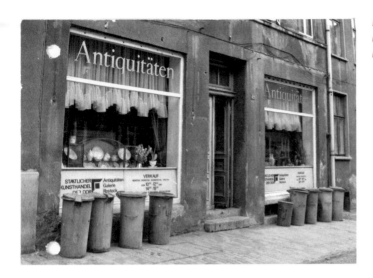

Die Antiquitäten Galerie Rostock, An- und Verkauf, im Barnstorfer Weg 42, um 1965, BArch DR 144/195

überbrückte. Beide Seiten erlagen der Illusion, dass eine Erhöhung des Exports zeitgenössischer Kunst den Anteil der auszuführenden historischen Stücke reduzieren würde. Die „Partei der Kulturgutschützer" hatte zudem die trügerische Hoffnung, dass die erzielten Valutaerlöse für Erwerbungen von historischen Werken wie von Werken der internationalen Gegenwartskunst eingesetzt werden würden.

Für den eigentlichen Adressaten der Aktivitäten eines staatlichen Kunsthandels in der DDR blieb bis 1990 das Manko, weder hochwertige historische Stücke noch – bis auf wenige Ausnahmen – Werke zeitgenössischer Kunst aus dem westlichen Ausland erwerben zu können. Während die Kunst und Antiquitäten GmbH in der Öffentlichkeit der DDR nahezu unsichtbar blieb, zeigte der Staatliche Kunsthandel die helle und die dunklere Seite seiner Geschäftstätigkeit. Die Galerien für Gegenwartskunst waren insbesondere in den Großstädten ansprechend ausgestattet, die Antiquitäten-Galerien muteten hingegen eher wie Trödelläden an.

Für diejenigen, die Kunst oder Antiquitäten sammelten, wurde die Situation immer schwieriger. Der wachsende Exportdruck ließ die Verantwortlichen bekanntlich nicht davor zurückschrecken, Sammler zu diffamieren und zu kriminalisieren.[32] Andererseits führte das „Kernstück" der 1971 beschlossenen „Einheit von Wirtschafts- und Sozialpolitik" – das Programm des industriellen Bauens von Wohnungen – dazu, dass es in der Neubauwohnung

schlicht an Raum zur Aufbewahrung fehlte. Historische Möbel, Teppiche, Tafelservices landeten im staatlichen Kunsthandel und bald „im Westen". Der Generaldirektor der Kunst und Antiquitäten GmbH, Horst Schuster, prognostizierte bereits 1977, dass die von der Parteiführung beschlossene Lösung der „Wohnungsfrage als soziales Problem" bis 1990 zum Versiegen des „Nachschubs"

Vgl. Beitrag von Bernd Isphording, S. 234.

führen würde.[33]

Für die Konsumgesellschaft der DDR entstand eine bizarre Situation. Mit der erlangten Verfügung über Devisen konnten all jene Dinge erworben werden, die nicht oder nur in geringer Anzahl im Sortiment der staatlichen Handelsbetriebe zu finden waren und aus der BRD oder westeuropäischen Ländern importiert wurden – mit einer Ausnahme: Kunst und Antiquitäten. Dieses Sortiment führte auch die Geschenkdienst- und Kleinexporte GmbH (Genex) nicht in ihren Katalogen.[34]

Uwe Hartmann

Uwe Hartmann ist Leiter des Fachbereichs Provenienzforschung am Deutschen Zentrum Kulturgutverluste in Magdeburg.

Der Text geht auf einen Vortrag der Herbstkonferenz am 30. November 2020 zurück, der vom Autor für diesen Band angepasst wurde.

Endnoten

[1] Horst Weiß: Urteilen, wählen, kaufen. Fünf Jahre Staatlicher Kunsthandel der DDR, in: Bildende Kunst, 31 (1979), Heft 12, S. 574–576, hier S. 575.

[2] Weiß 1979, S. 575. Die vom VIII. Parteitag der SED 1971 vorgegebene „Einheit von Wirtschafts- und Sozialpolitik" beinhaltete die „Hauptaufgabe" der Erhöhung des „materiellen und kulturellen Lebensniveaus".

[3] Erwin Pracht (Leiter des Autorenkollektivs u. a.): Ästhetik der Kunst, Berlin 1987, S. 135. Die Autorinnen und Autoren verwiesen unter dem Kapitel *Der Kunstmarkt* – nach Karl Marx – darauf, dass der „Warencharakter der Kunst [...] zwar Ausdruck einer bestimmten sozialhistorischen Vermittlungsform" sei, dennoch ginge „die Beziehung zwischen Kunstproduktion, Distribution/Austausch und Rezeption nicht schlechthin im Tauschwertprinzip auf. Der Warencharakter" sei „lediglich ein Moment in der komplexen Vermittlung zwischen Künstler und Rezipient" und beträfe vor allem den „Intervall zwischen Produktion und Konsumtion, wo die Produkte ‚als *verkäufliche Waren* in diesem Intervall zirkulieren können'". (Karl Marx/ Friedrich Engels: Theorien über den Mehrwert. Erster Teil, in: Marx-Engels-Werke, hg. vom Institut für Marxismus-Leninismus beim ZK der SED, Bd. 26.1, Berlin 1965, S. 385.)

[4] Weiß 1979, S. 575.

[5] Bernhard Heisig: Wo bleibt der sozialistische Kunsthandel?, in: Bildende Kunst, 26 (1972), Heft 1, S. 44 f.

[6] Auf dem VIII. Parteitag im Juni 1971 – dem ersten Parteitag nach der Entmachtung Walter Ulbrichts – hatte Erich Honecker als neuer Parteichef die „Schriftsteller und Künstler" aufgefordert, „in ihren Verbänden und Parteiorganisationen einen offenen, sachlichen, schöpferischen Meinungsstreit" zu führen, und die Zuversicht geäußert, dass sie „ohne Zweifel nicht nur die richtigen", der „sozialistischen Gesellschaft nützlichen Themen in den Mittelpunkt ihres Schaffens stellen", „sondern auch die ganze Breite und Vielfalt der neuen Lebensäußerungen erfassen und ausschöpfen" würden. Vgl. Bericht des Zentralkomitees an den VIII. Parteitag der SED, Berichterstatter: Erich Honecker, Berlin/DDR 1971, S. 78 f.

Auf der 4. Tagung des ZK der SED im Dezember 1971 bekräftigte Honecker die Abkehr von den ideologischen, „antiformalistischen" Einengungen. Vgl. Erich Honecker: Die Hauptaufgabe umfasst auch die weitere Erhöhung des kulturellen Niveaus, in: Erich Honecker: Reden und Aufsätze, Bd.1, Berlin 1975, S. 426–429, hier S. 427.

Der für Fragen der Kulturpolitik zuständige ZK-Sekretär Kurt Hager hatte im Juli 1972 während der 6. Plenums die Leitlinien für die von Honecker vorgegebene Enttabuisierung formuliert: „Die unveräußerlichen Grundlagen sozialistisch-realistischen Kunstschaffens – fester sozialistischer Standpunkt, Parteilichkeit und Volksverbundenheit – sind eine sichere Grundlage, um zunehmend die ganze Spannweite aller schöpferischen Möglichkeiten in der Kunst des sozialistischen Realismus, um eine reiche

Vielfalt der Themen, Inhalte, Stile, Formen und Gestaltungsweisen zu erschließen. [...] Unsere Kulturpolitik zielt auf die Förderung einer lebendigen, reichen und vielgestaltigen Kunst. Nicht ein Klang, nicht eine Farbe, nicht einen Lebensbereich wollen wir dabei außer acht lassen". Kurt Hager: Zu Fragen der Kulturpolitik der SED. Rede auf der 6. Tagung des ZK der SED am 6. Juli 1972, Berlin 1972, S. 35.

[7] Heisig 1972, S. 44.

[8] 1972 wurden etwa 6.700 Betriebe mit staatlicher Beteiligung, 3.400 private Unternehmen und 1.700 Produktionsgenossenschaften des Handwerks verstaatlicht. Vgl. Rainer Karlsch und Michael Schäfer: Industrielle Familienunternehmen in Ostdeutschland: Von der Jahrhundertwende bis zur Gegenwart, München 2019, S. 71.

[9] Heisig 1972, S. 44. Paul Kaiser hatte aus dem Grund von einer „Ersetzung des Kunstmarktes durch ein spezifisches Auftragssystem" gesprochen. Paul Kaiser: Boheme in der DDR. Kunst und Gegenkultur im Staatssozialismus, Dresden 2016, S. 63.

[10] Heisig 1972, S. 45.

[11] Ebd., S. 44.

[12] Klaus Werner: Bildende Kunst und gesellschaftliche Soziologie, in: Bildende Kunst, 26 (1972), Heft 7, S. 359 f.

[13] Ebd.

[14] Paul Kaiser: Malerfürsten im „Kunstkombinat" – Thesen zum Zusammenhang von Kunstsystem und Künstlerrolle in der bildenden Kunst der DDR, in: Die unerträgliche Leichtigkeit der Kunst. Ästhetisches und politisches Handeln in der DDR, hg. von Michael Berg, Knut Holtsträter, Albrecht von Massow, Köln/Weimar/ Wien 2007, S. 113–127, hier S. 114 und S. 115.

[15] Werner 1972, S. 360.

[16] Heike Schroll: Ost-West-Aktionen im Berlin der 1950er Jahre. Potentiale und Grenzen behördlicher Überlieferungen zum Kunsthandel in der Viersektorenstadt und in der jungen Hauptstadt der DDR (=Schriftenreihe des Landesarchivs Berlin, hg. von Uwe Schaper, Band 20), Berlin 2018, S. 24 und S. 35.

[17] Historisch gewachsen befand sich bereits in der Vorkriegszeit der größere Teil der Kunsthandlungen und Antiquitätengeschäfte im wohlhabenderen Westen der Stadt. Heike Schroll führt an, dass 1950 von der Existenz von ungefähr 100 mit Kunst und Antiquitäten handelnden Geschäften in Berlin ausgegangen werden kann. Aus dem Bestand „C Rep. 105 Magistrat von Berlin, Abteilung Finanzen, Treuhandverwaltung, Liquidierungen und Geschäftsauflösungen" führt sie 34 Kunsthandlungen, Antiquitätengeschäfte und auch Gebrauchtwaren- und „Trödelhändler" auf. Ebd., S. 73–76.

[18] Der Vermerk ist undatiert. In der Überlieferung des Ministeriums für Kultur im Bundesarchiv ist das Blatt allerdings zwischen Schriftstücken mit den Datierungen 28.6. und 19.11.1956 abgelegt. (BArch, DR 1/8351, Bl. 18.)

[19] „Einen Südsee-Speer bitte", in: Berliner Zeitung, 9. Februar 1957. Zitiert nach Sabine Tauscher: Zwischen Ideologie und Kommerz. Der Kunstmarkt

der DDR am Beispiel der Gegenwartskunst des Staatlichen Kunsthandels 1974–1990, Diss. Technische Universität Dresden, 2019, S. 53.

20 Landesarchiv Berlin, B Rep. 014, Nr. 1626 „Allgemeiner Schriftwechsel (Ra-Ri)", 1949–1953. Zitiert nach Schroll 2018, S. 24.

21 Gertrud Rudloff-Hille: Zur Frage der Treuhandverwaltung der Materialien des ehem. KFM und der Nationalgalerie in (Ost) Berlin durch Wiesbaden (Prof. Dr. Holtzinger, Frankfurt/M.), Dresden, den 20.5.1952, in: BArch, DR 1/5943, Bl. 3-6. Die Informationen zu den Vorgängen in Kamenz dürfte Rudloff-Hille von ihrem Mann erhalten haben. Dr. Otto Rudloff war Direktor des Lessing-Museums in Kamenz.

22 Vgl. Überprüfung Galerie Moritzburg, Verfahren gegen Direktor Otto Heinz Werner, in: BArch, DR 1/7868, Bl. 227-254.

23 Siehe Pätzke 1993, S. 65: „Bei sehr geringen Preisen – auf die vereinbarten Preise wurden zu Beginn noch einmal Rabatte bis zu 40 % gewährt, waren Dänen, Holländer, Schweden und Westdeutsche zunächst die Hauptabnehmer des über den DIA (Deutscher Innen- und Außenhandel) Kulturwaren geführten Exports".

24 Schriftwechsel zwischen dem Direktor des Instituts für Denkmalpflege und der HA Bildende Kunst des Ministeriums für Kultur, Mai/Juni 1957, in: BArch, DR 1/7977, Bl. 42-46, zitiert nach: Findbücher zu den Beständen des Bundesarchivs. Staatlicher Kunsthandel der DDR „VEH Bildende Kunst und Antiquitäten" (1974–2002) Bestand DR 144, bearbeitet von Anne Bahlmann, Falco Hübner, Bernd Isphording, Stefanie Klüh, Berlin 2017, S. 4, Bundesarchiv, https://www.bundesarchiv.de/DE/Content/Downloads/Meldungen/20180601-skh-findbucheinleitung.pdf?__blob=publicationFile (30.7.2021).

25 Vgl. Rundschreiben des Innenministeriums des Landes Sachsen-Anhalt vom 6.4.1951, in: Landesarchiv Sachsen-Anhalt, Abt. Magdeburg, K 10, Nr. 345; Thüringer Landtag. Stenographischer Bericht über die 34. Sitzung, Weimar, 25. Februar 1948, 11 Uhr, S. 915 und 916, Thüringer Universitäts- und Landesbibliothek Jena, https://zs.thulb.uni-jena.de/rsc/viewer/jportal_derivate_00197514/509000342_0722b.tif?logicalDiv=jportal_jparticle_00194576 (30.7.2021).

26 Schreiben des stellvertretenden Vorsitzenden der Staatlichen Planungskommission an den Minister für Kultur vom 1.2.1956, Betr.: Behandlung eingezogener Gegenstände und Waren, in: BArch, DR 1/8351, Bl. 177/178.

27 Aktenspiegel mit Inventar-Verzeichnis über die Republikflucht von Geerd [sic] und Marianne Richter vom 8.4.1961, 3 Blatt, Amt zur Regelung offener Vermögensfragen (ARoV) der Landeshauptstadt Dresden, in: Dietmar Elger: Gerd Richter 1961/62. Es ist, wie es ist/It is, as it is (=Schriften des Gerhard Richter Archivs, hg. von Dietmar Elger, Bd. 18), Dresden/Köln 2020, S. 15–17.

28 Jürgen Schreiber: Ein Maler aus Deutschland. Gerhard Richter. Das Drama einer Familie, München 2020 (5), S. 217 und 219.

[29] Bericht über eine Besprechung zur geplanten Reorganisation des SKH an den stellv. Minister für Kultur Hans Pischner vom 29.10.1962, in: BArch DR 1/7977, Bl. 11–13, zitiert nach: Findbücher zu den Beständen des Bundesarchivs. Staatlicher Kunsthandel der DDR „VEH Bildende Kunst und Antiquitäten" (1974–2002) Bestand DR 144, S. 4.

[30] BArch DR 1/7977 und DP 1/22232, zitiert nach: Findbücher zu den Beständen des Bundesarchivs. Staatlicher Kunsthandel der DDR „VEH Bildende Kunst und Antiquitäten" (1974–2002) Bestand DR 144, S. 4.
Zur weiteren Geschichte der Nachfolgebetriebe bis zur Gründung des VEH Bildende Kunst und Antiquitäten siehe Pätzke 1993, Tauscher 2019 und Findbücher des Bundesarchivs, Bestand DR 144, S. 3–15.

[31] Siehe hierzu Pätzke 1993, S. 67, und Tauscher 2019, S. 74–78.

[32] Siehe Ulf Bischof: Die Kunst und Antiquitäten GmbH im Bereich Kommerzielle Koordinierung (Reihe: Schriften zum Kulturgüterschutz/Cultural Property Studies), Berlin 2003; Ralf Blum, Helge Heidemeyer, Arno Polzin: Auf der Suche nach Kulturgutverlusten. Ein Spezialinventar zu den Stasi-Unterlagen, Berlin 2020, Stasi-Unterlagenarchiv, https://www.stasi-unterlagen-archiv.de/assets/bstu/de/Downloads/EV_Gutachten_Kulturgutverluste.pdf (30.7.2021).

[33] Perspektivische Entwicklung bis 1990 (1977), in: BArch DL 210/4819, zitiert nach: Findbücher zu den Beständen des Bundesarchivs. Betriebe des Bereichs Kommerzielle Koordinierung, Teilbestand Kunst und Antiquitäten GmbH (1974–2002), Bestand DL 210, bearb. von Bahlmann, Hübner, Isphording, Klüh 2017, S. 5, Bundesarchiv, https://www.bundesarchiv.de/DE/Content/Downloads/Meldungen/20180601-kua-findbucheinleitung.pdf (30.7.2021).

[34] „Da kriegst Du alles, was es nicht gibt." Wie die SED den DDR-Schwarzmarkt auf Kosten ihrer Bürger organisiert, in: Der Spiegel, 41/1985, S. 131–140. Online unter https://www.spiegel.de/politik/da-kriegst-du-alles-was-es-nicht-gibt-a-f4b20867-0002-0001-0000-000013514070 (30.7.2021).

Kunst und Antiquitäten GmbH

Geschäfte mit Museumsstücken aus der DDR auf dem internationalen Kunst- und Antiquitätenmarkt

Jan Scheunemann

Transactions with museum collections from the GDR on the international art and antiques market

This article deals with the "commercial exploitation" of works of art from museum collections in the GDR. The starting point is a watercolor by Adolf Hitler, which came to the Moritzburg in Halle (Saale) after 1945 in the course of the land reform expropriations, was removed from the collection in March 1973, and sold to the USA in 1975 through a middleman. Responsible for this transaction was Kunst und Antiquitäten GmbH (Art and Antiques Ltd.), which belonged to the Commercial Coordination Division of the GDR Ministry of Foreign Trade. This company had been founded in January 1973 with the aim of generating foreign currency to the tune of 55 million Valuta marks by exporting objects from GDR museums. Due to protests from the museums concerned and critical reporting in the Federal Republic, the sales campaign, which had already begun, was aborted. It is almost unknown to this day that the conceptual prerequisites for a systematic sale of museum objects ordered by the state had already been created in the 1960s. On October 1, 1963, the East German Minister of Culture issued an "Instruction on the transfer of antiquities of the fine arts, arts and crafts, and numismatics by the museums of the GDR to the state art trade," which assigned the nationally owned trading company VEH Moderne Kunst, founded on December 1, 1962, the task of taking over objects of "low art historical value" from archives and museums and selling them abroad.

Im April 1994 erhielt die Staatliche Galerie Moritzburg in Halle (Saale), das heutige Kunstmuseum Moritzburg, einen Brief aus Lewisville, Texas. „A client of mine has what she believes to be a Original-Aquarell by Adolf Hitler", erklärte ein Anwalt und fügte hinzu, dass auf der Rückseite des dazugehörigen Passepartouts Folgendes zu lesen sei: „Landesgalerie Sachsen-Anhalt, Moritzburgmuseum, Graphisches Kabinett, bez. München K[önig]l[iches]. Hofbräuhaus, Aquarell, Adolf Hitler, geb. 1889 Braunau, [gest.] 1945 Berlin, Inv. Nr. 843, Schr[ank]. IX, Mappe 16." Der Anwalt bat um Informationen zum Aquarell und dessen Geschichte und bedankte sich mit freundlichen Grüßen.[1]

Das Schreiben, das damals unbeantwortet blieb, warf mehrere Fragen auf: Hatte sich im Bestand des Moritzburg-Museums einmal ein Aquarell Adolf Hitlers befunden? Und wenn ja, wie war es

Adolf Hitler, Königliches Hofbräuhaus München, Aquarell, 28,8 × 21,8 cm, Privatbesitz USA

Gestell eines kleinen Tisches auf gedrechselten Beinen, 19. Jahrhundert, in einem Depot der Kulturstiftung Sachsen-Anhalt im ehemaligen Feudalmuseum Schloss Wernigerode

🖉 *Vgl. Beiträge von Thomas Rudert, S. 28, und Michael Busch, S. 81.*

in die Sammlung und dann in die USA gelangt? Ohne Zweifel, die auf dem Passepartout genannte Landesgalerie Sachsen-Anhalt hatte es tatsächlich gegeben. Sie war im Frühjahr 1950 auf Anweisung der Landesregierung Sachsen-Anhalts in Halle (Saale) gegründet worden, hatte ihren Sitz mit einer Gemäldegalerie und einem Graphischen Kabinett in der Moritzburg und war außerdem für den Betrieb von sechs Burgen und Schlössern sowie die fachliche Betreuung von 60 kommunalen Museen verantwortlich.[2]

Das Aquarell ließ sich im Inventarbuch der Grafischen Sammlung schnell finden. Der Eintrag vom 16. November 1951 stimmt fast wortgleich mit den Informationen auf dem Passepartout überein und enthält als Herkunftsbezeichnung die Abkürzung „V.E." für „Volkseigentum". Dieses Kürzel verweist in den Inventaren des Kunstmuseums Moritzburg auf Objekte, die aus Bodenreform-Enteignungen stammen. Bei der im September 1945 in der Sowjetischen Besatzungszone durchgeführten Bodenreform waren nicht nur Land- und Forstflächen entschädigungslos enteignet worden, sondern auch Schlösser und Gutshäuser mitsamt dem darin befindlichen Inventar. Neben Gebrauchsgegenständen gehörten dazu oft auch Kunstwerke, historische Möbel, wertvolle Teppiche, Silber und Porzellan. 🖉

Die Moritzburg hatte ab 1946 als Zentraldepot für diese Objekte gedient, weshalb sich in der Landesgalerie eine gesonderte Abteilung mit der Bergung, Inventarisierung, Magazinierung und

Verwertung des aus der Bodenreform stammenden Kunst- und Kulturguts beschäftigte. Ferner fand sich im Inventarbuch der Vermerk: „Am 27.3.1973 an Direktor [Heinz] Schierz ausgehändigt. Protokoll Nr. 64". In dem Protokoll bestätigte die damalige Leiterin der Grafischen Sammlung, dem Direktor das Hitler-Aquarell „nebst Karteikarte zur Weitergabe an den Rat des Bezirkes Halle" übergeben zu haben.[3]

Weiterführende Informationen fanden sich in den hauseigenen Dokumenten und Archivunterlagen nicht, doch ließ der Zeitraum März 1973 einen Zusammenhang mit dem ersten Versuch der Kunst und Antiquitäten GmbH (KuA) vermuten, Sammlungsobjekte aus Museen der DDR zur Erwirtschaftung von Devisen ins westliche Ausland zu verkaufen. Die weiteren Recherchen in Archiven und Aussagen von Zeitzeugen bestätigten diese Vermutung, und so lässt sich anhand des Aquarells nachzeichnen, auf welchen Wegen solch ein Verkauf abgewickelt wurde, wie das Räderwerk der kommerziellen Verwertung über Landesgrenzen hinweg funktionierte und welche politischen und persönlichen Konsequenzen sich für die handelnden Akteure damit verbanden. Der Weg des Hitler-Aquarells zeigt zudem, dass die KuA für Valuta auch mit NS-Devotionalien handelte.

Vgl. Beitrag von Margaux Dumas und Xenia Schiemann, S. 213.

Der Griff in die Museumsdepots der DDR

Der Verkauf von Sammlungsobjekten aus Museen der DDR zieht sich wie ein roter Faden durch die Geschichte des ostdeutschen Museumswesens; nicht alle Ausstellungshäuser waren davon betroffen, einige dafür umso mehr. Dass Museen Stücke aus der hauseigenen Sammlung verkaufen, ist nicht ungewöhnlich. Um den Erwerb anderer Werke finanzieren oder ihre Existenz sichern zu können, ist in Ländern wie den USA mit einer zu großen Teilen privatwirtschaftlich organisierten Museumslandschaft dieses „deaccessioning" gängige Praxis, die dennoch oft von Protesten und emotionalen Debatten begleitet wird. Auch in Deutschland haben Kunstverkäufe aus Museen – obwohl tabu – eine lange Tradition, die sich ausgehend vom 19. Jahrhundert bis in die jüngste Vergangenheit nachverfolgen lässt. Entscheidend für die Beurteilung der jeweiligen Verkaufssituation ist die Frage, was zu welchem Zweck an wen veräußert werden soll und wer darüber entscheidet.

In den historischen Gemäldeinventaren des Kunstmuseums Moritzburg haben sich aus den 1920er-Jahren mehrere Belege für Verkäufe von Gemälden erhalten. Im Juli 1946 veräußerte man 32 Gemälde aus dem Altbestand, die als „nicht museumswürdig" oder „künstlerisch wertlos" galten. Mitte der 1950er-Jahre erging von der Finanzabteilung der Stadt Halle die Aufforderung an die Museumsleitung, „abgabefähige Depotbestände" zu verkaufen, um so einen Beitrag zur Finanzierung der kulturellen Einrichtungen zu leisten.[4] Die Stadtverwaltung berief sich dabei auf eine im Oktober 1954 vom Finanzministerium der DDR erlassene Anordnung, die „zur Ausschöpfung aller [...] vorhandenen Reserven" festlegte, nicht mehr benötigte „bewegliche Vermögensgegenstände" gegen Erstattung des Zeitwertes⌀ an die staatliche Verwaltung, die volkseigene Wirtschaft oder an Parteien und Massenorganisationen abzugeben.[5] Laut dieser Anordnung war auch der Verkauf an Privatpersonen ausdrücklich erlaubt. Erhaltene Rechnungen dokumentieren beispielsweise, dass der Direktor der Universitätskinderklinik in Halle (Saale) im Mai 1956 unter anderem sechzehn Gemälde aus dem 17., 18. und 19. Jahrhundert erwarb, die alle aus Bodenreform-Enteignungen stammten.[6]

Ende der 1950er-Jahre geriet das Verwertungspotenzial von Kunstwerken aus der Bodenreform dann auch in den Fokus der zentralen Kulturadministration der DDR. Das Ministerium für Kultur (MfK) hatte den Hinweis erhalten, dass überall im Lande ein schwunghafter Handel mit Bodenreformgut getrieben wurde. Doch anstatt die Kunstgegenstände aufgrund ihrer kulturellen und historischen Bedeutung in Museen zu sichern, schlug das MfK vor, sie dem Staatlichen Kunsthandel zu überlassen.[7]

Konkrete, konzeptionelle Voraussetzungen für den Handel mit Museums- beziehungsweise Bodenreformbeständen wurden 1962 geschaffen. Der Staatliche Kunsthandel, der zur staatlichen Handelsorganisation (HO) gehörte, wurde aufgelöst.⌀ An seine Stelle trat der am 1. Dezember 1962 gegründete und dem MfK unterstellte VEH Moderne Kunst.[8] Sechs Wochen zuvor hatte im MfK eine Beratung stattgefunden, an der auch Vertreter aus dem Ministerium für Außenhandel und Innerdeutschen Handel (MAI) teilnahmen. Im entsprechenden Protokoll heißt es unter dem Punkt „Erschließung neuer Ankaufsquellen für Antiquitäten": „Die Museen der DDR können aus ihren magazinierten Beständen Antiqui-

täten an den staatlichen Kunsthandel verkaufen. Infrage kommen nur solche Gegenstände, die für alle Zeiten ausstellungsunwürdig sind und daher einen sehr geringen ideellen und gesellschaftlichen Wert besitzen. Der Museumsleiter muß diese Gegenstände (die zum großen Teil durch die Verwirklichung der Bodenreform in die Museen kamen) vorher anderen kleineren und Spezialmuseen zur musealen Verwendung angeboten haben. Erst wenn diese Museen ebenfalls abgelehnt haben, kann der Museumsleiter über den Verkauf an den staatlichen Kunsthandel entscheiden. Die Verantwortung dafür trägt der Leiter des Museums."[9]

Der Zeitpunkt, an dem der staatlich angeordnete, systematische und massenhafte Verkauf von Objekten aus Museumssammlungen der DDR begann, lässt sich ziemlich genau bestimmen. Im März 1963 wurde der VEH Moderne Kunst zunächst mit einer Verfügung des MfK für den „Antiquitätenhandel mit dem Ausland" legitimiert.[10] Am 1. Oktober 1963 erließ Kulturminister Hans Bentzien schließlich die als „vertrauliche Dienstsache" gekennzeichnete „Anweisung über die Abgabe von Antiquitäten der bildenden Kunst, des Kunsthandwerks und der Numismatik durch die Museen der DDR an den Staatlichen Kunsthandel".[11] In Umsetzung dieser Anweisung wurden Museen und Kunstsammlungen in der ganzen DDR dazu aufgefordert, „entbehrliche und nicht der Zielstellung der Museen entsprechende Gegenstände" für einen Verkauf zur Verfügung zu stellen. Die von den Museen übernommenen Gegenstände wurden in Leipzig gesammelt, am 3./4. Dezember 1963 im dortigen Museum des Kunsthandwerks von einer Expertenkommission begutachtet und am 5. Dezember 1963 vermutlich am selben Ort zur Auktion gebracht.[12] Die Maßnahme, die in den Archivquellen unter dem Begriff „Sonderaktion Leipzig" auftaucht, sollte die mangelhafte Planerfüllung des VEH Moderne Kunst durch einen erhöhten Export ausgleichen. An der Aktion waren schließlich 22 Museen beteiligt.[13] Dazu gehörten große Häuser wie die Staatlichen Kunstsammlungen Dresden und die Staatlichen Museen zu Berlin, aber auch kleinere Einrichtungen wie die Heimatmuseen in Neuruppin und Naumburg oder das Kreismuseum in Wurzen. Die Staatliche Galerie Moritzburg gab zwischen 1963 und 1966 mehrere Hundert Kunstwerke an den VEH Moderne Kunst ab, die später zum Teil in Kunsthandlungen in der Bundesrepublik, in Belgien oder in den Niederlanden auftauchten.[14]

Wie kam das Hitler-Aquarell in die USA?

Die „Sonderaktion Leipzig" 1963/64 bildete lediglich den Auftakt zu den Verkäufen aus Museumsbeständen. Das MfK erinnerte die Museen nun unablässig an ihre Verpflichtung, weitere Angebotslisten für den Export zu erstellen.[15] Ab Februar 1972 intensivierte das Ministerium seine Anstrengungen; im Mai lagen Angebotslisten aus acht Museen mit einem Gesamtumfang von 600.000 bis 700.000 DDR-Mark vor. Zu dieser Zeit gab es schon die Überlegung, weitere 50 Museen einzubeziehen. Kulturminister Klaus Gysi hatte im November 1972 vergeblich vorgeschlagen, durch ein eigenes, unter Verantwortung des MfK stehendes Außenhandelsunternehmen die Auslandsgeschäfte abzuwickeln, um so die erwirtschafteten Mittel den beteiligten Museen für Ankäufe zukommen zu lassen.[16] Stattdessen entstand im Januar 1973 innerhalb des von Alexander Schalck-Golodkowski im Ministerium für Außenhandel geleiteten Bereichs Kommerzielle Koordinierung die Kunst und Antiquitäten GmbH. Ihre vorrangige Aufgabe bestand laut der entsprechenden Verfügung 4/73 des Ministerrates darin, durch den Export von Antiquitäten und Museumsbeständen 55 Millionen Valuta-Mark zu erwirtschaften.[17] Zur Erreichung dieses Ziels erhielt der Generaldirektor der Staatlichen Schlösser und Gärten Potsdam-Sanssouci, Joachim Mückenberger, einen „Sonderauftrag" des DDR-Ministerrates. Allein aus den Sammlungen von Schloss Sanssouci sollten zum „Ausgleich der Devisenbilanz" Kunstgegenstände im Wert von 5 Millionen Mark zur Verfügung gestellt werden.[18]

Die Reaktionen aus den Museen waren nicht nur in Potsdam verheerend. Unverständnis mischte sich mit Verbitterung, sah man doch in der Aktion eine Maßnahme, „die einem nationalen Ausverkauf von Kunstgegenständen gleichkommt".[19] In den Staatlichen Museen zu Berlin unterschrieben über 60 Mitarbeiterinnen und Mitarbeiter eine Petition gegen den Verkauf von Kunstwerken.[20] Zudem war es nicht gelungen, die Verkaufspläne geheim zu halten. Die Informationen über die geplanten Exporte hatten sich wie ein Lauffeuer in der DDR verbreitet. Das Ministerium für Staatssicherheit (MfS) musste feststellen, dass in Potsdam-Sanssouci jeder Wiesenpfleger von der Aktion wusste.[21] Als Ende März 1973 dann in der Westpresse Artikel erschienen, die die Pläne der DDR

publik machten, und in der Bundesrepublik die Idee umlief, eine von der Bundesregierung finanzierte Stiftung zum Ankauf der Kunstwerke aus der DDR zu gründen,[22] wurde die Verfügung 4/73 am 28. März 1973 durch den Vorsitzenden des Ministerrates, Willi Stoph, ersatzlos aufgehoben.[23]

Damit war der geplante Export von Museumsgut durch die Kunst und Antiquitäten GmbH vorerst gestoppt. In der Moritzburg in Halle (Saale) schlug die Aktion dennoch hohe Wellen, denn die dort erstellte Verkaufsliste enthielt an erster Stelle das Hitler-Aquarell. Anhand von Archivunterlagen der Abteilung Kultur beim Rat des Bezirkes Halle lässt sich der Ablauf der Verkaufsaktion detailliert rekonstruieren. Demnach erging die Weisung, in den Museen Kunstgut für den Export ins Nichtsozialistische Wirtschaftsgebiet (NSW) zu erfassen, telefonisch vom MfK an die Kulturabteilungen der Räte der Bezirke und wurde von dort wiederum telefonisch an ausgewählte Museen durchgestellt.[24] Die Auswahl der Stücke trafen die Museen selbst. In der Moritzburg erhielten die Leiterinnen und Leiter der einzelnen Sammlungsbereiche vom Direktor die Aufforderung, nur solche Objekte auszuwählen, die nicht dem Sammlungsprofil des Museums entsprachen und nie in Ausstellungen gezeigt würden.[25] Die Liste der Moritzburg lag dem Ministerium für Kultur Mitte März 1973 vor. Am 26. März informierte Joachim Mückenberger die Abteilung Kultur beim Rat des Bezirkes Halle über das Hitler-Aquarell in der Aufstellung und löste damit einen politischen Skandal aus. Der für die Verkaufsaktion beim Rat des Bezirkes verantwortliche stellvertretende Leiter der Abteilung für Kultur, Gottfried Kormann, wurde zur Verantwortung gezogen. Da er als IM „Rainis" für das MfS tätig war, hat sich in seiner Akte eine vierseitige Stellungnahme erhalten, in der er sein „politisches Versagen" eingestand.[26] Dies konnte ihn allerdings nicht vor einer Parteistrafe bewahren. Kormann wurde in den VEB Waggonbau Ammendorf strafversetzt.

Hilfreich bei der weiteren Spurensuche erwies sich das im März 2020 veröffentlichte BStU-Spezialinventar zu Kulturgutverlusten.✐ Dort findet man den Hinweis auf die Berichterstattung eines IM „Sohle" zum Hitler-Aquarell.[27] In dem Dokument vom 15. November 1974 berichtet IM „Sohle" unter seinem Klarnamen Horst Schuster, bis 1980 Direktor der Kunst und Antiquitäten GmbH, an den „Genossen Schindler" – mit hoher Wahrscheinlich-

✐ *Vgl. Projekt-Eintrag in Proveana, PURL https://www.proveana.de/de/link/pro10000319.*

BSTU
0041

Betr. Aquarell "Hofbräuhaus" von Adolf Hitler

Werter Genosse Schindler !

Nach den bisherigen Untersuchungen ergeben sich
folgende Möglichkeiten:

1. Durch den von mir eingeschalteten Vermittler
 konnte durch Zeitungsanzeigen in zwei österreichi-
 schen Tageszeitungen ein Interessent ermittelt
 werden.

2. Ein Sachverständiger, ein gewisser Herr Jahn, der
 schon zu Lebzeiten des Autors dessen "Werke"
 betreute, erklärt das Aquarell nach den vorliegenden
 Fotos für e c h t .

3. Nach Informationen des gleichen Herrn, soll das
 fragliche Bild vor 4-5 Jahren schon einmal von
 einem Antiquitätenhändler aus Halle angeboten
 worden sein, ohne das damals nachgewiesen wurde,
 das das Bild tatsächlich vorhanden und verkäuflich
 gewesen ist.

4. Das Bild kann sofort übernommen werden.
 Der Nettoerlös wird bei ca. DM 5.000.- liegen.

5. Das Bild wird von meinem Vermittler als dessen
 Eigentum verkauft.
 Die Übergabe soll ohne Papiere erfolgen.
 Sicherheiten für die finanzielle Absicherung sind
 vorhanden.

Es wird hiermit um Aushändigung des Bildes
gebeten.

S c h u s t e r

Berlin ,15.11.1974

keit Helmut Schindler, Generaldirektor des Außenhandelsbetriebs Transinter GmbH –, dass es ihm mithilfe eines Vermittlers gelungen sei, einen Käufer für das Aquarell zu finden. Bei dem Vermittler dürfte es sich um die Rubens Consultant GmbH in der Schweiz gehandelt haben, zumindest legt dies der Titel auf der entsprechenden MfS-Akte nahe. Peter Jahn, der das Bild für echt erklärte, war ein in Wien ansässiger dubioser „Spezialist" für Hitler-Gemälde, der offenbar auch in die Fälschung und den Handel mit Hitler-Werken verwickelt war. Jahn hat zwischen 1966 und 1989 Hunderte sogenannte Echtheitsbestätigungen angefertigt.[28] Sein Gutachten zu dem Aquarell aus der Moritzburg datiert vom 17. Juli 1975.

Echtheitsbestätigung von Peter Jahn, Wien, vom 17. Juli 1975 [Kopie], Archiv Kunstmuseum Moritzburg Halle (Saale), Mappe Adolf Hitler

Da sich auch der aktuelle Besitzer des Aquarells im März 2001 aus den USA mit der Bitte um Auskünfte an die Moritzburg wandte, konnte durch eine Kontaktaufnahme der Weg des Blattes zumindest ab dem Verkauf nachverfolgt werden. Demnach erwarb ein New Yorker Auktionshaus das Aquarell 1975 in Österreich. Ein Jahr später, im Oktober 1976, wurde es auf einer Nachlassauktion im Bundesstaat Connecticut versteigert. Die damalige Käuferin verkaufte es 2001 über eBay an den jetzigen Besitzer.

Die Geschichte des Hitler-Aquarells aus der Moritzburg illustriert nicht nur die fragwürdigen Praktiken der KuA, sondern sie stellt auch die Frage nach dem Handel solcher Objekte auf dem internationalen Kunst- und Antiquitätenmarkt. Die Absicht der KuA, Museumsobjekte aus der DDR zur Devisenerwirtschaftung zu exportieren, mochte 1973 gescheitert sein. Schon Ende der 1970er-Jahre wurden diese Aktivitäten aber wieder aufgenommen, um dann in den 1980er-Jahren in einen massenhaften Abverkauf zu

münden. Dokumentationen, wie sie beispielsweise für die Kunstverkäufe aus den Staatlichen Kunstsammlungen Dresden schon 1990 erarbeitet wurden,[29] und die im Bundesarchiv Berlin vollständig erschlossenen Akten der KuA (Bestand DL 210) legen davon Zeugnis ab.

Jan Scheunemann

Jan Scheunemann ist wissenschaftlicher Mitarbeiter der Kulturstiftung Sachsen-Anhalt.

Der Text geht auf einen Vortrag der Herbstkonferenz am 30. November 2020 zurück, der vom Autor für diesen Band angepasst wurde.

Förderung des Grundlagenprojekts „Die Moritzburg in Halle (Saale) als zentrales Sammellager für Kunst- und Kulturgut, das in der Provinz Sachsen durch die sogenannte Bodenreform enteignet und entzogen wurde" von September 2018 bis Oktober 2021.

Endnoten

[1] Schreiben von Anwalt Ben E. S., Lewisville, Texas, USA, 14.4.1994. Archiv Kunstmuseum Moritzburg Halle (Saale), Mappe Adolf Hitler. Übersetzung: „Eine Mandantin von mir besitzt ein nach ihrer Überzeugung originales Aquarell Adolf Hitlers ...“

[2] Übersicht zur Landesgalerie Sachsen-Anhalt. Landesarchiv Sachsen-Anhalt, Abt. Magdeburg, K 10, Nr. 7448, Bl. 161.

[3] Auslieferungsprotokoll, 12.6.1973. Kunstmuseum Moritzburg Halle (Saale), Grafische Sammlung.

[4] Rat der Stadt Halle, Abteilung Finanzen, an den Rat des Bezirkes, Abt. Kultur, 24.6.1955, Einnahmefestsetzung für die Staatliche Galerie Moritzburg in Halle. Stadtarchiv Halle (Saale), A 3.21, Nr. 138.

[5] Anordnung über die Abgabe und den Verkauf beweglicher Vermögensgegenstände durch Organe der staatlichen Verwaltung und deren Einrichtungen, 28.10.1954, in: Zentralblatt der DDR, Nr. 145, 13.11.1954, S. 544 f.

[6] Rechnung, 19.5.1956, in: Archiv Kunstmuseum Moritzburg Halle (Saale), Schriftwechsel Gemäldesammlung 1955/1956.

[7] Schreiben von Walter Heese (MfK) an das Institut für Denkmalpflege der DDR, 3.6.1957, BArch Berlin, DR 1/7977, Bl. 43.

[8] Vgl. Anordnung über den volkseigenen Handelsbetrieb „Moderne Kunst", 7.1.1963, in: Gesetzblatt der DDR, Teil II, Nr. 8, 21.1.1963, S. 36 f.

[9] Schreiben von Günter Meier (MfK) an Hans Pischner (Stell. Minister für Kultur der DDR), 19.10.1962, BArch Berlin, DR 1/7977, Bl. 11–13, hier Bl. 11.

[10] Vgl. Anweisung über den volkseigenen Handelsbetrieb „Moderne Kunst", 1.2.1963, in: Verfügungen und Mitteilungen des Ministeriums für Kultur, Nr. 3, 31.3.1963, S. 13.

[11] Vgl. Anweisung über die Abgabe von Antiquitäten der bildenden Kunst, des Kunsthandwerks und der Numismatik durch die Museen der DDR an den Staatlichen Kunsthandel, 1.10.1963. Archiv der Staatlichen Kunstsammlungen Dresden, Generaldirektion 02/GD, Nr. 460. Ich danke Thomas Rudert (Staatliche Kunstsammlungen Dresden) für den Hinweis auf diese Anweisung.

[12] Schreiben von Eberhard Bartke (MfK) an Fritz Kämpfer (Museum des Kunsthandwerks Leipzig), 27.11.1963. Stadtarchiv Leipzig, Museum des Kunsthandwerks, Nr. 10, Bl. 254.

[13] Ergänzungsbericht zur Revision des VEH „Moderne Kunst" Berlin, 28.10.1966, Anlagen, BArch Berlin, DN 1/14277.

[14] Konrad Breitenborn: „Eigentum des Volkes" – Kunst- und Kulturgutenteignungen durch die Bodenreform, in: Die Bodenreform in Sachsen-Anhalt. Durchführung – Zeitzeugen – Folgen, hg. von Rüdiger Fikentscher und Boje Schmuhl in Verbindung mit Konrad Breitenborn, Halle/Saale 1999, S. 117–152, hier S. 117–119.

[15] Schreiben von Kurt Borg (Stell. des Ministers für Kultur) an Fritz Kämpfer (Museum des Kunsthandwerks Leipzig), 18.9.1970. Stadtarchiv Leipzig, Museum des Kunsthandwerks, Nr. 6, Bl. 7.

[16] Vgl. Ulf Bischof: Die Kunst und Antiquitäten GmbH im Bereich Kommerzielle Koordinierung, Berlin 2003, S. 76.

[17] Vgl. ebd., S. 73.

[18] Protokoll über die Dienstbesprechung am 1.2.1973. Archiv der Stiftung Preußische Schlösser und Gärten Berlin-Brandenburg, Nr. 4/424. Ich danke S. Olaf Oehlsen (Stiftung Preußische Schlösser und Gärten Berlin-Brandenburg) für die Übersendung des Dokumentes.

[19] Informationsbericht der Abteilung VI/Op/1 der BV Potsdam, 2.4.1973, BStU, MfS, HA XX, Nr. 10340, Bl. 63–68, hier Bl. 63.

[20] Vgl. Günter Schade: Protokoll eines gescheiterten Millionen-Deals, in: Jahrbuch Preußischer Kulturbesitz, Bd. 40 (2003), S. 231–261, hier S. 241.

[21] Einbeziehung von Museen der DDR zur Valutagewinnung. Bericht der Abteilung XX/7 der BV Halle, 6.4.1973. BStU, MfS, HA XX, Nr. 10340, Bl. 57–59, hier Bl. 57.

[22] Vgl. Süddeutsche Zeitung, 26.3.1973; Frankfurter Allgemeine Zeitung, 28. und 29.3.1973; Die Welt, 30.3.1973.

[23] Verfügung Nr. 41/73, 28.3.1973, gez. Stoph, BArch Berlin, DR 1/9018, Bl. 93.

[24] Information von R. Stephan (Rat des Bezirkes Halle, Abt. Wissenschaft, Volksbildung und Kultur) vom 27.3.1972. Landesarchiv Sachsen-Anhalt, Abt. Merseburg, Bezirkleitung der SED Halle, P 516, Nr. 5396, Bl. 66 f.

[25] Telefonische Auskunft von Andreas Hüneke (Potsdam), damals Mitarbeiter der Staatlichen Galerie Moritzburg in Halle (Saale), 15.1.2021.

[26] Gottfried Kormann: Stellungnahme zu meinem ernsten politischen Versagen, verbunden mit einer politischen Fehleinschätzung am 19. März 1973, 5.4.1973, BStU, MfS, BV Halle, Abt. XX, VIII 1956/74, Bl. 92–95.

[27] Vgl. Ralf Blum, Helge Heidemeyer, Arno Polzin: Auf der Suche nach Kulturgutverlusten. Ein Spezialinventar zu den Stasi-Unterlagen, Berlin 2020, S. 291 f.

[28] Das Münchner Auktionshaus Hermann Historica versteigerte im Mai 2015 zwei Aktenordner mit über 200 Gutachten Jahns zu Aquarellen und Zeichnungen Adolf Hitlers. Enthalten war darin auch das Gutachten zu dem Aquarell aus der Moritzburg.

[29] Abschlussbericht der Kommission zur Untersuchung von Kunstverkäufen der Staatlichen Kunstsammlungen Dresden, Dresden 1990.

Behind the Iron Curtain: A case study of East German art exports and the connection to National Socialist looting

Margaux Dumas, Xenia Schiemann

Hinter dem Eisernen Vorhang: Eine Fallstudie über die Kunstexporte aus der DDR und ihre Verbindung zum NS-Raubgut

Eine Kommode, die der bedeutende Pariser Möbelkünstler Guillaume Beneman 1787 gefertigt hatte und deren typengleiches Exemplar heute noch im Louvre ausgestellt ist, wurde von ihren wechselnden Besitzer:innen seit der Französischen Revolution auf eine bemerkenswerte Reise durch die europäische Geschichte geschickt.

1941, während der deutschen Okkupation, erwarb die Reichsbank das Möbelstück in Paris für das Berliner Hauptquartier. Nach dem Zweiten Weltkrieg wurde die Kommode als geplündertes Gut in das zwischen 1947 und 1949 erschienene Raubgut-Verzeichnis, das Répertoire des biens spoliés, aufgenommen. 1952 übergab das Finanzministerium der DDR die Beneman-Kommode in einem Konvolut mit anderen sogenannten Reichsbankmöbeln an das Märkische Museum in Ost-Berlin. Unter ungeklärten Umständen wurde dieses bedeutende Möbelstück aus der DDR exportiert und 1986 bei Christie's in London und elf Jahre später bei Christie's in New York versteigert.

Die Studie untersucht die Schnittstellen zwischen Provenienzforschung, Kunstmarkt und Museumswissenschaft einerseits und die enge Verbindung zwischen verschiedenen Aneignungskontexten andererseits.

A study of an object's journey through history permits to focus the analysis on the impact of numerous translocations on its materiality and further our understanding of how different contexts can be linked together and compared.

The article retraces the translocations of a *commode à trois vantaux* from the Château of Versailles through the French Revolution, the Second World War, and the GDR era.[1] The counterpart of this commode is in the collection of the Louvre.[2] Both are stamped by the Parisian *ébéniste* Guillaume Beneman (?–1811). They were commissioned by the wife of the Intendant Général de la Couronne, Madame Thierry de Ville d'Avray, in 1787 to furnish the Hôtel du Garde-Meuble in Versailles.[3] The pair were made of mahogany and *bleu turquin* marble. The bronze mounts are by Pierre-Philippe Thomire and Etienne-Jean Forestier. In 1792, one of the pairs was sent to the Cabinet du Conseil du Roi at the Tuileries before being transferred to the Mobilier National depot in 1870 and finally be-

ing transferred to the Louvre where it can still be seen today. The counterpart was most likely sold during the Revolution.[4]

Following a study of the history of the commode in the first half of the 20th century, the focus of this article will be on its journey to East Berlin and in particular the question how it came to be sold on the other side of the Iron Curtain at Christie's London in 1986, and again, 11 years later at Christie's New York.

Looted or not? The translocation of the commode 1933–1947

In 1933, the commode was presented at an exhibition at the Louvre entitled *Rétrospective du meuble du XVIIème siècle à nos jours* in the room dedicated to Louis XVI.[5] According to André Theunissen, who in the following year published a book about French ebenistes, the commode then belonged to a French art dealer, Marie Touzain.[6] No records were found regarding a sale of the commode, or other exhibitions between 1933 and 1941.

Between the end of February and November 1941, the commode was sold to the German Reichsbank, through the intermediary services of Margot Jansson.[7] Albert Bourdariat, an art and antiques expert, wrote a customs report dated 15 February 1941 with an estimated value of 400,000 Francs.[8]

Margot Jansson was a Swedish citizen who lived in Paris during the Occupation. She had met Walther Funk in Berlin in the 1920's, future director of the Reichsbank and Hitler's Minister of the Economy. In November 1940, Funk put Jansson in touch with Heinrich Wolff, chief architect of the Reichsbank in Berlin, because he wanted to have the Reichsbank headquarters decorated in a French 18th century style.[9] Wolff needed Jansson as an intermediary in this matter to carry out this work. She negotiated contracts between the Reichsbank and upmarket Parisian interior firms. During this period, Jansson worked exclusively for the Reichsbank and acted as an intermediary in many furniture and art purchases, including that of the Beneman commode.[10] Through its prestigious provenance, its high quality and the pair in the Louvre, the commode was a choice piece for Wolff.

Jansson often worked with Albert Bourdariat and Eugène Pouget, an art dealer, who was the brother and business partner of Marie Touzain, the last known owner of the commode before 1940.[11] This suggests that the commode belonged to Marie Touzain at the beginning of the war.

After the liberation of Paris, the French authorities became aware of the Beneman commode's sale through a report sent to the Ministry of Finance in September 1944.[12] It was forwarded in December 1945 to the Commission de Récupération Artistique (CRA).[13] The author of the report was Jansson's former secretary. She wrote that in her understanding, Jansson had been a stooge for the Reichsbank and that the funds used for the purchases were withdrawn from the Banque de France, through Mr. Boettcher, the Reichsbank's Delegate to the Banque de France.

This information helps to explain why the commode is listed in the *Répertoire des biens spoliés* published between 1947 and 1949. This repertory lists all looted assets that had not been located yet. It had a dual purpose: to record the missing assets, but also to prevent them changing hands. In the 4th volume, under no 2035, it states: "Un meuble d'appui. (Estampille de Benéman), en acajou portes pleines à baguettes en bronze doré, orné de bronzes attribués à Gouthière. (Le pendant de ce meuble se trouve au Musée du Louvre)".[14]

In the *Répertoire des biens spoliés* this piece of furniture is listed as claimed by the CRA and not by a private individual, together with

many similar objects. It seems reasonable that the CRA considered this object which was bought with money drawn from the Banque de France, as being stolen from France and wished to recover it.[15]

Another consideration with regard to this claim was a desire by some curators to enrich French public collections. In 1947, they drew up lists of "French" works held in German public collections to be claimed by France and used as reparations. These objects were intended to be given to the Château de Versailles, the Trianons, and the Louvre. Pierre Verlet, then Chief Curator of the Département des Objets d'Art of the Louvre, was among the authors.[16] It is possible that the Beneman commode was included in the *Répertoire des biens spoliés* in order to complete the pair in the Louvre, should it ever be found.

An Acquisition by the Märkisches Museum in 1952

After the Second World War, in 1951 and 1952 the Märkisches Museum in East Berlin took over 51 pieces of furniture from the GDR Ministry of Finance. This so-called Reichsbank furniture had been taken from the former Reichsbank building and included the Beneman commode. Indeed, it was one of the most important pieces in the acquisition.[17] According to the museum inventory, it was received on 5 September 1952 and given the inventory number I 52, 321. The entry included a note on the publication by Egon and Waldemar Hessling about the most important pieces of furniture in the Louvre.[18] Among those examples was the pair of the commode. While the museum in the GDR knew about the counterpart in the Louvre, the French museum was not aware of its twin being preserved in East Germany. Moreover, it appears that there was no contact between the Märkisches Museum and the Louvre regarding the objects.

The Stiftung Stadtmuseum Berlin, to which the Märkisches Museum today belongs, still owns the marble slab of the Beneman piece of furniture. The authenticity of the top is only confirmed by the type of marble and its size but also other references.[19] On the back of the slab there is a small piece of paper with fragments of letters written in ink. According to the Louvre, this label may be dated to the 18th century and could have been applied by the

Cf. project entries in Proveana, PURL https://www.proveana.de/de/link/pro00000101 und PURL https://www.proveana.de/de/link/pro10000334

Marble slab of the sold commode (frontside), Guillaume Beneman, France, 1787 (?), inventory number I 52/321, collection Stiftung Stadtmuseum Berlin

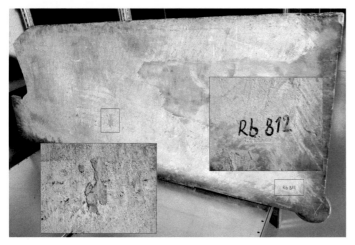

Marble slab of the sold commode (backside), Guillaume Beneman, France, 1787 (?), inventory number I 52/321, collection Stiftung Stadtmuseum Berlin

Garde-Meuble de la Couronne. Besides, on the back of the slab there is an inventory number of the Reichsbank furniture "Rb 812". Apparently, the top and the commode were separated during transportation because of the weight of the marble. Both parts were marked with the Rb inventory number in order to match them after their arrival in Germany.

The slab is damaged, and one of the broken-off pieces is also kept in the museum storage. Furthermore, it can be presumed that the top and the commode were stored separately in the Märkisches Museum. The newly acquired Reichsbank furniture was stored in the museum's tower, or probably in different places in the building.

Eventual sale by the Kunst und Antiquitäten GmbH

How did it come about that this high quality piece of furniture – with a new marble slab – was sold on the other side of the Iron Curtain at Christie's in 1986? So far, no direct references to the sale of the commode by the GDR have been found in the relevant archives. Nevertheless, the intermediary services of the Kunst und Antiquitäten GmbH (KuA) can be suspected to have played a role in this case. The KuA was founded in the GDR in 1973 and assigned to the Bereich Kommerzielle Koordinierung.[20] One year later, the KuA was made sole exporter of art objects, antiques and second-hand goods on Western art markets in order to receive foreign currency.[21] During its activity, the company also received art items from East German museums. On the one hand, the KuA entered into contractual agreements with some East German museums, whereby the museums were entitled to revenues from the sales.[22] On the other hand, the KuA benefited from exchanges of art items with museums. When a museum intended to purchase a new work of art in the West,[23] or wished to obtain protected cultural goods not authorised for export outside of the GDR, it had to provide other objects in exchange for the KuA [24].

Cf. article by Bernd Isphording, S. 234.

Among the most important customers of the KuA were Western auction houses. The records in the Bundesarchiv Berlin show, for example, that the KuA and the abovementioned London auction house Christie's concluded at least ten consignment contracts between 1979 and 1982.[25] However, in the archival records concerning the business relations between both companies, there is no trace of the sale of the Beneman commode from the Märkisches Museum. In this case, a sale by another intermediary firm of the KuA, or resale by a third party vendor could not be excluded.

The commode was probably never exhibited at the Märkisches Museum and it was not mentioned or illustrated in East German publications. Therefore, the object left no trace in terms of visibility and affiliation to the collection of the Märkisches Museum. The withdrawal of the commode was not mentioned in the museum's entry book. There is also the question why the slab remained in Berlin. If the KuA did not cause the damage to the marble plate, it may be assumed that the top was simply not found. Also, one can-

not exclude that the exporters could copy a similar top in the West, if the slab could not be transported for some reasons.

The high quality of the Beneman commode would undoubtedly put it in the category I of the regulations on the state museum fund of the GDR dating from 1978.[26] In this context it would be interesting to know whether the commode was reviewed by the East German commission for the protection of cultural heritage. According to the 3rd implementing provision of the art protection act of the GDR of 3 May 1982, the minister for culture decided about the export of cultural goods belonging to the category I after an appropriate examination of the request by the cultural heritage commission.[27] The question then arises on what basis the Märkisches Museum delivered the commode, and who was the forwarding agent as well as the insurance company covering the transport abroad? It might be helpful to extend the search area of further archival records.

With view to other printed sources, the auction catalogues regarding the sale of the Beneman commode are relevant. According to current research, the commode was first sold at Christie's London on 3 July 1986 by an unnamed seller[28] under lot number 138.[29] It did not have a printed estimate, but was marked "Refer Department", indicating the potential value of the object.[30] Eventually, the Beneman commode was sold for 151,200 pounds, the top price achieved in that auction comprising 147 lots.[31]

After the fall of the Berlin Wall, the Beneman commode was put up for auction again, this time at Christie's New York on 21 October 1997 where it was sold as lot 282 for USD 937,500.[32] The auction catalogues provided the reader with information about the commode including its description and its references in the literature. In terms of the object biography, the main focus was put on its provenance in the 18th century, also mentioning the counterpart in the Louvre. Furthermore, the stamps and the inventory numbers were mentioned. Inside of the central drawer there was the inventory number of the Märkisches Museum *I.52, 321* applied in white paint.[33] Christie's catalogue from 1997 also mentioned the following inventory numbers: "(…) inscribed twice on the top and back in ink *M38554* and *Rb872*, and with a paper label inscribed *I/132/ Ber…* (…)".[34] Finally, the Christie's catalogue from 1986 noted that the slab of the sold commode had been later eared and moulded.[35]

Last but not least, at the Christie's sale of 1997 the Beneman commode was sold as the property of the American collector Nancy Richardson. A picture in the September issue of the *New York Magazine* in 1995 supports this indication.[36] It would be interesting to know where the commode is today and whether the current owner knows about its exceptional history.

The itinerary of the Beneman commode, which is non-linear and particularly subject to historical vicissitudes, as well as to political changes, illustrates the need to investigate the question of the terms used to characterize this journey. The concept of looting does not encompass the appropriation of this object at different stages of its history, and the consequences on the perception of this commode and its value. Talking about looting adopts the point of view of the French CRA in 1947, but when studying the history of the commode during the Second World War, the situation is not at all clear. Its sale in 1986 also prompts us to think on how to define in which context it took place.

The study case also clearly illustrated the interface between provenance research, the art market, and museum studies on one hand and the close connection between different appropriation contexts on another. It also raises the question how the links between existing subject areas of the provenance research could be systematically explored and extended.

Margaux Dumas, Xenia Schiemann
Margaux Dumas promoviert an der Université de Paris und an der Technischen Universität Berlin zum Thema „The looting of furniture during the Second World War and its restitution (1940–1957)".
Xenia Schiemann ist wissenschaftliche Mitarbeiterin an der Technischen Universität Berlin und forscht zu den Aktivitäten der Kunst und Antiquitäten GmbH auf dem westlichen Kunstmarkt.

Der Text geht auf einen Vortrag der Herbstkonferenz am 30. November 2020 zurück, der von den Autorinnen angepasst wurde.

Förderung des Grundlagenprojekts „Die Geschäftsbeziehungen zwischen der Kunst und Antiquitäten GmbH der DDR und westlichen Auktionshäusern im Zeitraum von 1973 bis 1990: Mechanismen – Netzwerke – Objekte" von Dezember 2020 bis November 2022.

Endnoten

1 The authors would like to thank kindly Elizabeth Bartel, Andreas Bernhard and Aileen Laska from the Stiftung Stadtmuseum Berlin, Alain Prévet and Elsa Vernier-Lopin from the Mission de recherche et de restitution des biens culturels spoliés entre 1933 et 1945, Anne Labourdette, Marie-Hélène de Ribou, Marie-Cécile Bardoz and Frédéric Dassas at the Musée du Louvre as well Bénédicte Savoy from the Technische Universität Berlin for the valuable comments.

2 Inventory Number OA 5504, see Louvre's website http://cartelen.louvre.fr/cartelen/visite?srv=car_not&idNotice=16236 (23.12.2020).

3 Pierre Verlet, Le mobilier royal français, Tome 1 Meubles de la Couronne conservés en France (Paris, 1990) p. 45.

4 Ibid. p. 45.

5 Rétrospective du meuble du XVIIème siècle à nos jours, exhibition catalogue, Louvre (Paris, 1933).

6 André Theunissen, Meubles et sièges du XVIIIème siècles, menuisiers, ébénistes, marques, plans et ornementation de leurs œuvres (Paris, 1934) p. 8.

7 Archives Nationales, Z/6NL/105, Dossier Stavenow Cassagne.

8 Archives de Paris, 112W6, Dossier Jansson.

9 Archives Nationales, Z/6NL/105, Dossier Stavenow Cassagne.

10 Ibid.

11 Archives Nationales, F/12/9632, Dossier Touzain.

12 Archives Nationales, Z/6NL/105, Dossier Stavenow Cassagne.

13 Archives diplomatiques, 209SUP406, Dossier Jansson.

14 Répertoire des biens spoliés en France durant la guerre 1939–1945, Tome 4 Argenterie, Céramique, Objets précieux (Paris, 1948) p. 92, "A piece of furniture. (Estampille de Benéman), in mahogany, solid doors with gilt bronze rods, decorated with bronzes attributed to Gouthière. (The counterpart of this piece of furniture is in the Louvre Museum)." (free translation)

15 Archives diplomatiques, 209SUP406, Dossier Jansson.

16 Archives Nationales, 20150044/99.

17 On more details on the Reichsbank furniture at the Märkisches Museum see Andreas Bernhard, Eine mysteriöse Überweisung des Finanzministeriums, in: Andreas Bernhard, Verschlungene Wege – Sammlungsobjekte und ihre Geschichte, edt. by Paul Spies/Martina Weinland/Stadtmuseum Berlin (Berlin, 2018) p. 48–63.

18 Egon and Waldemar Hessling (eds.), Die Louis XVI. Möbel des Louvre (Berlin, 1912) p. 12, plate XIII.

19 Dimensions of the marble slab in the Stiftung Stadtmuseum Berlin: width max. 164,5 cm, depth 66 cm; in the Louvre: width max. 165,5 cm, depth max. 67,5 cm.

20 Decree No. 4/73 of 18 January 1973 by the President of the Council of Ministers of the GDR, in: BT-Drucksache 12/4500, document 2, p. 81–85,

http://dip21.bundestag.de/dip21/btd/12/045/1204500.pdf (23.12.2020); Partnership Agreement of the 20 February 1973, in: ibid., document 3, p. 86–91.

[21] Instruction No. 55/73 on the transfer of export tasks from the foreign trade company Buch-Export to Kunst und Antiquitäten GmbH of 10 December 1973, in: ibid., document 6, p. 99–102.

[22] Ibid., p. 25–28; Ulf Bischof, Die Kunst und Antiquitäten GmbH im Bereich Kommerzielle Koordinierung (Berlin, 2003), p. 366–386.

[23] Jörn Grabowski: In Ermangelung von Valuta – Kunst gegen Kunst. Zur Erwerbung des „Geblendeten Simson" von Lovis Corinth aus den Quellen des Zentralarchivs der Staatlichen Museen zu Berlin, in: Jörn Grabowski, Leitbilder einer Nation. Zur Geschichte der Berliner Nationalgalerie, ed. by Petra Winter for the Zentralarchiv – Staatliche Museen zu Berlin (Köln/ Weimar/ Wien, 2015) p. 253–271.

[24] Op.cit. BT-Drucksache 12/4500, p. 29-30; on the exchange agreement between the Märkisches Museum and the Kunst und Antiquitäten GmbH of 12 November 1986 see BArch DL 210/1567, BArch DL 210/1891.

[25] On the business relations between both firms, see Xenia Schiemann: Die Geschäftsbeziehungen zwischen der Kunst und Antiquitäten GmbH der DDR und dem Londoner Auktionshaus Christie's (Teil I), KUR – Kunst und Recht, Journal für Kunstrecht, Urheberrecht und Kulturpolitik, 2 (2020) p. 49–54; Xenia Schiemann: Die Geschäftsbeziehungen zwischen der Kunst und Antiquitäten GmbH der DDR und dem Londoner Auktionshaus Christie's (Teil II), KUR – Kunst und Recht, Journal für Kunstrecht, Urheberrecht und Kulturpolitik, 3/4 (2020) p. 77–81.

[26] Regulation on the State Museum Fund of the German Democratic Republic of 12 April 1978, § 5 (2), in: op.cit. BT-Drucksache 12/4500, document 25, p. 195–198.

[27] Op.cit. Bischof p. 343.

[28] The Arts of France, Christie's New York, 21 October 1997, lot 282, p. 370.

[29] Fine French Furniture, Objects of Art and Carpets, Christie's London, 3 July 1986, lot 138 "A Louis XVI Ormolu-Mounted Mahogany Breakfront Commode", p. 136–137, plate 138.

[30] Ibid., p. 136.

[31] Ibid., Price List.

[32] Op.cit. Christie's New York, 21 October 1997, lot 282 "A Royal Louis XVI Ormolu and Patinated Bronze-Mounted Mahogany Commode", p. 370, plate 282; see Christie's website https://www.christies.com/lotfinder/ lot/a-royal-louis-xvi-ormolu-and-patinated-314497-details.aspx?from= salesummery&intObjectID=314497&sid=7ec353b9-6412-4a73-95ba-2dd162aae009 (23.12.2020).

[33] Op.cit. Christie's New York, 21 October 1997, p. 370.

34 Ibid. The Reichsbank inventory number "Rb872" in the auction catalogue differs from the number on the slab "Rb 812" which could be from any typing mistake.

35 Op.cit. Christie's London, 3 July 1986, p. 136. Furthermore, according to the museum's entry, the stamp of G. Beneman was visible on four corners on the corpus under the marble slab. See also Ibid. and Op.cit. Christie's New York, 21 October 1997, p. 370.

36 David France, Mrs Richardson regrets, in: New York Magazine, 4 September 1995, p. 22–27, photo, p. 22–23.

Von Pralinenformen und Perkussionsflinten
Objekte der Provenienz Kunst und Antiquitäten GmbH in den Sammlungen des Deutschen Historischen Museums

Christopher Jütte

Of chocolate molds and percussion guns. Objects of provenance Kunst und Antiquitäten GmbH in the collections of the Deutsches Historisches Museum Founded in East Berlin in 1952, the Museum für Deutsche Geschichte (MfDG, Museum of German History) was the central history museum of the German Democratic Republic. Towards the end of its existence in 1990, the museum had about 450,000 individual objects—about 600 of which have a connection to Kunst und Antiquitäten GmbH (Art and Antiques Ltd., abbreviated as KuA). In the course of German unification, the holdings of the MfDG were transferred to the Deutsches Historisches Museum (DHM, German Historical Museum). The KuA pieces can be found in almost all of the DHM's individual collections. They include small pieces of furniture, paintings, prints, toys, posters, documents, medals and historical weapons. The MfDG purchased the majority of the objects in 1990 from the liquidation assets of the KuA. By the end of the 1980s, the DHM, which was founded in 1987, had also acquired museum objects that could be linked to the KuA. These purchases were made through a West Berlin firm that represented the KuA in transactions in the Federal Republic and West Berlin.

The MfDG already had relations with the KuA in the 1980s. These are evidenced by a 1983 barter transaction: The company gave the museum five historic hunting rifles in exchange for a 16th century wheel lock rifle. The trail of the five hunting rifles can be traced back to a private collection in Suhl. The findings so far indicate that the previous owner was forced to sell his valuable collection with the help of a contrived tax procedure. In many cases, this practice gave the KuA access to valuable art objects that were exported for foreign currency.

Das 1952 in Ost-Berlin gegründete Museum für Deutsche Geschichte (MfDG) war das zentrale Geschichtsmuseum der Deutschen Demokratischen Republik. 🖉 Gegen Ende seines Bestehens, im Jahr 1990, verfügte das Museum über ca. 450.000 Einzelobjekte – etwa 600 davon weisen eine Verbindung zur Kunst und Antiquitäten GmbH (KuA) auf. Im Zuge der Deutschen Einheit wurden die Bestände des MfDG an das Deutsche Historische Museum (DHM) übertragen. Die Erforschung der Objekte mit Bezug zur KuA ist eine von vielen Herausforderungen, vor denen die SBZ/DDR-spezifische Provenienzforschung am DHM steht.

🖉 *Vgl. den Beitrag von Doris Kachel, S. 45.*

224

Der DDR-Außenhandelsbetrieb Kunst und Antiquitäten GmbH wurde durch einen Ministerratsbeschluss vom 18. Januar 1973 gegründet und war eine Firma des Bereichs Kommerzielle Koordinierung (KoKo). Zweck der Gründung war es, Antiquitäten und Gebrauchtwaren aus der DDR ins westliche Ausland zu exportieren und damit Devisen zu erwirtschaften.[1] Die zum Verkauf bestimmten Antiquitäten stammten nicht selten aus problematischen Quellen. So profitierte die KuA in vielen Fällen von konstruierten Steuerverfahren, die die Voreigentümer:innen mit fingierten Steuerschulden zum Verkauf ihrer privaten Sammlungen zwangen.

Die rund 600 KuA-Stücke, die heute über die Museumsdatenbank nachweisbar sind, finden sich in fast allen Einzelsammlungen des DHM. Es handelt sich um Kleinmöbel, Gemälde, Druckgrafik, Spielwaren, Plakate, Dokumente, Medaillen und historische Waffen. Der Großteil der Objekte stammt aus der Liquidationsmasse der KuA. Die GmbH beendete im November 1989 ihre Exporttätigkeit, Ende Januar 1990 begann die Liquidation.[2] Wie andere Museen der DDR auch machte das MfDG von seinem Vorkaufsrecht Gebrauch und erwarb im Frühjahr 1990 zahlreiche Stücke aus den KuA-Depots in Mühlenbeck.[3]

Manche dieser Objekte gelangten in den 1990er-Jahren – nun unter der Hoheit des DHM – wiederum aus den Museumsdepots in den Kunsthandel und dadurch erneut in Umlauf. So wurde beispielsweise eine „klassizistische Kommode"[4], die für immerhin 15.000 Mark von der KuA angekauft worden war, an ein süddeutsches Auktionshaus abgegeben. In einem anderen Fall wurde ein auf etwa 1900 datiertes Vertiko[5] aus den Beständen des DHM ausgesondert und an einen Berliner Kunsthändler abgetreten. Die Aufnahme in eine Museumssammlung musste demnach nicht zwingend die Endstation für Objekte der Provenienz „Kunst und Antiquitäten GmbH" bedeuten. Die beiden angeführten Möbelstücke unterstreichen, dass die Streuung dieser potenziell belasteten Objekte auch nach Ende der DDR nicht beendet war und es vermutlich noch immer nicht ist.

Zudem erwarb das 1987 in West-Berlin gegründete DHM selbst Ende der 1980er-Jahre Objekte, die mit der KuA in Verbindung zu bringen sind. Es handelte sich hierbei um 226 Stücke, die sich in der Hauptsache auf die heutigen DHM-Sammlungen Alltagskultur und Dokumente verteilen.

Vgl. den Beitrag von Bernd Isphording, S. 234.

Vgl. den Beitrag von Julia M. Wendl, S. 157.

*Blick in ein Regal der KuA-Verkaufs-
und Lagerhallen in Mühlenbeck,
Aufnahme 1987, BStU, MfS,
AU 10611/87, Bl. 150-a*

Zu den erworbenen Objekten zählen unter anderem Formen zur Herstellung von Pralinen, Blechdosen für Kaffee und Zigaretten sowie Schaufensterfigurinen. Verkauft wurden sie über die Firma Wiegand Consulting, kurz WiCon. Diese hatte ihren Sitz in West-Berlin und übernahm spätestens 1987 die Vertretung der KuA bei Geschäften in der Bundesrepublik und in West-Berlin.[6] Die Sammlungen des DHM erlauben somit Einblicke in die gesamtdeutsche Dimension der Provenienz Kunst und Antiquitäten GmbH, denn innerhalb der heutigen Bestände befinden sich sowohl Objekte, die noch in der DDR über die KuA ins MfDG gelangten, als auch solche Realien, die von der GmbH in die Bundesrepublik und nach West-Berlin exportiert worden sind. Ein Tauschgeschäft zwischen der KuA und dem MfDG soll im Folgenden exemplarisch untersucht werden.

Fünf gegen eins – ein Tauschgeschäft zwischen der Kunst und Antiquitäten GmbH und dem Museum für Deutsche Geschichte

Ende 1983 wurden in der Militariasammlung des MfDG fünf historische Jagdgewehre inventarisiert.[7] In der Spalte „Vorbesitzer oder Einlieferer" des Inventarbuches findet sich zum einen der Verweis auf die „Kunst und Antiquitäten GmbH, 1080 Berlin, Französische Straße 15". Zum anderen nennt der Eintrag noch eine Vorprovenienz: eine Suhler Privatsammlung, und es wird ein Tauschvertrag vom 1. Dezember 1983 erwähnt.

Die fünf historischen Jagdgewehre, die das MfDG im Tausch von der KuA erhielt

Tauschvertrag

zwischen dem Museum für Deutsche Geschichte
1020 Berlin
Unter den Linden 2

und der Kunst und Antiquitäten GmbH
1080 Berlin
Französische Straße 15

Das Museum für Deutsche Geschichte übergibt der Kunst und Antiquitäten GmbH ein Radschloßgewehr Kursachsen, Dresden 1589.

Beschreibung desselben:

Auf dem kantigen Laufteil sind die Jahreszahl 1589 und am Laufende die Buchstaben "AW" des Laufschmiedes eingeschlagen.
Radschloß mit Druckknopf für Pfannenschieber und mit Hebesicherung.
Vergoldete Raddecke aus Messing mit Kursächsischem Wappen.
Marke des Schloßmachers eine Lilie.
Ganze Schäftung mit gravierten und eingeschwärzten Beineinlagen: Adler, Fabeltiere, behelmter Männerkopf, groteske Köpfe, Randleisten, Ladestock aus Holz. Abzug mit Schraube zur Feineinstellung; gefingerten Abzugbügel aus Eisen. Das Radschloßgewehr gehörte zur Ausrüstung der Kursächsischen Trabanten (Heilgarde) des Kurfürsten, Christian des I. W 59/1143

Das Museum für Deutsche Geschichte erhält dafür von der Kunst und Antiquitäten GmbH 5 Gewehre.

1. Luftbüchse mit Mehrladeeinrichtung, Italien 18. Jahrhundert, sign.
 Giradoni Inuenit et tecit BR 155/2

2. Doppelläufige Perkussionsflinte, Beschlagteile graviert, sign. Krauße
 Herzberg 18. Jahrhundert Hau 068/10

3. Steinschloßflinte, punzierter kantiger Lauf, sign. C. Müller,
 Halberstadt 18. Jahrhundert Hau 068/2

4. Doppelläufige Perkussionsflinte mit goldtauschiertem Lauf und geschnitztem
 Schaft, Jagdszenen sign. F. Kettner Anfang 19. Jahrhundert Hau 068/8

5. Doppelläufige Steinschloßflinte, sign. Preuost Arquebusier du Roi
 et de Monssieur a Versailles 18. Jahrhundert SB 9/162/22

Als Grundbetrag des Tausches wurden 30.000,-- Mark zugrundegelegt.
Der Verkaufswert der fünft Gewehre der Kunst und Antiquitäten GmbH entspricht dieser Summe.

- 2 -

Seite 1 des Tauschvertrags zwischen der KuA und dem MfDG vom 1. Dezember 1983

Ob es sich bei dem Aufkleber auf dem Kolben der Perkussionsflinte um ein Etikett der KuA mit einem Hinweis auf das Mühlenbecker Lager handelt, konnte noch nicht aufgelöst werden.

In den Unterlagen der heutigen Militariasammlung existiert ein Exemplar dieses Vertrages.[8] Das Dokument listet die fünf Gewehre auf, die das MfDG erhielt. Neben der Benennung und kurzen Beschreibungen der einzelnen Waffen sind auf dem Dokument auch Nummern aufgeführt, bei denen es sich vermutlich um die Inventar- beziehungsweise Ankaufsnummern der KuA handelt. So ist bei einer doppelläufigen Perkussionsflinte die Nummer „Hau 068/10" verzeichnet.[9] Auf dem Kolben dieser Waffe haben sich die Reste eines rechteckigen, weißen Aufklebers erhalten. Die darauf noch lesbaren Ziffern „068" könnten auf die Nummer auf dem Vertrag hindeuten. Weiterhin findet sich auf dem Aufkleber ein großes „A" in einem Kreis sowie das Kürzel „Mü".

Der Vertrag beschreibt auch ausführlich das Objekt, das das Museum abgab. Es handelte sich um ein wertvolles Radschlossgewehr[10] aus dem Jahr 1589. Die ursprünglich kursächsische Waffe gehörte zur Ausrüstung der Trabantengarde des Kurfürsten Christian I. (1560–1591). Der Tauschwert des reich verzierten Gewehres lag laut Vertrag bei 30.000 Mark. Festgelegt wurde der Wert durch Sachverständige der KuA auf der einen und den Experten für historische Waffen des MfDG auf der anderen Seite.

Folgt man dem Inventarbucheintrag und der Spur in Richtung Suhl, so stößt man bei der Recherche auf eine Akte des Finanzamtes Suhl, die sich heute im Staatsarchiv Meiningen befindet und die über die Voreigentümer:innen der Gewehre Aufschluss gibt.[11] Die von der KuA an das MfDG übergebenen Gewehre waren bis Ende der 1960er-Jahre im Privateigentum der Familie eines Gewehrfabrikanten, der auch eine kleine Fabrik in der Waffenstadt Suhl betrieb. Nach den bisherigen Erkenntnissen übertrug die letzte in Suhl ansässige Erbin Stücke aus der Sammlung an einen privaten Waffensammler. Dieser sah sich in den 1970er-Jahren mit den Suhler Steuerbehörden konfrontiert. Dem Verfahren zugrunde lag die aus Sicht der Behörde ungeklärte Eigentumsübertragung von der Erbin an den Sammler, da dieser den Kauf der Waffen nicht zufriedenstellend belegen konnte. Der Sammler gab an, Teile der Sammlung gekauft zu haben, die Steuerfahndung ging hingegen von einer Schenkung aus.

Im September 1975 wurde der Sammler von den Behörden aufgefordert, den Wert seiner Waffen in einer Vermögenserklärung anzugeben, da eventuell Vermögenssteuer anfallen könnte.[12]

Zusammen mit der Erklärung reichte er eine Aufstellung seiner Sammlung samt einer von ihm vorgenommenen Bewertung derselben ein. Auf dieser Liste finden sich auch vier der Gewehre, die später über die KuA ans MfDG gelangten.[13] Den Gesamtwert seiner Stücke gab er mit 48.980 Mark an.[14]

Die Steuerbehörden der Stadt Suhl beurteilten den veranschlagten Wert als zu niedrig[15] und beauftragten über die Vermittlung des Waffenmuseums in Suhl und mithilfe des Museumsrates der DDR zwei Fachgutachter, die die Sammlung einschätzen sollten.[16] Einer der Gutachter war der bereits oben erwähnte Waffenexperte des MfDG, der zweite kam vom Armeemuseum Dresden. Sie betonten den besonderen finanziellen und kulturellen Wert der Sammlung.[17] Sie gehöre zu den „größten und kostbarsten in Privathand befindlichen Schußgeräte-Sammlungen der DDR" und sie bescheinigten ihr einen „außerordentlichen kulturhistorischen, technikgeschichtlichen und materiellen Wert".[18] Die beiden Experten legten für die Sammlung einen Gesamtwert von 522.200 Mark fest.[19] Die Unterschiede in der Bewertung des Sammlers und der Gutachter können gut am Beispiel eines Steinschlossgewehrs des 18. Jahrhunderts nachvollzogen werden, das zu den Waffen gehört, die sich heute im DHM befinden.[20] Obwohl sich das Gewehr zum Zeitpunkt der Bewertung nicht im besten Zustand befand, taxierten es die Gutachter 1976 auf einen Wert von 5.000 Mark. Der Sammler selbst hatte 1975 einen Betrag von 150 Mark als angemessen angesehen.[21]

1977 wurde durch die Abteilung Finanzen des Bezirkes Suhl ein weiteres Gutachten beim Staatlichen Kunsthandel der DDR in Auftrag gegeben. Dieses erstellte der Sekretär der Kommission zum Schutz des nationalen Kulturbesitzes.[22] Das Gutachten diente „der Ermittlung des Wertes der einzelnen Stücke im Jahre 1969, 1975 und im Jahre 1977". Damit sollten die Werte der Waffen für das Jahr des Erwerbs, zum Zeitpunkt der Steuererklärung des Sammlers und zum Zeitpunkt des Gutachtens festgelegt werden. Inhaltlich wurde darin dem Gutachten von 1976 entsprochen. Bei den Preisen ergaben sich jedoch Unterschiede. Das bereits genannte Steinschlossgewehr beispielsweise wird für das Jahr 1969 mit 1.500 Mark bewertet, für 1975 mit 4.500 Mark und für 1977 mit 6.000 Mark taxiert.[23] Diese Preise spiegelten die geschätzten Verkaufspreise des Staatlichen Kunsthandels wider. Da das Gut-

⊘ Verordnung zum Schutze des
deutschen Kunstbesitzes und
des Besitzes an wissenschaftlichen
Dokumenten und Materialien vom
2. April 1953

achten der Sammlung jedoch nationale und damit museale Bedeutung zuschrieb, sollte dem Staat gemäß Kunstschutzverordnung von 1953⊘ das Vorkaufsrecht eingeräumt werden. Der Ankaufspreis würde dem des Staatlichen Kunsthandels, das heißt 60 Prozent des geschätzten Verkaufspreises, entsprechen.[24] Außerdem sollte eine Ausfuhr der Sammlung untersagt werden.

Trotz wiederholt eingelegter Beschwerde des Sammlers gegen den Steuerbescheid blieb die veranschlagte Steuerschuld in Höhe von rund 60.000 Mark bestehen, die sich aus angenommenen Rückständen aus der Schenkungs- und der Vermögenssteuer zusammensetzte. Dem Sammler wurde außerdem zur Last gelegt, er habe die Steuern vorsätzlich nicht gezahlt und seine Sammlung wissentlich zu gering bewertet.[25]

Ab diesem Zeitpunkt weist die Überlieferung Lücken auf. Eine Beschlagnahmung der Waffen scheint nicht erfolgt zu sein. Stattdessen wurde der Sammler offenbar angehalten, die Sammlung zur Begleichung der Steuerschuld zu veräußern. Hierbei stieß er jedoch auf Probleme, da weder das Waffenmuseum Suhl die Objekte übernehmen noch der Staatliche Kunsthandel sie ankaufen wollte. Ob die KuA oder das Ministerium für Staatssicherheit (MfS) zu diesem Zeitpunkt in den Prozess involviert waren, ließ sich bisher nicht sicher nachweisen. Fest steht jedoch, dass sich die Waffen spätestens 1983 in den Depots der KuA befunden haben und danach ihren Weg in die Bestände des MfDG fanden. Vermutlich ist die Nennung der Vorprovenienz im Inventarbuch auf den Waffenexperten des MfDG zurückzuführen, der an der Bewertung der Waffen beteiligt war, denn er nahm sie im Dezember 1983 für das MfDG entgegen.

Was mit der zum Tausch herausgegebenen Radschlossbüchse geschah, muss zunächst noch offenbleiben. Aus einer Aktennotiz der KuA, die im Bundesarchiv verwahrt wird, geht hervor, dass die Waffe vermutlich nicht ins westliche Ausland verkauft worden ist.[26] Demnach übergab die KuA sie für „Repräsentationszwecke" an das Ministerium für Außenhandel (MAH). Das MAH wiederum überließ der KuA ein Gemälde von Werner Tübke. Dieses wurde dann an einen Hamburger Privatsammler veräußert, zu einem Preis von 30.000 DM.[27] Die Verwertung des Gewehres erfolgte also indirekt. Was in diesem konkreten Fall mit „Repräsentationszwecken" gemeint war, konnte bisher noch nicht aufgeklärt

werden. Bekannt ist jedoch, dass KuA-Experte Siegfried Brach-
haus in manchen Fällen für die Beschaffung von Geschenken für
hohe SED-Funktionäre oder Staatsgäste verantwortlich war. So
stellte der Untersuchungsausschuss des 12. Deutschen Bundes-
tages, der sich 1993 mit der Kunst und Antiquitäten GmbH be-
fasste, fest, dass Angestellte der KuA auf Weisung des Leiters der
KoKo, Alexander Schalck-Golodkowski, Geschenke für Staatsgäste
beschafften.[28] In seiner Aussage vor dem Untersuchungsausschuss
hat Siegfried Brachhaus ausgeführt, „dass er den Auftrag hatte, in-
nerhalb von zwei Tagen eine Barlach-Plastik als Geschenk für den
Staatsgast Bundeskanzler Helmut Schmidt zu besorgen".[29] Weiter-
hin habe er zu einem früheren Zeitpunkt „ein bedeutendes Ge-
wehr als Staatspräsent für den französischen Staatspräsidenten de
Gaulle besorgt".[30] Es ist allerdings auszuschließen, dass die Waffe
aus dem MfDG jene ist, die de Gaulle als Geschenk erhalten hat,
denn dieser war bereits 1970 verstorben. Der dahinterstehende
Vorgang könnte jedoch von ähnlicher Art gewesen sein.

Christopher Jütte
*Christopher Jütte ist wissenschaftlicher Mitarbeiter für Provenienz-
forschung am Deutschen Historischen Museum in Berlin.*

Endnoten

[1] Vgl. Anne Bahlmann, Falco Hübner, Bernd Isphording, Stefanie Klüh: Betriebe des Bereichs Kommerzielle Koordinierung. Teilbestand Kunst und Antiquitäten GmbH (1974–2002). Bestand DL, Findbücher zu den Beständen des Bundesarchivs, Berlin 2017, S. 5. https://www.bundesarchiv.de/DE/Content/Downloads/Meldungen/20180601-kua-findbucheinleitung.pdf?__blob=publicationFile, (9.12.2020).

[2] Ulf Bischof: Die Kunst und Antiquitäten GmbH im Bereich Kommerzielle Koordinierung, Berlin 2003, S. 500.

[3] Ebd.

[4] Inventarnummer MK 90/255.

[5] Inventarnummer MK 90/257.

[6] Information über die Durchführung von Verkäufen mit Kunden vom 6. April 1987, Bundesarchiv, Bestand DL 210, BArch DL 210/2319, o. Bl.

[7] Inventarnummern W 83/14–18.

[8] Tauschvertrag zwischen dem Museum für Deutsche Geschichte und der Kunst und Antiquitäten GmbH vom 1. Dezember 1983, Deutsches Historisches Museum, Militariasammlung. Das Gegenstück dazu findet sich im Bundesarchiv im Bestand DL 210 unter der Signatur DL 210/1891, o. Bl.

[9] Die Datierung der Perkussionsflinte unter Pos. 2 auf dem Vertrag scheint falsch. In der Museumsdatenbank ist sie auf 1840 bis 1850 datiert. S. DHM Inventarnummer W 83/17.

[10] Die abgegebene Waffe trug die Inventarnummer W 59/1183.

[11] Landesarchiv Thüringen – Staatsarchiv Meiningen, Bestand 4-82-525 Finanzamt Suhl, Nr. 9189

[12] Schreiben des Referatsleiters Steuern der Stadt Suhl, 4.9.1975, LA Th – StA Meiningen, 4-82-525, Nr. 9189, Bl. 50.

[13] Kontrollliste der Vorderladerwaffen, 7. 10.1975, LA Th – StA Meiningen, Bestand 4-82-525, Nr. 9189, Bl. 52–55. Die Waffen, die an das MfDG gegeben wurden, tragen auf der Liste die laufenden Nummern 6, 7, 19 und 26.

[14] Schreiben des Rates der Stadt Suhl an den Sammler, 10.2.1976, LA Th – StA Meiningen, 4-82-525, Nr. 9189, Bl. 60.

[15] Ebd.

[16] Schreiben des Waffenmuseums Suhl an den Rat der Stadt Suhl, 19.12.1976, LA Th – StA Meiningen, 4-82-525, Nr. 9189, Bl. 59.

[17] Aktenvermerk über die Besichtigung der Waffensammlung, 8.4.1976, LA Th – StA Meiningen, 4-82-525, Nr. 9189, Bl. 83–85.

[18] Gutachten über die Waffensammlung, 30.4.1976, LA Th – StA Meiningen, 4-82-525, Nr. 9189, Bl. 88–106, hier Bl. 89.

[19] Ebd., Bl. 90.

[20] Die Waffe trägt die Inventarnummer W 83/16.

[21] Ebd., Bl. 92. Das Gewehr trägt auf der Liste die laufende Nummer 07.

[22] Gutachten des Staatlichen Kunsthandels zur Waffensammlung, 28.9.1977, LA Th – StA Meiningen, 4-82-525, Nr. 9189, o.Bl.

23 Ebd., o. Bl.

24 Ebd., o. Bl.

25 Abschlussprotokoll, 19.11.1977, LA Th – StA Meiningen, 4-82-525, Nr. 9189, Bl. 166.

26 Schreiben von Joachim Farken an die Buchhaltung über das Tauschgeschäft der KuA mit dem MfDG, 4. 1.1984, Bundesarchiv, Bestand DL 210, DL 210/1891, o. Bl.

27 Ebd.

28 Dritte Beschlussempfehlung und dritter Teilbericht des 1. Untersuchungsausschusses nach Art. 44 GG des 12. Deutschen Bundestages, BT-Drucksache 12/4500, Bonn 1993, S. 53 f. http://dip21.bundestag.de/dip21/btd/12/045/1204500.pdf , (28.1.2021).

29 Ebd.

30 Ebd., S. 54.

Die Kunst und Antiquitäten GmbH im Spiegel ihrer archivischen Überlieferung
Möglichkeiten und Grenzen der Provenienzforschung

Bernd Isphording

Art and Antiques Ltd. in the mirror of its archival records

Possibilities and limits of provenance research

From 1973 to 1989, Kunst und Antiquitäten GmbH (Art and Antiques Ltd., abbreviated as KuA) was the GDR's central foreign trade company for the export of cultural assets and second-hand goods of all kinds.

As a company of the Commercial Coordination Division of the GDR Ministry of Foreign Trade, its main goal was to generate foreign currency from the West for the party and state budget. KuA's business was characterized by a lack of usable supplies. It attempted to solve this problem by offering financial incentives to purchasing companies, the districts and ministries behind them, and to private individuals who consigned goods, for example by giving them a share of the foreign exchange earnings or access to western goods. But pressure was also exerted. Best known here are the fictitious tax proceedings in cooperation with state security and tax authorities, which deprived art collectors and private dealers of their collections and stocks of goods. The KuA exported these mainly via its central warehouse in Mühlenbeck near Berlin to the Federal Republic and other western countries.

The article presents the business methods of the KuA on the basis of its documents preserved in the Federal Archives in Berlin and takes a look at possible approaches and problems that arise for provenance researchers in the search for the origin and whereabouts of art objects with these documents. Scarce designations and the use of an internal KuA code system of sticker numbers make many searches in the KuA holdings extremely time-consuming. Only in the case of high-quality paintings, as the example of a painting by Wilhelm Riefstahl shows, are there relatively good research possibilities.

KUNST UND ANTIQUITÄTEN GMBH

Internationale Gesellschaft für den Export und Import von Kunstgegenständen und Antiquitäten

DDR – 1080 Berlin
Französische Str. 15
Tel: 2 20 26 71
Telegramm: Kunst Berlin
Telex: 112 962

Briefkopf der KuA auf Briefpapier von 1981, BArch DL 210/507

Die Kunst und Antiquitäten GmbH – kurz „KuA" oder nach dem Standort ihres Hauptlagers auch nur „Mühlenbeck" – wurde in den letzten Jahrzehnten zum Sinnbild für den Kulturgutverlust durch Kunst- und Antiquitätenexporte aus der DDR und die Übervorteilung und gewaltsame Enteignung von Kunstsammlern und -händlern in der DDR.

1973 vom Bereich Kommerzielle Koordinierung (KoKo) gegründet, diente die KuA, wie alle KoKo-Betriebe, vor allem dem schnellen Erwirtschaften von Westdevisen für die grauen Kassen

234

von Staat und Partei. Der Bereich KoKo konnte dabei außerhalb des Regelwerks der Planwirtschaft agieren.[1] Für die KuA bedeutete dies vor allem weitgehende Freiheit von der in der DDR sonst so strikt gehandhabten Devisenkontrolle sowie von der Exportüberwachung durch Zoll und Kulturgutschutz. Bis zur Einstellung ihrer Exporte 1989 erwirtschaftete die KuA einen Gesamtumsatz von rund 400 Mio. DM.[2]

Kulturgutexporte hatte die DDR schon vor 1973 durchgeführt. Zentral waren hierbei die zeitlich aufeinanderfolgenden Unternehmen des Staatlichen Kunsthandels⌀ gewesen[3]. Sie organisierten für westliche Händler begleitete Einkaufstouren durch die Antiquitätengeschäfte und Kunsthandlungen der DDR. Die Exportformalitäten wurden dann von einem Außenhandelsunternehmen, vor allem dem AHB⌀ Buchexport, abgewickelt.[4]

Mit der Gründung der KuA strebte der Bereich KoKo die Zentralisierung und Intensivierung des Exports von Kunstgegenständen und Antiquitäten an. Ziel der Zentralisierung war es, den Schwarz-

⌀ *Vgl. Beiträge von Thomas Widera, S. 171, und Uwe Hartmann, S. 181.*

⌀ *Abkürzung für „Außenhandelsbetrieb"*

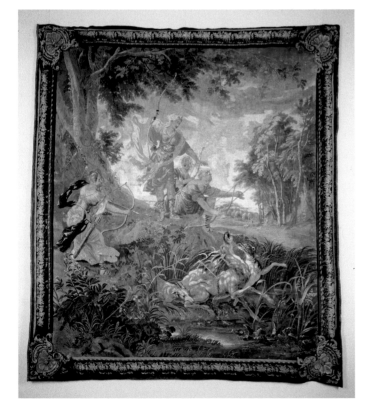

Erwerbung der Staatlichen Kunstsammlungen Dresden aus dem Antikhandel (Kath) in Pirna 1974: Wandteppich mit der Darstellung einer Jagd der Diana, Wolle in vielen Farbabstufungen in Gobelinweberei, Frankreich 1. Hälfte des 18. Jahrhunderts, 300 × 273 cm, Inv.-Nr. 40 449

handel zu unterbinden, aber auch die Begegnung von DDR-Bürgern und Besuchern aus dem westlichen Ausland zu reduzieren.[5] In Konkurrenz zu den noch bestehenden privaten Antiquitätenhandlungen nutzte die KuA vor allem staatliche Aufkaufbetriebe. Zum wichtigsten Zulieferer wurde der Antikhandel Pirna. Dieses erfolgreiche Privatunternehmen war nach Verhaftung und Abschiebung des Eigentümers Siegfried Kath zur nur formal unabhängigen Einkaufsabteilung der KuA umgestaltet worden.[6]

Die KuA hatte zwar den Export-Kundenstamm des Staatlichen Kunsthandels übernommen, konzentrierte sich aber bald auf den Großhandel und drängte andere Händler – mit Ausnahme einiger spezialisierter Kunsthandlungen für hochwertige Gemälde – aus dem Geschäft.[7] Für die Provenienzforschung heißt dies, dass zwischen Einlieferern und Endkunden eine Kette von mindestens drei bis vier Händlern zu erwarten ist.

Methoden des Ankaufs

Von Anfang an war die Beschaffung von Waren das Kernproblem der KuA. Bei ihrer Gründung hatte man an den Export aus Depotbeständen der Museen gedacht. Das scheiterte am massiven Widerstand von Museumsleuten in Ost und West.[8] Der Jahresabschlussbericht der KuA für 1973 spricht von „komplizierten Inlandsbeziehungen auch gegenüber dem Bereich des Ministeriums für Kultur". Dies habe „eine Reihe von Fortschreibungen der Konzeption notwendig gemacht".[9] Gemeint ist die Hinwendung zum Handel mit Gebrauchtwaren, der schon im Jahr der Gründung 80 Prozent des Umsatzes ausmachte.[10] Das forcierte Neubauprogramm der DDR versprach Nachschub an Möbeln, die nicht mehr in die Plattenbauwohnung passten, die anhaltende Nostalgiewelle im Westen Absatzmöglichkeiten. Es ging hier also vor allem um Trödelhandel.

Gleichzeitig drohte mit dem erfolgreichen Abschluss des Neubauprogramms das Austrocknen dieser Quelle. 1977 prognostizierte KuA-Generaldirektor Horst Schuster dies für das Jahr 1990. Schon bald expandierte die KuA deshalb in andere Bereiche wie Gaslaternen, Pflastersteine und alte Bahnschwellen. Briefmarken kamen durch Übernahme des VEB Philatelie Wermsdorf hinzu, und Ende der 1980er-Jahre stieg die KuA in den Handel mit anti-

Abkürzung für „Volkseigener Betrieb"

quarischen Büchern ein, der sie in direkte Konkurrenz zum Leipziger Zentralantiquariat der DDR treten ließ.

Doch wie sah es mit den namengebenden Bereichen Kunst und Antiquitäten aus? Zwar hatte Generaldirektor Schuster 1973 beschwichtigend festgestellt, der Bestand der Antiquitäten in der DDR sei „fix", und ein Ausverkauf müsse vermieden werden,[11] aber in Wirklichkeit kämpften die KuA und ihre Zulieferbetriebe verbissen um jedes hochwertige Stück für den Export, die Zulieferbetriebe vor allem durch intensive Akquisition.[12] Als KoKo-Firma konnte die KuA – anders als normale DDR-Betriebe – Westgeld und Westimporte gezielt als Geschäftsanreize im Ankauf nutzen. So importierte sie für ihre Inlandspartner dringend benötigte Westwaren, die diese aus sogenannten Valutaanrechten bezahlten, die sie mit ihren Lieferungen an die KuA erwirtschaftet hatten. Das Ministerium für Kultur kaufte so entspiegeltes Glas, Ballettschuhe oder Büromaterial🖉 im Westen, die Stadt Leipzig Kehrmaschinen oder die Stadt Pirna medizinisches Gerät.[13] In der Sammlerszene waren Einzelaufkäufer notdürftig getarnt als freie Sachverständige unterwegs. Von einigen sind Ankaufbelege erhalten, sodass sich die Herkunft einzelner Stücke klar nachvollziehen lässt.[14] Ankäufe bei Privatpersonen erfolgten üblicherweise gegen DDR-Mark. Ging es um besonders begehrte Ware, war die KuA allerdings bereit, Kommissionsverträge mit einer Teilzahlung in D-Mark abzuschließen oder den Tausch gegen Autos, Westfernseher oder andere Mangelware anzubieten; das waren die sogenannten Autotauschgeschäfte.[15] 🖉 Auch für diese Transaktionen sind Belege überliefert.[16]

Wer wertvollere Einzelstücke an die KuA verkaufte, weckte damit allerdings schnell den Hunger nach mehr und riskierte so den Verlust seiner ganzen Sammlung. Bekannt ist das Zusammenspiel von KuA und Steuerfahndung bei fingierten Steuerverfahren gegen Händler und Sammler, deren Besitz von Mitarbeitern der KuA oder des Antikhandels Pirna bewertet, von der KuA übernommen und exportiert wurde.[17] Eindeutig belegen lässt sich dies nur bei den Steuerverfahren. Bei Einzelankäufen hochwertiger Objekte durch Aufkäufer der KuA ist dagegen schwer abzuschätzen, ob und in welchem Maße Druck auf die Besitzer ausgeübt wurde.[18] Zeitwertfeststellungen🖉, Kaufverträge mit den zuständigen Finanzverwaltungen und Übernahmeprotokolle sind im KuA-Bestand meist als Eingangsbelege der Lagerverwaltung erhalten.

🖉 *Vgl. Beitrag von Peter Danker-Carstensen, S. 272.*

🖉 *Vgl. Eintrag „AT-Geschäfte" im Proveana-Glossar, URL https://www.proveana.de/de/glossar/*

🖉 *Es handelt sich um Listen mit dem Namen des Eigentümers, der Code-Nummer für den einzelnen Fall, Nummerierung, knapper Beschreibung und Preisschätzung der Gegenstände, die KuA-Mitarbeiter während der Beschlagnahme vor Ort erstellten.*

Hinweise auf die Kunden im Westen gibt es dagegen nur im Fall der Direktverkäufe, die in einem Ausstellungsraum in der KuA-Zentrale Mühlenbeck und vor allem in den Antiquitätengalerien der Devisenhotels stattfanden.[19]

Wege des Exports

Die Breite des Sortiments der KuA legte unterschiedliche Absatzwege für die verschiedenen Preiskategorien des Exportguts nahe. In den meisten Fällen war die Umschlagzeit mit ein bis zwei Jahren recht kurz.

Gebrauchtmöbel und Klaviere wurden in zahlreichen Behelfslagern gesammelt und den Westhändlern auf begleiteten Rundreisen angeboten – immer mit dem Ziel, möglichst das ganze Lager an eine Firma zu verkaufen. Kleinformatige und hochwertige Stücke wurden in das Zentrallager in Mühlenbeck transportiert und dort präsentiert, besonders wertvolle und vielversprechende Werke teils direkt, teils über Strohmänner bei renommierten Auktionshäusern vor allem in Großbritannien, der Bundesrepublik, den Niederlanden und der Schweiz eingereicht.[20]

Entscheidend für die Lagerhaltung und Rechnungsführung der KuA in Mühlenbeck waren sogenannte Aufklebernummern, die sich meist aus einem Buchstabenkürzel für den Ankäufer oder den Lieferbetrieb, dem Jahr und einer laufenden Nummer zusammensetzten. Diese Codierung ist bisher nur zum Teil entschlüsselt und scheint im Lauf der Jahre auch immer wieder geändert worden zu sein. Durch die Nutzung der Aufklebernummern und die meist

Ein Bogen mit fortlaufenden Aufklebernummern, BArch DL 210/1570

lfd. Nr.	Anzahl	Gegenstand	Wert
XIV/83/156	1	Fayencebierkrug, leicht def.	3.000,--
157	1	Fayencekrug, 19. Jahrhundert	1.500,--
158	1	Gemälde, Öl auf Holz, sign. H. Abeleren Frau im Trauerkleidung	500,--
159	1	Truhe	2.000,--
160	1	Gemälde, Mädchen am Teich, sign. Oskar Herrfurth, 1882, gerahmt, 63 x 64	3.500,--
161	1	Madonna mit Putto m. Resten alter Fassung	10.000,--
162	1	Reagenzkästchen	50,--
163	1	Pastell, Frau am Meer	1.500,--
164	26	Teile Porzellan, Gold und Blumendekor, z. T. def.	260,--
Werkstatt			
165	5	Taschenuhren, dav. 2 x Silber	800,--
			61.410,--
166	37	Porzellan-Apothekengefäße	740,--
167	20	Apothekenflaschen	200,--
168	1	figürliche Lampe, Bronze	500,--

Ausschnitt aus einem Übergabeprotokoll in einem Steuerverfahren von 1983, BArch DL 210/1851

Ausschnitt aus der internen Spezifikationsliste für einen Verkauf von 1984, BArch DL 210/1586

äußerst knappen Gegenstandsbeschreibungen auf den Spezifikationslisten der KuA ergibt sich für die Forschung ein Problem, denn Warenbezeichnungen und Bildtitel wurden von den Mitarbeitern immer wieder neu gebildet.

Ein Beispiel aus der Zeitwertfeststellung zu einem Steuerverfahren mit der Codierung „XIV/ 83 (+ laufende Nummer)", d. h., es handelt sich um die 14. Zeitwertfeststellung der KuA im Jahr 1983. Die Aufklebernummer „XIV/83/160" bezeichnet ein gut beschriebenes Gemälde von Oskar Herrfurth, betitelt: „Mädchen am Teich".

Verkauft wurde das Werk unter der eher mageren Bezeichnung „Gemälde Schwanenteich" ein gutes halbes Jahr nach Übernahme an eine Galerie in der Bundesrepublik. Die Verknüpfung ist allein über die Aufklebernummer möglich, die sich auf der internen, handschriftlichen Fassung der Spezifikationsliste findet, nicht jedoch auf der maschinenschriftlichen Fassung für die Käuferin.

Zur Illustration einige weitere Beispiele aus Verkäufen von Anfang 1984:

Titel bei Zeit- wertfeststellung	Wert (DDR-M)	Aufkleber- Nummer	Titel bei Verkauf	Preis (DM)
Gemälde, Karl Moor, Öl auf Leinwand, 93 × 147,4 cm, Nymphen	500	XIX 83 239	Gemälde Frauenakte in Landschaft	4025
Gemälde, Öl auf Leinwand, sign. C.E.we.M. (richtig: Ce.We.M = Carl Wilhelm Müller)	800	XIV/83 143	Gemälde Land-schaft mit Fluß	517,50
Konsolentisch, Biedermeier, Kirsch	500	XIV 83 132	Kl. Tischchen	460
Steinzeugtüllen-kanne, klein	3500	IV 83 105	Birnkrug	2530
Steinzeug-doppelhenkel-schale, mit Zinndeckel	3000	IV 83 104	Zuckergefäß	1265
Dose, Silber, Ende 19. Jahr-hundert	4000	VI 82 II 444	Zuckerdose	2875

Alle Stücke stammen aus Steuerverfahren und sind deshalb relativ exakt beschrieben, weil bei der Bewertung Spezialisten am Werk waren. Beim Verfassen der Spezifikationslisten für den Export reichten dagegen stichpunkthafte Bezeichnungen. Die Verknüpfung ist nur über die Aufklebernummer möglich. In den KuA-Akten können Recherchen nach dem Verkaufsweg einzelner Stücke deshalb sehr aufwendig sein und gegebenenfalls ergebnislos enden.

Ein glücklicher Sonderfall sind dagegen Kunstwerke, die im KuA-Schriftgut durchgehend sorgfältig beschrieben sind, wie ein Bild von Wilhelm Riefstahl, das im Oktober 1984 an den Großkunden Sabatier/Galerie pro Art in Verden an der Aller verkauft wurde[21]: Bei solchen Stücken handelt es sich meist um hochwertige

Wilhelm Riefstahl, Zigeuner vor dem Tor der Fasanerie Neustrelitz, BArch DL 210/2631

Gemälde, die für Auktionen vorgesehen waren. Auf diesen waren neben Aufklebernummern oft weitere Angaben auf einem Notizzettel befestigt, die dann in das Verkaufsschriftgut übernommen wurden.

Wilhelm Riefstahls „Zigeunergruppe vor der Orangerie Schloß Neustrelitz" liegt mit einem Verkaufspreis von 25.000 DM in der oberen Preiskategorie der KuA. Das Werk ist auf der Spezifikationsliste auffällig gut beschrieben mit Angaben zu Signatur, Titel, Rahmung, Maltechnik und Malgrund.

Die Recherche ergibt, dass das Bild mit anderen Stücken für eine Versteigerung beim Auktionshaus Koller in Zürich vorgesehen war. Einreichen sollte das Konvolut der wichtige Schweizer KoKo-Strohmann Ottokar Hermann[22] beziehungsweise dessen Firma Intrac S.A. in Lugano. Die „Zigeunergruppe" und weitere Bilder wurden ihm im November 1983 bei einem Treffen vorgeführt und Fotos der Gemälde für ein Vorgespräch mit Koller hergestellt. Diese Schwarz-Weiß-Aufnahmen sind – eine seltene Ausnahme – in der Akte enthalten; vielleicht deshalb, weil die Ware zwar in die Schweiz geliefert, dann jedoch nach Mühlenbeck zurückgeschickt wurde. Das Foto des Riefstahl-Gemäldes trägt auf der Rückseite neben der laufenden Lieferlistennummer des Bildes einen Vermerk zur Rücklieferung. Das Foto klärt zudem, dass es sich bei dem Bild um das in einem Werkverzeichnis genannte Gemälde „Zigeuner vor dem Tor der Fasanerie Neustrelitz" von 1865 handelt,[23] der KuA-Titel also irreführend war. Das Tor ist auf historischen Fotografien gut zu identifizieren.

Die handschriftliche Spezifikationsliste für den Export des Bildes in die Schweiz nennt als Aufklebernummer „AT 7/7". „AT" verweist hier auf ein Autotauschgeschäft, dessen Unterlagen erhalten sind. Die Abrechnung des AT-Vertrages 7 – undatiert, wohl von 1983 – nennt als 7. Position ein „Gemälde, Riefstahl" für 25.000 DM, daneben Möbel und ein weiteres Bild. Die KuA lieferte im Gegenzug zwei Volvo-Limousinen, von denen eine bei einem Händler in Beirut bestellt und mit belgischen Francs bezahlt wurde.

Zusammenfassung

Der KuA-Bestand des Bundesarchivs bietet mit gut 75 laufenden Metern Archivgut breite Einblicksmöglichkeiten in den Kunst- und Antiquitätenexport der DDR während der 1970er- und 1980er-Jahre. Allerdings ist der Umgang mit diesen Akten, besonders die Einzelfallrecherche, kompliziert und aufwendig – vor allem weil die KuA ein schnell getakteter Großhandel und keine klassische Kunsthandlung war, weil Devisen im Mittelpunkt des Interesses standen und nicht die Kunstgegenstände. Die Akten der KuA bieten der allmählich einsetzenden Forschung ein vielfältiges, wenn auch etwas widerspenstiges Material für neue Erkenntnisse nicht nur zu Kunsthandel und Provenienzforschung, sondern allgemein zur Gesellschafts- und Wirtschaftsgeschichte der Honecker-DDR.

Bernd Isphording
Bernd Isphording ist Projektmitarbeiter des Bundesarchivs und war u.a. an der Erschließung des Bestandes DL 210 – Kunst und Antiquitäten GmbH beteiligt.

Der Text geht auf einen Vortrag der Herbstkonferenz am 30. November 2020 zurück, der vom Autor für diesen Band angepasst wurde.

Endnoten

[1] Vgl. etwa Matthias Judt: KoKo – Mythos und Realität. Das Imperium des Alexander Schalck-Golodkowski, 2. Aufl. Berlin 2015, S. 244–247.

[2] „Perspektivische Entwicklung des AHB KuA bis 1995" (1989), in: BArch DL 210/4819.

[3] Mit „Staatlicher Kunsthandel" werden gemeinhin folgende einander ablösende Firmen bezeichnet, die sich mit der gesamten Produktpalette von Antiquitäten, bildender Kunst und Kunsthandwerk befassten: „Staatlicher Kunsthandel" (1955–1962), „VEH (= Volkseigener Handel) Moderne Kunst" (1962–1967), „VEH Antiquitäten" (1967–1974) und „VEH Bildende Kunst und Antiquitäten – Staatlicher Kunsthandel der DDR" (1974–1990).

[4] Anne Bahlmann, Falco Hübner, Bernd Isphording, Stefanie Klüh (Bearb.): Bundesarchiv. Findbuch Bestand DR 144. Staatlicher Kunsthandel der DDR „VEH Bildende Kunst und Antiquitäten", Berlin 2017, v. a. S. 3–6.

[5] Vgl. Horst Schuster, Perspektivische Entwicklung der Kunst und Antiquitäten GmbH bis 1990, S. 3, in: BArch DL 210/4819.

[6] Vgl. Ulf Bischof: Die Kunst und Antiquitäten GmbH im Bereich Kommerzielle Koordinierung, Berlin 2003, S. 92–110, sowie Christopher Nehring: Millionär in der DDR. Die deutsch-deutsche Geschichte des Kunstmillionärs Siegfried Kath, Marburg 2018.

[7] Vgl. in BArch DL 210/3136 die Beschwerde eines niederländischen Händlers, dass ihm nur Ware für 150.000 DM pro Monat angeboten werde, anderen aber für 400.000 DM; sowie in BArch DL 210/1855 die Beschwerde einer Antiquitätenhändlerin (Jahresumsatz 100.000–150.000 DM) gegen die „Neugestaltung der Außenhandelsbeziehungen" der KuA nach langer, problemloser Geschäftsbeziehung.

[8] Vgl. Bischof 2003, S. 73–80.

[9] Vgl. KuA Jahresabschlussbericht 1973, in: BArch, DL 210/1890 (Bundestagsdrucksache 12/4500, Dokument 7).

[10] Ebd.

[11] Vgl. Schuster: Perspektivische Entwicklung der Kunst und Antiquitäten GmbH bis 1990, S. 3, in: BArch DL 210/4819.

[12] Vgl. etwa die Anzeigen von Zulieferbetrieben der KuA in den Samstagsausgaben der Berliner Zeitung unter http://zefys.staatsbibliothek-berlin.de/ddr-presse/.

[13] Vgl. in BArch DL 210 den Klassifikationspunkt 30.3.2. Import.

[14] Vgl. etwa BArch DL 210/1570, 2715, 2763, 2764 u. ö.

[15] Vgl. hierzu Bernd Isphording: Archive und Provenienzforschung. Überlegungen zur archivischen Erschließung zum Zweck der Provenienzforschung am Beispiel des Teilbestandes „Kunst und Antiquitäten GmbH" im Bestand DL 210 (Betriebe des Bereichs Kommerzielle Koordinierung) des Bundesarchivs, Potsdam 2018 (https://nbn-resolving.org/urn:-nbn:de:kobv:525-21178), S. 69, S. 76–79, und Bischof 2003, S. 122–125.

[16] Vgl. etwa BArch DL 210/2439 u. 3058 (AT), DL 210/2329 u. 2457 (Kommissionen).

[17] Vgl. z. B. das Dankschreiben der Steuerfahndung Leipzig für die Überlassung von Ankaufbelegen in BArch DL 210/2715.

[18] So wies ein Vorbesitzer in einer Anfrage an den Liquidator der KuA 1991 darauf hin, dass er vor Ausreise aus der DDR 1986 von einem Stasimitarbeiter unter massiven Drohungen genötigt worden sei, Möbel weit unter Wert pro forma zu verkaufen, die bei der Auflösung der Warenbestände 1990 von der KuA an das Berliner Kunstgewerbemuseum gingen, vgl. BArch DL 210/3269.

[19] Vgl. in BArch DL 210 die Serie „Shop- bzw. Galerierechnungen".

[20] Vgl. etwa BArch DL 210/2631, 3090, 3304.

[21] Vgl. BArch DL 210/2631. Die weiteren Akten mit Bezug zum Bild sind BArch DL 210/2334, 2400 (mit Foto), 1586, 2593 und 2759 (AT-Vertrag).

[22] Vgl. zu Hermann: Richardo Tarli: Die geheimen Geschäfte der Stasi in der Schweiz. Technologieschieber und Devisenbeschaffer im Dienste von Schalck-Golodkowski, in: Gerbergasse 18, 2016/II, S. 29–32, bzw. ders.: Operationsgebiet Schweiz. Die dunklen Geschäfte der Stasi, Zürich 2015, v. a. S. 19–80.

[23] Wagner, Annelise: Der Maler Wilhelm Riefstahl (1827–1888), in: Carolinum 42, Nr. 76/77, 1977, S. 7–29, hier S. 15, 24, 26 (Nr. 139a).

„... daß auch hier wiederum die ‚Großen' die Sahne abschöpfen". Sammlungsankäufe aus dem Bestand der Kunst und Antiquitäten GmbH i. L. 1990

Alexander Sachse

"... that once again it's the major players who get to scoop up the best items"

Collection acquisitions from the inventory of Art and Antiques Ltd. (in liquidation) in 1990

In the fall of 1989, the Peaceful Revolution in the GDR also revealed the machinations of a division of the Ministry of Foreign Trade known as Kommerzielle Koordinierung. Particularly in the public spotlight were the dealings of Kunst und Antiquitäten GmbH (Art and Antiques Ltd., abbreviated as KuA), a company tasked by the government with selling cultural property from the GDR to buyers abroad in exchange for hard currency. Under public pressure, KuA ceased operating in late 1989 and its many well-stocked warehouses were sealed by the public prosecutor's office. At the instigation of civil rights activists and with the backing of the Ministry of Culture, the decision was made to first offer the stored cultural property to the museums of the GDR for purchase. Expert commissions were formed in every district to inspect and professionally assess the contents of KuA's warehouses. Alongside civil rights activists, cultural administrators and customs officers, these commissions also included numerous museum specialists—primarily directors of district museums. Following an assessment of the entire KuA inventory, the East German Ministry of Culture made a total of 10 million GDR marks available to museums to fund acquisitions, which led to what can only be described as a rush on the central KuA warehouse in Mühlenbeck near Berlin by these museums in the spring of 1990. Even smaller institutions acquired collection items for in some cases over 100,000 GDR marks. The objects purchased here were inventoried by the museums as "Mühlenbeck acquisitions" and can still be easily identified in their collections today.

Am 2. Dezember 1989 veröffentlichte die DDR-Tageszeitung *Neue Zeit* den Aufruf zahlreicher Künstler, Theologen und Wissenschaftler zu einer Demonstration vor dem Berliner Grand Hotel in der Friedrichstraße „gegen die Praxis, Kunstgegenstände und Antiquitäten gegen Devisen außer Landes zu verschieben".[1] Das Grand Hotel schien der geeignete Ort für den Protest zu sein, bot das Haus doch in einem Hochglanzprospekt als besonderen Service für seine Gäste aus dem westlichen Ausland „Besichtigungsfahrten zum Antiquitätenlager Mühlenbeck" an, um dort gegen frei kon-

vertierbare Währung „die schönsten Zeugnisse der Kultur vergangener Zeiten" zu erwerben. Die Demonstrierenden forderten den sofortigen Stopp des Ausverkaufs von Kulturgut und die „öffentliche Rückführung bisher nicht verkaufter Kunstgegenstände und Antiquitäten in Museen und andere Einrichtungen in der DDR".[2]

Vgl. Beitrag von Bernd Isphording, S. 234.

Was die Unterzeichner des Aufrufs nicht wussten: Bereits am 22. November 1989 hatte Joachim Farken, der Generaldirektor der Kunst und Antiquitäten GmbH (KuA), die auch besagtes Antiquitätenlager Mühlenbeck unterhielt, den sofortigen Stopp des Exports von Kunstgegenständen und Antiquitäten verfügt.[3] Die Entscheidung war unter dem zunehmenden Druck der Öffentlichkeit gefällt worden, da im Zuge der politischen Umwälzungen immer mehr Informationen über das Gebaren des Geschäftsbereichs Kommerzielle Koordinierung – zu dem die KuA gehörte – bekannt wurden.[4]

Zunächst war nicht klar, was mit den umfangreichen Warenbeständen der KuA, die an zahlreichen Orten in der ganzen DDR verteilt lagerten, geschehen sollte. Der Plan, den Geschäftsbetrieb unter anderem Namen fortzuführen,[5] stellte sich angesichts der rasanten Veränderungen schnell als unmöglich heraus. Alexander Schalck-Golodkowski, der Chef der Kommerziellen Koordinierung, setzte sich Anfang Dezember nach West-Berlin ab, staatsanwaltschaftliche Ermittlungen gegen die KuA begannen, und am 31. Dezember 1989 ging die GmbH in die Liquidation.[6]

Die Bewertung der Lagerbestände

Zum 31. Januar 1990 lud der Direktor des Instituts für Museumswesen in der DDR, Harri Olschewski, die Leitungen der Bezirksmuseen zu einem Gedankenaustausch über die weitere Entwicklung ihrer Häuser nach Berlin in den Französischen Dom ein. Hier war auch die Auflösung der KuA Thema, und der Direktor des Bezirksmuseums Potsdam, Dieter Schulte, notierte zu einem entsprechenden Vortrag eines Vertreters des DDR-Kulturministeriums: „Auflösung von Mühlenbeck/Aussonderung von Kulturgut f. Museen/ Erwerbsfragen (Finanzen?), Finanzierung soll zentral abgeklärt werden, T[ermin]: 15.2., Schleppende Arbeit und Hinhalte-Taktik! [...] inzwischen Liquidation."[7]

Einige Museumsmitarbeiterinnen und -mitarbeiter waren jedoch hinsichtlich der KuA-Bestände schon tätig geworden. Bereits am 8. Januar 1990 hatte sich der Minister für Kultur in einem Schreiben an die Räte der Bezirke gewandt, diese von der Liquidation der KuA in Kenntnis gesetzt und aufgefordert, die Warenbestände „durch staatliche Kommissionen zu begutachten und einer inländischen Verwertung zuzuführen. [...] Aufgabe dieser Kommissionen ist zu prüfen, welche Objekte [...] als geschütztes Kulturgut gelten und in den Staatlichen Museumsfonds *⌀* überführt und welche durch den Staatlichen Kunsthandel für den Inlandsverkauf erworben werden."[8]

⌀ Sammlungsbestand der Museen, Gesamtheit des in Staatseigentum befindlichen Museumsgutes; in gleicher Weise gebraucht bei Archivfonds, Bibliotheksfonds

Am 23. Januar 1990 hatte sich der Direktor des VEB (K)*⌀* Antikhandel Pirna[9] – de facto der wichtigste Betriebsteil der KuA – in einem Rundschreiben an die Kulturabteilungen der Räte der Bezirke gewandt.[10] Nach einem „bereits im Bezirk Dresden praktizierten Weg" sollten sich Arbeitsgruppen aus Experten und Mitgliedern der Bürgerbewegung bilden, um in Absprache mit der jeweiligen Bezirksstaatsanwaltschaft und einem Vertreter des VEB Antikhandel die regionalen Lager des Betriebes zu besichtigen. Nach einer Bewertung der kulturhistorischen Bedeutung der Bestände und der endgültigen „Klärung der Rechtsgrundlage", die sich nicht etwa auf die ursprüngliche Herkunft der Objekte bezog, sondern auf die Frage, zu welchem Betriebsteil der KuA die Stücke gehörten, sollten die Museen die Möglichkeit bekommen, „den bestellten Warenfonds zum Einkaufspreis plus Handelsspanne" zu übernehmen.[11] Im Zuge der Besichtigungen wurden die Standorte von der Staatsanwaltschaft entsiegelt und an den Rat des jeweiligen Bezirks übergeben, wobei vermerkt wurde: „Die Staatsanwaltschaft hat weder einen Überblick über den Inhalt der Lagerstätten, noch ist sie im Besitz der Schlüssel zu den gesicherten Objekten."[12]

⌀ Abkürzung für „Volkseigener Betrieb (kreisgeleitet)"

Im Bezirk Cottbus,[13] in dem die KuA vier Standorte unterhielt, fand die erste Lagerbesichtigung am 2. Februar 1990 statt, weitere folgten am 9. Februar.[14] Die Expertenkommission, die die Besichtigungen durchführte, bestand aus insgesamt 17 Personen, darunter neben zwei Vertretern des Bürgerkomitees auch mehrere Mitarbeiterinnen und Mitarbeiter des Rates des Bezirks sowie Vertreterinnen und Vertreter von Zoll, Polizei, Staatlichem Kunsthandel und KuA. Als Vertreter der Museen war lediglich der Direktor des Bezirksmuseums Cottbus, Siegfried Neumann, beteiligt. Die Be-

sichtigung der Lager in Schacksdorf, Calau, Vetschau und Sacrow-Waldow brachte Erstaunliches zutage: Neben zahlreichen Möbeln, Musikinstrumenten und historischem Hausrat wurden 140 Tonnen Rohbernstein und mehrere Tonnen Grundakten aus dem Bezirk Suhl vorgefunden.

Im Bezirk Potsdam waren dagegen zahlreiche Museumsleute als Sachverständige vertreten, darunter der Direktor der Potsdamer Schlösserverwaltung, Hans-Joachim Giersberg, die Direktorin des Museums der Stadt Brandenburg, Katharina Kreschel, und der Direktor des Kreismuseums Oranienburg, Willi Wiborny.[15] Im Bezirk gehörten allein fünf Objekte zum VEB Antikhandel Pirna, hinzu kamen noch mindestens acht Scheunen, Lagerräume, Garagen und Privathäuser, in denen Kulturgut aus den Beständen der KuA und ihrer Kooperationspartner, wie z. B. der Interport GmbH, untergebracht war.[16]

Im Bezirk Potsdam waren die Besichtigungen am 3. März 1990 abgeschlossen. Wie im Bezirk Cottbus wurde in keinem Fall geschütztes Kulturgut der höchsten Kategorie I[17] festgestellt, also Objekte mit außerordentlichem wissenschaftlichem, historischem und kulturellem Wert. Das war insofern nicht verwunderlich, als schon im Vorfeld die besten Stücke in das Zentrallager der KuA nach Mühlenbeck bei Berlin gebracht worden waren. Deshalb drangen die „Direktoren der profilierten Kreis- und Heimatmuseen [auf] die Möglichkeit der Besichtigung in Mühlenbeck".[18]

Museen im Einkaufsrausch

Trotz des zu Recht beklagten Mangels an Kulturgut der höchsten Kategorie reservierten die beteiligten Museumsvertreterinnen und -vertreter gleich bei den ersten Begehungen zahlreiche Objekte, um die eigenen Sammlungen zu ergänzen. Die Abteilung Kultur beim Rat des Bezirks Cottbus übermittelte am 14. Februar 1990 ihre Listen mit Erwerbungswünschen an den VEB Antikhandel Pirna,[19] der ein Angebot inklusive 40 Prozent Handelsspanne unterbreitete, vorbehaltlich der noch zu klärenden Rechtsfragen.[20] Für den Bezirk Potsdam wurden erste Reservierungen in einem Protokoll vom 28. Februar 1990 festgehalten.[21]

Inzwischen hatten auch die Museen, die nicht an den Lagerbesichtigungen beteiligt gewesen waren, vom bevorstehenden

Diesen zinnernen Wasserbehälter der Königlich Sächsischen Kriegsverwaltungskammer von 1825 erwarb das Museum Cottbus für 800 Mark am 8. Mai 1990 im Lager Mühlenbeck. Die zugehörige Karteikarte vermerkt inzwischen entfernte Aufkleber mit der Aufschrift: „T 642 (Nr. Übergabe/Übernahmeliste – Lagerbereich ZL), 89/254 (weiß), 1.500.- (grün), G 02/700 137 (grün)". Stadtmuseum Cottbus

Auszug aus der Ankaufsliste
des Museums Eberswalde in
Mühlenbeck, März 1990

```
Seite      1              Verkaufsspezifikation für
                             Heimatmuseum,Eberswalde
                          Verk.datum 05.03.90  Vertrag 05890
02.04.90

         Stok   Artikel                            Preis

  1.      1     Dampfmaschine                     1300.00
  2.      1     Puppenherd                         400.00
  3.      1     Blechspielzeug                     120.00
  4.      1     Muenzwaage                         500.00
  5.      1     Münzwaage,war nicht im BC          400.00
  6.      1     Wasserbehälter                     800.00
  7.      1     Zinnplatte                         400.00
  8.      1     Schloß                              80.00
  9.      1     Schloß                             800.00
 10.      1     Mufflonkopf,warPS                  250.00
 ***  Gesamt  ***
          10                                      5050.00
```

Ausverkauf erfahren. Am 8. März 1990 wandte sich der Leiter des Heimatmuseums Dahme/Mark, Günter Wagenknecht, mit einem eindringlichen Appell an den Rat des Bezirks Cottbus: „Ausgehend von der letzten Museumsleiterbesprechung bitte ich Sie um Mitteilung, wie auch wir kleineren Museen unsere Interessen wahrnehmen können bei der Räumung des Lagers Mühlenbeck. Für das Museum sind besonders interessant: Trachten [...] des Flämings sowie Münzen, Medaillen und Orden [...]. Bei der Besprechung in Cottbus hatten wir den Eindruck, daß auch hier wiederum die ‚Großen' die Sahne abschöpfen. Also immer noch (schein-) ‚Demokratischer Zentralismus'? Folglich noch nichts gelernt?"[22]

Diese Befürchtungen waren nicht unberechtigt: Die großen Museen der DDR hatten sich bereits sehr früh aus dem Fundus

Zusammenstellung eines Kauf-
konvolutes in den Mühlenbecker
Lagerhallen der KuA i. L. für das
Heimatmuseum Eberswalde, BArch
DL 210-BILD/7-08

der KuA bedient, so erwarben die Staatlichen Kunstsammlungen Dresden erste Objekte bereits im November 1989. Bis zum September 1990 summierten sich ihre Ankäufe in Mühlenbeck auf ein Volumen von mehr als 800.000 Mark.[23]

Im März und vor allem im April 1990 fand ein regelrechter Ansturm auf das Zentrallager statt. Nun bekamen auch zahlreiche kleine Häuser die Gelegenheit, ihren Sammlungsbestand aufzustocken. Es ist davon auszugehen, dass inzwischen sämtliche für den Verkauf vorgesehenen Stücke aus den Außenlagern hierher verbracht worden waren, denn alle Museen der DDR tätigten ihre Ankäufe aus den Beständen der KuA ausschließlich in Mühlenbeck.[24] In der Regel wechselten mindestens Dutzende, teilweise aber auch deutlich mehr Objekte den Besitzer. So erwarb beispielsweise das Heimatmuseum Strausberg 154 Objekte für 63.350 Mark, das Museum Eberswalde erstand 117 Objekte für 144.000 Mark.[25] Angekauft wurde quasi alles: vom Barockschrank über Biedermeierkleider bis hin zu Puppengeschirr aus den 1930er-Jahren. Persönliche Vorlieben der Einkaufenden mochten bei der Auswahl keine geringe Rolle gespielt haben. Gezielte Ankäufe zur Ergänzung der Sammlungen dürften unter dem Zeitdruck und der Auswahl an Objekten auch kaum möglich gewesen sein.

In der Regel waren es die Museumsleiterinnen und Museumsleiter selbst, die nach Mühlenbeck fuhren, um die Objekte auszusuchen. Die Ankäufe erfolgten teilweise in mehreren Tranchen. Im Bundesarchiv Berlin befinden sich im Bestand DL 210 die Kopien

Ein Blick auf den Lagerkomplex der Kunst und Antiquitäten GmbH und deren Tochterfirma Delta Export Import GmbH in Mühlenbeck im Dezember 1989, HdG 2017/03/0171 (67)

der „Übergabe/Übernahmelisten" der Objekte. Diese Listen – die in Kopie auch in vielen Hausarchiven der Museen zu finden sind – enthalten neben laufenden Nummern unter anderem kurze Objektbezeichnungen wie „Waage", „Dose" oder „Pfeife", die Einordnung des Objekts in die Kulturgutkategorie sowie den Buchwert.

Das Ministerium für Kultur hatte bereits im März 1990 in einem Rundschreiben an die Bezirke darauf aufmerksam gemacht, dass die aus dem Bestand der KuA erworbenen Objekte sofort nach Eingang ordnungsgemäß zu inventarisieren seien.[26] Wie ein Schreiben des Generaldirektors des Kulturfonds der DDR an den Direktor des Bezirksmuseums Potsdam zeigt, wurde die umgehende Inventarisierung auch überprüft.[27] In einigen Museen wurden diese Ankäufe sogar in gesonderten Mühlenbeck-Inventaren erfasst.[28]

Wer bezahlt?

Die Frage nach der Finanzierung der Ankäufe – die in dieser Größenordnung kein Museum in der DDR aus dem laufenden Etat hätte leisten können – war bereits im Schreiben des Kulturministers vom 8. Januar 1990 angesprochen worden: „Ich mache darauf aufmerksam, daß die Erwerbung der [...] Kulturgüter [...] gegen Bezahlung erfolgen muß. Modalitäten zur Finanzierung werden noch nach Abstimmung auf zentraler Ebene festgelegt."[29]

Das Ministerium der Kultur verständigte sich mit dem Ministerium der Finanzen und Preise darauf, dem Haushaltsplan des Kulturministeriums für das 2. Quartal 1990 zusätzlich vier Millionen Mark „zum Kauf von Kunstgegenständen" zu bestätigen; hinzu kamen weitere zwei Millionen Mark aus dem Kulturfonds der DDR.[30]

Die Expertenkommissionen in den Bezirken hatten inzwischen den Warenwert der KuA im Zentrallager Mühlenbeck und in den Außenlagern mit 10,2 Millionen Mark beziffert, und so wandte sich das Kulturministerium mit der Bitte um eine entsprechende Erhöhung des Budgets an das Finanzministerium – allerdings erfolglos.[31] Dass die Finanzierungslücke doch noch geschlossen werden konnte, war offenbar einem Regierungsbeschluss zu verdanken, nach dem weitere vier Millionen Mark aus dem Vermögen der SED für Ankäufe von Kulturgut zur Verfügung gestellt wurden.[32]

Die Auszahlung der Gelder erfolgte differenziert nach dem Status, den die Museen in der hierarchisch gegliederten Struktur innehatten. In den meisten Fällen wurden die Zahlungen über die Kulturabteilungen der Räte der Bezirke abgewickelt, was hieß, dass die Museen die Rechnungen, die sie von der in Liquidation befindlichen KuA erhalten hatten, an den Rat des Bezirks weitergaben, der sie wiederum gesammelt beim Ministerium für Kultur einreichte, welches dann die Rechnungen beglich. Für die Staatlichen Museen wurden die Zahlungen per „Kassenplanfortschreibung" innerhalb des Haushalts des Ministeriums der Kultur geregelt, und in einigen besonderen Fällen, wie zum Beispiel dem Verkehrsmuseum Dresden, dem Museum der bildenden Künste Leipzig oder dem Postmuseum der DDR, reichten die Museen die Rechnungen direkt beim Ministerium ein.[33] Bisher konnten keine Hinweise darauf gefunden werden, dass die Museen einen Eigenanteil leisten mussten.

Über den Verbleib der gezahlten Gelder kann bisher nur spekuliert werden. Möglicherweise flossen die Mittel nach Begleichung aller Außenstände der KuA deren Nachfolgefirma Internationale Beratungs- und Vertriebsgesellschaft (IVB) GmbH zu, die die Warenlager mit übernommen hatte.[34]

Nach einer internen Hausmitteilung des Ministeriums der Kultur vom 24. August 1990 über den „Stand der Ausreichung der finanziellen Mittel für den Ankauf von Kunstgut aus der KuA GmbH i. L." waren zu diesem Zeitpunkt die Mittel des Kulturfonds

und des Haushalts des Ministeriums nahezu ausgeschöpft.[35] Ledig-
lich aus den „PDS-Mitteln" war erst die Hälfte abgerufen worden.

Ansätze der Provenienzforschung

Die „Mühlenbeck-Ankäufe" sind, nicht zuletzt aufgrund der be-
sonderen Vorschriften zur raschen Inventarisierung, relativ gut im
Sammlungsbestand eines Museums zu identifizieren. Ergänzend
können die erwähnten Übergabelisten im Bundesarchiv Auskunft
über die Anzahl, die Art und den Ankaufspreis der Objekte Aus-
kunft geben. Damit erschöpfen sich allerdings die schnell zugäng-
lichen Informationen zu den Provenienzen. Die Listen der KuA sind
sehr oft handschriftlich und offensichtlich in großer Eile ausgefüllt
worden. Historisches Werkzeug oder Fayencevasen waren in den
Augen der KuA-Verkäufer in erster Linie Handelsware, dement-
sprechend fehlen grundlegende Informationen wie Datierung,
Größe oder gar Angaben zur Vorgeschichte der Objekte. Die inter-
nen Inventarnummern der KuA, die ebenfalls auf den Übergabe-
listen erscheinen, geben nach bisherigem Kenntnisstand besten-
falls Auskunft über das jeweilige Erwerbungsjahr und vielleicht den
Lagerstandort.

Auch in den im Bundesarchiv überlieferten Unterlagen der KuA
gibt es so gut wie keine Hinweise auf die ursprüngliche Herkunft
der Stücke. Es muss als wahrscheinlich gelten, dass Provenienz-
merkmale beim Ankauf der Objekte durch die KuA nicht beachtet

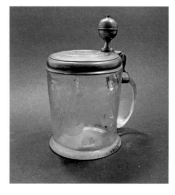

*Für stolze 1.800 Mark kaufte das
Museum Cottbus dieses Henkelglas
von 1767 in Mühlenbeck. Stadt-
museum Cottbus*

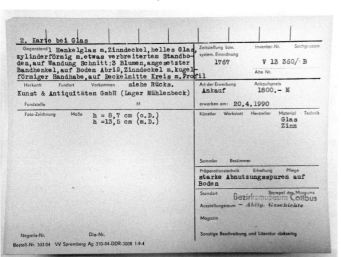

*Inventarkarte für das Henkelglas.
Auf der Rückseite der Karteikarte
wurden akribisch die Aufkleber
vermerkt, die sich bei der Ankunft
im Museum auf dem Glas
befanden: „T 583 (Nr. Übergabe/
Übernahmeliste) Lagerbereich
Metropol, A 5197 1800.– (weiß)".
Stadtmuseum Cottbus*

oder sogar gezielt getilgt worden waren. Hier stehen detaillierte Forschungen allerdings noch aus.

Untersuchungen von „Mühlenbeck-Beständen" zeigen jedoch, dass es durchaus Ansätze gibt, die Provenienzforschung an diesen Objekten voranzubringen. So wurden im Museum Cottbus bei der Inventarisierung der knapp tausend Stücke sehr akribisch auch alle Aufkleber und Beschriftungen aufgenommen. In der überwiegenden Mehrzahl klebte auf den Objekten mindestens die Auspreisung der KuA. Daneben gibt es Hinweise auf Lagerungsorte und gelegentlich auf ein Dienstleistungskombinat, was zum ursprünglichen Ankaufsort führen könnte. Erste Schritte zur Aufschlüsselung der von der KuA verwendeten Abkürzungen und Nummern bietet das Findbuch zum Bestand der KuA im Bundesarchiv.[36] Für eine historische Waffe wurde beim Ankauf das Gutachten eines Restaurators mitgeliefert, das bereits 1980 vom Ministerium für Außenhandel der DDR in Auftrag gegeben worden war.

Eine genaue Autopsie der Objekte sowie eine intensive Archivrecherche dürften weitere Hinweise zutage bringen. Es gibt also noch viel zu tun.

Alexander Sachse

Alexander Sachse ist Referent in der Geschäftsstelle des Museumsverbandes des Landes Brandenburg e. V. in Potsdam.

Förderung des Grundlagenprojekts „Zwischen Schlossbergung und Kommerzieller Koordinierung. Pilotprojekt zur Untersuchung kritischer Provenienzen aus der Zeit der SBZ und DDR in brandenburgischen Museen" von Oktober 2017 bis September 2018.

Endnoten

1 Neue Zeit, 45. Jahrgang, Ausgabe 284, 2.12.1989.

2 Ebd.

3 Dritter Teilbericht über die Praktiken des Bereichs Kommerzielle Koordinierung bei der Beschaffung und Verwertung von Kunstgegenständen und Antiquitäten, Deutscher Bundestag, 12. Wahlperiode, Drucksache 12/4500, 15.3.1993, S. 56 (Dokument 88).

4 Zusammenfassend dazu u. a. der Abschlussbericht des 1. Untersuchungsausschusses zu Organisation, Struktur und Wirken des Bereichs Kommerzielle Koordinierung im wirtschaftlichen System der DDR, Deutscher Bundestag, 12. Wahlperiode, Drucksache 12/7600, 27.5.1994. Zum Wirken der KuA vgl. v. a. Ulf Bischof: Die Kunst und Antiquitäten GmbH im Bereich Kommerzielle Koordinierung, Berlin 2003.

5 Dritter Teilbericht, 1993, S. 56f.

6 BLHA, Rep. 801, 24435, Schreiben des Ministers der Kultur an den Rat des Bezirks Cottbus vom 8.1.1990. Laut dem Findbuch zum Bestand DL 210 im Bundesarchiv (Betriebe des Bereichs Kommerzielle Koordinierung, Teilbestand Kunst und Antiquitäten GmbH [1974–2002], Bestand DL 210, Findbuch bearbeitet von Anne Bahlmann, Falco Hübner, Bernd Isphording u. a., Berlin 2017, hier Teil A, S. 19) wurde die Liquidation am 31.1.1990 von der Gesellschafterversammlung beschlossen.

7 Hausarchiv Potsdam Museum (HAPM), 131.

8 BLHA, Rep. 801, 24435, Schreiben des Ministers der Kultur an den Rat des Bezirks Cottbus vom 8.1.1990.

9 Zum Antikhandel Pirna siehe u. a. Bischof 2003, S. 92–94, sowie Christopher Nehring: Millionär in der DDR. Die deutsch-deutsche Geschichte des Kunstmillionärs Siegfried Kath, Marburg 2018, S. 43–117.

10 BLHA, Rep. 401, 22892, Rundschreiben des VEB (K) Antikhandel Pirna vom 23.1.1990. Dass. in: BLHA, Rep. 801, 24435.

11 Ebd. Vgl. BLHA, Rep. 401, 22892, Aktennotiz eines Gesprächs zwischen dem Liquidator der KuA und Vertretern der Abt. Kultur des Rates des Bezirks Potsdam in Mühlenbeck am 9.2.1990.

12 BLHA, Rep. 401, 22892, Schreiben des Bezirksstaatsanwalts Potsdam an den Rat des Bezirks Potsdam, 23.2.1990.

13 Ausgangspunkt der vorliegenden Untersuchung sind die Ergebnisse eines Provenienzforschungsprojekts des Autors zu Museen zwischen 1945 und 1989 im Land Brandenburg, das die Vorgänge in den Bezirken Potsdam, Frankfurt (Oder) und Cottbus in den Fokus nahm. Alexander Sachse: Schlossbergung, Republikflucht, Kommerzielle Koordinierung. Kritische Provenienzen aus der Zeit der SBZ und DDR, in: Museumsblätter, Heft 35, 2019, S. 18–37.

14 BLHA, Rep. 801, 24435, Protokoll der Begutachtung der Warenbestände, erstellt durch Dr. Gudrun Frömmel, Mitglied des Rates für Kultur im Rat des Bezirks Cottbus.

[15] BLHA, Rep. 401, 22892, undatierte, teilw. handschriftliche Liste.

[16] BLHA, Rep. 401, 22892, Liste in der Anlage zu einem Schreiben des Rates des Bezirks Potsdam an den Ministerrat der DDR, 6.3.1990.

[17] Verordnung über den Staatlichen Museumsfonds der DDR vom 12.4.1978, GBl. der DDR I, 14/78, S. 165, vgl. u. a. Sachse 2019, S. 28.

[18] BLHA, Rep. 401, 22892, Schreiben der Abt. Kultur beim Rat des Bezirks Potsdam an den Minister für Kultur der DDR, 6.3.1990.

[19] BLHA, Rep. 801, 24435, Schreiben des Rates des Bezirks Cottbus, Abt. Kultur an den VEB Antikhandel, 14.2.1990.

[20] Ebd.

[21] BLHA, Rep. 401, 22892, Festlegungsprotokoll 01 über auszusondernde Warenbestände der Kunst- und Antiquitäten GmbH/u. Kooperationspartner.

[22] BLHA, Rep. 801, 24435.

[23] Vgl. Gilbert Lupfer, Thomas Rudert: Schlossbergung, Republikflucht, Kunst gegen Devisen. Provenienzforschung in ostdeutschen Museen, in: arsprototo, Heft 1, 2016, hg. von der Kulturstiftung der Länder, S. 60–63.

[24] Vgl. dazu die zahlreichen Ankaufslisten im Bestand DL 210 im Bundesarchiv Berlin.

[25] Vgl. Sachse 2019, S. 34 f.

[26] U. a. in BLHA Rep. 801, 24435, Schreiben der Stellvertreterin des Ministers der Kultur, Brigitte Weiß, 26.3.1990.

[27] HAPM 27, Schreiben vom 10.4.1990. Der Kulturfonds bittet um umgehende Mitteilung (auf mitgeschicktem Formblatt), dass die Objekte inventarisiert wurden und damit in Volkseigentum übergegangen sind.

[28] So z. B. in den Museen in Cottbus und Strausberg.

[29] BLHA, Rep. 801, 24435.

[30] BLHA, DR 1, 90975, Schreiben der stellv. Ministerin für Kultur an den stellv. Minister für Finanzen, 27.3.1990.

[31] BLHA, DR 1, 90975, Schreiben des stellv. Ministers für Finanzen an die stellv. Ministerin für Kultur, 3.4.1990.

[32] BLHA, DR 1, 90975, Hausmitteilung des Ministeriums der Kultur vom 3. September 1990. Der Posten wird als „PDS-Mittel" bezeichnet.

[33] BLHA, DR 1, 90975, interne, undatierte Zusammenstellung der Zahlungen, ca. Ende Mai 1990.

[34] Für diesen Hinweis vielen Dank an Mathias Deinert, DZK.

[35] BLHA, DR 1, 90975.

[36] Bestand DL 210, Findbuch Teil A, S. 23 f.

Nachwirkungen

Otto Nagel. Der Künstler – und sein Vermächtnis

Salka-Valka Schallenberg

Otto Nagel. The artist—and his legacy
The Berlin painter Otto Nagel—a communist, politically persecuted and active in the resistance to the Nazi regime—chose the path of helping to build up the GDR after World War II—as an influential cultural politician, co-founder of the Kulturbund (Cultural Association), vice president and later president of the Akademie der Künste der DDR (Academy of Arts of the GDR).

When he died in 1967, the socialist state got interested in his artistic legacy and sought out his widow, Walentina "Walli" Nagel. She gave the entire artistic estate on permanent loan to the Magistrat of East Berlin free of charge. In return, the Berlin Märkisches Museum established the Otto Nagel House in 1969 as an exhibition space for proletarian and anti-fascist art—from 1972 privately run by Götz Schallenberg, the husband of Otto Nagel's daughter Sibylle, who became a research associate at the house.

Subsequently, however, the legacy became more and more a matter of dispute between the family and the government. The estate was considered a "national matter" and a privately run museum was not wanted in the GDR anyway. Furthermore, three institutions showed great interest in Otto Nagel's estate: the Märkisches Museum, the Academy of Arts, and the Magistrate of East Berlin. Party officials tried to influence Nagel's widow in order to be taken into account in her will. When Walli Nagel finally died in 1983, her daughter Sibylle was coerced into making an extensive donation and dividing up her inheritance.

The author is the granddaughter of the artist. In her article, she describes the de facto expropriation of Otto Nagel's artistic estate by GDR cultural officials, which the family experienced in six stages, as well as the difficulties of recovering this legacy after 1990 by legal means.

Der Berliner Maler Otto Nagel (1894–1967), Kommunist, politisch Verfolgter und im Widerstand gegen das NS-Regime, wählt nach dem Zweiten Weltkrieg den Weg, die DDR mit aufzubauen: als engagierter Kulturpolitiker, Mitgründer des Kulturbundes in der Landesleitung Brandenburg, Vizepräsident und später Präsident der Deutschen Akademie der Künste (DAK) 🔗. Der Maler aus dem Berliner Arbeiterbezirk Wedding und sein Realismus werden zum Ideal sozialistischer Kunst. Schulkinder lernen Käthe Kollwitz und Otto Nagel als Vertreter des „revolutionären Klassenkampfes" kennen.

1967 stirbt Otto Nagel. Das Wohnhaus der Familie war schon längst der „Kulturbetrieb Nagel", in dem seit 1963 auch Tochter Sibylle (1943–2015) als kunstwissenschaftliche Mitarbeiterin tä-

🔗 *Ab 1974 Akademie der Künste der DDR, 1993 in der Akademie der Künste Berlin aufgegangen*

*Otto Nagel in seinem Atelier in Bies-
dorf 1960, Hintergrund „Mädchen-
bildnis Sibylle, unvollendet", um
1953, Öl auf Leinen, 84 × 65 cm,
WVZ 612, 1985 aus dem Familien-
besitz mit der staatlich angeordneten
Schenkung abgegeben*

tig ist. Sie dokumentieren gemeinsam das Œuvre Otto Nagels und
arbeiten an zahlreichen Publikationen über andere Künstler. Drei
Viertel von Nagels Hauptwerk waren 1945 zerstört oder verschol-
len. In den Jahren danach malte er kaum noch. Nach dem Tod ihres
Mannes führt Walentina „Walli" Nagel das Werk weiter und macht
das Wohnhaus zum Ort des kulturellen Austausches – ganz im
Sinne Otto Nagels.

1969 beschließt der Magistrat von Berlin die „Einrichtung
eines Otto Nagel Haus des Märkischen Museums". Es soll „den
Nachlass und die Kunstsammlung Otto Nagels […] der wissen-
schaftlichen Arbeit voll zugänglich machen" sowie Ausstellungen
zeigen, auch von Werken der Freunde Käthe Kollwitz und Heinrich
Zille. 1969 richtet das Märkische Museum in zwei Wohnungen im
Märkischen Ufer 16–18 erste Räume ein.[1]

Die Erben wollen weiterhin den künstlerischen Nachlass von
Otto Nagel pflegen. Mit dem Ost-Berliner Oberbürgermeister
Herbert Fechner handelt Walentina Nagel daher einen umfangrei-
chen Vertrag aus, der für beide Seiten zufriedenstellend scheint.
So heißt es im § 2: „In Übereinstimmung mit dem Wunsch des

Erblassers übergibt die Erbin den gesamten künstlerischen Nach-
lass als ständige Dauerleihgabe unentgeltlich an den Magistrat
von Groß-Berlin." Weiter heißt es, dass zusammen mit der DAK
das Werk Otto Nagels zu pflegen ist, wissenschaftlich aufbereitet
und vor allem der Öffentlichkeit zugänglich gemacht werden soll.
Walentina Nagel und ihre Tochter und Erbin Sibylle Schallenberg-
Nagel unterzeichnen am 27. Oktober 1972 mit dem Oberbürger-
meister den Vertrag.[2] Schon vor der Vertragslegung versuchten der
Stadtrat für Kultur im Magistrat, Dr. Horst Oswald, und der Sekre-
tär der SED-Bezirksleitung, Dr. Roland Bauer, die Tochter sowie die
DAK aus dem Vertrag auszuschließen. Oswald sah darin „die beste
Möglichkeit, den Nachlass Otto Nagels für die Gesellschaft nutz-
bar zu machen und ihn in gesellschaftliches Eigentum zu bringen".[3]

Im Juli 1973 öffnet das Haus unter großem Interesse der
DDR-Staatsführung und der Presse, auch der Medien im west-
lichen Ausland. Leiter des Museums ist der Schwiegersohn Götz
Schallenberg, Tochter Sibylle wissenschaftliche Mitarbeiterin. Walli
Nagel kümmert sich um die organisatorischen Aufgaben. Zum Ge-
burtstag von Otto Nagel gibt es stets eine Festwoche. Sonderaus-
stellungen, auch mit internationalen Künstlern, finden regelmäßig
statt, am Künstlerwettbewerb nehmen jährlich etwa 800 Nach-
wuchskünstler aus der gesamten DDR teil. Das Werkverzeichnis
der Pastelle und Ölbilder, die wissenschaftliche Publikation *Otto
Nagel. Zeit, Leben, Werk* von Erhard Frommhold und viele weitere
Werke entstehen in den folgenden Jahren.[4]

Doch von Anfang an ist das Verhältnis zwischen dem Otto-
Nagel-Haus und dem Märkischen Museum problematisch. Kurz
nach der Eröffnung schreibt Jutta Engler vom Magistrat, Abteilung
Kultur, dem Sekretär der SED-Bezirksleitung einen siebenseiti-
gen Brief, in dem sie schildert, dass es vonseiten des Märkischen
Museums am Willen zur Kooperation mangele.[5] Seit Anfang 1974
arbeitet das Otto-Nagel-Haus eigenständig, was die Zusammen-
arbeit noch weiter verschlechtert. Götz Schallenberg als Leiter des
Hauses wird ebenso abgelehnt wie die Zusammenarbeit mit seiner
Frau Sibylle Schallenberg-Nagel.[6]

Im März 1977 bekommt Walentina Nagel Besuch von Kultur-
stadtrat Oswald, der in Erfahrung bringen soll, wie sie auf einen
Vertragsentwurf des Ministeriums für Kultur (MfK) „zur Regelung
der Nachfolgeschaft im Wohnhaus von Gen. Otto Nagel" reagiert.

„[...] nachdem sich Genn. Nagel [...] erregt zeigte", schreibt Ober-
bürgermeister Erhard Krack dem Kulturminister Hans-Joachim
Hoffmann: „Die Regelung über das Wohnhaus und die eventuelle
Rechtsnachfolge kann auch nur durch Dich veranlasst werden [...]"[7]

Ein privat geführtes Museum ist in der DDR nicht erwünscht.
Arbeitsverweigerung, private Vorteilsnahme und dergleichen Miss-
stände bestimmen den Alltag im Otto-Nagel-Haus. Beschwerden
beim Magistrat, dem Dienstherrn, bleiben folgenlos, eingeleitete
Disziplinarverfahren muss der Direktor zurücknehmen. Zur Aus-
stellung „Berliner Bilder" im Herbst 1978 eskaliert die Situation.
Der Kurator fälscht mit der Hilfe von zwei Mitarbeitern Werke von
Otto Nagel, darunter eine Leihgabe aus der BRD. Auch eine Fäl-
schung des „Jüdenhofs" (WVZ 535) könnte hier entstanden sein.
Eine Kopie davon findet sich später bei der KoKo.[8] Die Umstände
sind noch längst nicht geklärt. Der Leiter und Walli Nagel wissen
von den Fälschungen, doch rechtliche Schritte führen ins Nichts.
Ein Disziplinarverfahren wird Anfang 1979 eingestellt. Als Schäden
an den Werken von Otto Nagel zunehmen und Sicherheitsmän-
gel auftreten, verlässt die Familie Ende 1978 mit den Leihgaben
das Museumshaus.[9] Darunter ist auch die Sammlung Worms, ein
größeres Konvolut an Bildern, das Walli Nagel 1970 mit eigenen
Mitteln aus der BRD zurückkaufte.[10] Doch die Kulturfunktionäre
betrachten die Bilder als Staatseigentum[11] und es entbrennt ein
jahrelanger Konflikt.

Otto Nagels Nachlass – eine „Angelegenheit der Nation"

In einem Resümee zum Otto-Nagel-Haus und zur weiteren Aus-
richtung schreibt Kurt Löffler 1980: „Die Versuche der Erben, in lei-
tenden Positionen des ONH wider die Interessen des Staates per-
sönliche Interessen durchzusetzen, führten zu ernsten Differenzen
mit der Familie Otto Nagels." Der Staatssekretär bringt daher die
AdK zur Pflege des Nachlasses ins Spiel: „Dadurch bestände für
die Betreuer des Nachlasses [...] nicht mehr die Möglichkeit in Ar-
beitsabläufe einzugreifen, die notwendig sind, um kulturpolitische
Ziele zu erreichen."[12] Zeitgleich erwägen die Staatlichen Museen
zu Berlin eine Übernahme des Nachlasses, die durch einen Be-
schluss des Ministerrates der DDR jede Mitbestimmung anderer

ausschließen soll.[13]Als dritter Akteur versucht der Magistrat an Otto Nagels Nachlass zu gelangen: In einem Testamentsentwurf, der auf 1979 rückdatiert ist, eine Zeit, in der Walli Nagel länger im Krankenhaus war, heißt es: „Unter der Voraussetzung, daß die Staatsorgane auf die Erhebung der Erbschaftssteuer meiner Tochter gegenüber, falls diese die Erbschaft annimmt, verzichten, vermache ich alle in meinem Besitz befindlichen Ölbilder, Handzeichnungen und Pastelle von Otto Nagel [...] als unveräußerlichen Nationalbesitz der DDR dem Magistrat von Berlin." Hinzu kommen die künstlerischen Arbeiten von Zille, Barlach und Kollwitz, zudem „das Wohngrundstück in Berlin-Biesdorf, Otto-Nagel-Str. 5 und die Ateliergrundausstattung, die Ausstattung des Ikonenzimmers (ohne die Ikonen selbst) und das Bibliothekszimmer mit den Buchbeständen [..]."[14] Walli Nagel denkt allerdings nicht daran, dieses Testament zu unterzeichnen, sondern bezichtigt Kurt Löffler der Intrige.[15]

1981 erfolgt der Beschluss, das Otto-Nagel-Haus an die Staatlichen Museen anzugliedern. Damit wird der bestehende Vertrag zwischen Magistrat, Walli Nagel und Sibylle Schallenberg-Nagel gegenstandslos. Ein neuer Leihvertrag soll allein mit Walli Nagel geschlossen werden. Damit wird die Tochter von der künftigen Arbeit am Nachlass des eigenen Vaters ausgeschlossen, denn zum Vertrag mit dem Magistrat von 1972 gehörte ein Arbeitsvertrag. Konzeptionell soll das Museum der „[...] Gesamtdarstellung der proletarisch-revolutionären Kunst sowie der antifaschistischen deutschen Kunst dienen", der „künstlerische Nachlass und das wissenschaftliche Archiv Otto Nagels werden in die Arbeit des Hauses eingeordnet".[16]

Nach dem Tod von Walli Nagel im Oktober 1983 legt Sibylle Schallenberg-Nagel dem MfK dar, was der Nachlass beinhaltet und wie mit ihm zu verfahren ist. „[...] im Sinne eines Memorial-, Archiv- und Ausstellungskomplexes zur wissenschaftlichen und kulturellen Nutzung" schlägt die Tochter die Einrichtung einer öffentlichen „Otto und Walli Nagel Gedenkstätte" in Biesdorf vor. Die Möbel und Bilder will Sibylle Schallenberg-Nagel teilweise als Dauerleihgabe überlassen.[17]Am 12. Januar 1984 kommt es im Wohnhaus der Familie Nagel zu einem Gespräch unter der Leitung Kurt Löfflers. Anwesend sind auch Günter Schade, der Generaldirektor der Staatlichen Museen (SMB), und Werner Wolf von der Abteilung Museen

und Denkmalpflege des MfK. Es hat den Anschein, dass das MfK der Nachlassverfügung wohlwollend gegenübersteht. Auch von einem Honorarvertrag für Sibylle Schallenberg-Nagel ist die Rede. „Bis zum 31.01.84 nimmt eine Expertengruppe der SMB [...] den gesamten künstlerischen Nachlass und das künstlerische Inventar [...] auf und schätzt es wertmäßig ein." Die Aufnahme des Nachlasses soll am 17. Januar 1984 im Beisein von Sibylle Schallenberg-Nagel erfolgen. „Gen. Kurt Löffler erläuterte, dass es bei dieser Aufnahme nicht um die Aufteilung des Erbes gehe, sondern allein um eine Erfassung und Bewertung."[18]

Am 16. Januar 1984, einen Tag vor der geplanten Sichtung des Nachlasses, schreibt Günter Schade an Werner Wolf: „Beiliegend erhältst Du die Nachlassliste von Otto und Walli Nagel."[19] Die handschriftliche Notiz in einer Akte, „Nachlassliste vom 15.12.1983 + die von d. SMB aufgenommenen Kunstwerke", deutet darauf hin, dass die Erfassung längst ohne Wissen der Erbin stattgefunden hatte. Übergeben wurden beide Aufstellungen im November 1984 an den Vorsitzenden der Kulturgutschutzkommission der DDR, Werner Schmeichler.[20] Der bereits zitierte Brief, in dem Kurt Löffler Gespräche mit Walli Nagel zum Testament erwähnte, enthält auch Vorschläge, „die ‚Verteilung' des Nachlasses auszuarbeiten (Übereignung der entscheidenden Werke Otto Nagels an die DDR, Übergabe des wesentlich weiteren Teils als ständige Leihgabe an die Staatl. Museen zu Berlin, Festlegung des Anteils der Werke, die im Privatbesitz bleiben.)" Grundlage sei das Schriftstück von Sibylle Schallenberg-Nagel. Darin steht aber nur, dass einige Werke an den Staat herausgegeben werden sollen, nicht die entscheidenden. Nach Abschluss der Vorarbeiten möchte Löffler von Wagner informiert werden, „damit wir sie [die Informationen, Anm. d. A.] gemeinsam dem Minister für Kultur vorlegen und nach seiner Bestätigung den für die Entscheidung zuständigen Zentralen Staatsorganen sowie der Parteiführung einreichen können".[21] Was folgte, war de facto eine Enteignung der Erbin Nagels.[22]

Zum 90. Geburtstag von Otto Nagel schreibt Sibylle Schallenberg-Nagel zur Frage der Verfahrensweise mit dem künstlerischen Nachlass eine Eingabe an den Staatsrat der DDR.[23] Es folgt ein langer intensiver interner Schriftverkehr, wie darauf zu reagieren sei. Die Idee, das künstlerische Werk Otto Nagels zur „Angelegenheit der Nation" zu erklären, im Prinzip zu verstaatlichen, steht im Raum.

Der Justiziar Wolfgang England empfiehlt dem Ministerrat eine Beschlussfassung, die die „Sicherung, Pflege und Erschließung eines künstlerischen Nachlasses zur ‚Angelegenheit der Nation‘" erkläre. „Inhaltlich sollte der Beschluß – etwas deutlicher als die bisherigen – die Wahrung der Rechte der Erben ausdrücklich erwähnen und auch sonst optisch und substantiell ‚erbenfreundlich‘ gehalten sein." Dem Beschlusstext ist der Hinweis angefügt, dass er auch als rechtlicher Rahmen „für weitergehende Vereinbarungen mit der Erbin [...] sowie [...] für absehbare Anträge an den Minister der Finanzen auf Steuererlass oder Ermäßigung" hilfreich sein könnte.[24]

Ende 1984 stellte der Minister für Kultur mit einem Schreiben den künstlerischen Nachlass von Otto Nagel sowie Werke von Käthe Kollwitz unter das Kulturgutschutzgesetz der DDR.[25] Wenig später erfährt Sibylle Schallenberg-Nagel, dass ihrem Antrag auf Befreiung der Erbschafts- und Vermögenssteuer in Höhe von 1,6 Millionen DDR-Mark entsprochen wird. Im Gegenzug soll sie Werke von Otto Nagel in diesem Wert als Schenkung bereitstellen. Weitere Kunstwerke, auch Ikonen und kunstgewerbliche Gegenstände, soll sie „als Dauerleihgabe für Museen der DDR zur Verfügung stellen".[26]

Zum Thema Steuererlass ist eine Aktennotiz von Günter Schade interessant, die sich auf sein Treffen mit dem Stellvertreter des Ministers, Friedhelm Grabe, und Werner Wolf bei Staatssekretär Löffler bezieht: „Auf der Grundlage der von Genn. Schallenberg-Nagel angebotenen Schenkung von Werken Otto Nagels an den Staat, die in etwa die Höhe der fälligen Erbschaftssteuern besitzt, ist durch das MfK, Abt. Museen und Denkmalpflege, ein entsprechender Antrag auf Steuerbefreiung für Genn. Schallenberg-Nagel beim Ministerium der Finanzen zu stellen oder eine Sonderentscheidung des Ministerrates einzuholen."[27]

Wenige Wochen später, laut einem Protokoll der AdK am 11. Oktober 1985, erfolgt die Übergabe der fast 300 Werke von Otto Nagel und einiger Werke anderer Künstler.[28] Im Dezember wird der sogenannte Schenkungsvertrag mit Sibylle Schallenberg-Nagel geschlossen. Nach der Übergabe der Bilder bleibt aber die Steuerschuld bestehen: „Der Steuererlaß erfolgt erst, wenn die von Ihnen beabsichtigte Schenkung vertraglich vollzogen ist."[29]

Sibylle Schallenberg-Nagel meldet 1990 die Rückübertragung des Wohnhauses von Otto und Walentina Nagel an. 1991 erweitert sie den Antrag auf Bilder von Otto Nagel.[30]

1998 ist die Restitution gescheitert. Die Kunstwerke und das Haus sind verloren. Dieser Akt der Nötigung, „veranlasst durch Kurt Hager und mit den Modalitäten beauftragt seinerzeit Kurt Löffler […]" blieb ohne Beweise.[31] Erst 2005 urteilt das OLG Brandenburg: Immerhin die Sammlung Worms bleibt Familienbesitz.[32]

Dank einem Forschungsprojekt mit der Beauftragten des Landes Sachsen-Anhalt zur Aufarbeitung der SED-Diktatur fanden sich über 3.000 Seiten unter anderem in Akten des Ost-Berliner Magistrats, des Ministeriums für Kultur der DDR und von Museen, darunter viel interner Schriftverkehr.[33] Jetzt gilt es, alles auszuwerten, Otto Nagel ins Heute zurückzuholen.

Salka-Valka Schallenberg
Salka-Valka Schallenberg arbeitet als freie Kulturjournalistin in Magdeburg und ist Enkelin des Malers Otto Nagel.

Ihr Forschungsprojekt „Otto Nagel – Sein Wirken in der ehemaligen DDR, seine Überwachung durch das MfS und der Umgang des Staatsapparates der ehemaligen DDR mit seinem Erbe nach seinem Tod im Jahr 1967" wird seit Juli 2019 unterstützt von der Beauftragten des Landes Sachsen-Anhalt zur Aufarbeitung der SED-Diktatur, Birgit Neumann-Becker.

Endnoten

[1] Magistrat von Berlin, Büro des Magistrats, Magistratsvorlage 160/69 zur Beschlussfassung für die Sitzung am 20.8.1969, Landesarchiv Berlin Akte C Rep. 100-05 Nr. 1411; Magistrat von Berlin, Büro des Magistrats, Magistratsbeschluss 160/69 vom 20.8.1969, Landesarchiv Berlin Akte C Rep. 100-05 Nr. 1411.

[2] Kopie Vertrag mit Unterschrift, Landesarchiv Berlin, Akte C Rep. 101 Nr. 2724.

[3] Brief Magistrat von Groß-Berlin, Abt. Kultur Dr. Horst Oswald Stadtrat an BL SED Berlin Leiter der Abt. Kultur, Gen. Dr. Kiessig, 16.8.1972, Landesarchiv Berlin Akte C Rep. 902 Nr. 3626.

[4] Archiv Akademie der Künste, Nachlass Walli Nagel, Archiv Otto-Nagel-Haus.

[5] Brief Jutta Engler, Magistrat Abt. Kultur, an Roland Bauer, Sekretär der SED-Bezirksleitung, 23.7.1973, Landesarchiv Berlin, Akte C Rep. 902 Nr. 3626, Bezirksleitung Berlin der SED.

[6] Information für Gen. Dr. Bauer von Elly Kern, Abt. Kultur SED-Bezirksleitung, 16.8.1974, Landesarchiv Berlin, Akte C Rep. 902 Nr. 3626, Bezirksleitung Berlin der SED.

[7] Stadtrat für Kultur Horst Oswald an OB Krack, Notiz über ein Gespräch mit Genn. Walli Nagel, 8.3.1977, Landesarchiv Berlin, Akte C Rep. 101 Nr. 1721; Brief Stadtrat für Kultur Horst Oswald an OB Krack, 12.5.1977, ebd.; Brief OB Krack an Minister für Kultur Hans-Joachim Hoffmann, 30.3.1977, Landesarchiv Berlin, Akte C Rep. 101 ebd., Nr. 2558.

[8] MDR Exakt – die Story: Der Maler Otto Nagel oder wem gehört die Kunst, Sendetermin 30.9.20.; Kunst u. Antiquitäten GmbH, Schriftwechsel des Generaldirektors mit dem Bereich KoKo, Rechnung mit Informationen zum Gemälde „Jüdenhof", 31.5.1983, Bundesarchiv Berlin, Akte DL210/2429.

[9] Vgl. u. a. Dokumentation Otto-Nagel-Haus (1973–1978), Zusammenstellung: Götz Schallenberg, Direktor des ONH, Berlin, Januar 1979, an Ursula Ragwitz, ZK der SED, Bundesarchiv Berlin, Akte DR 1/1708 S. 15–26, MfK Sekretariat des Staatssekretärs für Kultur Kurt Löffler.

[10] Friedegund Weidemann: Das Otto-Nagel-Haus als Abteilung der Nationalgalerie 1982–1995. Die Geschichte eines adoptierten Mus(e)n-Kindes, in: Jahrbuch Preußischer Kulturbesitz Band XXXII/1995, S. 244 f.

[11] Vgl. u. a. Staatliche Museen zu Berlin DDR OMR Dr. Günter Schade an MfK Leiter Abt. Museen und Denkmalpflege Werner Wolf, 20.6.1984, Bundesarchiv Berlin, MfK Sekr. des Staatssekretärs für Kultur Kurt Löffler, Akte DR 1/1707, S. 126.

[12] Gedanken zur weiteren Entwicklung des Otto-Nagel-Hauses mit Anlage Möglichkeiten zur Effektivität des ONH, 12.5./13.5.1980, Bundesarchiv Berlin, Akte DR 1/1708, S. 52–56.

[13] Vorschlag zur künftigen Unterstellung und Profilierung für „Otto Nagel Haus" Berlin, Eberhard Barthke, GD Staatliche Museen Nationalgalerie, 12.5.1980, Zentralarchiv, Akte SMB ZAII/VA 4180.

[14] Brief von Magistrat Dr. Schuchardt, Stadtrat für Kultur an Ministerium für Kultur, an Staatssekretär Kurt Löffler, 16.5.1980, Bundesarchiv Berlin, Akte DR 1/1708, S. 57–59.

[15] Brief von Staatssekretär Kurt Löffler, Ministerium für Kultur, an Siegfried Wagner Stellvertreter des Ministers für Kultur, 19.1.1984, Bundesarchiv Berlin, Akte DR 1/1708, MfK Büro Staatssekretär Kurt Löffler, S. 139 f.; Brief Walentina Nagel an Ministerium für Kultur, Staatssekretär Kurt Löffler, Eingangsstempel 12.9.1980, ebd., S. 68 f.

[16] Brief Minister für Kultur Hans-Joachim Hoffmann an Prof. Dr. Kurt Hager ZK der SED, Kopie an Löffler mit Anlage Entwurf Beschluss Übernahme Otto-Nagel-Haus durch Staatliche Museen zu Berlin, 29.5.1981, Bundesarchiv Berlin, Akte DR 1/1708, S. 94–98; Übergabe-/Übernahmeprotokoll Otto-Nagel-Haus an die Staatlichen Museen nach Magistratsbeschluss 16/81 vom 1.7.1981, 13.11.1981, Zentralarchiv, Akte SMB ZAII/VA 5447, Otto-Nagel-Haus; Weidemann 1995, S. 248.

[17] Sibylle Schallenberg-Nagel, Nachlass Otto und Walli Nagel, Bundesarchiv Berlin, Akte DR 1/1707, MfK Büro Staatssekretär Kurt Löffler, S. 16–21.

[18] Aktennotiz über Gespräch im Haus Otto und Walli Nagel, 12.1.1984, 9.00–10.30 Uhr, geschrieben von Günter Schade, Bundesarchiv Berlin, Akte DR 1/1707, S. 32–35.

[19] Brief von Werner Wolf, Abt. Museen und Denkmalpflege des Ministeriums für Kultur, an Günter Schade, Generaldirektor Staatliche Museen, 16.1.1984, ebd., MfK Büro Staatssekretär Kurt Löffler, S. 28.

[20] Zentralarchiv, Akte Büro Günter Schade, Generaldirektor Staatliche Museen, SMB-ZA II/VA 4403.

[21] Brief von Staatssekretär Kurt Löffler Ministerium für Kultur an Siegfried Wagner Stellvertreter des Ministers für Kultur, 19.1.1984, Bundesarchiv Berlin, Akte DR 1/1708, S. 139 f.; Akte DR 1/1707 MfK Büro Staatssekretär Kurt Löffler, S. 51 f.

[22] Kurt Löffler, in: MDR Exakt – die Story, Sendetermin 30.9.20.

[23] Brief Sibylle Schallenberg-Nagel an den Staatsrat der DDR, Eingabe zur Verfahrensweise den Nachlass Otto und Walli Nagel betreffend, 27.9.1984, Bundesarchiv Berlin, Akte DR 1/1707 MfK Büro Staatssekretär Kurt Löffler, S. 177.

[24] Schreiben von Büro des Ministers, Rechtsstelle Justiziar England, Künstlerischer Nachlass Otto Nagel, 29.10.1984, Bundesarchiv Berlin, Akte DR 1/1707 MfK Büro Staatssekretär Kurt Löffler, S. 180–182.

[25] Brief Minister für Kultur Hans-Joachim Hoffmann an Sibylle Schallenberg, 10.12.1984, Landesamt zur Regelung offener Vermögensfragen, Reg. akte 608856 Band II, S. 153.

[26] Brief Ministerium der Finanzen, Minister Höfner an Sibylle Schallenberg, 16.9.85, Landesamt zur Regelung offener Vermögensfragen, Reg.akte 608856, Band I, S. 116.

[27] Aktennotiz über ein Gespräch beim Staatssekretär Gen. K. Löffler am 2.7.1984, Zentralarchiv, Akte SMB ZAII/VA 4403, Büro des GD SMB Günter Schade; vgl. Gespräch beim Staatssekretär Gen. K. Löffler am 2.7.1984, Werner Wolf Abt. Museen und Denkmalpflege, Bundesarchiv Berlin, Akte DR 1/1707 MfK Büro Staatssekretär Kurt Löffler, S. 148 f.

[28] Übergabe-Übernahme-Protokoll unterschrieben von Hans Hoffmann für Akademie der Künste und Sibylle Schallenberg, 11.10.1985, Archivdirektion Akademie der Künste, Vorgang Schenkungsvertrag 17.12.1985.

[29] Vertrag zwischen der Akademie der Künste der DDR, Nationale Forschungs- und Gedenkstätten der DDR f. deutsche Kunst u. Literatur d. 20. Jhd. und Sibylle Schallenberg mit angefügten Listen über Werke von Otto Nagel u. a. Künstlern, (Schenkungsvertrag), 17.12.1985, LaRoV, Reg.akte 608856 Band I, S. 9–22.; Brief Ministerium der Finanzen, Minister Höfner an Sibylle Schallenberg, 16.9.85, LaRoV, Reg.akte 608856 Band I, S. 116.

[30] Brief Anmeldung Rückübertragung Sibylle Schallenberg-Nagel an Stadtbezirk Berlin Marzahn, Stadtverwaltung LaRoV, 1.10.1990 Reg.akte 608856 Band I, S. 1.

[31] Widerspruchsbescheid gegen Bescheid des ARoV, 10.1.1997, AROV VI D 11-60856, 5. 3.1998, LAROV III B-W-605/97; Brief Anmeldung Rückübertragung Sibylle Schallenberg-Nagel an Stadtbezirk Berlin-Marzahn, Stadtverwaltung LaRoV, 1.10.1990 Reg.akte 608856 Band I, S. 1.

[32] Vgl. Urteil 6.2.2003 LG Neuruppin 3056/02; Urteil 12.4.2005 OLG Brandenburg 6 U 51103.

[33] Beauftragung der Beauftragten des Landes Sachsen-Anhalt zur Aufarbeitung der SED-Diktatur, Birgit Neumann-Becker, zum Forschungsprojekt über Otto Nagel für Salka-Valka Schallenberg und Bernd Schallenberg vom 10. Juli 2019.

Gescheiterte Aufklärung – Über den Umgang mit verschwundenem Kulturgut aus Rostocker Museen 1989–1992

Peter Danker-Carstensen

A failed investigation. Dealing with missing cultural property in Rostock's museums 1989–1992

In March 1991, Rostock's citizenry set up a committee of inquiry to trace the art treasures that had disappeared from museums in the city of Rostock over the past decades and to name those responsible. The Committee on Disappeared Cultural Property invited former and current museum directors and staff, the two heads of culture at the city council and criminal investigators to hearings.

The article focusses on a painting from the collection of the Rostock Kulturhistorisches Museum (Museum of Cultural History), which came into the possession of the Deutsches Schifffahrtsmuseum (German Maritime Museum) in Bremerhaven through a swap. The painting was a work by the Dutch painter Jakob Willem Gruyter (1817–1880) entitled "Vor Bremerhaven" (Off Bremerhaven), purchased by the Rostock Städtische Kunstsammlung (Municipal Art Collection) in 1870.

There were several reasons for the unsatisfactory results of the committee's investigation. The committee had no legal basis and only very limited powers. The persons heard did not testify under oath, so they could not be held accountable for false testimony. Another shortcoming was the fact that the files of the Rostock public prosecutor's office, which had previously investigated the case, were not available. Nor did the committee have access to State Security Service files, since the Stasi Records Act did not come into force until late 1991.

Im Frühjahr 1990 wurden Anschuldigungen gegen ehemalige und gegenwärtige Museumsdirektoren sowie frühere SED-Funktionäre laut, am Verschwinden wertvoller Kunstwerke aus Rostocker Museen beteiligt gewesen zu sein, die zum Teil schon vor längerer Zeit im westdeutschen Kunst- und Antiquitätenhandel wiederaufgetaucht waren. In der Lokalpresse tobte bald eine Auseinandersetzung, der frühere 1. Sekretär der SED-Bezirksleitung Rostock wurde als größter Kunsträuber der Geschichte neben Dschingis Khan und Hermann Göring bezeichnet und sogar dänische Zeitungen berichteten über den Rostocker „Kulturskandal"[1]. Es gab Hausdurchsuchungen bei verhafteten hohen Rostocker SED-Funktionären sowie staatsanwaltliche Ermittlungen.

Das Kulturamt der Hansestadt setzte eine „Kommission zur Kontrolle der Sammlungstätigkeit im Kulturhistorischen Museum Rostock" ein, weil die meisten verschwundenen Objekte aus diesem Haus stammten. Als Reaktion auf die in dem Abschlussbericht der Kommission benannten zahlreichen Mängel, wie unzureichende Dokumentation der Herkunft von Objekten, fehlerhafte Inventuren, nicht inventarisierte oder fehlende Stücke, beschloss die Rostocker Bürgerschaft, einen Untersuchungsausschuss „Verschwundene Kulturgüter" zu bilden, der die Spur der verschwundenen Kunstschätze zurückverfolgen und die dafür Verantwortlichen benennen sollte. Dieser Ausschuss konstituierte sich am 21. März 1991.[2]

Ein Gemälde wechselt den Besitzer

Unter den Kunstwerken, deren Verschwinden aus Rostocker Sammlungen der Untersuchungsausschuss erforschte, war auch ein Gemälde des Niederländers Jakob Willem Gruyter (1817–1880) mit dem Titel *Vor Bremerhaven*. Obwohl das Werk in der Tradition niederländischer Marinemalerei Eigentum des Kulturhistorischen Museums Rostock (KHMR) war, befand es sich bis 1976 in den Räumen des Rostocker Schifffahrtsmuseums (SMR). Nach dessen Etablierung 1968 waren viele Sammlungsobjekte des vorher an diesem Standort befindlichen Städtischen Museums, aus dem später das Kulturhistorische Museum hervorging, dort verblieben.

Jakob Willem Gruyter, Vor Bremerhaven, 1870, Öl auf Leinwand, 90,7 × 133 cm, bezeichnet l. u.: Willem Gruyter jr. 1870. Ein flussaufwärts fahrender Raddampfer auf der Unterweser, der die Geestemündung passiert. Am rechten Bildrand ist das Fort Wilhelm zu sehen, das im 19. Jahrhundert den Hafen verteidigen sollte. Im DSM wurde das Gemälde unter der Bezeichnung „Fort Wilhelm" erst 1983 (nach)inventarisiert. Inv.-Nr. I/02672/83

𝒪 Personen, die als politisch
besonders zuverlässig galten und
denen deshalb Dienstreisen ins nicht-
sozialistische Ausland gestattet
waren

Dr. Johannes Lachs (1929–2007)
war von 1971 bis 1982 Direktor des
Rostocker Schifffahrtsmuseums.

𝒪 Vgl. Beitrag von Michael Busch,
S. 81.

Gruyters Gemälde hatte die Städtische Kunstsammlung Rostock
1870 angekauft.[3] Da man in Bremerhaven von der Existenz die-
ses für die Geschichte der Hafenstadt bedeutsamen Gemäldes
wusste, trat der damalige Direktor des dortigen Deutschen Schiff-
fahrtsmuseums (DSM), Gert Schlechtriem (1929–1998), an seinen
Rostocker Kollegen Dr. Johannes Lachs (1929–2007), der als „Rei-
sekader"𝒪 gute persönliche Kontakte in Bremerhaven pflegte, mit
einem Kaufangebot für das Gruyter-Gemälde heran. Lachs wusste,
dass bei einem Verkauf eines Kunstwerks in die Bundesrepublik
der Erlös in den Staatshaushalt der DDR fließen würde, deshalb
strebte er ein Tauschgeschäft gegen „Schreib- und Medientechnik"
an, die in der DDR nicht zu beschaffen war.

Auf einer internationalen Tagung im englischen York ließ Lachs
dem Kollegen aus Bremerhaven seine „Wunschliste" und sein Ange-
bot zukommen, das neben dem vom DSM gewünschten Gemälde
noch zwei Schiffsmodelle beinhaltete. Die beiden Museumsdirek-
toren waren sich rasch einig und die Tauschaktion wurde auf den
Weg gebracht. Das DSM beschaffte die gewünschten Geräte mit-
hilfe einer Spende der Stiftung des Bremerhavener Unternehmers
John Mahn in Höhe von 11.000 DM, denn Haushaltmittel des
DSM durften für dieses Tauschgeschäft nicht eingesetzt werden.[4]

Lachs ließ über den Rat des Bezirkes den obligatorischen An-
trag auf Ausfuhr von Kulturgut beim Kulturministerium stellen.
Noch vor der Antragstellung stufte er die kunsthistorische Be-
deutung und den Wert des Bildes herunter, um die bürokratischen
Hürden bei der Ausfuhr zu verringern.𝒪 Der Antrag wurde nach
einigem Hin und Her vom Ministerium für Kultur genehmigt. An
den DDR-Frachtschiffsmodellen hatte das DSM offenbar kein In-
teresse, denn nur das Gemälde wurde per Schiff von Rostock nach
Bremerhaven geliefert.[5] Das DSM bestätigte am 7. Juli 1976 den
Empfang des Bildes.[6] Am 9. August 1976 reiste Erich Wilke, Verwal-
tungsleiter des DSM, nach Rostock und brachte zwei IBM-Kugel-
kopfschreibmaschinen, zwei Uher-Tonbandgeräte und zwei Kodak-
Karussell-Diaprojektoren sowie ca. 30 Bände maritime Fachliteratur
ins dortige Schifffahrtsmuseum.[7] Eine der Schreibmaschinen ging
ins Rostocker Rathaus an den Stadtrat für Kultur, Hans-Joachim
Pommerenke (1924–2001), der als Vorgesetzter von Johannes
Lachs die Tauschaktion befürwortet hatte.[8]

Tauschgeschäft oder Dauerleihgabe?

Die Aufklärung in Sachen „verschwundenes Kulturgut" begann in Rostock Anfang Dezember 1989 mit einem Bericht in der *Ostseezeitung* (OZ), in dem über eine der sogenannten Dialog-Veranstaltungen der SED-Kreisleitung berichtet wurde, auf der es um Aufklärung der Machenschaften von SED-Funktionären ging. Der ein gutes halbes Jahr zuvor auf eigenen Wunsch aus dem Amt geschiedene Direktor des Rostocker Schifffahrtsmuseums Jörg Meyer (geb. 1944) behauptete auf dieser Versammlung, „daß zwei wertvolle Gemälde aus den Rostocker Museumsbeständen verkauft" worden seien.[9] Weiter hieß es, dass Andreas Waack (geb. 1941), Stadtrat für Kultur, und Dr. Wolf Karge, bis 1991 Direktor des KHMR, diese Behauptung als falsch bezeichnet hätten. Die *OZ* lieferte hingegen eine mit viel Insider-Wissen gespickte Darstellung des Tauschgeschäfts von 1976 und urteilte: „Der Tausch, bei dem sich das Schiffahrtsmuseum sicher übers Ohr hauen ließ, ist juristisch einwandfrei, moralisch aber sehr zweifelhaft."[10] Daraufhin gab es, ebenfalls in der *OZ*, eine „Notwendige Erwiderung" von Johannes Lachs.[11] Er ging dabei auf die frühere Tätigkeit Meyers als HVA⌀-Spion ein, der in Dänemark enttarnt und zu einer mehrjährigen Gefängnisstrafe verurteilt worden war, bevor er treibende Kraft bei Lachs' Entlassung 1982 und schließlich sein Nachfolger wurde, der nun „verantwortungsvolle Kulturmitarbeiter, die gesetzlich völlig korrekt und ohne persönlichen Vorteil handelten", diffamiere.[12] Seine damalige Tauschaktion rechtfertigte Lachs damit, dass das Gemälde in Bremerhaven nun „eine Funktion zur heimatkundlichen Dokumentation" erfülle, „die es in Rostock nie erfüllt hat und hätte".[13]

Schon am 8. Dezember 1989, noch bevor die öffentliche Diskussion über verschwundene Kulturgüter in Rostock einsetzte, hatte sich Andreas Waack in einem Brief an den Bremer Senator für Bildung und Wissenschaft, Hans Werner Francke (SPD), gewandt, der auch stellvertretender Verwaltungsratsvorsitzender des DSM war.[14] Unter bewusster Umgehung des DSM-Direktoriums berichtete Waack über das Tauschgeschäft von 1976 und schnitt dabei die Frage nach Rückgabe des Gemäldes an, da es sich nach seiner Lesart um eine Leihgabe aus Rostock handeln würde. Eine offizielle Stellungnahme vonseiten des Bremer Senats zu dieser

⌀ *Abkürzung für „Hauptverwaltung A(ufklärung)", die MfS-Auslandsspionage*

Forderung aus Rostock erfolgte nicht.[15] Gut zwei Monate später informierte Waack – mittlerweile stellvertretender Leiter des neu gebildeten Kulturamtes – die Rostocker Kultursenatorin Ulrike Oschwald (FDP) über den Fall und behauptete, dass das DSM die Eigentumsrechte des KHMR an dem Bild anerkannt hätte. Es müsse nur noch ein Leihvertrag abgeschlossen werden, um es zu einer Dauerleihgabe zu machen.[16] Mit dieser falschen Aussage versuchte Waack, der die Zusammenhänge und die Verwicklung seines Vorgängers Pommerenke in diesen Tauschhandel kannte, das Gruyter-Gemälde aus der aktuellen Diskussion um verschwundene Kunstobjekte und die dafür in Rostock Verantwortlichen herauszuhalten. Diese Verschleierungstaktik führte dazu, dass sowohl die Rostocker Stadtverwaltung als auch das KHMR sich die „Sprachregelung", das Gemälde sei nur ans DSM verliehen, zu eigen machten, ohne die wirklichen Hintergründe des Tauschgeschäftes zu kennen.[17] Mitte März 1991 vermeldete die Presse dann: „Kontroverse hat ein Ende gefunden."[18]

Die zahlreichen skandalträchtigen Pressemeldungen über das nach Bremerhaven eingetauschte Gemälde sorgten dort für Irritationen. Insbesondere die Mutmaßungen und Verdächtigungen, das DSM hätte mit SED-Genossen in Rostock gemeinsame und wohl „illegale" Sache gemacht, verärgerten das Direktorium. Da das DSM wegen dieses Vorgangs in ein schiefes Licht zu geraten drohte, wandte sich DSM-Direktor Detlev Ellmers an die Rostocker Kultursenatorin.[19] Ellmers wies darauf hin, dass laut Pressemeldungen ein Untersuchungsausschuss im Zusammenhang mit dem Tauschvorgang „keinerlei Unregelmäßigkeiten" festgestellt habe. Weiter erwähnte Ellmers, dass es bereits Verhandlungen zwischen der Stadt Rostock und dem Land Bremen, leider ohne Beteiligung des DSM, gegeben hätte. Da aber der betreffende Vertrag seinerzeit von zwei DSM-Direktoren und Vertretern der Stadt Rostock unterzeichnet worden sei, bat Ellmers sich aus, zukünftig alle auftretenden Fragen direkt mit ihm zu klären.[20] In ihrer Antwort erläuterte Senatorin Oschwald die Aufgaben des sechs Wochen zuvor installierten Untersuchungsausschusses und die daraus entstandenen politischen Konflikte in Rostock. Weiter erwähnte Oschwald, dass es eine polizeiliche Untersuchung gegeben hätte, „die feststellte, daß dieser Vorgang den damaligen Gesetzlichkeiten entsprach".[21] Als der Leiter der Bremer Senatskanzlei, Dr. Andreas

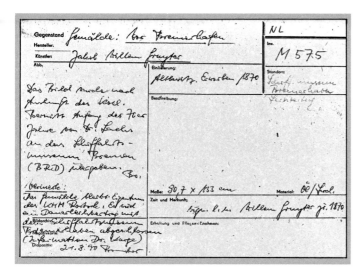

Karteikarte des KHMR zum Gemälde Vor Bremerhafen von Jakob Willem Gruyter (Inv.-Nr. KHMR M 575) mit Notizen zur Weggabe des Bildes und zum nicht abgeschlossenen Leihvertrag mit dem DSM

Fuchs, Rostock besuchte, gab die Kultursenatorin ihm gegenüber eine „Ehrenerklärung" für das DSM ab. Der Ankauf des Gemäldes sei „absolut korrekt abgewickelt worden"; das DSM und dessen Direktor hätten „sich nicht an dubiosen SED-Machenschaften beteiligt", es habe keine Verletzung von Strafgesetzen festgestellt werden können.[22] Zu diesem Ergebnis sei auch der von ihr eingesetzte Kontrollausschuss gekommen. Durch diese Mitteilung und die „Ehrenerklärung" der Senatorin gegenüber dem DSM-Direktorium schien der „Fall" des Gruyter-Gemäldes für die Rostocker Kommunalpolitik erledigt.

Die Befragungen durch den Ausschuss

Währenddessen hörte der Ausschuss mehrere in den Fall verwickelte Personen an. Befragt wurden unter anderem die Kulturfunktionäre Pommerenke und Waack, die ehemaligen Museumdirektoren Werner Schäfer, Johann Joachim Bernitt, Dr. Johannes Lachs sowie der Kriminalbeamte Heimann. Jörg Meyer, Lachs' Nachfolger und mittlerweile als IM geoutet, verweigerte sein Erscheinen vor dem Ausschuss. Zunächst wurde festgestellt, was schon der Presse zu entnehmen gewesen war: dass es sich im Fall des nach Bremerhaven gelangten Gemäldes eben nicht um verschwundenes Kulturgut handelte.

Auch hier erklärte Andreas Waack, dass „wir uns mit dem Museum in Bremerhaven dahingehend geeinigt haben, daß der Besitz dieses Bildes bei uns verbleibt [...] und daß es bei Eigenbedarf jederzeit zurückgeholt werden kann".[23] Als der Ausschussvorsitzende zur endgültigen Klärung des Falles selbst ans DSM schrieb und dessen Direktor Ellmers mit Waacks Aussage konfrontierte, zeigte sich Ellmers „sehr ungehalten" und teilte dem Ausschuss seine Sicht der Dinge mit: „Der Tauschvertrag ist von den rechtmäßigen Vertretern der Stadt Rostock und des Deutschen Schiffahrtsmuseums unterzeichnet worden. Das Gemälde hängt seitdem als Eigentum des Deutschen Schiffahrtsmuseums in dessen ständiger Ausstellung. Dies ist die unveränderte Rechtslage bis heute."[24]

Bei den Recherchen des Untersuchungsausschusses spielte auch die Taxierung des Gemäldes eine Rolle, da der Verdacht bestand, dass das Bild einen wesentlich höheren Wert als die dafür erhaltenen Geräte und Rostock „ein schlechtes Geschäft" gemacht hätte. Das konnte aber nie bewiesen werden, da es mehrere sich widersprechende Wertgutachten beziehungsweise Wertangaben gab. Gut 25 Jahre später – im Zusammenhang mit den Recherchen des Autors zur Rolle von Johannes Lachs als Museumsdirektor und seiner langjährigen Tätigkeit als IM des MfS – stellte sich heraus, dass für das Gemälde nicht nur Büro- und Medientechnik geliefert, sondern in Bremerhaven ein treuhänderisch verwaltetes Konto mit einem Anfangsbestand von 11.000 DM für Lachs eingerichtet worden war, DSM-intern „Austauschbestand" genannt. Lachs konnte bei seinen Besuchen in Bremerhaven darüber verfügen und Bestellungen von Fachliteratur und „Westwaren" abwickeln.[25] Lachs behielt die Existenz des Kontos aus guten Gründen immer für sich und nach Aktenlage erfuhr selbst das MfS nichts davon. Welche Beträge bis zu Lachs' Entlassung im Herbst 1982 abgebucht worden sind, bleibt offen, da die diesbezüglichen Unterlagen nicht im Hausarchiv des DSM archiviert worden sind. Aus heutiger Sicht lässt sich konstatieren, dass beide Museen von dem Tauschgeschäft profitierten und – sofern keines der Geräte in private Hände überging – keine der beteiligten Personen einen persönlichen Nutzen daraus zog.

Die Rolle des MfS

Der Untersuchungsausschuss versuchte auch die Rolle des MfS im Zusammenhang mit dem „Kulturgutexport" zu beleuchten. Ein Kriminalbeamter hatte den Hinweis gegeben, dass Lachs das Tauschgeschäft auf Weisung von Dr. Heinz Gundlach (1936–2017), Abteilungsleiter Kultur beim Rat des Bezirkes Rostock, und in enger Abstimmung mit seinem damaligen Vorgesetzten Pommerenke eingefädelt hätte. Hintergrund sollte der Plan des MfS gewesen sein, über Lachs und dessen gute Kontakte zum DSM Zugang zu einer internationalen Museumsorganisation zu erhalten. Gemeint war die International Association of Transport and Communications Museums (IATM), die dem Internationalen Museumsrat (ICOM) angeschlossen war. Lachs verneinte dieses Vorhaben, die Initiative sei allein von ihm „und von Bremerhaven" ausgegangen. Welche Interessen vonseiten des Stadtrates Pommerenke oder anderer Stellen bestanden hätten, könne er nicht beurteilen. Ein Zusammenhang mit der Staatssicherheit habe nicht bestanden.[26]

 Dass er gleichwohl vom MfS mit dem Fall „Gemäldetausch" konfrontiert worden war, verschwieg Lachs gegenüber dem Ausschuss.[27] Das MfS hatte Anfang April 1987 mit seinem 1982 bei der Rostocker SED in Ungnade gefallenen IM „Stephan Jantzen" „operative Gespräche" geführt, als deren Folge Lachs entsprechende Dokumente zur Bildausfuhr vorgehalten worden waren, worauf dieser Pflichtverletzungen einräumte. Wie die Ermittler feststellten, sei ein Motiv für den Kunstgutexport die von Lachs angestrebte Aufnahme in den Vorstand der IATM gewesen, wodurch er sich regelmäßige Reisen ins nicht sozialistische Ausland versprochen hätte.[28] Nach Auswertung von IM-Berichten und offiziellen Akten stellte das MfS fest, dass sich zwar Anhaltspunkte für „persönlich-egoistische und kriminelle Motive" zum Handeln Lachs' ergeben hätten. Diese wären aber keine strafrechtlich relevanten „Veruntreuungshandlungen" gewesen. Entscheidend für diese Einschätzung war die Kategorisierung des Gemäldes: Nach einer gutachterlichen Stellungnahme vom 19. November 1986, die der Rostocker Kunstwissenschaftler [Name von BStU geschwärzt] für das MfS angefertigt hatte, gehörte das Gemälde zur Kategorie II und galt als zu schützendes Kulturgut von nationaler Bedeutung. Es hätte nicht ausgeführt werden dürfen. Demgegenüber stand die

Einschätzung von Werner Schmeichler, Vorsitzender der Kulturgutkommission beim Ministerium für Kultur, der 1976 die Ausfuhrgenehmigung für das Gemälde erteilt hatte. Er hatte es in die Kategorie III eingestuft – Kunstwerke von regionaler Bedeutung –, weil es sich nicht um ein Kunstwerk handelte, „dessen Verbringung aus der DDR die Gefahr eines Verlustes für den nationalen deutschen Kunstbesitz mit sich gebracht hätte".[29] Auch sei kein Schaden für das „sozialistische Eigentum" eingetreten, da für den angegebenen Wert des Gemäldes technische Geräte geliefert worden seien. Der Zeitwert des Gemäldes sei sowohl von Schmeichler als auch von der [Name und Funktion von der BStU geschwärzt] bestätigt worden. Für eine mögliche Rückführung des Bildes in den Kunstbesitz der DDR konnten „ebenfalls keine operativen Hinweise erarbeitet werden".[30] Das MfS versäumte nicht zu erwähnen, dass Heinz Gundlach seinen „Freispruch" für Johannes Lachs vom April 1983 aufgrund von „falschen und nicht sachgemäß geprüften Voraussetzungen" – nämlich dem von Lachs für den Ausfuhrantrag absichtlich verringerten Wert des Gemäldes – getätigt hätte.[31] Die MfS-Offiziere klärten Gundlach über die Zusammenhänge des Tauschgeschäftes auf, verzichteten aber aus „politisch-operativen Gründen" auf eine öffentliche Auswertung der Ermittlungsergebnisse.[32] Die Beteiligung hoher SED-Funktionäre in Rostock und Berlin an dem Tauschgeschäft beziehungsweise ihre Kenntnis dessen waren Grund genug, die Ermittlungen nicht weiterzuführen. Im September 1986 schloss die Untersuchungsabteilung des MfS ihre Ermittlungen „zur Ausfuhr eines Ölgemäldes" ab. Die 258 Blatt umfassende Akte wurde der Abteilung XX der BV Rostock übergeben und dort archiviert.[33]

Resümee

Vom Ausschuss zu konkreten Fällen von verschwundenem Kulturgut angehört wurden ehemalige und amtierende Museumsdirektoren und Museumsmitarbeiter wie auch die beiden Abteilungsleiter Kultur beim Rat der Stadt zwischen 1976 und 1990 sowie weitere mit Rostocker Kulturgut befasste Mitarbeiter. Allerdings konnten die Ermittlungsergebnisse die an den Ausschuss gestellten Erwartungen nicht erfüllen. Nicht nur in der Causa Tauschgeschäft mit einem BRD-Museum, sondern auch in anderen Fällen, wie etwa

im Zusammenhang mit den aus einem ungesicherten Museums-
magazin verschwundenen – mutmaßlich gestohlenen – Möbeln
des ehemaligen Warnemünder Lotsenkapitäns Stephan Jantzen
(1827–1913),[34] musste der Ausschussvorsitzende frustriert fest-
stellen, dass die Befragten ihre jeweils sehr eigenen Versionen
der Geschehnisse präsentierten, ohne dass sie für vermutete oder
offensichtliche Falschaussagen zur Rechenschaft gezogen wer-
den konnten.[35] Diese für die Wahrheitsfindung hinderliche Situa-
tion war aber nur ein Grund für das Scheitern des Ausschusses
im Sinne der Aufklärung. Da es sich nicht um einen Parlamenta-
rischen Untersuchungsausschuss handelte, hatte der Ausschuss
keine gesetzliche Grundlage und damit nur beschränkte Befug-
nisse. So konnten zum Beispiel die angehörten Personen nicht ver-
eidigt werden. Ein weiteres Manko bestand in der Tatsache, dass
die Akten der Rostocker Staatsanwaltschaft dem Ausschuss nicht
zur Verfügung standen, sodass die Ausschussmitglieder nicht über
den Stand der Ermittlungen gegen bestimmte SED-Funktionäre in-
formiert waren. Ebenso wenig hatte der Ausschuss Zugang zu den
Akten des MfS, da das Stasi-Unterlagengesetz (StUG), das den Zu-
gang und die Benutzung dieser Akten regelt, erst Ende 1991 in
Kraft trat. Die Öffnung dieser Akten und ihre spätere Auswertung
erlaubten schließlich eine zeithistorische Bewertung der Arbeit
des Rostocker Untersuchungsausschusses und seine weitgehend
gescheiterte Aufklärung.

Peter Danker-Carstensen
Peter Danker-Carstensen war von 1994 bis 2015 Leiter des Schiffbau-
und Schifffahrtsmuseums Rostock.

Endnoten

[1] Norddeutsche Neueste Nachrichten (NNN), 8.10.1990.

[2] Dem Ausschuss gehörten an: Vorsitzender Klaus Böhme (CDU), stellvertretender Vorsitzende Drecoll (SPD) sowie die Bürgerschaftsabgeordneten Krummacher (Bündnis 90), Schütt (SPD), Timm (SPD) und Vaternam (PDS).

[3] Erworben 1870, Inv.-Nr. M 575. Katalog Niederländische Malerei, Grafik und Kunsthandwerk. Bestände des Kulturhistorischen Museums Rostock, hg. vom KHMR, Rostock 1966, S. 16.

[4] Vorlage zu TOP 14 b der Verwaltungsratssitzung DSM am 25.1.1991, Hausarchiv DSM.

[5] Auf dem Warenbegleitschein von 1976 ist nur das Gemälde aufgeführt. StAHRO, VA, Präsidium der Bürgerschaft, Signatur: aus 15/96, UA Kulturgüter, Abschlussbericht, 25.5.1992, S. 19.

[6] Akte Bremerhaven, Nr. 18. Brief von G. Schlechtriem, DSM an J. Lachs, SMR, 7.7.1976.

[7] Brief J. Lachs, SMR, an U. Schnall, DSM, vom 28.7.1976; mündliche Auskunft von Wolf Dieter Hoheisel (früherer DSM-Direktor), 24.9.2014, und Erich Wilke (Bremerhaven), 2.2.2016 und 17.2.2016.

[8] Zu den kommunalpolitischen Nachwehen des Tauschgeschäftes s. Peter Danker-Carstensen: „Juristisch sauber, doch moralisch zweifelhaft" – Zum Umgang mit Kulturgut aus den Rostocker Museen in den 1970er Jahren, in: Zeitgeschichte regional, 19. Jg. , H. 2/2015, S. 31–41.

[9] Ostseezeitung (OZ), 7.12.1989, S. 8.

[10] Ebd.

[11] OZ, 9./10.12.1989, S. 8.

[12] Ebd.

[13] Ebd.

[14] StAHRO, VA, Präsidium der Bürgerschaft, Signatur: aus 15/96, UA Kulturgüter, Protokoll 23.1.1992, S. 4.

[15] Gespräch des Verf. mit Andreas Waack, 10.12.2014. Da Waack nicht wusste, dass in Bremen nicht der Senator für Bildung und Wissenschaft, sondern der Innensenator für die Stiftung DSM zuständig war und es zwischen den Ressorts immer wieder zu Querelen kam, scheint es möglich, dass Waack beschieden wurde, sich mit seinem Anliegen an den zuständigen Senatsbereich zu wenden.

[16] StAHRO, VA, Präsidium der Bürgerschaft, Signatur: aus 15/96, UA Kulturgüter, Protokoll 23.1.1992, S. 4.

[17] Auf der KHMR-Inventarkarte (M 575) wurde am 21.8.1990 von der Sammlungsleiterin vermerkt: „Das Gemälde bleibt Eigentum des KHM Rostock. Es wird ein Dauerleihvertrag mit dem Schiffahrtsmuseum Bremerhaven abgeschlossen." Später wurde von derselben Hand ein „abgelehnt!" hinzugefügt.

18 NNN, 14.3.1991 – Verfasser dieses Gastbeitrages war der Radio-Bremen-Journalist Jürgen Paape. Der Artikel enthielt einige falsche Informationen, denn Paape schrieb, dass ein Bremerhavener Reeder die Geräte für 10.000 DM gekauft und diese ins Rostocker Schifffahrtsmuseum geschafft hätte. Im Gegenzug hätte der Unternehmer das Bild „zum Geschenk" erhalten.

19 Schreiben D. Ellmers, DSM, an Senatorin U. Oschwald, HRO, 19.4.1991, StAHRO, VA, Präsidium der Bürgerschaft, Signatur aus 15/96.

20 Ebd.

21 Schreiben HRO, Senatorin für Bildung, Kultur und Wissenschaft, Oschwald, an DSM, Dr. Ellmers, 29.4.1991, StAHRO, VA, Präsidium der Bürgerschaft, Signatur: aus 15/96, UA Kulturgüter.

22 Ebd.

23 StAHRO, VA, Präsidium der Bürgerschaft, Signatur: aus 15/96, UA Kulturgüter, Abschlussbericht, 25.5.1992, S. 22.

24 Ebd.

25 Interview des Verf. mit Erich Wilke, Verwaltungsleiter DSM, 2.2.2016 und 17.2.2016.

26 StAHRO, VA, Präsidium der Bürgerschaft, Signatur: aus 15/96, UA Kulturgüter, Protokoll 25.11.1991, S. 22f.

27 Zu den Ermittlungen des MfS gegen Lachs siehe Peter Danker-Carstensen: „Zweifellos war das MfS die treibende Kraft im Hintergrund" – Eine biografische Fallstudie zum Umgang des Ministeriums für Staatssicherheit mit unbequemen Inoffiziellen Mitarbeitern, in: Zeitgeschichte regional, 21. Jg., Heft 2/2017, S. 67–84.

28 BStU, MfS, BV Rostock, AIM I 1146/86, Bl. 287, Abschlußbericht OV „Kogge", 8.12.1987.

29 Ebd., Bl. 285/286.

30 Ebd., Bl. 286/287.

31 BStU, MfS, BV Rostock, AIM 2616/86, Bd. I, Bl. 189.

32 BStU, MfS, BV Rostock, AIM I 1146/86, Bl. 288, Abschlußbericht OV „Kogge", 8.12.1987.

33 BStU, MfS, BV Rostock, AIM 2616/86, Übergabeprotokoll der Abt. II, 30.9.1986.

34 Zu der misslungenen Aufklärung des Falles s. Peter Danker-Carstensen: „Eine Anzeige an die DVP zur Fahndung erfolgte nicht" – Des Lotsenkapitäns verschwundene Möbel. Zum Umgang mit Kulturgut aus den Rostocker Museen in den 1970er und 1980er Jahren. In: Zeitgeschichte regional, 22. Jg., Heft 1/2018, Rostock 2018, S. 81–86.

35 StAHRO, VA, Präsidium der Bürgerschaft, Signatur: aus 15/96, UA Kulturgüter, Abschlussbericht, 25.5.1992, S. 23–25.

Konferenznachlese

„Enteignet, entzogen, verkauft"
Eine Podiumsdiskussion zum Stand der Aufarbeitung der SBZ/DDR-Kulturgutverluste

Mathias Deinert

"Expropriated, confiscated, sold." A panel discussion on the current state of research into the losses of cultural property in the Soviet occupation zone (SBZ) and in the former GDR

On the eve of its autumn conference 2020, the German Lost Art Foundation invited participants to a panel discussion at the Leopoldina National Academy of Sciences in Halle (Saale). As a prelude and introduction to the actual conference day and after almost four years of historical context research on seizures in the SBZ and GDR, the panel was to assess the current situation.

The host Stefan Nölke from Mitteldeutscher Rundfunk (Central German Broadcasting) welcomed four penalists:

Ulrike Lorenz, president of the Klassik Stiftung Weimar since 2019, one of the most important cultural institutions in Germany, referred to the mission statement of her institution making the proactive evaluation of cultural property losses 1945–1989 a central task—especially since, according to initial estimates, the number of questionable object provenances from this period exceeds that of Nazi-looted art by a factor of nine.

Roland Jahn, Federal Commissioner for the Stasi Records, openly called the GDR an "Unrechtsstaat" (unconstitutional or criminal state), where arbitrary action was taken in the interest of retaining power also in the area of cultural property protection and expropriation. He stressed the all-German dimension of coming to terms with the past and encouraged people not to wait for political commitment, but rather to bring about a historical reappraisal through civic engagement.

Ulf Bischof, a Berlin-based lawyer and publicist, made it clear that research is not just about the objects and mechanisms involved, but first and foremost about the victims behind them and their fates. If the current legal status quo remained, public collections would indeed identify their problematic property, but would not return it to the previous owners, since all claims are already statute-barred.

Uwe Hartmann, head of the provenance research department at the German Lost Art Foundation in Magdeburg, emphasized that research on object movements between 1945 and 1990 should not be carried out "on the side" by cultural property heritage institutions, but by specialized collection historians and provenance researchers—provided that society wants it and that it contributes to domestic reconciliation. Thus, the political level is called upon to strengthen the foundations laid in this regard.

Zum 29. November 2020, dem Vorabend der Herbstkonferenz, hatte das Deutsche Zentrum Kulturgutverluste zu einer Podiumsdiskussion nach Halle (Saale) in die Nationale Akademie der Wissenschaften Leopoldina eingeladen. Als Auftakt und Einleitung zum eigentlichen Konferenztag und nach fast vier Jahren Grundlagenforschung im Aufgabenfeld SBZ/DDR galt es, eine Standortbestimmung vorzunehmen. ℘ Die Diskussion sollte auf das Thema einstimmen und der Konferenz bereits dahingehend Profil geben, welches Optimum an Aufarbeitung fachlich noch anzustreben oder politisch noch zu wünschen sei.

℘ Vgl. Beiträge von Mathias Deinert, S. 1, und Joëlle Warmbrunn, S. 298.

Aufgrund der Corona-Beschränkungen musste die Podiumsdiskussion ohne Saalpublikum stattfinden – also auch ohne Raunen, Zwischenfragen und Meinungsäußerungen, das heißt ganz ohne Reibung mit einer interessierten Öffentlichkeit. Doch der Mitteldeutsche Rundfunk als Medienpartner zeichnete die Diskussion auf und sendete sie am übernächsten Tag in seiner Reihe „MDR-Kultur Werkstatt", ℘ sodass eine kritische Auseinandersetzung immerhin nachträglich und privatim möglich war. Der MDR gestaltete auch die Moderation auf dem Podium: Das Hervorkitzeln, Herausstellen oder Gegeneinandersetzen unterschiedlicher Standpunkte lag damit beim Geschichtsredakteur Stefan Nölke als Gesprächsleiter.

℘ www.ardaudiothek.de/episode/ gespraeche/enteignet-entzogen- verkauft-zur-aufarbeitung-der- kulturgutverluste-in-der-ddr/ mdr-kultur/83806422

Aufs Podium geladen waren Ulrike Lorenz, seit 2019 Präsidentin der Klassik Stiftung Weimar (KSW), einer der bedeutendsten Kultureinrichtungen Deutschlands, welche die Provenienzforschung zur Zeit vor und nach 1945 in ihr Leitbild aufgenommen hat,[1] Roland Jahn, seit 2011 Bundesbeauftragter für die Unterlagen des Staatssicherheitsdienstes der ehemaligen DDR (BStU), vorher Journalist und auch mit der Aufarbeitung des DDR-Kulturgutentzugs beschäftigt, Ulf Bischof, Berliner Rechtsanwalt und Publizist, dessen Mandanten vielfach Opfer staatlichen Kulturgutentzugs waren und deren Anliegen er in der Öffentlichkeit vertritt, und Uwe Hartmann, Leiter des Fachbereichs Provenienzforschung am Deutschen Zentrum Kulturgutverluste in Magdeburg.

℘ „Entziehungen von Kulturgütern in SBZ und DDR. Der Stand der Forschung und die Perspektiven". Fachöffentliche Konferenz am 21. November 2016 in Kooperation mit der Stiftung Brandenburger Tor

Wer noch das Podiumsgespräch im Vorfeld der Herbstkonferenz 2016 ℘ in Erinnerung hatte,[2] bemerkte einen entscheidenden Unterschied: Standen damals mit der sogenannten Bodenreform, der „Republikflucht", konfiskatorischen Steuermaßnahmen und der Kulturgutschutz-Gesetzgebung noch Schilderung und historische

Abgrenzung einzelner Entzugsarten im Mittelpunkt des Gesprächs, so war 2020 die übergeordnete Frage des wissenschaftlichen und praktischen Umgangs damit Dreh- und Angelpunkt, auf den das Gespräch immer wieder zurückkam.

Bei der Frage nach der Aufarbeitung des Komplexes seit 2015 durch das Deutsche Zentrum Kulturgutverluste konnte Uwe Hartmann zunächst auf die Erschließung zweier wichtiger Überlieferungsbestände – des Staatlichen Kunsthandels der DDR und der Kunst und Antiquitäten GmbH – im Bundesarchiv verweisen, ebenfalls auf die Erarbeitung eines Spezialinventars zu den Stasi-Unterlagen.[3] Die Grundlagenforschung SBZ/DDR, die vom Zentrum seit 2017 gezielt gefördert wird, soll wiederum Voraussetzungen verlässlicher Forschung schaffen – sowohl mit dem Aufbau einer hilfreichen Infrastruktur als auch durch Fallstudien. ✐

Zum Stand der Aufarbeitung in den sammelnden Einrichtungen berichtete Ulrike Lorenz von ihren eigenen Erfahrungen und Eindrücken: Während 13 Jahren als Museumsdirektorin in Gera habe sie die Aufarbeitung des Komplexes gemäß Vermögensgesetz (1990) und gemäß Ausgleichsleistungsgesetz (1994) kennen-

Teilnehmer der Podiumsdiskussion v. l. n. r.: Ulf Bischof, Uwe Hartmann, Ulrike Lorenz, Roland Jahn und MDR-Moderator Stefan Nölke

✐ Vgl. Beitrag von Mathias Deinert, S. 1.

Ulrike Lorenz, Präsidentin der Klassik
Stiftung Weimar

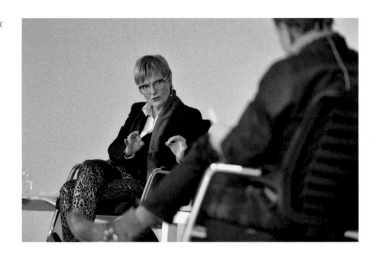

gelernt. Eingebunden in die Vermögensauseinandersetzungen mit dem Haus Reuß-Gera jüngere Linie, hatte sie eine gütliche Einigung über den beanspruchten Besitz miterreichen können. Danach habe sie weder in Regensburg noch in Mannheim, obgleich in leitender Position, irgendeine Berührung mit solchen Fragen gehabt. „Das Thema ist im Westen noch nicht angekommen, obwohl es westliche Museen ebenso betrifft."

Erst in Weimar stand Provenienzforschung für die Zeit nach dem Kriegsende 1945 dann wieder auf ihrer Agenda. Um die Größenordnungen zu verdeutlichen, gab sie hier einen Vergleich zu NS-verfolgungsbedingt entzogenem Kulturgut: Die KSW habe 39.000 Erwerbungen aus der NS-Zeit einem Erstcheck unterzogen und in 11.000 Fällen sei aufgrund von Verdachtsmomenten eine vertiefende Erschließung erfolgt. Von diesen 11.000 Fällen seien wiederum 2.700 Objekte restituiert – und dann teilweise zurückgekauft worden. Für die Zeit zwischen 1945 und 1990 hingegen „haben wir das Neunfache an Erwerbungen, das heißt 290.000 Erwerbungen an Kunst, Büchern, Archivalien. Sie verstehen, dass wir da als Stiftung, die auch mit wirtschaftlichen Überlegungen umgehen muss, kurz innehalten und überlegen müssen, wie wir das angehen. Wir haben uns entschieden, 2020 und 2021 zunächst ein Mengengerüst zu erstellen, also prinzipiell den Rahmen abzustecken, und werden daraufhin eine strategische Entscheidung fällen, wie wir mit der Provenienzforschung in Bezug auf SBZ und DDR weiter umgehen wollen."

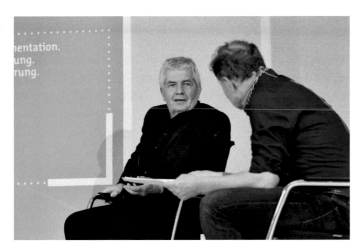

Roland Jahn, bis Juni 2021 Bundes-beauftragter für die Unterlagen des Staatssicherheitsdienstes der ehemaligen DDR

Da den Moderator das Desinteresse der Museumsleute in den alten Bundesländern an problematischen Provenienzen 1945 bis 1990 verwunderte, kam er noch einmal darauf zurück. „Das meiste landete im Westen, landete im Export. Gibt es irgendein Bewusstsein darüber, was da womöglich schlummert an dubiosen Beständen?" Dies könne sie ganz klar mit Nein beantworten, entgegnete Ulrike Lorenz. Desto mehr müsse man darauf hinweisen, „dass in diesem Forschungsbereich ein gesamtstaatliches, ein gesamtdeutsches Problem besteht".

Nachdrücklich forderte auch Roland Jahn, dies als gesamtdeutsche Aufgabe zu behandeln. Und noch einen Schritt weiter ging er: Es stelle sich dabei stets die Frage nach der Mitverantwortung westlicher Handelspartner und ihrer heutigen Haltung dazu. Das betreffe auch jene westlichen Firmen, die davon profitierten, dass ihre Erzeugnisse von Häftlingen in DDR-Gefängnissen konkurrenzlos günstig produziert wurden. Wer sich damals am Kunst- und Antiquitätenhandel zwischen Ost und West beteiligte, der habe wissen können, dass großteils Waren zweifelhafter Herkunft angeboten wurden – beispielsweise Gegenstände, die bei der Ausreise entweder aufgrund des Kulturgutschutzes oder unter sonstigem Druck zurückgelassen werden mussten. „Wir sind jedenfalls dazu bereit, hier weitere Dokumente zur Verfügung zu stellen. Ich glaube, in den Archiven findet sich dazu noch einiges."

Auf die Frage des Moderators nach der absoluten Anzahl betroffener Objekte in kulturgutbewahrenden Einrichtungen der Republik antwortete Uwe Hartmann, dass darüber eine abschließende

Aussage zu treffen schwierig sei. Nach wie vor seien die Häuser nicht mit ausreichend Personal und Mitteln für Tiefenprüfungen ausgestattet, deshalb erwarte er von der politischen Ebene, „dass wir und die Öffentlichkeit in der nächsten Zeit von den Ämtern zur Regelung offener Vermögensfragen eine Bilanz erfahren: Wie viele Verfahren hat es gegeben, wann sind sie wie abgeschlossen worden, wie viele Objekte konnten restituiert werden?" Wie es mit der Provenienzforschung für die Zeit nach 1945 im Einzelnen weitergehe, werde der Stiftungsrat des Zentrums entscheiden.

Während der gesamten Diskussion war Rechtsanwalt Ulf Bischof immer dann um seine Einschätzung gebeten worden, wenn es um Begriffsinhalte wie die sogenannte Würdigkeitsprüfung bei der Rückgabe beweglicher Sachen aus der Bodenreform gegangen war, die Struktur staatlicher Willkür, die etwa in der konstruierten Besteuerung zahlreicher Sammler in der DDR zutage trat, oder die heutige Einordnung historischer Umstände wie der Kulturgutschutz-Gesetzgebung im Widerspruch zum DDR-Außenhandelsbereich KoKo. Dabei blieb es ihm stets wichtig zu verdeutlichen, dass bei der Aufarbeitung nicht allein die Dinge und Mechanismen, sondern in erster Linie die dahinterstehenden Menschen und deren Schicksale gesehen werden sollten.

Konkret auf die Möglichkeiten der Aufarbeitung und Wiedergutmachung angesprochen, sah Uwe Hartmann jene Schwierigkeiten zeitlich versetzt wiederkehren, mit denen auch die Aufarbeitung des NS-Kulturgutraubes umzugehen hatte: Zwar habe es vor gut 30 Jahren mit dem Vermögens- sowie dem Ausgleichsleistungsgesetz für die Zeit von 1945 bis 1990 natürlich rechtliche Grundsätze für Rückgaben und Wiedergutmachungen gegeben. Doch deren Geltungsfristen waren kurz und sind heute längst abgelaufen, sodass Betroffene, die damals aus verschiedensten Gründen keinen Antrag auf Rückgabe stellten, keine Berechtigung mehr besäßen. Aus wissenschaftlicher wie aus gesellschaftlicher Sicht aber müssten wir über diese Zeiträume hinausdenken: Museen wollen wissen, was sie in ihren Sammlungen haben und unter welchen Bedingungen diese Sammlungsstücke wann genau ans Haus gekommen sind. Hierzu bestehe enormer Forschungsbedarf.

Solange keine Verpflichtung mehr zur Aufarbeitung dieser Fragen bestehe, wie noch in den 1990er-Jahren, sei es in jedem

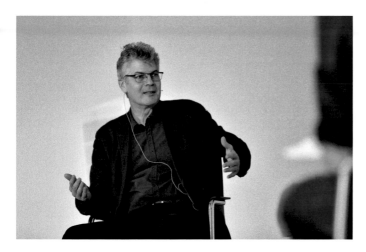

Uwe Hartmann, Leiter des Fachbereichs Provenienzforschung am Deutschen Zentrum Kulturgutverluste

einzelnen Fall Sache der jeweiligen Institution oder eines Trägers zu entscheiden, bestimmte Objekte aus museumsethischen Gründen ihren Voreigentümern zurückzugeben. Ein Museumsdirektor sei in solchen Belangen auch nicht alleiniger Entscheider, sondern die verantwortlichen Gremien müssten sich jedes Mal aufs Neue damit auseinandersetzen. Und wenn beispielsweise das Rechtsamt einer Stadt formaljuristisch korrekt argumentiere und das städtische Museum auffordere, die Gesetzeslage einzuhalten, dann bleibe es beim Status quo – dann erfolge weder Restitution noch Entschädigung.

Von Ulf Bischof wollte der Moderator erfahren, ob es nicht allmählich angezeigt wäre, sich für die Aufarbeitung des Kulturgutentzugs in SBZ und DDR auf eine ähnliche Willensbekundung zu verständigen, wie sie die Washingtoner Prinzipien (1998) und die Gemeinsame Erklärung von Bund und Ländern (1999) für NS-Raubgut darstellen.

„Auf jeden Fall", betonte Bischof. „Wenn wir hier heute besprochen haben, dass die Forschung zu diesem ganzen Kontext jetzt 30 Jahre nach der Wiedervereinigung erst in Schwung kommt, dann ist klar, dass Sie das in vielen Fällen juristisch nicht mehr fassen können – weil es einfach zu spät ist. 🖉 Wenn Museen aus solchen Enteignungskontexten etwas finden, braucht es eine politische Erklärung, die aus moralischen Gründen eine Rückgabe an die Betroffenen erlaubt." Ansonsten stünden die Einrichtungen als sozusagen letzte Verantwortliche in einem juristisch-moralischen Dilemma. Diese Willenserklärung erfordere jedoch Forschung und

🖉 Z. B. durch Verjährung von Herausgabeansprüchen

Ulf Bischof, Rechtsanwalt und Publizist

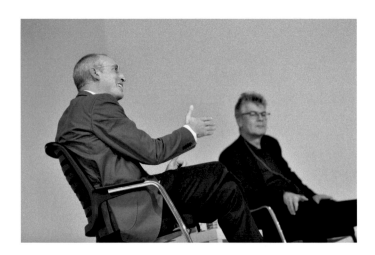

die nötigen Mittel dafür. „Und wir brauchen einen Streitlösungs-
mechanismus, weil es immer auch Streitfälle geben wird, wo der
Anspruchsteller und die Museen nicht übereinkommen."

An dieser Stelle kam das Problembewusstsein der Leiter und Mit-
arbeiter von sammelnden Kultureinrichtungen zur Sprache. Ob es
nicht generell so sei, dass ein Museumsleiter ungern Objekte her-
ausgebe, erkundigte sich Stefan Nölke. Hierzu versicherte ihm je-
doch Ulrike Lorenz, dass das Bewusstsein heutiger Museumsfach-
leute zumindest kontinuierlich wachse. Sie erläuterte das Leitbild
der Klassik Stiftung Weimar, den Stellenwert der Provenienzfor-
schung darin sowie den gesellschaftlichen Auftrag zur Transparenz,
den jede öffentlich-rechtliche Einrichtung habe. Wenn man jedoch
nach den Konsequenzen von Forschung und Aufklärung frage,
komme es mitunter zum Konflikt mit der Verpflichtung zum Ver-
mögenserhalt einer Stiftung wie der KSW. Im Rahmen der gesetz-
lichen Regelungen tue man jedoch auch heute in Weimar schon
das Möglichste.

Hier entgegnete Ulf Bischof, dass dies leider genau der Punkt
sei, an dem man heute im Bereich SBZ/DDR stehe: Denn „ange-
messene Lösungen im Rahmen der Gesetze" hießen real nichts
anderes, als dass man vielleicht etwas Problematisches besitze, es
aber nicht herausgeben könne, wenn kein schriftlicher Anspruch
aus den 1990er-Jahren vorliege. Überhaupt sei zivilrechtlich je-
der Herausgabeanspruch verjährt, weil bereits 30 Jahre abgelau-
fen sind. Insofern hätten Betroffene, deren entzogenes Eigentum

man heutzutage in einer Sammlung fände, erneut „leider Pech". Beim Wiederbeginn der Aufarbeitung des NS-Raubguts sei diese Problemlage berücksichtigt worden: Auch hier habe man mit sehr kurzen historischen Antragsfristen als rechtlicher Hürde umgehen müssen. So sei es zur Gemeinsamen Erklärung von Bund, Ländern und kommunalen Spitzenverbänden 1999 gekommen, die rückgabebereiten Institutionen nun als legitimierende Grundlage dienen könne: „Da hat man nicht die Klammer gesetzt ‚im Rahmen der geltenden Gesetze' – denn solche Gesetze, die gab es nicht mehr."

Ulrike Lorenz stimmte ihm zu: „Wir warten auf eine politische Entwicklung der Frage. Ich bin da ganz bei Ihnen."

„Warten?", unterbrach Roland Jahn. „Dann können wir lange warten. Wir müssen alle dazu beitragen, dass diese politische Entwicklung kommt. Da ist Ihre Stimme genauso gefragt wie die eines SED-Opfer-Beauftragten🔗, um klar und deutlich zu machen, dass die bisherige Regelung den Menschen und auch dem Anspruch des Umgangs mit Kulturgut nicht gerecht wird." Auch kritisierte Jahn die behördlich allen Betroffenen des Kulturgutentzugs abverlangte Nachweis- und Beweispflicht – „die fast nicht leistbar ist" – bereits in den Antragsverfahren der 1990er-Jahre. Man müsse sich bewusst bleiben, dass die DDR kein Rechtsstaat, sondern ein Unrechtsstaat gewesen sei, „wo im Interesse des Machterhalts nach Belieben gehandelt worden ist. Das müssen wir berücksichtigen, wenn wir heutzutage einen Umgang mit den Opfern finden wollen, der ihnen gerecht wird."

Der Moderator wandte sich hierauf abschließend an Uwe Hartmann: Wie zuversichtlich man sein könne, in fünf Jahren bei dieser Diskussion noch ein gutes Stück weiter vorangekommen zu sein? Hartmann knüpfte an Ulrike Lorenz' positive Einschätzung der Verantwortlichen in kulturgutbewahrenden Einrichtungen an und verwies auf deren inzwischen tägliches Hinterfragen des tradierten, eurozentrischen Sammlungsgedankens. Sensibilisiert seien diese Fachleute durch Diskussionen, die vor etwa 20 Jahren mit dem ungenügend aufgearbeiteten Kapitel des NS-Raubguts in öffentlichen Einrichtungen begannen und die aktuell weitergingen mit dem globalen Thema kolonialer Sammlungsgüter. Auch auf Roland Jahns Einwand der ungerechten Beweislastverteilung bei Ansprüchen nahm Hartmann Bezug und bestätigte, dass weder ein einstiger Ausreiseantragsteller noch ein Flüchtling überhaupt

🔗 *Seit dem 17. Juni 2021 ist die ehemalige DDR-Bürgerrechtlerin Evelyn Zupke als Bundesbeauftragte für die Opfer der SED-Diktatur beim Deutschen Bundestag in diesem (neu geschaffenen) Amt.*

wissen könne, wo sein zurückgelassener Besitz heute zu finden und anzufragen wäre. Deswegen müsste diese Art der Forschung von Sammlungshistorikern und Provenienzforschern geleistet werden – sofern die Gesellschaft es wolle und sofern es zu ihrer Aussöhnung und ihrem inneren Frieden beitrage.

Moderator Stefan Nölke bedankte sich nach fast anderthalb Stunden bei den Podiumsgästen mit einigen zusammenfassenden Worten: „Die Gesellschaft ist also gefordert, die Politik ist gefordert, aber auch die Museen sind gefordert, jetzt die Provenienzforschung für die Zeit nach 1945 voranzutreiben. Und klar ist auch, dass das eine gesamtdeutsche Aufgabe ist und für die nächsten Jahre sein wird."

Mathias Deinert
Mathias Deinert ist wissenschaftlicher Referent im Fachbereich Provenienzforschung am Deutschen Zentrum Kulturgutverluste in Magdeburg.

Endnoten

[1] „Im Jahr 2011 wurde die Provenienzforschung als Aufgabe im Leitbild der Klassik Stiftung Weimar verankert. Ab 2020 wenden sich die Recherchen dem Erwerbungszeitraum ab dem 9. Mai 1945 zu und werden über NS-verfolgungsbedingte Entziehungen hinaus auf unrechtmäßige Entziehungen während der sowjetischen Besatzung (SBZ) und der DDR-Zeit ausgeweitet." Zitat aus: Provenienzforschung – Klassik Stiftung Weimar, unter https://www.klassik-stiftung.de/forschung/forschungsaktivitaeten/provenienzforschung/ (20.4.2021).

[2] „Beschlagnahmt, enteignet, verkauft: Der staatliche Kunstraub in der DDR", Erstausstrahlung am 16.11.2016 in der Reihe „SWR2-Forum", Gesprächsleitung Susanne Kaufmann.

[3] Auf der Suche nach Kulturgutverlusten. Ein Spezialinventar zu den Stasi-Unterlagen. Bearb. von Ralf Blum, Helge Heidemeyer und Arno Polzin. Hg. vom Bundesbeauftragten für die Unterlagen des Staatssicherheitsdienstes der ehemaligen DDR und dem Deutschen Zentrum Kulturgutverluste, Berlin 2020.

„VEB Kunst" – Kulturgutentzug und Handel in der DDR
Bericht zur Herbstkonferenz am 30. November 2020

Joëlle Warmbrunn

"VEB Kunst"—cultural property confiscation and trade in the GDR.
Report on the digital conference on November 30, 2020
On November 30, 2020, the German Lost Art Foundation invited participants to the digital conference "'VEB Kunst'—Kulturgutentzug und Handel in der DDR" (State-owned art business: Cultural property confiscation and trade in the GDR) in order to summarize the last three years of basic research on the confiscation of cultural property in the Soviet occupation zone (SBZ) and the GDR and to identify current scientific and political needs for action.

By the time of the conference, a total of seven basic research projects had been funded by the Foundation, five of which have already been completed. The results of these projects should serve as a scientific base and enable a museum-ethical classification of individual types of loss and acquisition between 1945 and 1990. Thus, some important spoliation contexts in the SBZ and GDR could already be processed and archive research could be facilitated by newly developed special inventories. The conference provided information on several of these results. Another focus was on the regulation discrediting and criminalization of the art trade. The history of two galleries was used to illustrate the possibilities and limits of both the art trade and collecting, as well as the lively, unregulated cultural exchange. The business documents of the Kunst und Antiquitäten GmbH (Art and Antiques Ltd.) and Staatlicher Kunsthandel der DDR (State Art Trade of the GDR), which have been made accessible, provide information about buyers and business methods. Multiple contexts of seizure and the international entanglement of the GDR art trade were also discussed. For this reason, coming to terms with the seizures must not remain an East German task alone. Further political and financial support as well as cross-national awareness are required to continue the research.

Vier Jahre nach der ersten Tagung zu Kulturgutentziehungen in der DDR und der Sowjetischen Besatzungszone (SBZ) lud das Deutsche Zentrum Kulturgutverluste am 30. November 2020 zur Herbstkonferenz „VEB Kunst' – Kulturgutentzug und Handel in der DDR" ein.[1] Rund 170 Wissenschaftler:innen, Expert:innen und Interessierte fanden sich im digitalen Raum ein, um nach drei Jahren Grundlagenforschung den Status quo zu eruieren sowie aktuellen wissenschaftlichen und politischen Handlungsbedarf festzustellen.

Nachdem Staatsminister Rainer Robra, Chef der Staatskanzlei und Minister für Kultur von Sachsen-Anhalt, in einer aufgezeich-

neten Videobotschaft die Wichtigkeit der historischen Aufarbeitung von Kulturgutentziehungen in der SBZ und der DDR betont und politische Unterstützung zugesagt hatte, 🔗 bilanzierte Gilbert Lupfer, Vorstand des Deutschen Zentrums Kulturgutverluste, die letzten drei Jahre. 🔗 Für die weitere Forschung, für Betroffene, Nachfahr:innen, Museen und andere Institutionen solle die geleistete Grundlagenforschung als Wissensfundus dienen. Es sei nicht Absicht, den Fokus auf Restitutionen zu setzen, sondern vielmehr eine fundierte, differenzierte und museumsethische Umgangsweise mit Kulturgütern zu ermöglichen. Wichtig sei ferner, den Unterschied zum Umgang mit NS-Raubgut zu betonen. Während es hierfür durch die Washingtoner Erklärung und Folgedokumente etablierte Verfahrensabläufe gibt, sind die Antragsfristen auf Grundlage expliziter Gesetze zu Rückforderungen von entzogenem Kulturgut der Zeit zwischen 1945 und 1989 bereits verstrichen. Ab 1990 galt das Vermögensgesetz (VermG) für Entziehungen zur Zeit der DDR, das Entschädigungs- und Ausgleichsleistungsgesetz (EALG) ab 1994 regelte Kompensationen für Verluste zur Zeit der SBZ.[2] Die Fristen zur Antragstellung sind für das VermG seit 30. Juni 1993, für das Ausgleichsleistungsgesetz (AusglLeistG) als Teil des EALG seit 31. Mai 1995 abgelaufen.[3] Das Zentrum könne aufgrund der unterschiedlichen Bewertung der rechtlichen Lage der historischen Kontexte nicht garantieren, dass Forschung zu Entziehungen im Kontext der DDR und SBZ künftig ebenso gefördert wird wie die zu Entziehungen im Nationalsozialismus oder in kolonialen Kontexten. Hierüber entscheide nicht das Zentrum selbst, sondern dessen Stiftungsrat, so Lupfer.

In der ersten Sektion lagen „DDR-Museen im Spannungsfeld zwischen Kulturgutentzug und Kunsthandel" im Fokus. Mathias Deinert, Referent am Deutschen Zentrum Kulturgutverluste, resümierte die vom Zentrum seit 2017 finanzierten Grundlagenforschungsprojekte. 🔗 Der Stiftungsrat hatte entschieden, zunächst Grundlagenforschung zu fördern, um einen Überblick über die Quellensituation in Archiven zu erhalten, Entzugsfälle richtig einordnen und weitere Konsequenzen ziehen zu können.[4] Mit sieben Kooperationspartner:innen hat das Zentrum seither Projekte entwickelt. Gemeinsam mit dem Hannah-Arendt-Institut für Totalitarismusforschung e. V. an der TU Dresden wurde die „MfS-Aktion ‚Licht' 1962" aufgearbeitet. Die Ergebnisse erstaunen und

🔗 *Vgl. Grußwort von Rainer Robra, S. VIII.*

🔗 *Vgl. Vorwort von Mathias Deinert, Uwe Hartmann und Gilbert Lupfer, S. XVI.*

🔗 *Vgl. Beitrag von Mathias Deinert, S. 1.*

zeigen, dass die Beschlagnahme von Kulturgut bei der Aktion nicht an erster Stelle stand, sondern sie vielmehr stattfand, um Machtstrukturen des SED-Staates zu testen.[5] Im zweiten Projekt wurde mit der Behörde des Bundesbeauftragten für die Unterlagen des Staatssicherheitsdienstes der ehemaligen DDR (BStU) ein „Spezialinventar für ausgewählte Aktenbestände des MfS zu Entziehungen von Kunst- und Kulturgut in der SBZ und der DDR unter dem Aspekt der Provenienzforschung" entwickelt.[6] Dieses Findmittel ermöglicht, eigenständig zu Künstler:innennamen, Werktiteln oder Geschäften des Kunst- und Antiquitätenhandels zu recherchieren. Anhand des dritten Kooperationsprojekts „Zwischen Schlossbergung und Kommerzieller Koordinierung. Pilotprojekt zur Untersuchung kritischer Provenienzen aus der Zeit der SBZ und DDR in Brandenburgischen Museen" mit dem Museumsverband des Landes Brandenburg e. V. ℘ wurde stellvertretend für viele Recherchen und Transparenzbemühungen auf datenschutzrechtliche Probleme hingewiesen. Aufgrund der im Vergleich zum NS-Kunst- und Kulturgutraub jüngeren Ereignisse müssen datenschutzrelevante Personenangaben in Veröffentlichungen geschwärzt werden. Der Abschlussbericht des Museumsverbandes liefert Informationen darüber, wie sich die Kulturgutentziehungen beispielhaft in vier ehemaligen DDR-Museen darstellen.[7] Mit der Kulturstiftung Sachsen-Anhalt als Kooperationspartnerin wurde in einem weiteren Projekt „Die Moritzburg in Halle (Saale) als zentrales Sammellager für Kunst- und Kulturgut, das in der Provinz Sachsen durch die sogenannte Bodenreform enteignet und entzogen wurde" erforscht. Am Deutschen Historischen Museum (DHM) wurde als Grundlagenforschungsprojekt eine „Repräsentative Studie zu den Übergaben staatlicher Institutionen und Organisationen an das Museum für Deutsche Geschichte der DDR" durchgeführt. Die zwei letzten Kooperationsprojekte „Umgang der Verwaltungsinstanzen im ehemaligen Bezirk Schwerin mit Kulturgut aus Flüchtlings-Rücklässen von 1945 bis 1989" mit dem Museumsverband Mecklenburg-Vorpommern e. V. und „Die Rolle und Funktion des Staatlichen Museums Schwerin zwischen 1945 und 1990 beim Umgang mit entzogenen Kulturgütern auf dem Gebiet des ehemaligen DDR-Bezirks Schwerin" mit den Staatlichen Schlössern, Gärten und Kunstsammlungen Mecklenburg-Vorpommern befinden sich in der Forschungsphase. Weitere

℘ *Vgl. Beitrag von Alexander Sachse, S. 245.*

Projekte zu Institutionen, Akteur:innen und Netzwerken in Westdeutschland wurden 2020 angestoßen. Im Online-Portal Provenienzforschung wurde zudem ein Gruppenforum gebildet, das Wissenschaftler:innen, die zu diesen Themen forschen, vernetzen soll.[8]

Anschließend referierte Jan Scheunemann zum bereits erwähnten Kooperationsprojekt, das sich der Moritzburg in Halle (Saale) widmete. ✎ Er skizzierte das Ausmaß der Bodenreform sowie der kommerziellen Verwertung von enteigneten und entzogenen Kunst- und Kulturgütern, bevor er den Blick auf die Moritzburg lenkte, die als Depot für entzogenes Kulturgut aus der Bodenreform diente. 1950 wurde hier die Landesgalerie Sachsen-Anhalt gegründet, in deren Bestand Kulturgüter aus der Bodenreform übergingen. Fünf Jahre später erging durch die Stadtverwaltung die Aufforderung, „abgabefähige Depotbestände" zur Finanzierung von Kultureinrichtungen zu verkaufen, und schließlich wurde das Ministerium für Kultur auf das kommerzielle Verwertungspotenzial der Kulturgüter aus der Bodenreform aufmerksam: Der Minister für Kultur der DDR, Hans Bentzien, wies die Museen am 1. Oktober 1963 an, bestimmte Kunst- und Kulturgüter zwecks Devisenbeschaffung dem Staatlichen Kunsthandel zur Verfügung zu stellen. Das inzwischen in Staatliche Galerie Moritzburg (Halle) umbenannte Museum gab daraufhin ein großes Konvolut ab. Auch 22 weitere Museen stellten für die sogenannte Sonderaktion Leipzig Objekte bereit. Die Rolle der Museumsmitarbeiter:innen, die dieser Anweisung sehr unterschiedlich begegneten, sei differenziert zu betrachten.

✎ Vgl. Beitrag von Jan Scheunemann, S. 201.

Doris Kachel berichtete über das im DHM durchgeführte Kooperationsprojekt, welches erst im November 2020 endete und die Sammlungsgeschichte des Museums für Deutsche Geschichte der DDR (MfDG) behandelte, dessen Bestände nach Auflösung ans DHM übergegangen waren. ✎ Das 1952 gegründete Museum verzeichnete bereits wenige Jahre nach seiner Etablierung eine umfangreiche Sammlungserweiterung, die auch mit Translokationen von entzogenem Kulturgut in Verbindung steht. Ziel des Projekts war es, Erwerbspraxis, Akteur:innen sowie Mechanismen der Translokationen zu eruieren. Hierbei wurde neben des Enteignungskontextes der Bodenreform und der Schlossbergungen auch die Übergabe von Gütern aus Fluchtkontexten an das MfDG be-

✎ Vgl. Beitrag von Doris Kachel, S. 45.

handelt. Viele Objekteingänge in das MfDG erfolgten durch staatliche Institutionen und Organisationen der DDR.[9]

In der anschließenden Diskussion wurden Fragen besprochen, die parallel zu den Vorträgen im Chat gestellt werden konnten, der darüber hinaus als vernetzende Plattform diente: Literatur und Hinweise wurden verschickt, Tagungsinhalte offen oder privat diskutiert – ein großer Vorteil der digitalen Konferenz. Dass die Dimension der entzogenen Kunst- und Kulturgüter in der SBZ und der DDR unterschätzt wurde, verneinten Mathias Deinert und Jan Scheunemann. Trotzdem sei wahrscheinlich, dass die Menge an Objekten mit ungeklärter Provenienz in Museen deutlich höher sein könnte als die Anzahl NS-verfolgungsbedingt entzogener Kunst- und Kulturgüter, was insbesondere durch die Bodenreform zu erklären ist. Allerdings wurden bereits seit den 1990er-Jahren in Museen diesbezüglich Provenienzen erforscht und Werke aus der Bodenreform restituiert. Dennoch besteht ein großer Forschungsdruck ob der Quantität der entzogenen Objekte. Dieses Fazit müsse sich auch in einem politischen Willen zur Förderung abbilden. Finanzielle Mittel und Unterstützungen seien für weitere Erforschung nötig.

In der zweiten Sektion wurde der „DDR-Kunsthandel im Spannungsfeld zwischen Monopol und Missbilligung" behandelt. Uwe Hartmann, Leiter des Fachbereichs Provenienzforschung am Deutschen Zentrum Kulturgutverluste, berichtete über die Kulturpolitik und den Kunst- und Antiquitätenhandel in der DDR und nahm dabei bildende Künstler:innen wie Gerhard Richter und deren Rezeption in der DDR in den Blick. ⸂ Im Diskurs um die Provenienzforschung zur DDR sonst eher zweitrangig, bot dieser Blick viel Aufschluss über das Kunstverständnis des sozialistischen Staates. Weiter thematisierte Hartmann die Reglementierung, Diskreditierung und Kriminalisierung des Kunsthandels. Die hierdurch entstandenen Verunsicherungen führten sowohl in breiten Kreisen der Bevölkerung in der DDR als auch unter den Mitarbeiter:innen der Museen und Kultureinrichtungen zu einem latenten und nahezu permanenten Misstrauen gegenüber den staatlichen Kunsthandelsbetrieben und Antiquariaten. Es blieb das ungute Gefühl, dass der An- und Verkauf nicht „auf reeller ökonomischer Grundlage" erfolgte, wie es Curt Belz, der Leiter des ersten Kunsthandelsgeschäfts der Handelsorganisation (HO), 1956 angepriesen hatte.

⸂ *Vgl. Beitrag von Uwe Hartmann, S. 181.*

Zumal er selbst unter dem Vorwurf der Untreue sechs Jahre später seine Tätigkeit beenden musste.

Die Vorträge der Kunsthistorikerinnen Claudia Maria Müller und Christin Müller-Wenzel beleuchteten das Schicksal zweier Kunsthändler. Müller erzählte die Geschichte ihres Großvaters Alphons Müller, der von 1936 bis 1972 in Dresden eine Kunsthandlung führte, zu deren Kund:innen beispielsweise die Staatlichen Kunstsammlungen Dresden oder der Sammler Friedrich Pappermann zählten. Trotz schwieriger Rahmenbedingungen waren beachtliche private Kunstsammlungen in der DDR möglich, so Claudia Maria Müller. Nicht eindeutig aufgeklärt werden konnte ein Galerieeinbruch, in dessen Folge die gestohlene Ware im Staatlichen Kunsthandel wieder auftauchte.

Vgl. Beiträge von Claudia Maria Müller, S. 137, und Christin Müller-Wenzel, S. 148.

Christin Müller-Wenzel stellte in ihrem Vortrag „Magnet für Kunstliebhaber oder Ort der Provokation?" die Verortung und Rezeption der Galerie Henning in Halle (Saale) im Kontext der DDR-Politik vor. Die Galerie widmete sich von 1947 bis 1961 der Kunst der Klassischen Moderne und stellte Künstler wie Pablo Picasso, Marc Chagall oder Karl Schmidt-Rottluff aus. Sie war ein Ort des behördlich ungeregelten kulturellen Austausches und seitens des SED-Staates bald unerwünscht. Der Galerist Eduard Henning geriet mehrfach in Bedrängnis, bis die Galerie 1961 nach Diffamierungen schließen musste. Am 21. Juni 1962 beendete Henning sein Leben.[10]

Die anschließende Diskussion verdeutlichte, dass für die Aufarbeitung der Geschäftsunterlagen von Galerien und Kunsthandlungen weitere Recherchen in Archiven und Museen notwendig sind, deren Unterlagen dazu bisher unerschlossen oder unzugänglich waren.

Im dritten Sektor stand das „Spannungsfeld Aufarbeitung zwischen Ost und West" im Fokus samt Strukturen der Auslandsgeschäfte mit Kunst und Antiquitäten. Bernd Isphording, seit 2016 Projektmitarbeiter im Bundesarchiv, war dort mit der Erschließung des Archivmaterials der Kunst und Antiquitäten GmbH (KuA) und des Staatlichen Kunsthandels der DDR betraut. Die Geschäftsunterlagen der KuA geben Aufschluss über Käufer:innen und Geschäftsmethoden wie das Fingieren von Steuerschulden zahlreicher Kunst- und Antiquitätenhändler:innen. Ein Ziel der Erschließung war es, die Archivalien entsprechend aufzubereiten,

Vgl. Beitrag von Bernd Isphording, S. 234.

Screenshot der Konferenz während des Vortrags von Xenia Schiemann. Videos der Konferenzbeiträge sind auf dem YouTube-Kanal „Kulturgutverluste/German Lost Art Foundation" veröffentlicht. www.youtube.com/channel/UC7tsinBmyUDhfInQJiLmVmg

⊘ Vgl. Beitrag von Margaux Dumas und Xenia Schiemann, S. 213.

sodass Provenienzforscher:innen die Bezeichnungen, Kürzel und Aufklebernummer entschlüsseln können. Die nicht einheitlich geführten Bezeichnungen der KuA stellen eine Herausforderung für Recherche und Aufarbeitung dar. Hierfür wurde ein Findbuch erstellt.[11]

Auf eine internationale Ebene gebracht haben die Provenienzforscherinnen Xenia Schiemann und Margaux Dumas die Thematik in ihrem Vortrag „Behind the Iron Curtain: A case study of the East German exports of art and their connection to Nazi loot".⊘ Sie konzentrierten sich auf die Herkunftsgeschichte eines Möbelstücks. Im besetzten Frankreich wurde es 1941 an die Reichsbank veräußert und durch die Commission de Récupération Artistique im Band *Répertoire des biens spoliés (1947–1949)* als geplündert aufgeführt. Durch das DDR-Finanzministerium gelangte die Kommode 1952 in die Sammlung des Märkischen Museums in Ost-Berlin. 1986 wurde sie in London beim Auktionshaus Christie's versteigert. Das Beispiel verdeutlicht die Problematik der mehrfachen Unrechtskontexte und die internationale Verstrickung des DDR-Kunsthandels. Es ist kein ostdeutsches oder osteuropäisches Problem, weshalb für die Erforschung fallweise ausländische Archive von Relevanz sein können.

In der Diskussion wurden Grenzen der heutigen Provenienzforschung deutlich. So sind im Bundesarchiv einzelne Objekte noch nicht mit einer korrekten Verschlagwortung recherchierbar. Der

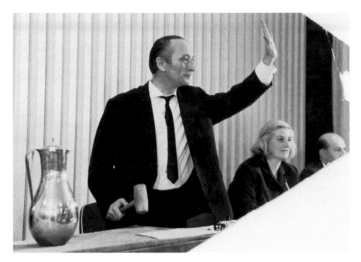

Bedarf an besseren Recherchetools wird aber so schnell nicht gedeckt werden können. Zudem stellen die wenigen Überlieferungen des Staatlichen Kunsthandels ein Problem für eine genaue historische Aufklärung dar. Hoffnungen werden in die Analyse von Rechnungen gesetzt – wie sie beispielsweise von der Galerie Alphons Müller vorliegen –, die Aufschluss über Verkaufswerte geben und zu einer besseren Einschätzung der Verkaufskontexte führen könnten. Bezüglich des mehrfachen Entzuges aus unterschiedlichen Enteignungskontexten bilanzierte Gilbert Lupfer, dass noch nicht klar sei, wie viele Objekte betroffen sind. Bevor der Umgang mit mehrfach entzogenen Objekten diskutiert werden könne, müsse weitere Forschung betrieben werden.

Die Tagung zeigte eindrücklich, dass in den letzten Jahren erfolgreich Grundlagenforschung zum Kunst- und Kulturgutentzug in der DDR und in der SBZ betrieben wurde. Unverkennbar wurde aber auch der immense Bedarf, erschlossenes Material weiterführend zu erforschen. Druck müsste jetzt nicht nur von politischer Seite kommen, sondern auch von Museen deutschlandweit. Es gilt, ein länderübergreifendes Bewusstsein für diese Entzugskontexte zu schaffen und den Willen zur historischen Aufarbeitung zu wecken. Als weiterer Schritt sind Handlungsempfehlungen für Museen nötig, um einen geschärften Umgang mit Sammlungsobjekten zu konstituieren, die zwischen 1945 und 1990 transloziert oder entzogen wurden.

Endnoten

[1] Die vom Zentrum organisierte Tagung „Entziehungen von Kulturgütern in SBZ und DDR. Der Stand der Forschung und Perspektiven" hatte am 21. November 2016 in der Stiftung Brandenburger Tor, Berlin, stattgefunden.

[2] Vgl. Gesetz zur Regelung offener Vermögensfragen (VermG), http://www.gesetze-im-internet.de/vermg/index.html (18.12.2020); Gesetz über die Entschädigung nach dem Gesetz zur Regelung offener Vermögensfragen und über staatliche Ausgleichsleistungen für Enteignungen auf besatzungsrechtlicher oder besatzungshoheitlicher Grundlage (Entschädigungs- und Ausgleichsleistungsgesetz [EALG]), http://www.gesetze-im-internet.de/ealg/BJNR262400994.html (18.12.2020).

[3] Vgl. Bundesamt für zentrale Dienste und offene Vermögensfragen: Offene Vermögensfragen. Vermögensrecht. Fristen, https://www.badv.bund.de/DE/OffeneVermoegensfragen/Vermoegensrecht/Fristen/start.html (24.1.2021); Vgl. Ausschlussfrist EALG, § 6 Abs. 1 Satz 3 AusglLeistG, https://www.gesetze-im-internet.de/ausglleistg/__6.html (24.1.2021); Durch verschiedene Rehabilitierungsgesetze können noch heute Ansprüche auf Grundlage des VermG oder des EALG entstehen – und im Falle einer Rehabilitierung geltend gemacht werden.

[4] Vgl. Konferenz nationaler Kultureinrichtungen, AG 1949-89: Eckpunktepapier der Arbeitsgruppe 1949–89 hinsichtlich der Provenienzforschung für die Zeit 1949 bis 1989, [unveröffentlichtes Typoskript] o. J. [2015]; vgl. Konferenz nationaler Kultureinrichtungen, AG 1949–89: Denkschrift der in der Konferenz nationaler Kultureinrichtungen (KNK) zusammengefassten Museen hinsichtlich der Provenienz-Forschung für die Zeit von 1949 bis 1989, [unveröffentlichtes Typoskript] o. J. [2015]; Museumsverband Brandenburg: Museumsblätter 31 (Dezember 2017), Mitteilungen des Museumsverbandes Brandenburg; vgl. Jan Thomas Köhler: Zwischen 1945 und 1989. Ein Forschungsprojekt an der Stiftung Preußische Schlösser und Gärten Berlin-Brandenburg, in: Museumsblätter 23 (Dezember 2013), Mitteilungen des Museumsverbandes Brandenburg

[5] Der Abschlussbericht „MfS-Aktion ‚Licht'" ist seit Ende 2020 in der Datenbank Proveana zu finden, PURL www.proveana.de/de/link/pro00000021.

[6] Arno Polzin, Helge Heidemeyer, Ralf Blum: Auf der Suche nach Kulturgutverlusten. Ein Spezialinventar zu den Stasi-Unterlagen, Berlin 2020, https://www.bstu.de/assets/bstu/de/Downloads/EV_Gutachten_Kulturgutverluste.pdf (18.12.2020).

[7] Der Bericht ist in die Datenbank Proveana eingestellt, PURL https://www.proveana.de/de/link/pro10000313.

[8] Portal Provenienzforschung: Kulturgutverluste SBZ/DDR, https://provenienzforschung.commsy.net/commsy.php?cid=1244511&mod=home&fct=index&jscheck=1&isJS=1&SID=eae997b49ded398df3dbf2664ac3e5ff&db_pid=1244511&https=1&flash=-1 (18.12.2020).

[9] Projektlaufzeit: Oktober 2018 bis November 2020. Der Abschlussbericht zur Studie s. unter PURL https://www.proveana.de/de/link/pro00000023.

[10] Vgl. Christin Müller-Wenzel: Der Staatliche Kunsthandel in der DDR – ein Kunstmarkt mit Plan? Ein Kompendium, Dissertation an der Universität Marburg, Halle (Saale) 2021.

[11] Anne Bahlmann, Falco Hübner, Bernd Isphording, Stefanie Klüh: Findbücher zu den Beständen des Bundesarchivs. Bestand DL 210 – Betriebe des Bereichs Kommerzielle Koordinierung. Teilbestand Kunst und Antiquitäten GmbH (1974–2002), Berlin 2017, https://www.bundesarchiv.de/DE/Content/Downloads/Meldungen/20180601-kua-findbucheinleitung.pdf (19.12.2020).

Joëlle Warmbrunn

Joëlle Warmbrunn ist Studentin der Kunstgeschichte an der Rheinischen Friedrich-Wilhelms-Universität Bonn und derzeit wissenschaftliche Hilfskraft im Projekt „Israeli-German Dialogues: Provenance Research and Restitution Rules for Nazi-Confiscated Art in a Binational Perspective".

307

Anhang

Abbildungsnachweis

Cover: Alfred Kantorowicz nach einer Vorlesung an der Freien Universität in West-Berlin, 1963 © bpk/Kunstbibliothek, SMB/Bernard Larsson; Erwerbung der Staatlichen Kunstsammlungen Dresden aus dem Antikhandel (Kath) in Pirna 1974: Wandteppich mit der Darstellung einer Jagd der Diana, Wolle in vielen Farbabstufungen in Gobelinweberei, Frankreich 1. Hälfte des 18. Jahrhunderts, 300 × 273 cm, Inv.-Nr. 40 449 © Staatliche Kunstsammlungen Dresden, H.-P. Klut; Gestell eines kleinen Tisches auf gedrechselten Beinen, 19. Jahrhundert, in einem Depot der Kulturstiftung Sachsen-Anhalt im ehemaligen Feudalmuseum Schloss Wernigerode © Kulturstiftung Sachsen-Anhalt, Charlen Christoph; Blick in ein Regal der KuA-Verkaufs- und Lagerhallen in Mühlenbeck, Aufnahme 1987, BStU, MfS, AU 10611/87, Bl. 150-a © BStU, Fotograf:in unbekannt

Mathias Deinert: S. 3, 8 © BStU/Fotograf:in unbekannt; S. 5 © BStU/Mathias Deinert, S. 9, 10 © Mathias Deinert; Ulrike Schmiegelt-Rietig: S. 20 © Max Beran, S. 21 © Stiftung Preußische Schlösser und Gärten/Roland Handrick; Thomas Rudert: S. 30 © SLUB Dresden/Deutsche Fotothek/Abraham Pisarek, S. 31 © Staatliche Kunstsammlungen Dresden, Archiv/Fotograf:in unbekannt, S. 32 © SLUB Dresden/Deutsche Fotothek/Else Seifert, S. 33 © Sächsisches Hauptstaatsarchiv Dresden/Thomas Rudert, S. 37 (oben) © SLUB Dresden/Deutsche Fotothek/Erich Höhne/Erich Pohl, S. 37 (unten) © Staatliche Kunstsammlungen Dresden, Archiv/Vera Wobad; Doris Kachel: S. 46 © Deutsches Historisches Museum, S. 47, 52 (Mitte) © Doris Kachel, S. 52 (oben) © Deutsches Historisches Museum, S. 52 (unten) © Christopher Jütte; Ronny Licht: S. 56 © Ronny Licht, S. 58 © Bundesamt für zentrale Dienste und offene Vermögensfragen/Ronny Licht, S. 62 (links) © Sächsisches Hauptstaatsarchiv Dresden/Ronny Licht, S. 62 (rechts) © Bundesarchiv/Ronny Licht, S. 63 © Staatliche Museen zu Berlin, Zentralarchiv/Ronny Licht; Heike Schroll: S. 70, 71, 75, 77 © Landesarchiv Berlin/Gestaltung: Ute Langbein; Michael Busch: S. 83, 89, 92 © Staatliche Schlösser, Gärten und Kunstsammlungen Mecklenburg-Vorpommern; Antje Strahl und Reno Stutz: S. 106 (links) © Archiv des Landkreises Rostock/Antje Strahl, S. 106 (rechts) © Heimatmuseum Bützow (Krummes Haus)/Antje Strahl, S. 107 © Stadtmuseum Güstrow/Antje Strahl, S. 109 © Heimatmuseum Bützow (Krummes Haus)/Annette Hübner (Bützow); Regine Dehnel und Michaela Scheibe: S. 114 © bpk/Kunstbibliothek/SMB/Bernard Larsson, S. 115 © SBB PK/Thomas Rose, S. 116, 118, 119 © SBB PK/Hagen Immel; Cora Chall: S. 125, 126, 127 © Klassik Stiftung Weimar; Claudia Maria Müller: S. 138, 143, 145 © Archiv Alphons Müller, S. 139 © Staatliche Kunstsammlungen Dresden/

Personen- und Sachregister

Das Deutsche Zentrum Kulturgutverluste ist eine vom Bund,
den Ländern und den kommunalen Spitzenverbänden
errichtete Stiftung bürgerlichen Rechts.

Das Deutsche Zentrum Kulturgutverluste wird gefördert durch

 Die Beauftragte der Bundesregierung
für Kultur und Medien

ISBN 978-3-11-074450-7
ISSN 2629-5857

Library of Congress Control Number: 2021951758

Bibliografische Information der Deutschen Nationalbibliothek
Die Deutsche Nationalbibliothek verzeichnet diese Publikation in der
Deutschen Nationalbibliografie; detaillierte bibliografische Daten sind im
Internet über http://dnb.dnb.de abrufbar.

Herausgeber der Schriftenreihe: Deutsches Zentrum Kulturgutverluste
Herausgeber dieses Bandes und Redaktion: Mathias Deinert,
Uwe Hartmann, Gilbert Lupfer
Lektorat: Karin Schneider, Berlin
Bildredaktion: Mathias Deinert, Karin Schneider, Berlin
Übersetzungen: DELTA International CITS GmbH, KERN AG Sprachen-
dienste, Sophie Leschik, Susanne Meyer-Abich, Maria Obenaus
Layout: Bureau Steffi Holz, Brandenburg an der Havel
Satz: SatzBild GbR, Sabine Taube, Kieve
Druck und Bindung: DZA Druckerei zu Altenburg GmbH, Altenburg

www.degruyter.com